THE
UNSEEN
MAURETANIA 1907

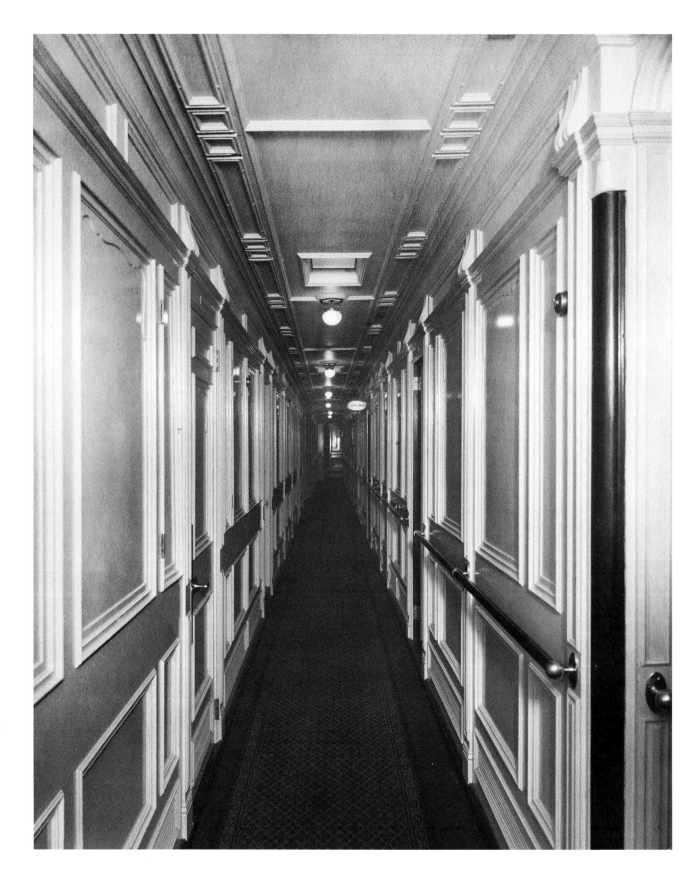

This photograph, taken shortly before the *Mauretania* entered service, looks forward along the corridor on A Deck's port side. The door to stateroom A-24 is visible on the right, and just beyond that a sign points the way to one of the gentlemen's public baths. (Author's Collection)

THE UNSEEN MAURETANIA 1907

J. KENT LAYTON

The History Press

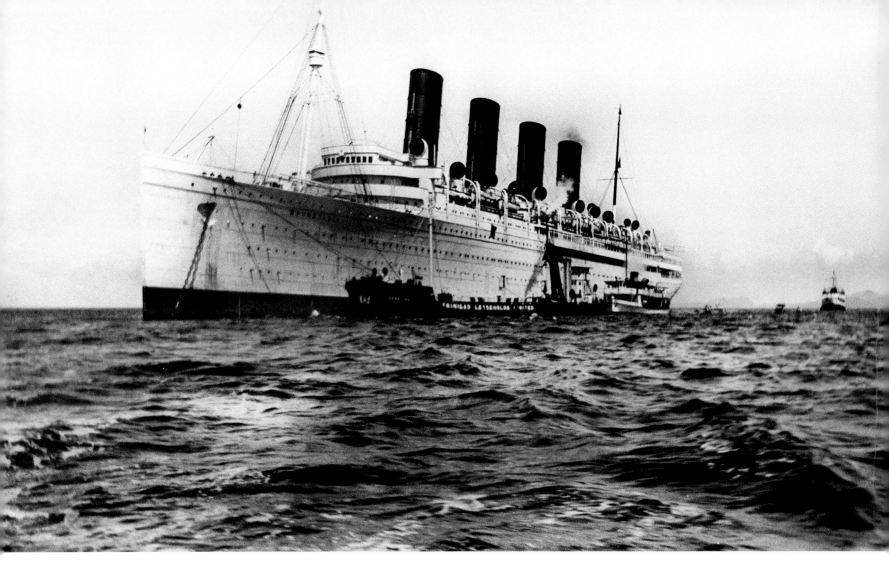

This unique 1933 photograph shows the *Mauretania*, painted in her white cruising colour scheme, off the island of Trinidad. A passenger tender lies alongside, and just forward of the tender is a fuelling barge. (Author's Collection)

First published 2015
This paperback edition published 2021

The History Press
97 St George's Place
Cheltenham
GL50 3QB
www.thehistorypress.co.uk

© J. Kent Layton, 2015, 2021

British Library Cataloguing in Publication Data.
A catalogue record for this book is available from the British Library.

ISBN 978 0 7509 9654 9

Typesetting and origination by The History Press
Printed in Turkey by Imak

Cover illustrations.
Front: The Mauretania during her trial runs. Her First Class Promenade Deck was enclosed with canvas during the tests. (Beamish Museum)
Back: A very rare starboard-bow view of the incomplete Mauretania in early 1907. (Beamish Museum)

CONTENTS

AUTHOR'S NOTE FOR THE FIRST EDITION

As I write this personal message, I am sailing the Caribbean in the world's largest cruise ship. The breeze is fresh, the skies are overcast and there have been occasional showers this afternoon. Sitting on my balcony, feeling the sea air caress the towering sides of my vessel, I cannot help but think of another ship that once sailed these same Caribbean seas, a great ocean liner which was built for service on the North Atlantic route. Unlike the hapless *Titanic*, this liner enjoyed a long and happy career of crossing and cruising. Her passengers experienced many happy, warm, calm evenings such as the one I now enjoy. There were also many occasions when that great ship was breaking speed records, or when she was pitted in battle against the power of nature and the elements; somehow she always came through like the champion that she truly was.

Her name was *Mauretania*.

She was the largest and fastest ship in the world when she entered service in 1907, and she served along with her slightly older, slightly smaller sister *Lusitania* for seven-and-a-half years. For four of those years, the pair was entirely matchless; having survived the horrors of the Great War, or First World War as we know it today, *Mauretania* continued a splendid service on the Atlantic and retained the Blue Riband for the fastest Atlantic crossing until 1929.

What is interesting about the *Mauretania* is that even after she was no longer the largest ship in the world, even after she was no longer the fastest, she had a charisma that drew passengers from all walks of life. The study of maritime history often focuses on the tragedies, but there were also many success stories that should be told. *Mauretania*'s has no equal.

I am proud to compile a book that tells the *Mauretania*'s story in both words and pictures. I hope that it reveals her unseen history to readers as it has never been told before. So now, sit back and enjoy your voyage on one of the greatest liners in history: the *Mauretania*.

The boat-express is waiting your command!
You will find the *Mauretania* at the quay,
Till her captain turns the lever 'neath his hand,
And the monstrous nine-decked city goes to sea.

Rudyard Kipling, *The Secret of the Machines*

FOREWORD TO THE SECOND EDITION

We are living in very uncertain times. When I wrote the Author's Note to the first edition of this volume back in early 2015, I was comfortably ensconced in the balcony of my stateroom on the world's largest cruise ship, enjoying the warm fresh breezes of the Caribbean. As I write this Foreword, I could not even board such a cruise ship, due to the greatest worldwide pandemic in over a century, the likes of which have not been seen since the Spanish Influenza. It is utterly remarkable how stable life can seem, but how quickly and thoroughly our lives can be upended by global upheaval or catastrophe.

Looking back on the career of *Mauretania*, however, it is also noteworthy that the legendary liner pushed through incredibly tumultuous times herself: she was born into the peaceful Edwardian Era, that Gilded Age that so many of us look back on with fondness, but those times were far from perfect. There was still crime, poverty, disease and so many other things that continue to plague mankind. However, things at least seemed stable ... there was a brightness on the horizon, and a nearly universal hope that things were going to get better.

Then came the Great War, later known as the First World War because it was succeeded by a second such, even greater, conflict. *Mauretania*'s life was forever changed in that war: her running mate *Lusitania* was lost to a German torpedo and *Mauretania* herself had her share of near misses when she did service as a hospital ship and later a troopship.

After the war, the world had changed. A pandemic swept the globe and a global economy tried to pick up the pieces. Yet *Mauretania* forged forth, undaunted.

The 1920s were not known as the 'Roaring Twenties' for nothing. *Mauretania* reliably and consistently ferried passengers between America and England during those raucous years but, as the decade drew to a close, the party came to an abrupt end with the onset of another global catastrophe, the financial meltdown known as the Great Depression. At that point, brave old *Mauretania* continued to soldier on, seemingly unflustered by the uncertainty around her as she braved her way into new territories – literally and figuratively – and took on more and more cruises rather than crossings. By the time she finally gave up to a younger generation of liner, she had become one of the most beloved passenger ships the world had ever seen.

And perhaps that is where *Mauretania*'s story holds a lesson for us today: no matter how gloomy things look, no matter how uncertain our modern world is, never give up. Be there for others. Keep pressing forward.

J. Kent Layton
New York, United States
October 2020

ACKNOWLEDGMENTS

Every book that bears my name on the cover is produced only with the assistance of many others, and that is again the case with *The Unseen Mauretania*. I would like to take a moment to thank all those who have contributed to the finished version of this book.

First, a special thanks to my editor Amy Rigg and the staff at The History Press. They believed in this volume's merits when I first approached them, and they were willing to give it the lavish format it truly deserves. Their professionalism and courtesy during every step of the process also aided me in the sometimes harrowing research and creative process.

I must also thank Mark Chirnside for consistently steering me, with nearly uncanny ability, to the exact original reference material and sources that answered questions to which I could not find answers elsewhere. Thanks are also due to Julian Harrop and the staff of the Beamish Museum, who eagerly and graciously opened their entire photo archive for my use in this project. Also deserving of special mention is Jeremy Philip Cusker, of Cornell University, for turning up the 1936 report of the surveys taken on the *Mauretania* during her demolition, which helped me to understand how the ship had withstood decay through the years, and even answered some questions regarding her later paint schemes. I would also like to thank Mike Priestley for the information he supplied on his grandfather's November 1907 photographs of the *Mauretania*, and Roger Marks for providing the details on the 1932 abstract card.

Major photographic and illustrative contributions were made by the following individuals, each of whom spent hours going through their collections with a fine-tooth comb specifically for this project: Steven B. Anderson, Michael Cundiff, Ralph Currell, Tad G. Fitch, Clyde George, Ioannis Georgiou, Roger Marks, Mike Poirier, Eric Sauder, Jonathan Smith and Russ Willoughby. If I have managed to omit anyone from this list, please accept my apologies and remind me so that I can incorporate your name in future editions.

Lastly, while I tried very hard to create an accurate picture of the *Mauretania*'s story through these pages, if any errors have been made in this book, they are mine and mine alone.

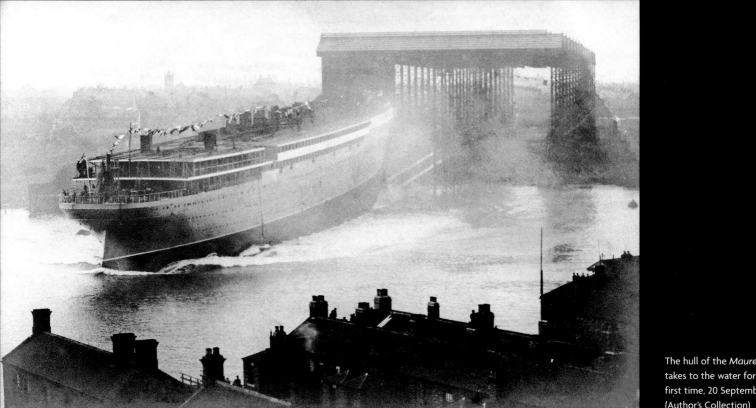

The hull of the *Mauretania* takes to the water for the first time, 20 September 1906. (Author's Collection)

Saturday 24 September 1904, was a pleasant day in New York City. The chilled sting of winter was yet weeks away, but the worst heat of midsummer had already passed. Temperatures topped out at 71°F, and the weather was fair with a light southerly breeze. Altogether it was a fine afternoon for American customs inspectors – who worked at the Lower West Side Manhattan docks, where the greatest transatlantic liners berthed – to do their work.

On this day the customs men were particularly busy. Three large ships were coming up the North River to finish their crossings: the British Cunard liner *Umbria*, a venerable if ageing ship with nearly two decades of service to her credit; also the American liner *St Paul*, which was much newer and larger than the *Umbria*; finally, there was the giant White Star liner *Celtic*. Just three years old, she was eclipsed in size only by her two newer sisters, *Cedric* and *Baltic*. On this trip she had carried a very full list of 3,318 souls, including the ship's crew.

Amid the hectic scene on the docks, one particularly distinguished-looking and well-seasoned transatlantic traveller came ashore from the *Umbria*. Nearing 60 years of age, his dark hair was greying and slightly receding, and he had a full and nearly white beard. His name was George B. Hunter and he was the chairman of the English shipbuilding firm with the wholly improbable name of Swan, Hunter & Wigham Richardson, which was located on the Tyne River at Wallsend. The town derived its name from the fact that it was built on the eastern extreme of Hadrian's Wall at the site of the ancient Roman fortress Segedunum, and quite literally at the 'wall's end'.

It was said that few names were better known in shipbuilding circles than that of Mr Hunter, and with good reason. In 1880, he had become the principal partner in C.S. Swan and Hunter, as the shipbuilding firm was then known. By 1895 he had succeeded in becoming chairman of the growing company, which had, by 1903, merged with the Wigham Richardson yard. Hunter's newly amalgamated firm had set to a massive modernisation effort, during which time two enormous new building slips were constructed, each about 750ft long and 100ft wide, and each enclosed by glass-roofed sheds to protect workers labouring beneath.

American reporters, always eager to see which famous or noteworthy people were disembarking from ocean liners, were on hand that September day, and they inevitably found George Hunter. No, he told them, he had not come to the United States to look into acquiring American steel – there was no need to, since English steel was just as good and was 'a trifle cheaper' to boot. His main purpose was, instead, to visit the St Louis International Exposition. But he did give a cryptic tidbit to the reporters. He told them that his firm was currently working on an enormous new liner. 'This ship will be bigger than the *Celtic*,' he said, perhaps pointing the White Star liner out for effect, 'and 800 feet long.' With that bombshell, the interview was over.

In the absence of further details, the reporters were forced to speculate, but they knew their ships rather well. That Hunter's yard was working on a liner of those proportions could only mean one thing: that they had got the contract to build one of a pair of much-discussed and, some would have said, impossibly audacious ocean liners.[1]

In point of fact, even as Mr Hunter landed in New York, workers were labouring in those sheds to build a ship that many might have believed impossible just a few short years before. Her yard number was 735, but the name she would eventually bear would be one of the most famous in the history of the North Atlantic. She would be called *Mauretania*.

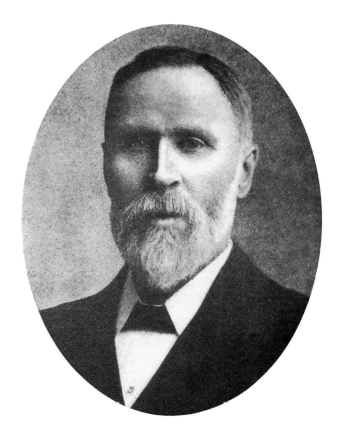

George B. Hunter, the driving force behind the Swan, Hunter & Wigham Richardson shipyard. (Author's Collection)

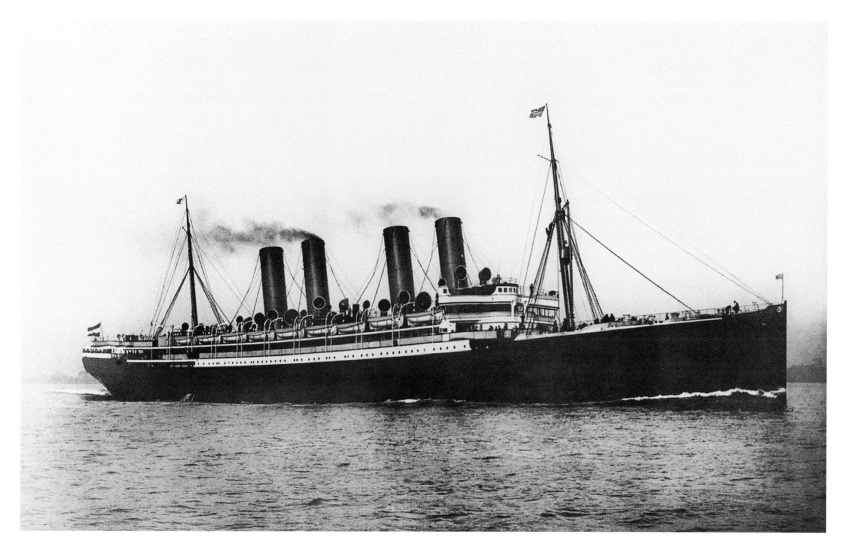

The *Kaiser Wilhelm der Grosse* of 1897. (Author's Collection)

The Cunard Steamship Company, or Cunard Line as it was also called, had embarked upon an audacious adventure borne of desperation. Founded in 1840 by Halifax native Samuel Cunard, the firm had built a steady reputation for reliability, comfort and speed over the next fifty-seven years. In an age when Great Britain was the dominant world power and the sun never set upon her empire, the only way to move people and goods to and from the island nation was by ship. Cunard shared the pride on the transatlantic route with ships from another British-owned company, the White Star Line. Ships of other nations also plied the North Atlantic, but British ships were always on the cutting edge.

Previously content to be just reliable, in 1884 Cunard introduced the *Etruria* and *Umbria*. They were not only the largest ships of the day but also captured the coveted 'Blue Riband' – and in spite of its physical nonexistence, this

corporeally challenged trophy is never properly referred to as a 'Blue Ribbon' – for the fastest crossing of the Atlantic. They were soon challenged by the American liners *City of Paris* and *City of New York*, and the White Star liners *Teutonic* and *Majestic*, but Cunard trumped the competition again in 1893 with the *Campania* and *Lucania*.

In 1897, however, British dominance in shipping was usurped by a new liner, the *Kaiser Wilhelm der Grosse*. Built in Germany, she was in the service of the North German Lloyd Line. She was named in honour of Kaiser Wilhelm I; his grandson, Wilhelm II, was then emperor of Germany. Ambitious Wilhelm II, also grandson of England's Queen Victoria, had urged the North German Lloyd and Hamburg-Amerika lines to challenge Britain's mercantile prestige. As both the largest and fastest liner in the world when she entered service, the *Kaiser Wilhelm der Grosse*

Cunard Chairman Lord Inverclyde.
(Author's Collection)

delivered on that threat. In her wake followed a stream of even larger and faster German ships from both companies, all heavily subsidised by the German government. An international rate war soon broke out between the major shipping lines, which further ate into profits for the British Cunard and White Star companies. In April 1902, American financier J.P. Morgan further damaged British maritime pride when he bought out the White Star Line and formed the conglomerate International Mercantile Marine. Even worse, Morgan made an alliance with the German shipping companies, thus threatening to extinguish all competition on the Atlantic. Then he began courting Cunard – the final British torchbearer, with only an ageing fleet of ships in its arsenal – with the idea of adding that firm to his growing monopoly.

The British public at large was horrified. How could upstart Germany have taken their long-held place in merchant shipping? How could White Star be falling in to the hands of an American? Would Cunard be able to stand against Morgan and the Germans?

The chairman of the Cunard Line, George Arbuthnot – the Second Baron of Inverclyde and grandson of Sir George Burns, one of the company's co-founders – was determined that he would not sell out. Yet, the line was in a financially difficult spot. In order to recapture its place of prestige, it had to build the largest and fastest vessels in the world. Entering such uncharted territory – and in a way that put the competition in its place for long enough to make the venture worthwhile – would prove expensive. Where would the money come from?

Lord Inverclyde, born in September 1861, was highly familiar with how to run a shipping line. He had apprenticed in various departments of the Cunard Company, and had thus acquired 'a wide knowledge of the ramifications of the shipping trade'.[2] He was known as 'much more a thinker than a talker', as a man 'who dealt with a critical situation in a firm and broad-minded way', and he soon came up with an idea. If the German government could subsidise the German merchant steamers, why couldn't the British government do the same? In March 1902, he approached the British government for assistance.

In July, Prime Minister Salisbury was handing the reins over to incoming prime minister Arthur Balfour. Balfour's younger brother Gerald was then president of the British Board of Trade, and their relationship seems to have proved quite conducive to coming to an agreement with Cunard. On 30 September, there came news on the subject, with

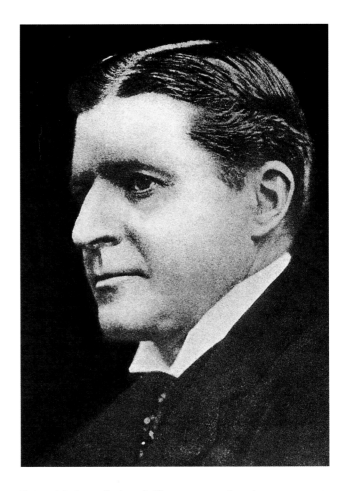

Prime Minister Arthur Balfour announcing the agreement. His brother Gerald gave a speech in Sheffield that same day, in which he discussed the threat from the German shipping lines, and how incapable the Cunard Company was of funding a response on their own. He then announced a tentative agreement with Lord Inverclyde, which he expected would soon be approved by Cunard's shareholders.

'The Cunard Company have pledged themselves to remain in every respect a British company,' he said, in a speech interrupted numerous times by applause and cheering. He added that it would be 'managed by British directors, with the shares not to be transferred to anybody but British subjects', and their ships were 'to be officered by British officers'. He next added the big news: 'They also engage to construct two vessels of 24 to 25 knots', at which point the excited audience cheered again. He resumed by explaining that these two ships would be 'a knot faster than any other in the fleet', would 'remain at the disposal of the Admiralty' and be liable to charter or purchase at any time on terms fixed in the agreement. In order to

'reduce the expenditure as far as possible the agreement provides that the capital necessary for the construction of these vessels should be advanced by the government to the Cunard Company, of course, on proper security and on proper conditions of repayment'. This statement brought on further cheering. He added: 'The Cunard Company is also to receive from the government a subsidy in lieu of the present Admiralty subvention, amounting to £150,000 a year.' He then hastily said that, although the per annum sum seemed large, it was 'not more than a fair remuneration for the services to be rendered'.

He next announced that an agreement had also been reached with J.P. Morgan to keep British ships in the IMM combine, which included all White Star liners, 'British, not merely nominally, but in reality'. This meant that the majority of those companies' directors would remain British subjects, that their ships would fly the British flag, be British-registered, staffed by all British officers and manned in 'reasonable proportion' by British crews. 'In other words,' he said, 'these British companies are to remain to all intents and purposes British companies.'[3]

Balfour's audience was certainly enthusiastic, but the next day the British press proved considerably less so. 'There is nothing to crow about,' the *St James Gazette* complained, 'we pay handsomely to keep the Cunard ships and the deal with the Morgan-Pierrie [*sic*] concern is a very ricketty business.' The *Westminster Gazette* complained that the idea of the government financing by loan to a private enterprise was 'wholly objectionable'.[4]

Yet complainers were in the minority, and the deal moved forward. When the formal agreements were signed on 30 July 1903, the British government agreed to loan Cunard £2.6 million for a twenty-year term, on debentures at 2.75 per cent interest – or less than half of the general interest rates at the time. The annual subsidy of £150,000 was to be divided between the new ships evenly, and the Admiralty was to have a heavy say in the final design of the liners, with the idea of using them as armed auxiliary cruisers in time of war. The agreement called for the two new ships to maintain a 'minimum average ocean speed of 24½ knots in moderate weather'. If that speed was not met, but the speed did not fall below 23½ knots, then 'a deduction' would be made from the annual subsidy. *Engineering* magazine, following the story with great interest, postulated that Cunard would 'aim at, and will probably get, 25 knots, costly as that may be in respect of first charge, coal consumption, and upkeep'.[5]

Cunard had already begun considering designs for a response to the German threat. As far back as November 1899, Cunard had asked John Brown & Co., at Scotland's Clydebank, to give them a quote, or tender, for a single ship with the dimensions of 700ft in length by 71ft wide. The quoted price was £445,000, and Cunard did not proceed. By 1901, Cunard saw the need to build a pair of ships to properly counter its competitors. Its general superintendent, James Bain, and naval architect, Leonard Peskett, had created rough plans for 700ft liners capable of up to 24 knots. They went so far as to submit rough plans to the Newcastle firm C.S. Swan & Hunter, but nothing really came of it.[6]

In February 1902, Cunard had approached three prominent shipbuilders – John Brown; Vickers, Sons & Maxim of Barrow; and the Fairfield Shipbuilding & Engineering Co. – with the idea of getting quotes for a pair of ships. It was not until October that the Cunard Board of Directors had a full report on the companies' submissions.[7] Based on these reports, which indicated the project was feasible, Cunard drew up new draft specifications and general arrangement plans, and planned to submit them to those three firms, and also to Swan & Hunter.

Charles Parsons, the inventor of the marine steam turbine. (Author's Collection)

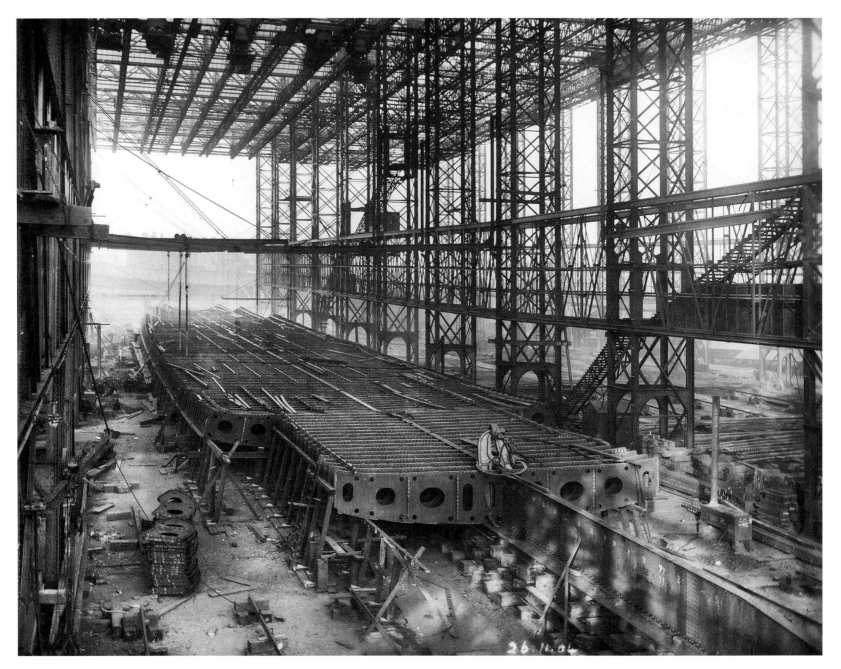

This photograph was taken on 26 November 1904 and shows work progressing on the double bottom of the *Mauretania*. The stern section of the ship is in the foreground, and work in this area lags behind work at the bow. (Eric Sauder Collection)

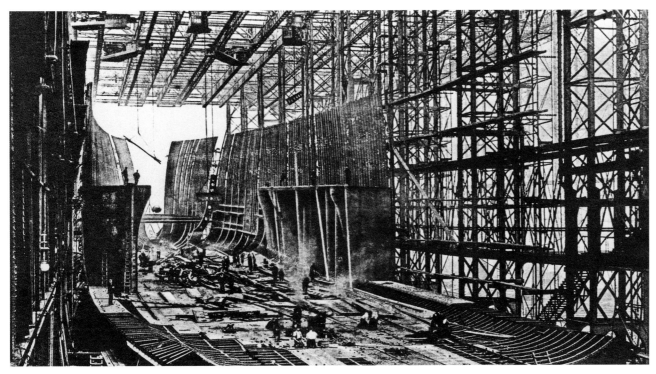

This view was taken around March 1905, and shows work progressing on erecting the side frames. Again, the view looks toward the bow. On either side, construction of the coal bunkers which lined the ship's sides outboard of the boiler rooms has commenced. (Beamish Museum)

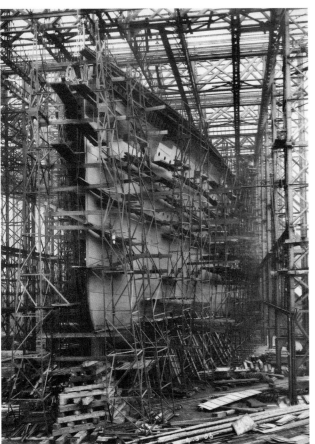

Swan & Hunter was not really considered a top-of-the-line shipbuilder at the time, for it was a relatively new company with somewhat limited facilities. However, it was keen to become peers with 'A-list' companies such as John Brown or Harland & Wolff, and saw in this contract the potential of establishing that reputation. It also had a good relationship with Cunard, having built three intermediate vessels for the company: the 8,845 gross registered ton (grt) *Ultonia* of 1899; the 13,799grt *Ivernia* of 1900; and the 13,555grt Cunarder *Carpathia*, then nearing completion and due to enter service in the spring of 1903. Based on the strength of their previous collaboration, George Hunter convinced Cunard's board to allow Swan & Hunter to compete for one of the contracts. If its bid was successful, the company would have to undertake a large-scale expansion of its yard before ever laying a single plate of steel.

In early 1903, Cunard's working idea was to build two ships of 750ft between perpendiculars (b.p.) by 76ft wide, with a speed of 25 knots, and to farm the contract for each ship out to a different yard. When Cunard reviewed the tenders from all four companies in December 1902, the most attractive submissions were by Swan & Hunter, which proposed a ship of 760ft b.p. by 80ft, and Vickers, which proposed a ship of the same length but with a beam of 78ft. At Cunard's behest, each of these designs would have been powered

By 4 May 1906, much of the liner's outer hull plating has been attached to the frames. The work is not yet finished, however, for the ribs are still visible just below the forecastle. (Eric Sauder ollection)

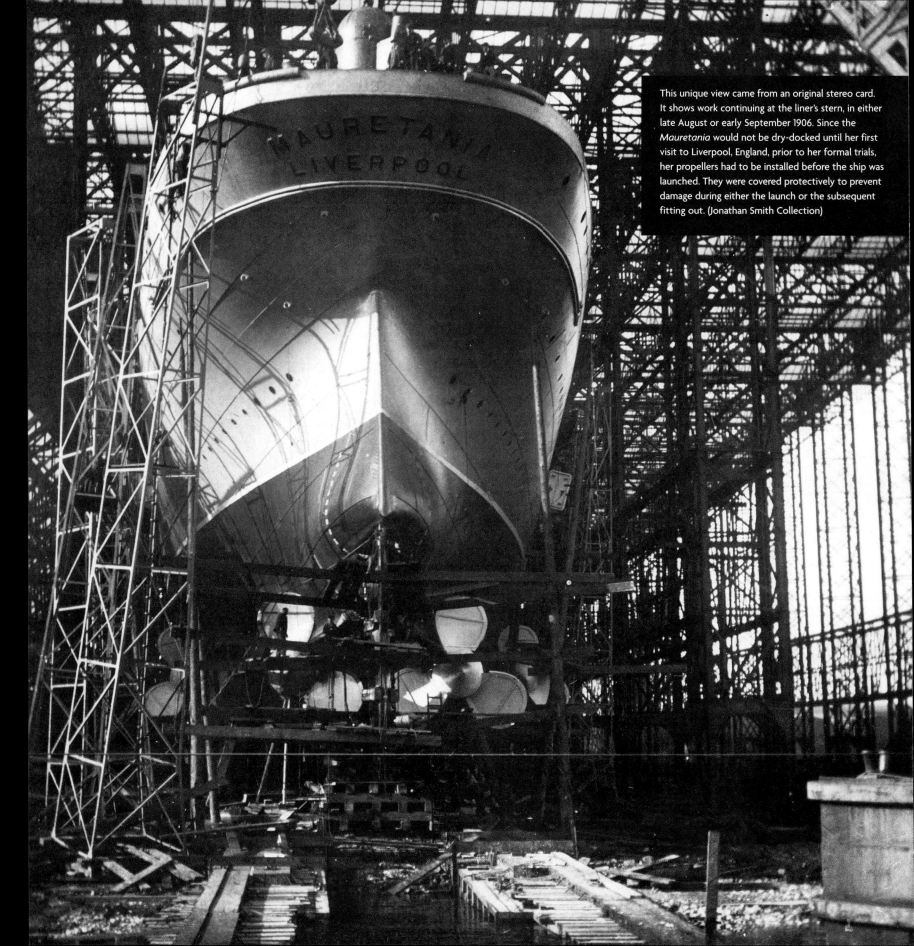

This unique view came from an original stereo card. It shows work continuing at the liner's stern, in either late August or early September 1906. Since the *Mauretania* would not be dry-docked until her first visit to Liverpool, England, prior to her formal trials, her propellers had to be installed before the ship was launched. They were covered protectively to prevent damage during either the launch or the subsequent fitting out. (Jonathan Smith Collection)

by three sets of tandem quadruple-expansion five-cylinder reciprocating engines putting out over 60,000 horsepower. Models of these forms were built and tested, and it was found that the Swan & Hunter design required 7 per cent less power to achieve the same speed as the Vickers design. John Brown proposed a ship of 725ft b.p. by 80ft wide, but it didn't model-test very well.

Further model tests were carried out under the supervision of Sir Philip Watts, the Director of Naval Construction to the Admiralty. The final result of the tank tests, concluded in April of 1904, was for ships of 760ft b.p. by 87½ft in width with a working draught of 33½ft.[8] Ostensibly because Vickers did not have facilities to build a ship of that width, they were forced to drop out of the running. Yet at a formal meeting with representatives from all three firms on 8 May 1903, nearly a year before, Cunard had already showed a preference for John Brown and Swan & Hunter. As long as the two companies could 'collaborate with the view to producing duplicate ships', or sister vessels based upon the same general design, those two companies were considered the clear choices for construction.[9] Before May 1903 was out, and based on their hopes to receive the contract for one of the ships, Swan & Hunter and the nearby yard of Wigham Richardson agreed to merge and form Swan, Hunter & Wigham Richardson.

Yet another detail still needed attention: how to power the new liners at the high speeds demanded by the government loan. There were two options available. The first was the tried-and-tested reciprocating engine. Variants of this type of steam engine had powered all steamships since they had first been introduced. They were large, had grown ever larger and more powerful with each successive generation, and had many moving parts. High-pressure steam from boilers was fed into cylinders, which turned crankshafts, which turned the propellers. However, a new and rather novel form of propulsion, the marine steam turbine, had been designed by a man named Charles Parsons, and demonstrated in his test vessel *Turbinia* in 1897. They were much simpler in principle, as they had but one moving part: the boiler steam was focused onto a series of blades attached to a drum, a setup rather similar to a windmill. When the drum spun, it turned the propeller shafts and thence the propellers.

In late 1901, Parsons had proposed the use of turbine machinery in Cunard ships, but Cunard swung conservatively during 1902 because there was very little practical experience in their use. As a result, the early 1903 plan was to use

reciprocating engines in the upcoming liners.[10] Yet this idea butted heads with practicality: reciprocating engines powerful enough to drive 25-knot liners of this scale would have consumed most of the internal space on the ships – too much space, in fact, to allow them to carry enough passengers to operate at a profit. So on 20 August 1903, a committee was formed to consider what type of propulsion would be employed in the new sister ships. It included Parsons and representatives from Cunard, the Admiralty, John Brown and Swan, Hunter. They researched

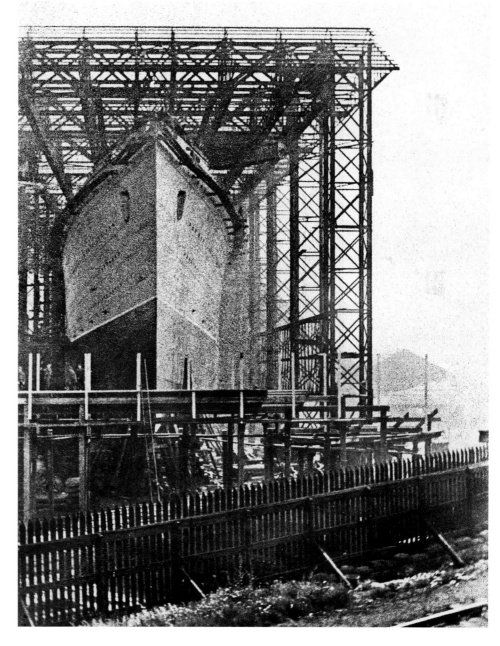

By 6 September, the vessel was clearly getting close to being ready for launch. Behind the fence, rows of grandstands are being built to accept spectators on the day of the event. (Beamish Museum)

the matter thoroughly and did not reach a conclusion until 24 March 1904; their final recommendation was to adopt Parsons-style steam turbines.[11] It was a gamble, as turbines had never before been used on this scale, but the reciprocating engine alternative was simply impracticable.

Once that vital detail had been settled, it was still important to obtain further data before drawing up final plans and beginning construction. While John Brown carried out 1/48-scale model tests, Swan, Hunter came up with a larger-scale method of testing: they built a 1/16-scale, 47½ft launch, an exact model of the proposed liner they would build. Constructed of wood, so that it could easily be refined as data was obtained, it was powered by electric motors fed by storage batteries, which it carried in its bow. For several weeks the launch was run up and down the length of the Northumberland dock on the Tyne River, which was 24ft deep and free of currents that could negatively affect the tests' results. Valuable information on the hull's form, propeller design, placement and rotation, wind resistance to various deck structures and shapes, and many other details were obtained. All of these were carefully recorded and noted for incorporation into the launch's full-sized counterpart.

On 7 April, Lord Inverclyde, the 'leading spirit of the Cunard Line in its darkest hour' who had brought the company 'out of an acute crisis ... [in] one of the most significant achievements of modern times'[12] initialled the outline specification and conditions for the ships. On 23 April, Swan, Hunter submitted an estimated cost for their ship of £1.301 million, excluding the costs of interior decoration. A week later, Cunard personnel met with representatives of both John Brown and Swan, Hunter. Cunard informed the two shipbuilders that they should 'regard the order as having been placed' with them, pending approval by the Admiralty. With this commitment, both shipyards began work on their separate projects.

The keel for the first of the new Cunard superliners, then known only as Hull No. 367, was laid at the John Brown shipyard on Wednesday 17 August 1904.[13] Lord Inverclyde participated in the ceremony. A day later, Thursday 18 August, and about 130 miles to the south-east, the keel for the second ship was laid at the Swan, Hunter yards.[14] At that time she was known only by her yard-assigned hull number, 735.

Incredibly, because some of the vessels' specifications were still undecided or required Admiralty approval, neither

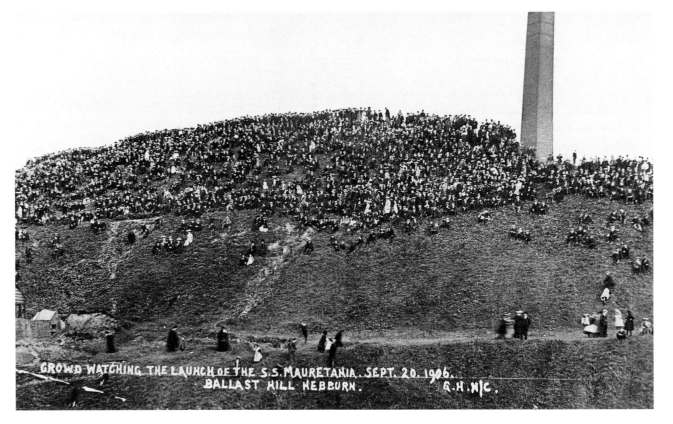

The launch of the *Mauretania* was a matter of national importance and pride. Here a crowd forms on a ballast hill directly across the River Tyne from the shipyard; if not as prestigious as a direct invitation into the yard, this vantage point would give a splendid view of the event. (Beamish Museum)

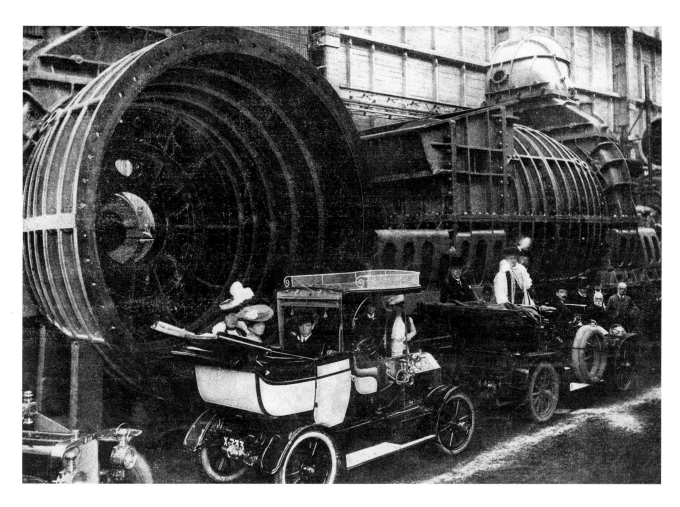

Photographed on launching day, the Dowager Duchess of Roxburghe's entourage drives past the turbine engine casings of the *Mauretania*. (Author's Collection)

shipbuilder had signed contracts for their orders when work began. The final contracts were signed in London on 18 May 1905, at a meeting between Cunard representatives and representatives of both shipbuilders.[15] The contracts stipulated delivery of both ships within thirty months from the date of signing, or by 18 November 1907.[16]

The contract for Yard No. 735 was for an unspecified sum, and was instead based on a 'cost-plus' arrangement; Cunard agreed to pay for the costs – materials and labour – involved in building the vessel, plus 15 per cent of that sum for overhead, in addition to all costs incurred in trials up to the moment they took ownership, plus a 5 per cent profit on the entire project's total. A similar arrangement was made with John Brown for Hull No. 367. Both yards were to submit a monthly bill to Cunard, which would in turn be submitted for a monthly draw from the government loan.

Cost-plus arrangements were known to work well between builders and owners with close and long-lasting relationships, such as White Star and Harland & Wolff. However, there

should have been indications, even as the ink dried on the contracts, of potential problems. While no shipbuilder had experience in building ships this big or expensive, Swan, Hunter in particular was new to projects of this scale; additionally, their estimate of cost already exceeded half of the fixed-total loan made by the government for the construction of *two* ships, and the estimate did not include the cost of interior decoration. Precisely estimating costs for building unprecedented turbine power plants was also questionable. Finally, while Cunard and Swan, Hunter did have a past working relationship, it was not as intertwined and long-standing as that enjoyed by White Star and Harland & Wolff.

Yet work proceeded on both ships. In order to gain experience in the layout, auxiliary equipment, and operation of turbine engines on a full-sized ship, Cunard made an unusual request of John Brown. The Scottish shipyard was then building a pair of large 19,500-ton steamships for Cunard, which would eventually be named *Caronia*

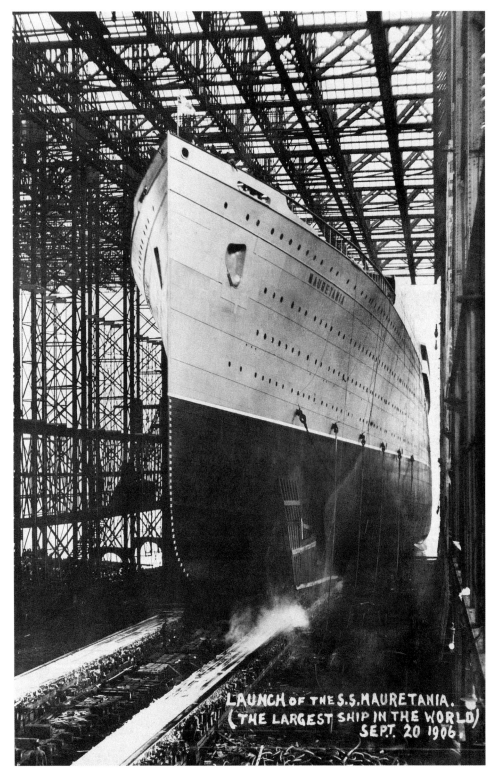

and *Carmania*. Cunard asked John Brown to convert the second ship, *Carmania*, to run on turbines rather than the triple-expansion reciprocating engines her sister sported; this was in spite of the fact that construction of *Carmania*'s reciprocating engines had already commenced. John Brown complied, converting the *Carmania* to run on turbines; it also constructed a smaller set of turbines for a little vessel it was then building, the *Atalanta*.[17]

It is important to note that contrary to maritime lore, oft-repeated through the years, the use of turbines in the *Carmania* was not intended to aid in the decision on whether or not to adopt turbines for the two new super ships. *Carmania* did not make her maiden voyage until December 1905, by which time the decision in favour of turbines was over twenty months old. *Carmania*'s power plant was, instead, the first practical application of turbines in a large passenger liner. The turbines were very smooth in operation and more compact than traditional reciprocating engines, and *Carmania* made an average of 20.19 knots over the measured mile on her trials, as opposed to *Caronia*'s 19.5 knots on the same run.[18]

Yet there were bound to be teething problems in the venture. Behind the scenes, John Brown personnel found that the design or integration of some of the auxiliary equipment built to interact with the turbines was rather disappointing, but little or no word of this leaked to the press and the general conclusion was that the *Carmania*'s turbine power plant was an unqualified success.[19] This experience, however, no doubt improved the quality of auxiliary equipment on the superliners then under construction. In the meanwhile, steelwork on both ships was focused on their bow and amidships regions, so that if experience with the *Carmania* required last-minute alterations to their design, these could be incorporated more easily.

On Thursday 15 February 1906, Cunard's Board of Directors met and decided on the names for their two new ships. Cunard had, at times, recycled the names from previous ships when putting a new one into service, but in this instance they felt that two all-new names were called for. They decided that John Brown Hull No. 367 would be called *Lusitania*, and Swan, Hunter Hull No. 735 would be named *Mauritania*. Both names were drawn from ancient Roman provinces – the former encompassing the area now known as Portugal, and the latter referring to the territory of north-western Africa in the area of modern Morocco. Both names also ended in the traditional Cunard -*ia* suffix.

As the liner moves down the ways and into the Tyne, smoke can be seen rising from the sliding ways. The lines attached to the hull are connected to carefully positioned piles of anchor chain, designed to slow the ship and bring her to a stop in mid-river. (Ioannis Georgiou Collection)

The press and trade journals, like *Engineering*, released the names to the public within a couple of weeks. *Scientific American* magazine was highly critical of the names, joking that 'the ships will never need to take in water ballast, their names being heavy enough to keep them on an even keel in any weather'. They added that 'it would be a thousand pities if these two noble ships, representing the highest effort of the shipbuilder's art, should be dispatched ... carrying names which have no appropriate significance whatever.' It suggested naming them *Britannia* and *Hibernia* – the names of Cunard's original ship and that of one of her sisters, and names which Cunard had actually considered.[20] A week later the journal said that the names had 'been received very unfavorably' in the United States, on the grounds that 'they are cumbersome and have no appropriate importance or significance'.[21]

In the event, the name *Mauritania* proved controversial for another reason: the correct spelling of the actual ancient Roman province contained an 'e', not two 'i's, as the modern nation of Mauritania is spelled. For three months, Cunard weighed the spelling issue carefully; on 17 May it determined

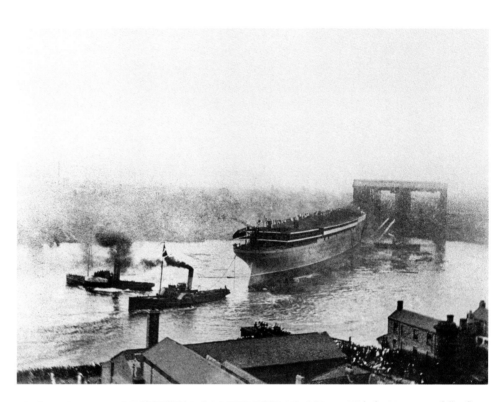

With the *Mauretania* fully afloat for the first time, tugs begin the process of shepherding her to the location where her fitting out will take place. (Beamish Museum)

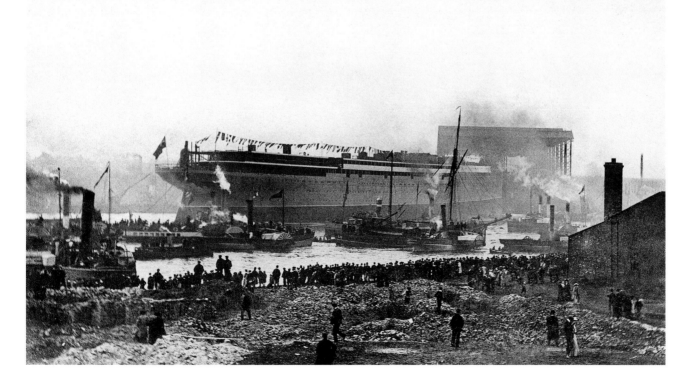

The Tyne becomes more and more crowded with sightseers as the tugs continue to move the *Mauretania* from the ways. The crowd stays on to watch the complicated process. (Eric Sauder Collection)

that if it was going to name the ship after the ancient province, it would spell it that way, as well. The new liner thus became known as *Mauretania*.[22]

Beneath the steel and glass enclosure on the Wallsend slipway, workers buzzed away. *Mauretania*'s keel and the tanks of her double bottom were formed first. On 31 January 1905, the process of adding over 300 vertical frames – a steel skeleton to which her outer hull plates would eventually be attached – began. The framing was not completed until 9 February 1906. It was said that if 'placed end on', these frames and beams would 'extend about thirty miles'. Finally, the ship's skin was attached to the frames. It consisted of about 26,000 steel plates, the largest of which was about 40ft in length, and each of which weighed from 4 to 5 tons. To secure the plates to each other and form a watertight shell, and attach this to the steel frame beneath, they were connected with over 4 million rivets, each up to 8in long, and altogether weighing roughly 500 tons.[23] Through twenty-five months' demanding labour, the giantess was finally identifiable as having the basic

form of an enormous liner; the shell plating was finished on 7 September 1906. On Thursday 20 September, the time arrived for her to take to the water for the first time.

That morning, thousands of spectators and distinguished guests began to converge on the Wallsend shipyard; they also swarmed over points on both banks of the Tyne where they could overlook the launch. Special trains were run from around Britain to bring all of them in. The whole of Wallsend, it seemed, 'was in holiday attire' and 'ordinary work was suspended for the day'.[24] Some 2,400 guests were invited by Swan, Hunter, and in all, 15,000 guests were packed into the yard for the event. Yet it was said that 'both banks of the river for some miles were black with great crowds of spectators, the river was congested with heavily-laden excursion craft, and in particular a ballast hill … right opposite the yard had the appearance of a huge ant hill, alive and crowded with humanity'. It was conservatively estimated that 150,000 people 'enjoyed a fine afternoon in the open, and had a more or less perfect view of the great event'.[25]

This breathtaking view shows the liner's fitting out under way. It dates from around February 1907. The lower portions of each smokestack are in place, but the upper segments have not yet been installed; most of the Boat Deck deckhouses have been mounted, but the area of what would become the Verandah Café is still unfinished, awaiting a final decision on how to treat the space. (Beamish Museum)

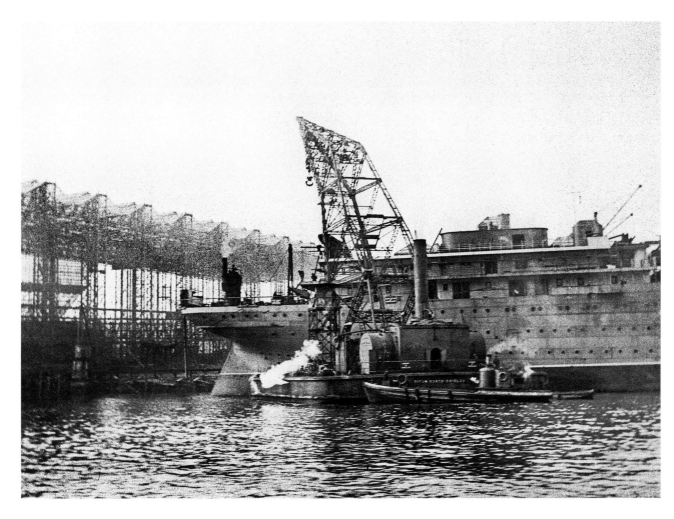

The floating crane being employed in work at the liner's second-class sections. On the Boat Deck, the Second Class Lounge's deckhouse has been built; its skylight, and the ones located just forward and aft of it – for the Second Class Drawing and Smoking rooms – have also been installed. (Beamish Museum)

The view before the launch, of the ship sitting in her cradle, was not as spectacular as that of the *Lusitania* before her launch on 7 June. The Scottish ship had been built without surrounding gantry, and it was said that she looked 'simply colossal in her naked grandeur'. However, the *Mauretania* could only be seen 'through a lacework of steel girders, which enveloped her on both sides … Thus overmatched, though by no means dwarfed, by the iron scaffolding,' the *Mauretania* did not really seem to 'look her size'.[26] This was in spite of the fact that she would become the world's largest moving object that day, for at 790ft in overall length, she was 3ft longer than the *Lusitania*, 6in fuller in the beam, and would eventually sport both a larger displacement and gross registered tonnage.

Visitors in the yard gawked up at the liner's light-painted hull and inspected the launching apparatus, eventually taking their place on the spectators' stands and waiting for the ceremony to begin. VIP guests included the Dowager Duchess of Roxburghe, who would launch the ship, Charles Parsons, who had invented the marine steam turbines, and Wallsend personnel. Cunard's delegation was headed by William Watson, chairman since Lord Inverclyde had passed away nearly a year before, and Alfred Booth, who would eventually lead the Cunard Company.

At 4.30 p.m., the shoring timbers, which kept the hull from toppling off the ways, were finally cleared away, and a signal was given that everything was ready. The Duchess 'operated a small handle, which set the electrical relieving apparatus at work'[27] and simultaneously released a suspended bottle of wine so it could shatter itself against the ship's port bow. The ship was christened *Mauretania* and for the next seven seconds her 16,250-ton mass – excluding the 550-ton launching cradle[28] – moved only 6ft. Then she began to move more easily. She slid 'slowly down her well-greased ways, amid thundering and reverberating cheers, and without as much as a tremor she continued her descent

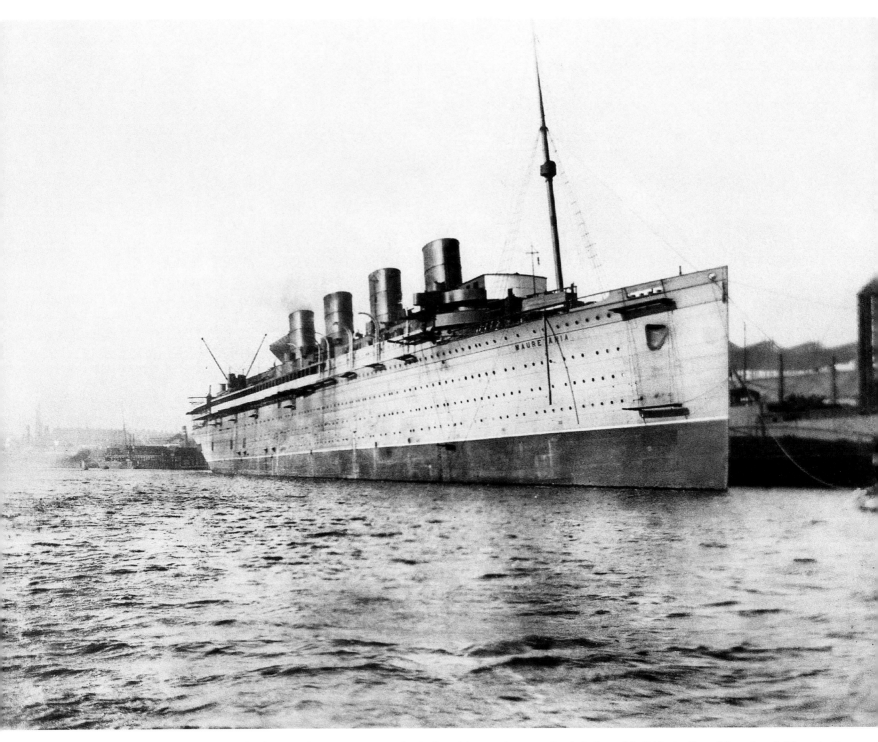

A very rare starboard-bow view of the incomplete liner in early 1907. Again, we see that the funnels have not been completed; the face of the Bridge is still carefully enshrouded for protection from the elements. None of the lifeboats has yet been installed. A number of workmen's platforms line the side. On the starboard side of the forecastle, a temporary set of workers' toilets has been put in place. The waste discharge pipe, facing a dubious task, dangles down toward the river and partially obscures the vessel's name. (Beamish Museum)

and plunged stern first into the deep channel of the Tyne like some sea monster seeking its native element.'[29] As she moved backward, the cables connecting to her drag chains and weights, designed to check her momentum before she careened into the opposite bank of the Tyne, tightened 'like fiddle-strings'. She travelled the 794ft length of the ways in fifty-five seconds, and came to a full stop in mid-river after travelling a total of 951ft in seventy seconds. Her maximum speed as she thundered down the ways was 14 knots.[30]

For an event where anything could – and sometimes did – go wrong, everything had gone smoothly. The only hitch was that one of the starboard cables parted prematurely, but it had caused no damage.[31] A 'shrill chorus of sirens, which completely drowned the united effort of a hundred thousand throats' filled the air. The *Mauretania* had successfully taken to the water for the first time.

Six tugs hurried up and took the empty, high-riding hull in their care to shepherd her to the spot on the Tyne's north shore where she would be fitted out. There was no wharf at the yard large enough to accommodate her, and the river was not of sufficient depth to allow her to lie right alongside the river bank, either. The yard had, therefore,

found it necessary to construct two mooring dolphins, to which the hull was attached that evening, to hold her fast during the coming months' work. To connect the ship with the shore during the work, a steel gangway some 120ft in length had been built.[32]

Later that evening, 800 VIPs gathered for tea in the shipyard's moulding loft, where the shape of *Mauretania*'s ribs and plates had been formed during the preceding months. Congratulatory telegrams were read, wishes of 'success to the *Mauretania* and the Cunard Company' were expressed, and speeches were made. Lord Tweedmouth, the First Lord of the Admiralty and brother-in-law of the Duchess of Roxburghe, said that, while the Admiralty was 'to some extent a partner in this great enterprise,' it was his hope 'that they would never be anything but a sleeping partner, and that the blessings of God would prevent the necessity' of calling upon 'the services of these magnificent vessels'. To this there was a hearty response of 'Hear, hear!' from the other attendees.

Sir William Forwood, vice-chairman of the Cunard Company, proposed 'success to the Builders and Engineers' of the *Mauretania*, and thanked Swan, Hunter and their

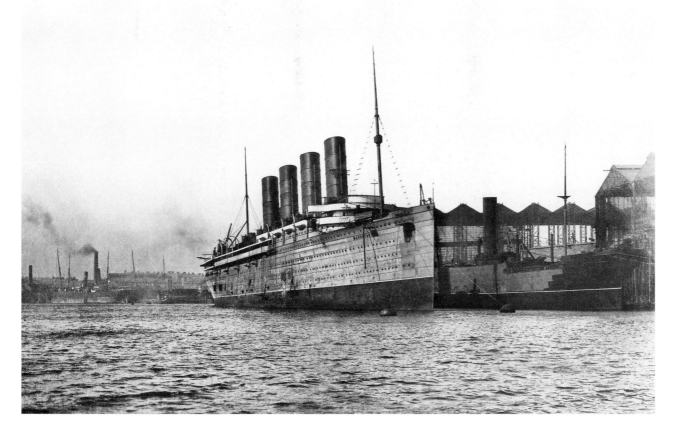

This view, from a very similar angle, was published as a photo postcard. It shows the forward four lifeboats in place on the starboard side, and the now-complete funnels standing at their full height. (Author's Collection)

This photograph was taken shortly thereafter. The forward boat of the aft-most group has been installed, but three sets of davits remain empty. Every gangway door on E Deck has been at least partially opened, and many of the coal-loading chutes are also open. (Jonathan Smith Collection)

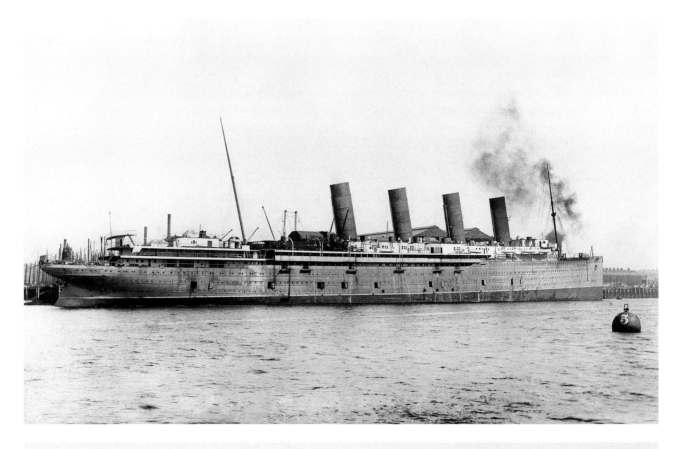

Steam coming from the forward two funnels shows signs that the ship's machinery has been brought to life. Two naval vessels are at anchor on the Tyne's south side, while a small steamer moves east past the *Mauretania*. (Beamish Museum)

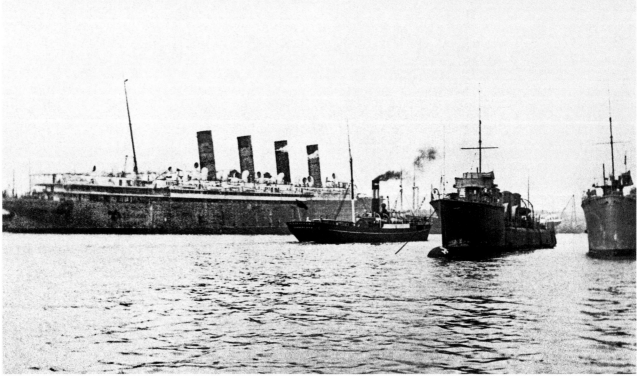

staff for their cordial cooperation in the endeavour of turning out 'one of the two greatest ships ever built in this country'. Noticing that Sir William White, KCB, a director of Swan, Hunter shipyards, was wearing white heather in his buttonhole, Forwood said that he hoped that this was an 'augury that the marriage of the *Mauretania* with Father Neptune would be a happy one', which brought a hearty round of applause.[33]

Despite the celebratory nature of the event, the reality was that there was much work yet to be done before the *Mauretania* was delivered to the Cunard Company. Sixteen of the thirty months until delivery was due had already elapsed. Swan, Hunter's work in building the *Mauretania*'s hull had taken three and a half months longer than it had taken John Brown & Co. to build the hull of the *Lusitania*. The enormous empty shell of the *Mauretania* had to be turned into a finished ship – the largest and fastest in the world – in less than fourteen months.

As 1906 came to a close, the warm sentiments expressed by Cunard and Swan, Hunter on launch day began to evaporate over financial difficulties. In December, George Hunter increased his estimate on the *Mauretania*'s final cost, excluding interior decorations, from £1.301 million to £1.617 million; another £118,000 was estimated for additional interior work, for a revised total of £1.735 million. At about the same time, John Brown estimated that the *Lusitania*'s final cost would also run over original estimates, and up to £1.48 million. Cunard was suddenly in a precarious position: the government loan was fixed at £2.6 million, based on the concept that each ship would cost £1.3 million. Now they were looking at a total expenditure of nearly £3.25 million, or more than half a million more than the government loan. They simply did not have the funds to cover this overage.

Cunard was outraged by the increases, and especially wondered why the Newcastle firm's revised total was roughly a quarter of a million pounds higher than the Scottish firm's; Swan, Hunter thus bore the brunt of Cunard's wrath on the subject. Cunard demanded to know if Swan, Hunter's original estimate had been deliberately low-balled to obtain the contract or, if there had been price increases, what they consisted of. George Hunter replied that the original estimate had been made in good faith, and refused to open his ledgers for inspection by Cunard when it demanded access to them.

It seems that there were several reasons for the cost overages on the *Mauretania*; some of these were demands made by Cunard personnel and on-site supervisors for upgrades or alterations from the original plans as work progressed. Swan, Hunter personnel were also working to ensure that the liner's quality of construction and the materials they used were of the very best quality, which may also have increased costs. For the Newcastle yard there were other increased expenses: labour rates were higher than on the Clyde; costs for steel and castings were also higher for them, since they needed to order in from outside suppliers, whereas John Brown was owned by the Atlas Steel Works at Sheffield; the costs from their engine-building subcontractors, the Wallsend Slipway & Engineering Company, were also running over budget by tens of thousands of pounds.

Swan, Hunter did not back down against pressure from Cunard to lower their costs. After their 20 April 1907 payment to the shipbuilder, Cunard suspended further monthly payments and began consulting with their solicitors. Swan, Hunter also consulted with their solicitors. In the end, it was found that Cunard would be in breach of contract if it did not continue making monthly payments to the shipbuilder. On 27 May 1907, the final payment was made by the government to Cunard for costs. With that loan exhausted, Cunard was forced to issue debentures in order to raise capital, so that it could continue making payments to both shipyards. It resumed payments to Swan, Hunter on 22 October 1907 – some six months after its last payment.[34]

Despite the six-month hiatus in payments, work had been continuing on the *Mauretania*. All of the ship's boilers and turbines had been hoisted aboard; this task had been carried out by the shipyard's 140-ton capacity crane – a new crane specially ordered by the yard for use on this project. Twenty-three double-ended and two single-ended boilers were installed, divided among four main boiler rooms. Each of the aft three boiler rooms, designated Nos 2–4, held six double-ended boilers arranged in two rows of three abreast. The forward-most boiler room, No. 1, found the hull's taper too constrictive to adopt an identical arrangement; it thus contained a row of three double-ended boilers aft, preceded by a second row of two double-ended boilers, with two single-ended boilers squeezed in at its forward end. All of these monstrous boilers were in place aboard the ship by the end of 1906.

These boilers' 192 coal-burning furnaces would superheat water until it turned to steam at a pressure of 195psi. The steam would then be piped aft into a series of six turbine engines. Four of these turbines were utilised for ahead propulsion, two high-pressure turbines for the ship's

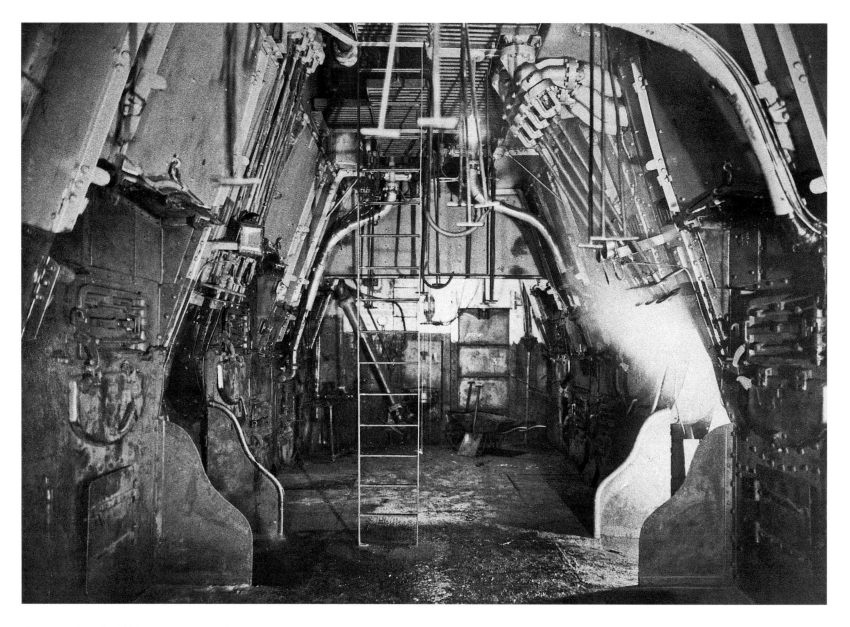

This view in the stokehold shows a space remarkably devoid of coal. At the far end a shovel rests beside an empty wheelbarrow. Just behind them one of the watertight doors leading into the coal bunker has been closed. (Beamish Museum)

forward, outboard propellers, and two low-pressure turbines to drive the aft, inboard screws. Since turbine engines are non-reversible, another set of high-pressure turbines, located inboard of the high-pressure turbines which drove the outboard shafts, was provided to give astern thrust. They were placed in line with the inboard propeller shafts and were designed to drive only those propellers.

The steam from the ship's boilers was also used to feed a large electrical power plant, consisting of four sets of Parsons turbo-generators, which were each capable of supplying 375kw, or 4,000 amperes at 110 volts when operating at 1,200rpm. It was said that it was an installation capable of supplying power to a city of 100,000 people. Approximately 100 tons of electrical cabling, 250 miles in total length, brought this electricity to every nook of the ship. It ran some 6,000 16-candlepower lights, 720 alone of which were fitted in the engine spaces and stokeholds; it also provided power for countless pieces of auxiliary equipment, from ovens in the galley and the ship's entire ventilation system, right down to the motors for the boot and knife-cleaning machines and the electrical bells used by passengers to summon a friendly steward for service.[35] One correspondent who toured the ship called her system of illumination an 'electric fairyland'.[36]

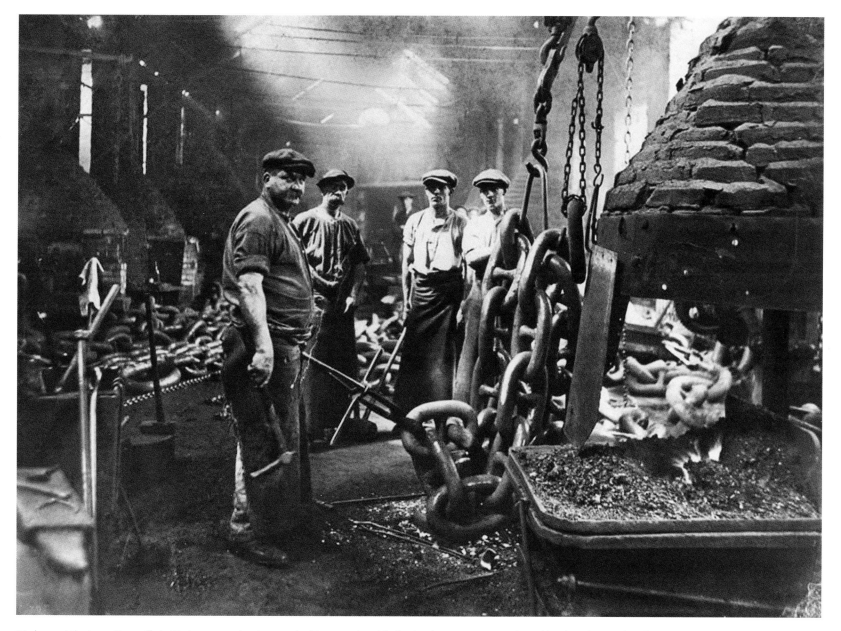

Workmen at the Lenox Brown Chain Works pause to be photographed for posterity while forging the *Mauretania*'s anchor cables. (Jonathan Smith Collection)

To feed the boilers and keep the ship moving, the lights burning and the passengers happy, coal was needed – and a lot of it. The Admiralty had called for the ship's vital equipment to be placed below the waterline and insulated from the potential of attack by enemy warships through longitudinal bulkheads. Most ships of the time, when utilising a system of transverse, or side-to-side, watertight bulkheads, placed coal bunkers between the boiler rooms. However, to carry the needed 6,000-odd tons of coal needed for a single crossing, it was found necessary to place the fuel in the longitudinal spaces outboard of the boiler rooms. Apertures were cut into the base of the longitudinal bulkheads to pass coal through to the boilers within, and each aperture was fitted with a watertight door in case of emergency.

It was known that large longitudinal coal bunkers could pose problems with the ship's stability if enough of them were pierced on one side of the ship, particularly since debris could frequently jam the watertight doors separating them from the inner compartments; however, the ship was felt to have more than enough watertight compartments. She bore twelve primary transverse bulkheads, and the longitudinal bulkheads created an inner and outer hull; combined with many other watertight sections in the ship's double bottom, plus a watertight deck above the machinery spaces, she had a total of 175 watertight compartments. In this regard, the *Mauretania* was comparable with warships of the day, and was even called 'as unsinkable as a ship can be'.[37]

Once her machinery was in place, another vital step needed to be taken: creating comfortable interior spaces for her passengers and crew. To attract potential first-class passengers, who had invariably high standards of interior decor, it was clear that each of the two new superliners would need to stand out as something special. Thus, Cunard tapped the services of two different and prominent architects. For the *Lusitania*, this proved to be Scotsman James Miller; he created what was considered 'the highest conception of artistic furnishing and internal decoration'. Primarily, the Scottish liner's decor utilised light colours, which are quite appealing to modern sensibilities when seen through the prism of period black-and-white photographs.

The contract to design the interior spaces of the *Mauretania* went to an English architect named Harold Peto, who had created interior spaces for many private homes, as well as the garden architecture for many more.

Peto had never worked on a ship before, nor would he again afterward. His fees were both higher than Miller's and higher than Cunard – seeing their budget already running into the red – really wanted to pay. However, the results of his work were astonishing. His designs were to be carried out by several contractors, including W. Turner Lord of London. The shipyard undertook the design of the second-class spaces, but their concepts had to be approved by Peto.

Looking at black-and-white photographs of the *Mauretania*'s first-class interior spaces really does them little justice. That grey medium is hard pressed to convey the original beauty, the colour, the grain, the warmth of the wood panels and their intricate carvings. Nor can they impart the selection of colours in the fabrics and painted surfaces that offset the woodwork. In photos, the woodwork simply comes out looking dark, making the spaces appear gloomy and even vaguely oppressive.

Yet the living reality of those interior rooms was stunning when seen in person. When the liner entered service, it was said: 'In regard to the appointment of the passenger accommodation, the "Mauretania" excels her sister ship in luxury.'[38] It was boasted that Peto's use of natural woods, when combined with 'a darker and more somber tone of tapestries and upholstery [than the *Lusitania*'s], gives an effect of rich and substantial beauty'.[39] The ordinarily reserved *Shipbuilder* magazine raved: 'The passenger accommodation of the *Mauretania*, when its spaciousness and beauty of decoration are taken into account, certainly justifies the use of the somewhat extravagant term "a floating palace." ... In the internal decorations an entirely fresh departure has been made, and the effect is unlike anything we have previously seen.'[40]

Second-class spaces were also quite comfortable, and in many respects were more luxurious than Atlantic liners' first-class rooms of just a few years before. Even the third-class spaces, while starkly utilitarian, were practical and comfortable. Indeed, when showing reporters these areas, Cunard 'strongly condemned' the use of the word 'steerage' – typically synonymous with third-class accommodation on Atlantic liners; the word was too reminiscent of unwashed and suffering emigrants packed into small spaces as veritable human freight. It was said that third-class accommodations were 'quite in keeping with the general luxury and comfort of the ship; in fact, the bathrooms and lavatories are ... quite equal' with some of the first-class provisions on boats of the Adriatic and Mediterranean run.[41]

MAURETANIA: AN INTERIOR TOUR

FIRST CLASS

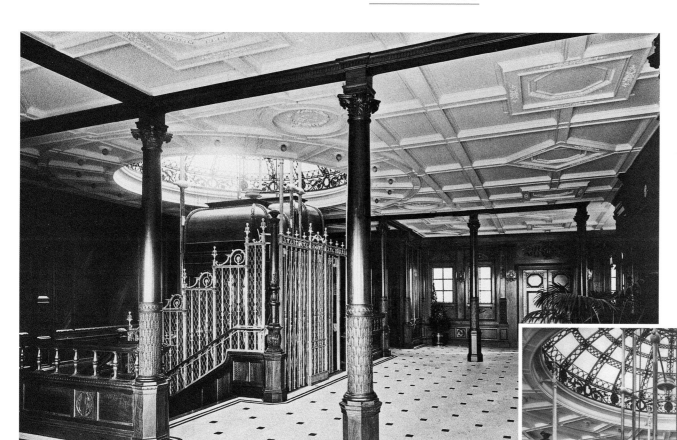

ENTRANCE: The first-class entrance on the Boat Deck looking forward and to starboard. Executed by Messrs W. Turner Lord to Harold Peto's specifications, it was very difficult to find enough of the walnut veneers for the room – all of England and France were scoured before a sufficient quantity was obtained. The lift cars are visible behind the aluminium grille. The use of aluminium was a first for the *Mauretania*, but it saved nearly 20 tons of weight over the use of wrought iron or bronze. This view, chosen for its remarkable clarity, was often used in publicity material, and was even colourised for some mediums; unfortunately this photo demonstrates the limitations of black-and-white photography in conveying the warmth of the liner's woodwork, a deficiency that nags most interior photographs ever taken aboard. (Beamish Museum)

This photograph looks aft and to port through the elevator grillwork. The Waygood lift cars are both on the Promenade Deck level. This view nicely demonstrates how the stairs wrapped around the central well of the lifts. (Eric Sauder Collection)

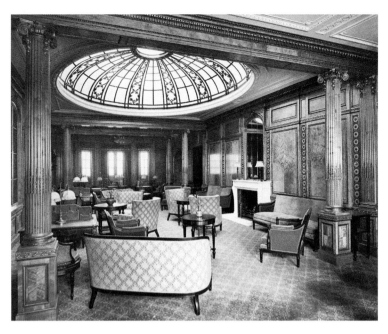

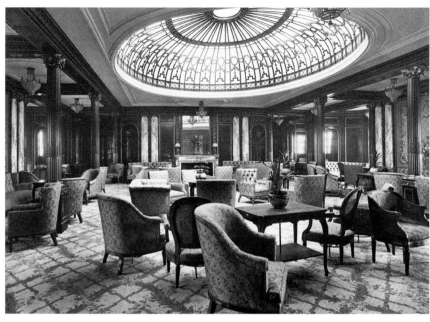

LIBRARY: Directly forward of the entrance was the Library and Writing Room. In this photo we are looking slightly forward and to port. Executed by Messrs Ch. Mellier and Co. of London, the wall panelling was in sycamore stained grey. It gave a first impression of 'shimmering marble ingrained with silver'. A large bookcase is built into the aft wall. Although the furniture is in place, Cunard stationary has not yet been placed in the writing tables. (Beamish Museum)

LOUNGE: The Lounge and Music Room, located aft of the entrance on the Boat Deck, was also done by Messrs Mellier. This view looks forward; the panelling was in dull-polished mahogany with gold moulding and interspersed with lilac-coloured marble pilasters. (Beamish Museum)

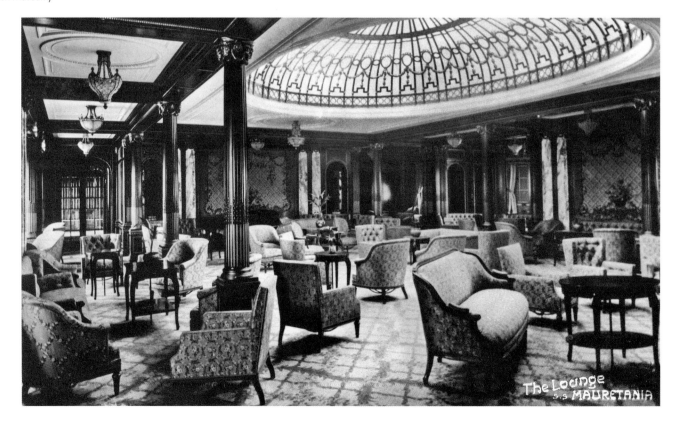

This Davidson Brothers postcard view shows the Lounge but looks aft and to port. Glass-paned swinging doors, a set of which is visible on the left, gave access through most of the rooms on the Boat Deck. (Ioannis Georgiou Collection)

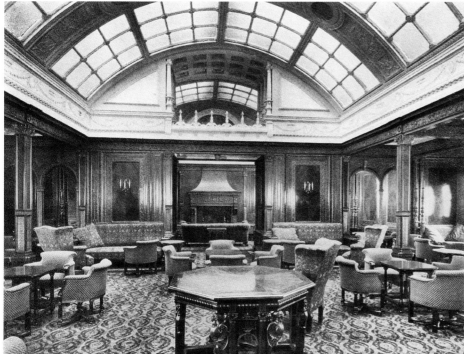

SMOKING ROOM: The Smoking Room, aft on the Boat Deck, was divided into two main sections by a partial wall seen here. This view looks forward, and shows the fireplace at the far end. The design was carried out by Messrs W. Turner Lord & Co. Rich walnut panelling in sixteenth-century Italian style was designed to match the entrance, forward, yet was much richer in decoration. (Ioannis Georgiou Collection)

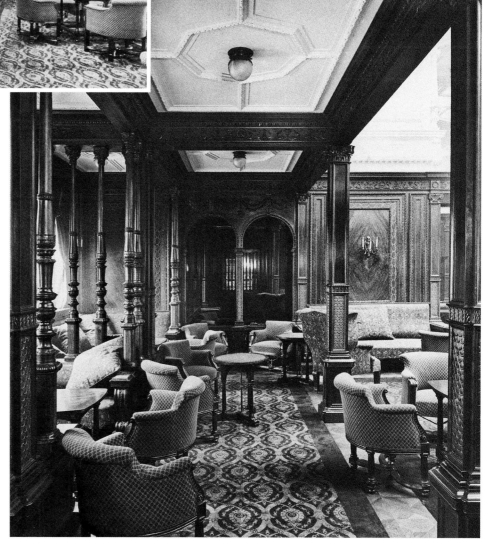

The photography company Bedford Lemere was commissioned to carry out a number of portraits of the liner before she entered service; this photo is just one example of their work among several that intersperse this volume. This is the view looking forward along the port side of the Smoking Room, showing the rich woodwork. This space was designed to be the sole preserve of gentlemen; the sexes could mingle freely, however, in the other public rooms of the ship. (Beamish Museum)

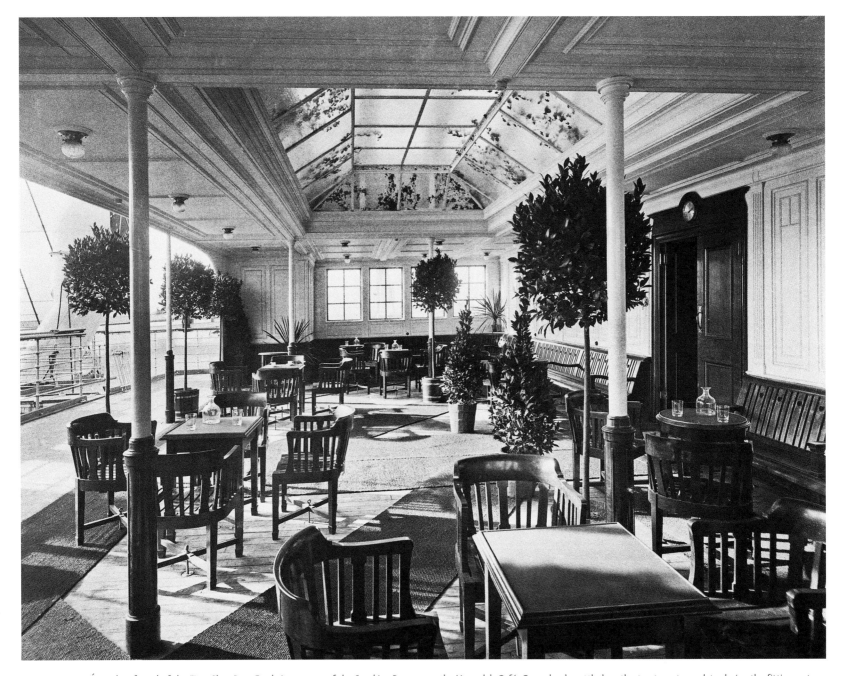

VERANDAH CAFÉ: At the aft end of the First Class Boat Deck, just astern of the Smoking Room, was the Verandah Café. Cunard only settled on the treatment very late during the fitting-out process. The room was rather banal, with sturdy (if unimaginative) chairs and benches, carpet runners laid over wooden decks, and an aft bulkhead that was left entirely open – not an ideal scenario during inclement weather. Passengers were able to enjoy fresh air while protected on three sides from the elements; as they enjoyed their coffee or tea, with a view over the second-class decks astern. (Beamish Museum)

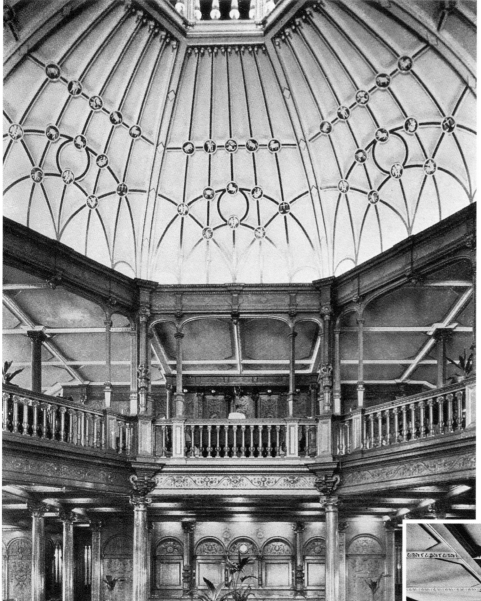

DINING SALOON: Spanning C and D decks, with a vaulted ceiling expanding upward into B Deck, the Dining Saloon was breathtaking. Decorated in 'straw-coloured oak in exquisite taste in Francis I style' with 'beautifully carved' panels,* it spanned the full width of the ship; the lower level was some 87ft long, while the upper segment was 62ft long. It could accommodate 328 diners on the main floor and another 152 on the upper deck.

Part of the room's success was not just in woodwork, but also in lighting. It was said that the 'dome, which is painted in white and gold, is entirely lit by concealed lights. The effect by night is magical, as not a lamp is seen, but a brilliant glow is thrown down on the tables beneath,' an effect of which, it was also said, photographs could give 'but a faint idea'.** (Ioannis Georgiou Collection)

* *Page's Engineering Weekly*, 1 November 1907, vol. 11, p. 889
** *The Electrical Engineer*, November 8, 1907, vol. 40, p. 661

A view looking aft along the upper level of the Dining Saloon, on the starboard side. Contrary to oft-repeated lore, this area was not an à la carte restaurant; while some steamship lines had adopted such facilities, the Cunard Company was firmly opposed to the concept. (Beamish Museum)

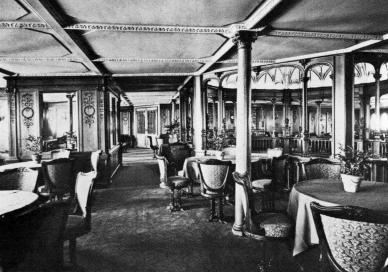

STATEROOMS: A special stateroom, D-20, looking forward. Although on a lower deck, this room offered the 1907 novelty of a private toilet and bath. In 1909, when occupied by two passengers in the slow season, rates were $450 per person; this rate soared to $750 per person with two occupants in the high season. (Beamish Museum)

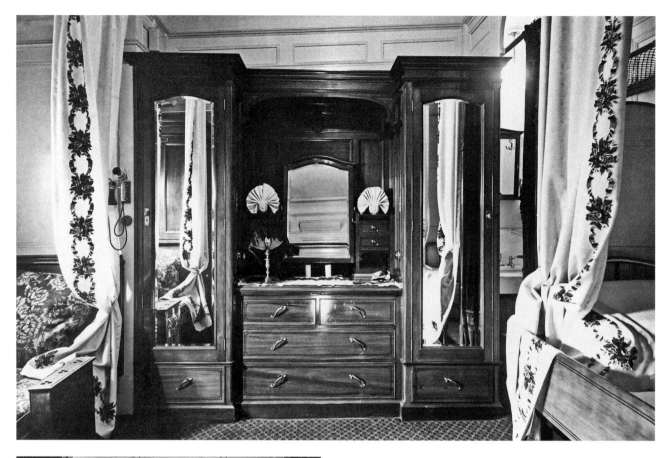

A view of en suite cabins A-17 and A-19 on the Boat Deck. Situated on the starboard side, this view looks aft through the interconnecting door. In the mirror at the far end, the camera can be seen reflected in the mirror. (Beamish Museum)

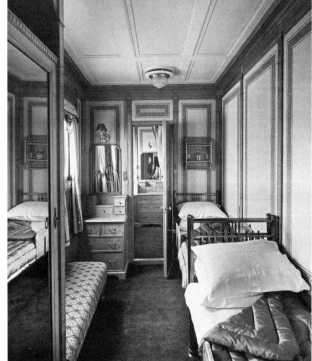

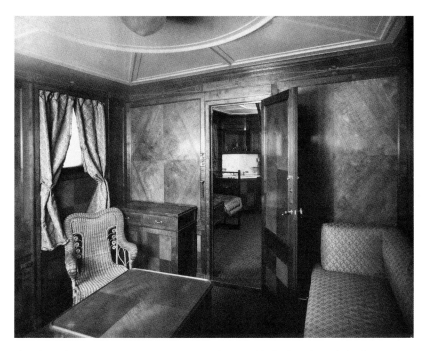

This photo shows en suite sitting room B-70 on the port side, looking through the door into adjoined bedroom B-68. The windows overlooked the Promenade Deck, and the suite offered a private toilet and bath. (Eric Sauder Collection)

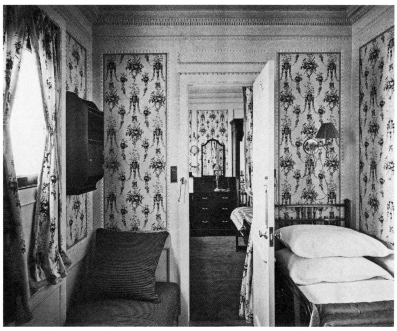

On the port side of the Boat Deck, forward, were en suite rooms A-22 and A-20. This view looks forward. The doors which gave entry to this suite are visible on the left side in the hallway photograph seen on page 7. (Beamish Museum)

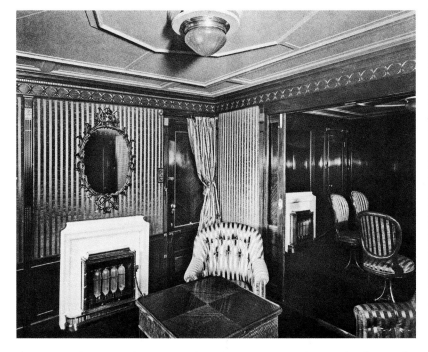

The epitome of ocean travel in 1907 were the *Mauretania*'s two Regal Suites. This photograph shows the port suite, looking forward and to starboard in sitting room B-52. The dining room can be seen through the open archway. The door by the sitting room fireplace led forward into the suite's bedrooms. (Beamish Museum)

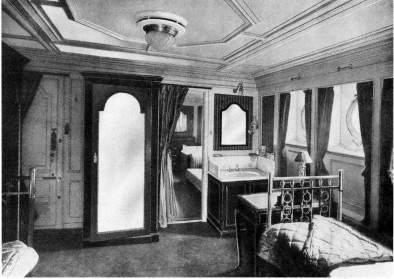

This view looks aft from the forward wall of the port Regal Suite's forward bedroom, B-48. B-50 is visible through the open door. Each of the Regal Suites could be booked, in 1909, for $1,250 per person in the off season, or $2,000 per person in the peak season. (Ioannis Georgiou Collection)

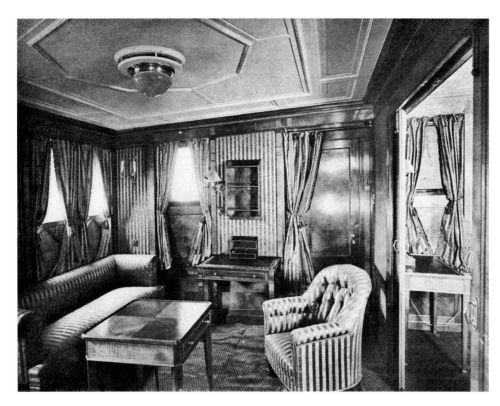

The starboard Regal Suite was just as grand as its port-side counterpart. This is the sitting room B-51, looking aft. The window by the mantle looked down the length of the Promenade Deck. On the right side is the doorway leading into the private dining room. (Ioannis Georgiou Collection)

Looking forward and to port from the sitting room B-51 into the private dining room. The doors on the right side both led into the private corridor and gave access to the bedrooms and private bath. (Ioannis Georgiou Collection)

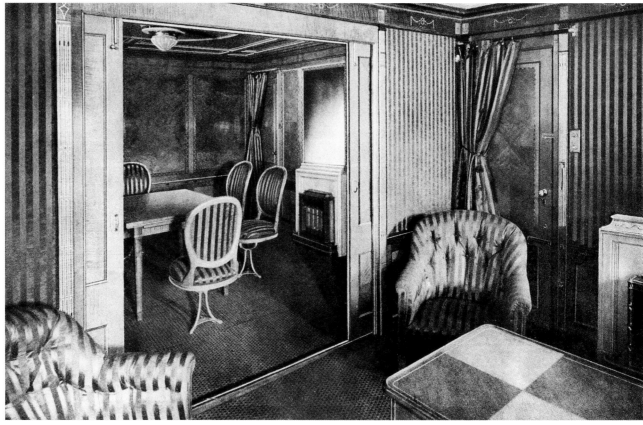

SECOND CLASS

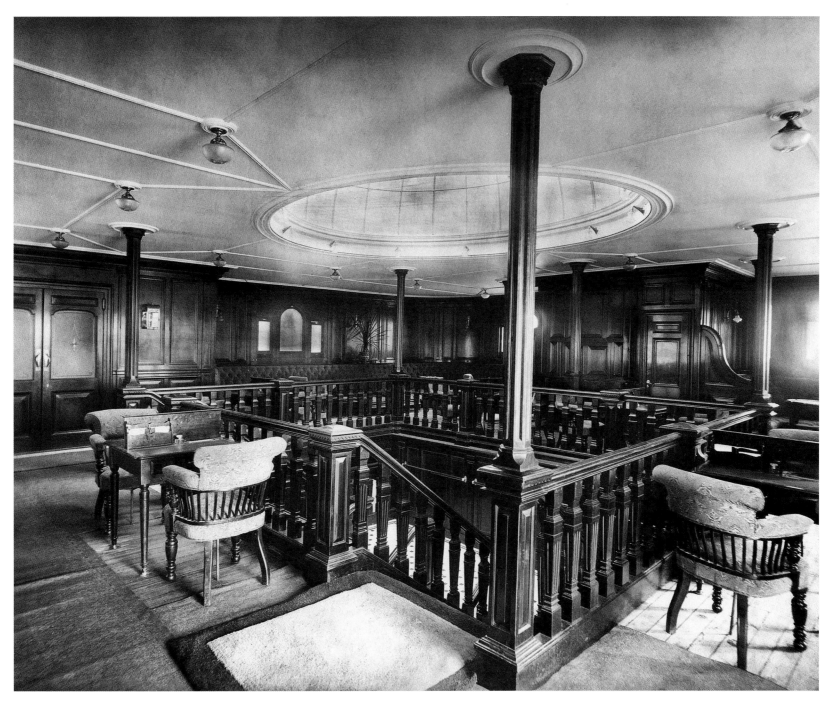

Second-class spaces were built to a high standard; the interiors were executed by the shipyard and approved by Harold Peto. This photograph shows the skylight and the central section of the Lounge. The teak stairs led below to other spaces and to passenger cabins below that. (Eric Sauder Collection)

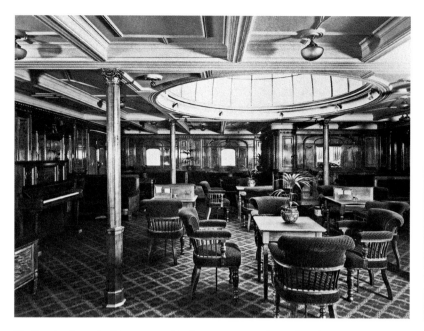

The Drawing Room, looking to port. This pleasant space was located on the Promenade Deck, forward of the main stairs, which came down from the Lounge above. Its panelling was in maple, while the furniture's upholstery was in crimson with matching Brussels carpet. (Beamish Collection)

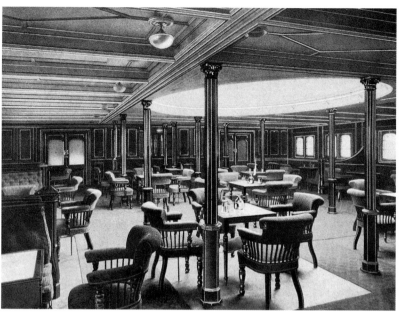

The Smoking Room was located on the Promenade Deck, aft of the main stairs. The mahogany panelling was inlaid with English boxwood and burr mahogany, while the carpets and upholsteries were dark blue. (Steven B. Anderson Collection)

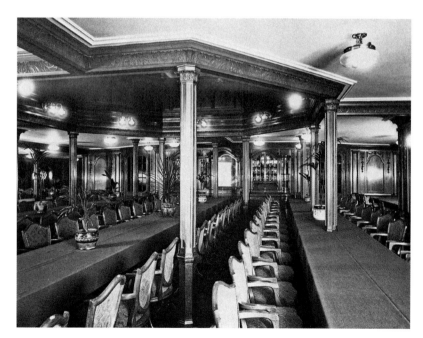

The Dining Saloon was located on D Deck, astern of the main floor of its first-class counterpart, and separated from that space by the galleys and pantries. A central well in the middle of the room gave a feeling of extra height and a view up onto the landing on C Deck above. The room was panelled in oak, decorated in the Georgian style. (Beamish Museum)

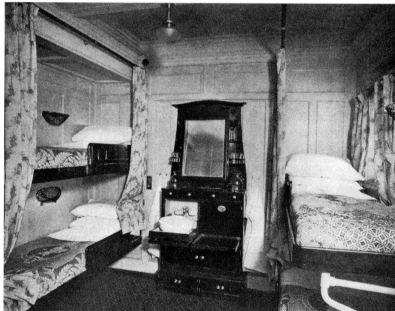

A typical four-berth second-class cabin. (Author's Collection)

THIRD CLASS

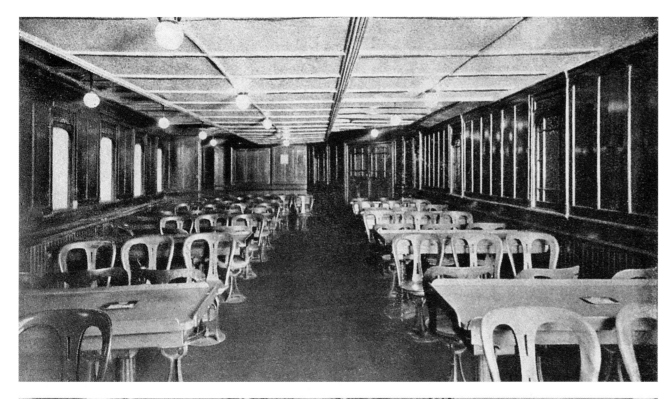

Third-class spaces were more utilitarian, but were a far cry from the unsanitary conditions of just a couple of decades earlier. This is a view of the Smoking Room, located on the port side of C Deck. (Steven B. Anderson Collection)

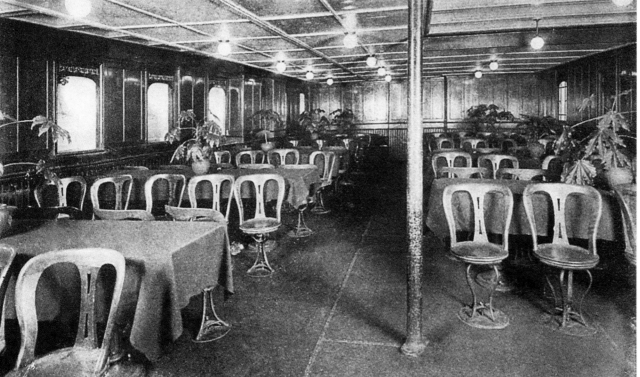

On the starboard side of C Deck, just opposite the Smoking Room, was the General Room, also called the Ladies' Room at times. Despite a certain lack of frills, furniture for all third-class spaces was made to withstand heavy use by large numbers of emigrants. (Steven B. Anderson Collection)

The Dining Saloon, located on D Deck forward, could accommodate 330 passengers at a sitting. Third-class fare was simple but nutritious and, in many cases, was a large step up from the diet that emigrants were accustomed to. All public rooms of this class featured polished ash panelling with teak mouldings. (Steven B. Anderson Collection)

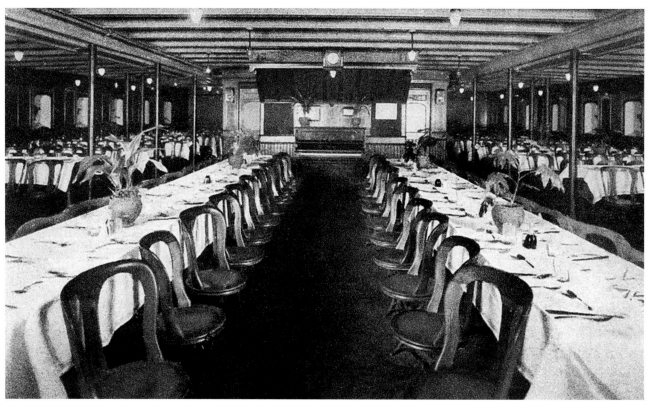

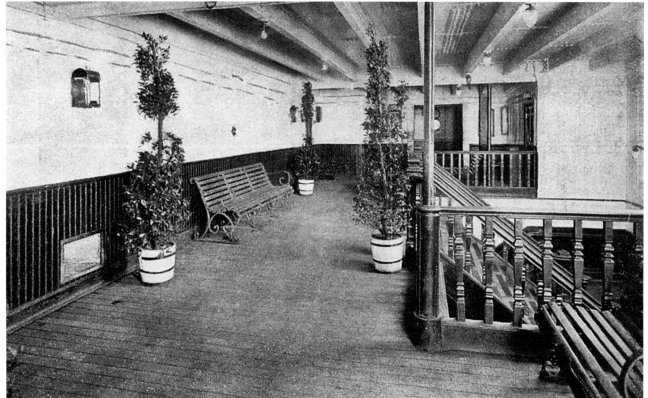

A view of the third-class entrance, located just forward of the No. 2 funnel on C Deck. The doors on the outboard sides gave access to the third-class open-air Promenade. (Steven B. Anderson Collection)

As the *Mauretania* neared completion, on 7 September, her older sister *Lusitania* began her maiden voyage from Liverpool to New York. Although she did not win the Blue Riband on her first round trip, it was only a matter of time before she did. Meanwhile, public interest in the *Mauretania* was also very strong: by mid September it was estimated that nearly 100,000 photographs of the *Mauretania* had been taken during the preceding few weeks. In preparation for the ship's first foray from the builder's yard, a diver spent several days clearing the lower hull of appendages such as the launching gear.

On Tuesday 17 September, the time arrived for the nearly completed ship to begin a series of semi-secret preliminary trials. The purpose of these tests was to detect any trouble with the ship's machinery, and also to find out if the *Mauretania* suffered from vibration problems, an affliction that had plagued the *Lusitania* on her trials.

By the time the ship left the yard at 9.30 a.m. that morning, she was nearly complete, with just a few exceptions: the First Class Smoking Room was not finished, and would take two weeks to complete; since the ship was overall 'exceedingly dirty', the silk panels in the Regal Suites were

not yet installed, to prevent them from getting soiled; some painting still needed to be done in the officers' quarters; the ship's hull was still painted in a light-coloured primer, and still needed to be painted from top to bottom.

For the trip to the open sea, she was placed in command of South Shields pilot Thomas Young; a North Sea pilot was also aboard.[42] She was shepherded by six tugs: four local craft and the Dutch tugs *Poolzee* and *Ocean*. Her average draft was 31ft 3in at the time of departure, meaning that she was displacing 34,800 tons.

Her unfinished external appearance did nothing to dampen local enthusiasm over the event. South Shields was crowded with people who came to see the world's largest ship venture into open water for the first time. 'Every available space' overlooking the river 'from Wallsend to the sea entrance, was occupied by spectators'. The Tyne General Ferry Company took passengers out to accompany the ship down the river, and many other river craft accompanied her as well.[43] As the ship moved downriver, several blocks used in the launching, which had eluded the diver's cleaning efforts, broke free and floated away.

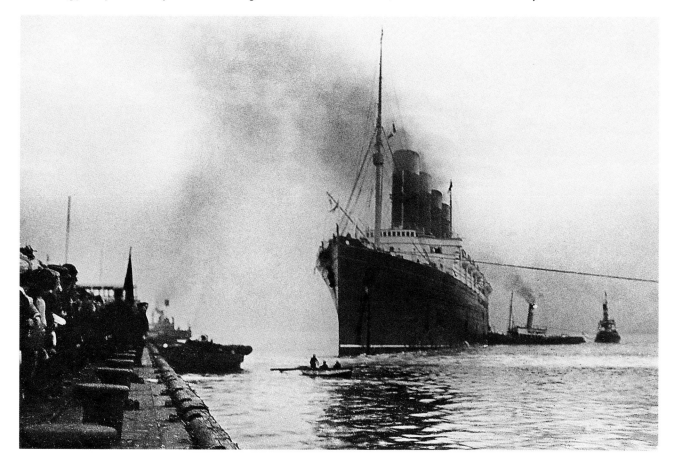

The *Lusitania* approaches the landing stage in Liverpool to take on her first batch of passengers on the evening of 7 September 1907. (Author's Collection)

Mauretania passed the harbour piers at 10.45 a.m. Her compasses were adjusted first, and then the ship cruised just off the coast for several hours while her machinery was tuned up; having hardly broken a sweat, she anchored at 6.35 p.m. that night. The next day, she weighed anchor at 10.35 a.m. after a diver inspected the propellers and reported all was well. The ship proceeded to St Abb's Head, where four runs were made over the measured mile. The average of the two best runs was 23.57 knots with the engines averaging 168rpm – a respectable speed, but not earth-shattering. At 7.15 p.m., she again returned to the mouth of the Tyne to anchor overnight.

On Thursday 19 September, she weighed anchor at 7.35 a.m. and made nine runs over the St Abbs measured mile. The result of the two best runs were 24.93 knots with the engines averaging 177rpm. These were better speeds than her previous runs, but there was more to come. On Friday 20 September the ship made four further runs on the same course. This time, her average speed over the two best runs was 25.9 knots at 189rpm – an excellent speed, but not

quite as high as the showing the *Lusitania* had made, with her hull cleaned, during her formal acceptance trials. While *Mauretania* was engaged in these runs, at about 1.45 p.m. the passengers of the East Coast train were given a 'splendid view' of the liner, a sight which caused quite a stir. The vessel was 'about a mile north of Berwick' at the time. 'To all appearance she was moving slowly, yet she must have been going at full speed. The water behind her was churned up white, and her four huge funnels were belching out smoke as black as Styx. The sea was as calm as a mill pond.'[44] She did not re-enter the Tyne that night.[45]

On Saturday 21 September, the ship made four runs on the Whitley Bay measured mile to test the rate of water consumption by the boilers. She averaged 12.6 knots and 17.14 knots on these. She was then ramped up to 23 knots, and the order was given for 'Full Stop'. In forty-five seconds, her turbines were stopped, and the reversing turbines were then engaged. She came to a complete stop three minutes and fifty-eight seconds after the order was given, having travelled forward about three-quarters of a nautical mile,

The *Mauretania* poised to enter open water for the first time on 17 September 1907. A veritable flotilla of harbour craft escort her. Visible just to the right of her prow, a unique pair of lighthouses shows that she is about to pass the breakwater at the mouth of the Tyne River. (Jonathan Smith Collection)

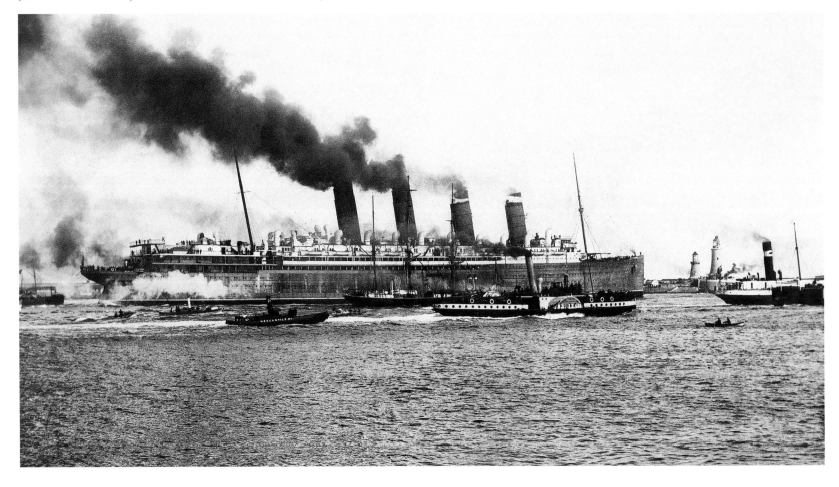

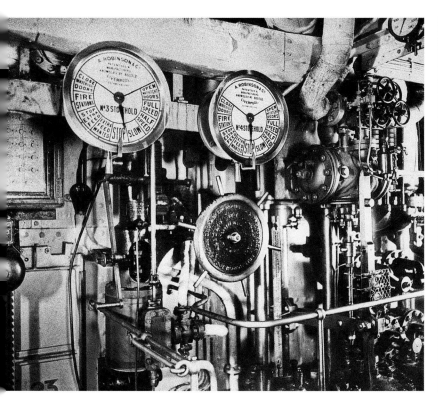

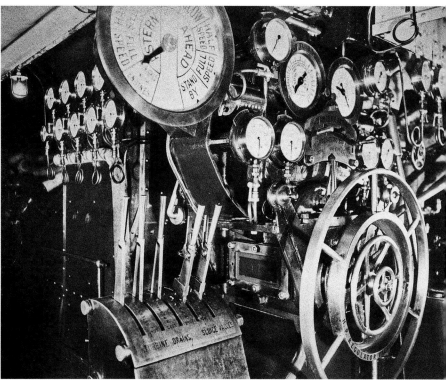

or approximately 4,500ft. She returned to the shipyard at 4.00 p.m.; thousands of spectators watched the great ship coming back from the sea for the first time. Turning the ship in the Tyne was 'made extraordinarily difficult' because of the many small craft on the river.[46]

The press chafed at being kept in the dark on the results of these tests. They could only guess at what speeds she had reached, and no one from Cunard or Swan, Hunter was giving them details. One newspaper stated that the ship had 'frequently' reached 27¾ knots and had averaged 26¾ knots. They declared her the 'world's fastest liner' as those speeds were faster than those achieved by the *Lusitania* up to that time, yet this report was printed before any 'official statements' had yet been made on the subject.[47]

Perhaps everyone was so tight-lipped because not everything had gone smoothly. Everyone's worst fears had materialised in the form of vibration. With the engines running between 160 and 164rpm, the second-class superstructure aft, the first-class entrances and Lounge, as well as the Bridge, the Marconi Shack amidships on the Sun Deck, and the turbo-generator platforms all shook badly.

The shaking was so violent that the ship's commander reportedly rang down for 'Full Stop' during a high-speed run. When asked the reason for his otherwise inexplicable

order, the tart response was said to have been 'Because I was being shaken off my bridge.'[48] Happily, when the ship had ramped up to her maximum speed, the vibrations decreased in the Lounge, Entrance and Bridge, but they also got much worse in the second-class spaces, making them all but uninhabitable.

Swan, Hunter representatives promised to carry out stiffening measures in the ship's hull and superstructure in order to combat the bone-rattling vibrations. Similar work had been done on the *Lusitania* before she had entered service, with partial success. There did not seem to be enough time for the yard to finish that task before the specified delivery date, even working seven days a week, but it had to be done – there was no alternative.

Work progressed at a breakneck pace aboard the ship. By Saturday 12 October, work had gone far enough that the ship could be opened for public inspection from 1.00–8.30 p.m.; on Monday 14 October, she was opened again from 1.00–10.00 p.m. Tickets were 2*s* 6*d* each, with the proceeds going to local charities.[49]

The *Mauretania*'s second departure from the builders came on Tuesday 22 October. She was setting off for a cruise around the north of Scotland and back down the Irish Sea along the west coast of Scotland and England

Above left: This very rare photograph shows the A. Robinson & Co. telegraphs, which communicated from the engine room up to the men in the boiler rooms, forward. The Nos 3 and 4 stokehold indicators are fully visible, while that for No. 2 stokehold is only partially visible on the left. A closed watertight door can be seen below the telegraphs. (Beamish Museum)

Above right: This is the Starting Platform in the engine room. From here, engineers responded to the commands from the Bridge. The set-up looks like something from a Jules Verne novel, with a plethora of gauges, valves, and handles, which regulated the operation of each primary component of her mighty machinery. (Beamish Museum)

to Liverpool, the ship's home port and primary terminus once she entered service. While there, she was scheduled to enter dry dock so that her hull could be cleaned and painted in time for the formal trials, thus helping her to realise her maximum potential. For this trip, the builders invited a large party of about 450 guests, including fifty-eight members of various press agencies.[50] That morning, the *Turbinia* – Charles Parsons' test bed for turbine machinery and the progenitor of the *Mauretania* – was brought alongside. The tiny white band of the experimental vessel's hull showed up for but a short length of the *Mauretania*'s forecastle, and her short funnel barely extended above the white stripe of the liner's waterline. It was a fitting demonstration of just how far the turbine concept had evolved in the span of a single decade.

For this voyage, the ship was manned with a full engineering staff but fewer victualling crew – stewards and other passenger-service personnel – than she would ordinarily carry, for the passenger list on this trip was much shorter than it would be for a transatlantic crossing. All told, the crew list for this trip was planned to be about 800.[51] During the morning hours, there came a brief scare as over one hundred of the Glasgow-based stokers engaged by Swan, Hunter for the trip demanded higher pay after boarding. When their demands were refused, they walked off the ship carrying their kits as if never planning to return. Representatives of the owners met with them and soon the dispute was settled, averting a potentially ugly incident that could have marred the festive event.[52]

By 2.30 p.m., all was in readiness for departure. Six Newcastle tugs – *Washington* and *President* at the bow, and *Champion*, *Prince*, *Snowden* and *Gauntlet* at the sides and stern – took their positions to help guide the ship down the river. It was said that she 'made a prodigious spectacle', presenting an impression of 'colossal size' as the 'smoke from her four great funnels moved like a pall.'[53]

A view taken before the maiden voyage, looking forward along the starboard Boat Deck toward the Bridge wing. (Eric Sauder Collection)

Every coign of vantage on both sides of the river had been seized by those anxious to speed the vessel farewell, and to the hooting of steamer whistles and syrens and the waving of hats and handkerchiefs the great leviathan slowly and majestically moved away from the Wallsend shipyard. The progress down the Tyne to the coast was one long triumphant ovation, the afternoon being evidently regarded as an unofficial half-holiday by the population of Northumberland and Durham. Tens of thousands of people thronged the four-and-a-half miles of river, lining the wharves, jetties, and vessels moored at the various shipyards, and cheering enthusiastically as the vessel proceeded on her stately course …

… The progress down the river was of a most exhilarating character. The thousands of spectators on both banks cheering themselves hoarse, and the incessant blowing of every description of whistle, from the shrill, puny, piping baby note of the small launch to the deep-throated boom of the ocean liner, struck a high keynote of encouragement and farewell.[54]

As the ship passed Palmer's Yard at Jarrow, and the incomplete battleship *Lord Nelson*, she received hearty cheers from hundreds of workers, and the streets of the town were packed with 'dense masses of cheering spectators'.[55] As she passed the training ship *Wellesley*, the ship's band played the national anthem, 'which was taken up on both banks, for it was realised the occasion betokened … the triumph of representative British shipbuilding and engineering'.[56] The *Mauretania*'s passengers, lining her rails, were presented with the remarkable spectacle of 'miles upon miles of shipyards, ships building, ships lying alongside the slips, coming up stream and dropping down, and all lined with people gazing at the *Mauretania*'.[57]

In spite of the enthusiastic cheering, it was said that you 'could only hear them in the pauses of sirens and steam whistles' for every sort of 'craft that had anything to blow, blew it' – which played havoc with the efforts of the pilot, Harbourmaster Captain Bruce, to communicate with the tug captains.[58] Finally, he grew annoyed enough to shout through a megaphone: 'If you've got a return ticket, take and use it!' One of the tugs, 'looking no bigger than a walnut shell' then dropped astern.[59]

As the procession moved closer to open water, they came upon the greatest reception yet at North and South Shields. One passenger wrote:

A large number of people can be seen climbing the gangplank and boarding the *Mauretania*, while numerous others are visible along the port side Boat Deck. The photo is difficult to date, but was likely taken on 12 or 14 October 1907, as the public made their first visit to the liner to see her wonders. (Beamish Museum)

As far as the eye could see the quays, streets, beaches and piers were packed with tens of thousands of people, all waving farewell to 'the big boat'. As the two tugs threw off their towing ropes we steamed out of the harbour into the North Sea, the atmosphere being dusky with the smoke from the surrounding lighters, tugs and excursion steamers all booming and hooting their boisterous adieus.[60]

The ship then paused, and some time was taken to adjust her compasses. In total, it was estimated that along the entire route to sea, a quarter of a million people had turned out to wish the *Mauretania* a fond farewell.[61]

At six o'clock that evening, the ship was ready to proceed.[62] Mary, Lady Inverclyde – widow of Cunard's former chairman and the woman who had launched the *Lusitania* at Clydebank the previous June – was invited to the Bridge to give the signal on the engine-room telegraphs that would start the liner into motion. After she had completed this ceremonial task, Thomas Bell – chairman of the Wallsend Slipway and Engineering Company, the firm that had built the liner's engines – presented her with 'a handsome gold bracelet composed of exact reproductions of the smallest blades' of the turbine engines, 'decorated with a centre-piece set with diamonds, representing in miniature a ring of blades in the rotary portion of the engine'.[63]

'Huzzas from below told those on deck' that the order to start the engines had been given from the Bridge.[64] Then the engineers worked the controls at the Starting Platform, and allowed steam to flow into the turbine engines. The turbines began to spin, turning the propellers and creating an alien whine. The engine noise was very different from that of ships powered by reciprocating engines, with their

During the morning of 22 October, the *Mauretania*'s tiny progenitor was brought up alongside the ship, just before she departed on her trials. Her funnel barely pokes above the white stripe of the liner's waterline. The liner appears to be nearly ready to cast off. (Beamish Museum)

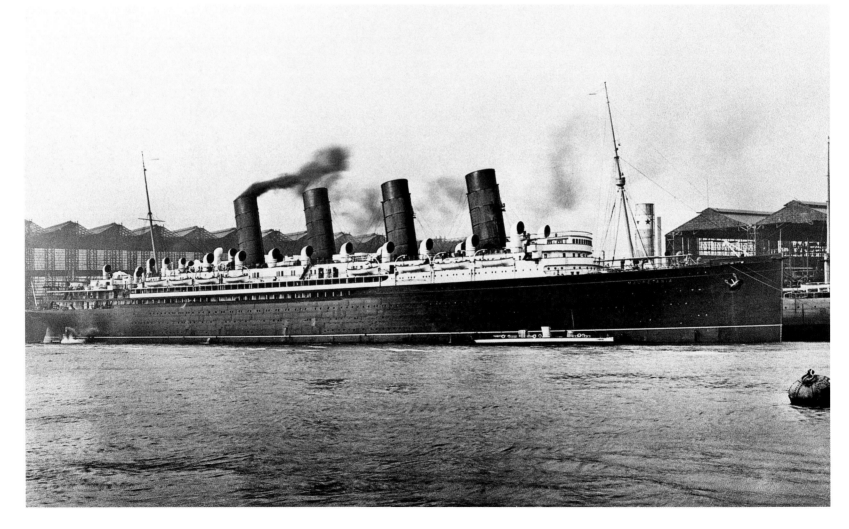

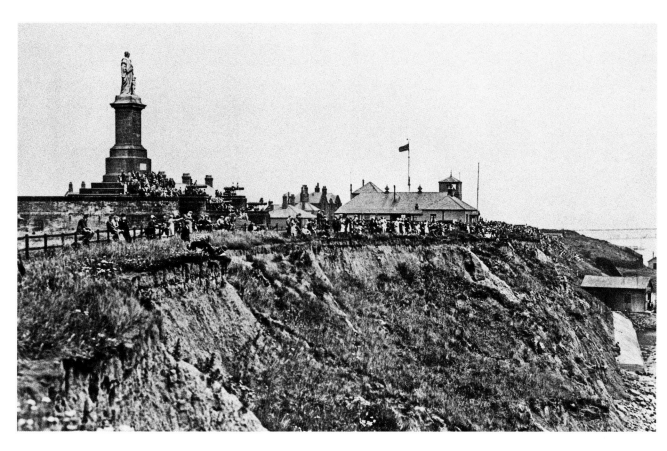

This view shows spectators lining the shore of Tynemouth, with the pier visible just beyond. On the left is the Collingwood Monument, a tribute to Lord Collingwood, Lord Nelson's second-in-command during the Battle at Trafalgar. The photo was taken during one of the *Mauretania*'s first two departures for open water. (Beamish Museum)

characteristic 'recurrent shocks'.[65] As she steamed north, a 'mist crept over the horizon, and only an occasional lighthouse beacon announced the coastline'.[66] No attempt would be made to conduct speed tests on this voyage; several of the boilers were not even fired.[67]

Dinner was served at 7.00 p.m. 'Full justice was done to the excellent repast, for appetites had by that time been sharpened by the keen sea air,' wrote one passenger. Everyone was abuzz over the 'unprecedented farewell' given the ship. An orchestra played in the Lounge after dinner.[68] Later, most 'of the men adjourned to the luxurious smoke room, where old friends were met and yarns cracked'.[69] The passengers were so excited by the voyage that many of them stayed up for most of the night; some of these were just turning in when those who had turned in early were turning out for an early-morning walk about the decks.

Over dinner the first night, many passengers had commented on the 'absence of vibration'.[70] It is clear that the stiffening and weight redistribution made by the builders had improved the vibration issue. Yet one of the passengers made some very detailed observations on the subject during the cruise:

At sea ... vibration is noticeable, though relatively slight. Generally speaking, it is maximal in the after part and diminishes thence to the bows. The distribution, however, is erratic, regions of maximal vibration often being close to regions of minimal vibration. In the great dining saloon at 22 knots the tremors were barely noticeable, being something like the passage of a vehicle in a street outside. On the other hand, a region of marked vibration was forward of this, about the level of the second funnel ...

... The turbines themselves are singularly free from [vibration]. Leaning against their great steel shells one is not conscious of movement. In the shaft tunnels, however, it is very marked. ... The vibrations themselves are markedly periodic, mounting by a long crescendo to a climax, followed usually by complete quiet. This periodic nature unquestionably suggests a dependence upon synchronism between propellers on opposite sides of the ship. ... The whole subject is being investigated on the *Mauretania* by means of the pallograph, which registers at the same time the shaft movements and the vibrations.[71]

This unique original photo was likely taken on the evening of 22 October as the ship steamed around Scotland in mist. (Author's Collection)

By 7.00 a.m. on Wednesday, things were very quiet on deck. The *Mauretania* was abreast of John O'Groats on the north-eastern tip of Scotland. Breakfast was served at 8.30 a.m., and some of the reporters were then given a tour of the engine spaces. Here things were 'totally dissimilar to all that one has been previously accustomed' in a steamship's engine room. Gone were the enormous reciprocating engines with greasers and oilers fussing at them. Instead, the 'engineers appear to be standing about doing nothing, and the only thing that can be seen to be moving is the governor. Everything is enclosed and concentrated.'

The day passed quickly, with fine sunny weather and no wind. As the sun set, the liner 'heaved slightly' in the swell of the Atlantic for the first time. Once dinner had ended, that motion had ceased, but that was not soon enough for some diners, who were seen abruptly leaving the Saloon mid-meal.[72] After dinner there was a concert, organised by several of the passengers.

By 5.00 a.m. the next morning, the *Mauretania* had anchored off the Mersey Bar, about 20 miles from the Prince's Landing Stage, in a dense fog; she was some seven hours ahead of schedule, and had to wait for the tide to rise before she could enter the Mersey.[73] Passengers were treated to a hearty breakfast, at which there were a number

A proud group of shipyard representatives, Cunard personnel and officers pose on the Sun Deck with Captain Pritchard (seated middle row, just right of centre), during the cruise down to Liverpool. (Author's Collection)

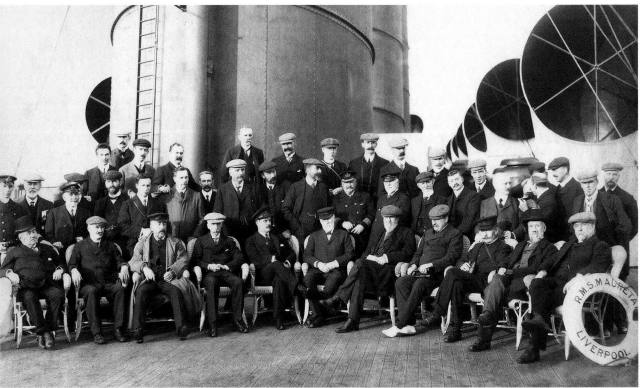

of speeches. One speaker was Lord Brassey, former Liberal MP, Governor of Australia, a keen sailor and founder of *Brassey's Naval Annual*. Brassey said that the construction, equipment and maintenance of the *Mauretania* seemed to add to national glory and to national resources. He quipped that Cunard should have given her a local name, and that *Pride of the Tyne* would have been more appropriate. Everyone in the Saloon rose to their feet, gave three 'rousing cheers' and sang, 'They are jolly good fellows', which was followed by three more cheers.[74]

After this, the passengers prepared to disembark. The ship had waited for the tide to cross the bar; she was able to enter the Mersey at about 9.30 a.m., and shortly thereafter dropped anchor in the Mersey opposite New Brighton. Two tenders pulled up alongside and took off the passengers and their luggage.[75] The ship later proceeded into the Huskisson Dock and tied up, and by that evening had moved into the Canada Dry Dock.[76] *Mauretania* left the dry dock on 30 October, and final preparations were subsequently made for the ship's formal acceptance trials.

She departed Liverpool early on 3 November and steamed north to the starting point for the tests, off the Wigtownshire coast of Scotland. She commenced trials the next morning. They involved four 304-mile runs – two south-bound and two north-bound – through the Irish Sea and St George's Channel, between Corswall Point Light at Wigtownshire, and Longship Lighthouse in Cornwall, England. The weather did not seem inclined to assist the ship in attaining the 25-knot service speed Cunard and the builders had aimed for, as a moderate gale of Force 7 was blowing during the first run south. However, conditions did improve somewhat during the remaining three runs.

When the ship was finished with these long-distance tests by about 8.00 p.m. on Tuesday 5 November, she had steamed some 1,216 miles at an average speed of 26.04 knots – 1.04 knots higher than the intended design speed for both ships, and 1.54 knots better than the minimum average she would need to maintain during a transatlantic passage of roughly 3,000 miles. It was also a better performance than the 25.4-knot average the *Lusitania* had turned in over

This view was taken on the morning of 24 October, as the *Mauretania* made her first arrival in the port of Liverpool. (Author's Collection)

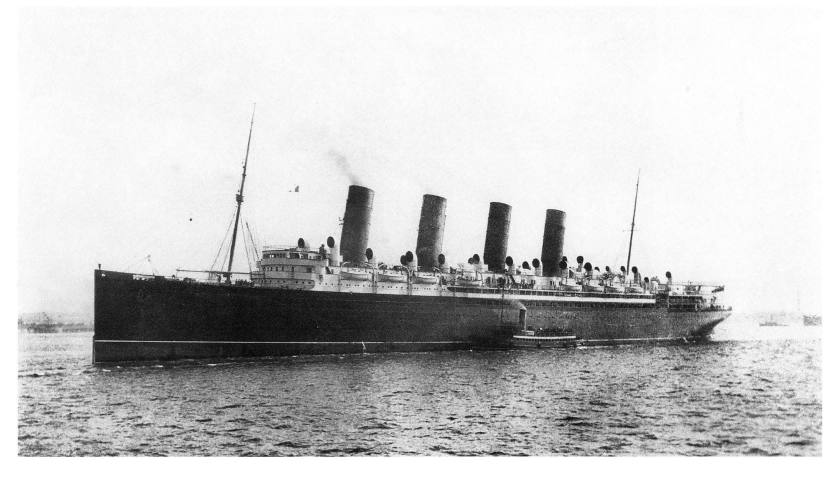

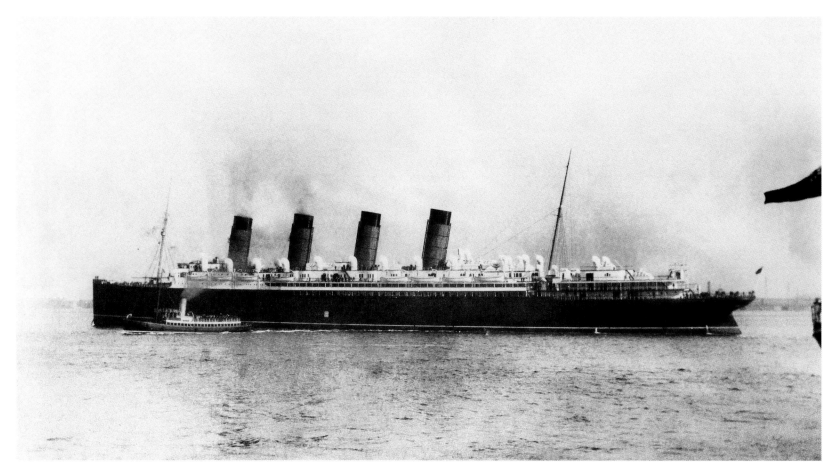

The small craft alongside in the previous photograph has now pulled away from the ship, although the *Mauretania*'s gangway door has yet to be closed. A group of passengers lines the midship First Class Boat Deck. (Author's Collection)

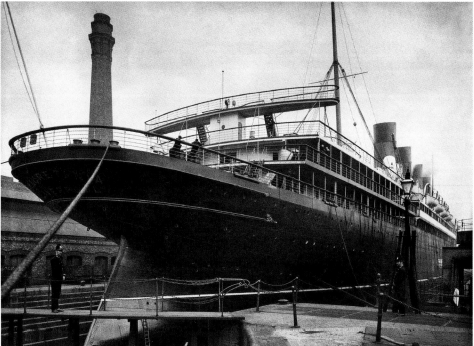

A very rare stern view taken of the *Mauretania* during her first dry-docking. (Eric Sauder Collection)

the same course three months before. This indicated that the *Mauretania* might be able to better her older sister's performance on the Atlantic. It was also clear that the *Lusitania* would be hard at her heels, for, over a 59-mile course on 1 August, the Scottish-built ship had averaged a higher showing of 26.45 knots.

The *Mauretania* anchored overnight near the Skelmorlie measured mile, and at daybreak on 6 November began a series of five round-trip runs at increasing speeds. Her average for these were 18.32, 20.93, 22.83, 25.64, 26.03 knots. Then she ran from Ailsa Craig Light to Holy Isle Light and back. The first run took thirty-seven minutes and thirty-five seconds at an average speed of 25.6 knots; going the other direction, the trip took thirty-five minutes and fifty-four seconds, at an average speed of 26.75 knots, for a mean speed between the two runs of 26.17 knots – truly impressive performances.[77]

While the ship was put through her paces, Cunard personnel were busy inspecting her from stem to stern to make sure she was satisfactorily completed. There were still a number of things that needed attention. Although

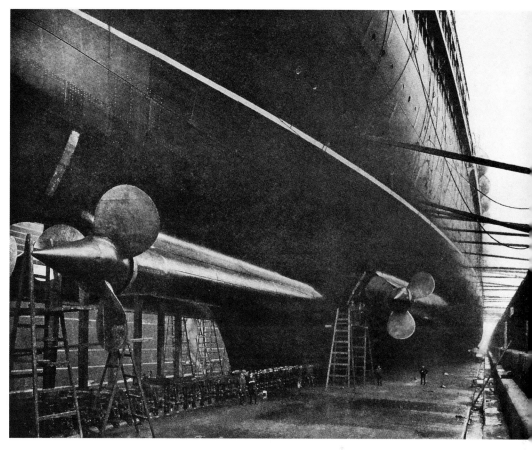

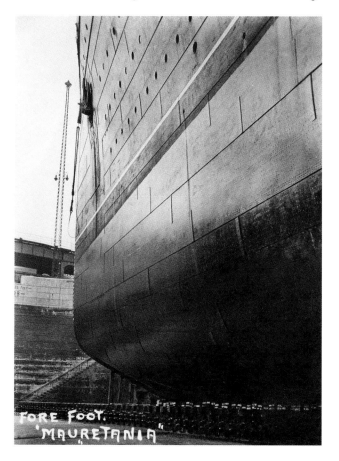

FORE FOOT. "MAURETANIA"

improved since September, vibration was still creating problems; it was expected that passengers would find reading in the Smoking Room nearly impossible. Vibration also produced a lot of sympathetic rattling. To combat this, recommendations were made to stay the domes of the First Class Smoking Room and Lounge, as well as that of the Second Class Smoking Room, to the outer casing; the globes on many of the electric lights needed to be fitted with gaskets; the flues of the First Class Lounge and Writing Room fireplaces needed to be stayed – all to stop rattling noises. In the Lounge, the mirror over the mantel and the chandelier rattled; the mirror needed battens fitted behind it. The aluminium grillwork surrounding the lifts rattled at certain speeds as well. The collapsible gates also seemed too weak, and needed firmer outer rails to prevent bending; stays also needed to be fitted to the top tracks of the gate. Second-class spaces were still vibrating badly. Even at that point, shipyard personnel were installing extra stanchions in the Lounge and Smoking Room aft, as well as beneath the Boat Deck, and it was hoped that these measures would continue to improve the situation.

Above: During the ship's first stay in dry dock, men stand beneath her huge propellers and towering hull. (Author's Collection)

Left: This view shows the liner's bow hull after it had been cleaned. The strip of 'boot topping' paint below the white stripe of the waterline is clearly visible. (Eric Sauder Collection)

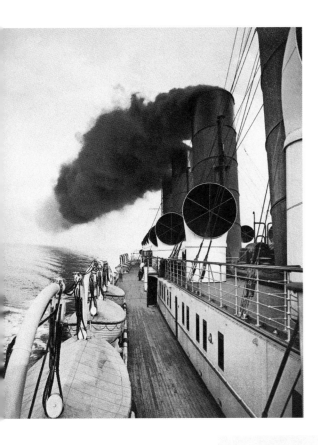

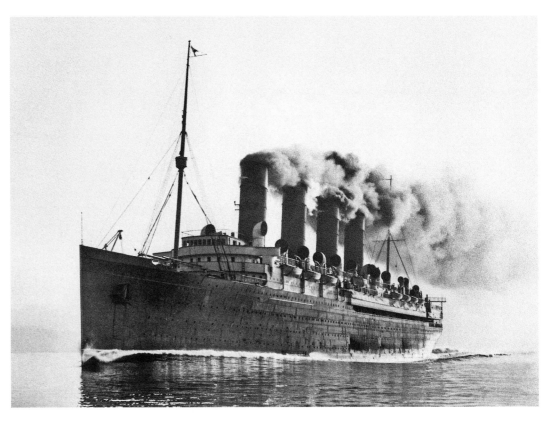

Right: This photograph of the *Mauretania* in Liverpool is from before her maiden voyage. It was taken by photographer Arthur Priestley, who worked with his father Sam in a Liverpool-based photography business. The handwritten notes made by Arthur place the date of the photograph as 1 November, or before the ship's formal trials. However, the paint at her bow just above the waterline match more closely her appearance just after the trials and before the maiden voyage, after it had been scoured by water while moving at high speed. The ship is being coaled, and the paint at her bow is about to be touched up. (Author's Collection)

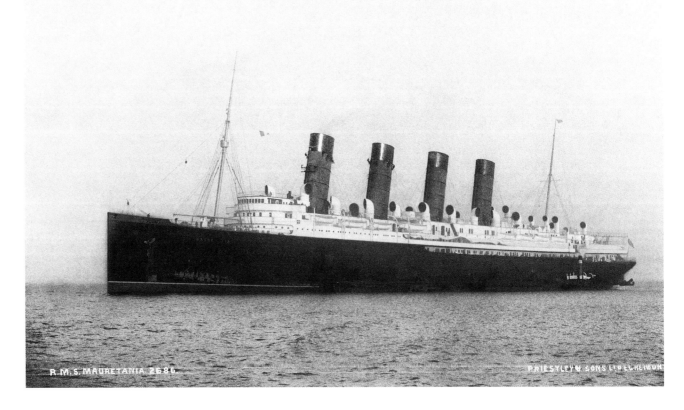

R.M.S. MAURETANIA 2686. PRIESTLEY & SONS LTD ELHEICON

There were a few other odds and ends to be seen to: doors in the First Class Lounge needed to be eased; lights had to be fitted in the dome over the entrance, which sat atop the staircase and lifts, for without them, the dome looked gloomy at night; there were also a number of details that needed attention in the passenger staterooms; some on E Deck would need extra insulation, for they were all but uninhabitable because of heat bleeding in from nearby engine spaces.

None of these issues, however, marred the spectacular results of the formal trials. The ship was an unqualified success as she returned to Liverpool at the trials' conclusion on Thursday 7 November. She was formally handed over to Cunard on 12 November.[78] Final preparations were made for her maiden voyage, set to begin on Saturday 16 November. One correspondent wrote that the Mauretania's 'magnificent achievement forms the most eloquent testimony to the supremacy of British shipbuilding and marine engineering.'[79]

Cunard was ecstatic with the performance of their two new ships, despite the ongoing cost overages to build them. The final cost to build the Lusitania was £1,651,871, while the Mauretania was £1,855,848. Throughout 1908, Cunard negotiated with both shipbuilders for a reduction in price on the ships. John Brown agreed to a £30,000 rebate on the Lusitania, while Swan, Hunter allowed for a reduction of almost £76,000. Once all miscellaneous fees had been accounted for, Cunard paid John Brown £1,625,463 for the Lusitania and £1,812,252 to Swan, Hunter for the Mauretania, for a grand total expenditure of £3,437,715, or £837,715 more than the £2.6 million government loan.[80] At the time, they were easily the two most expensive ships ever built, merchant or naval. Fortunately, Cunard and both shipbuilders managed to keep the financial problems, as well as the rather bitter disputes with Swan, Hunter, from the public eye, preventing all of the negative publicity that would have come along with that.

With nearly £3.5 million spent to build the world's largest ships, Cunard was keen to recoup its investment. The Lusitania had broken the German transatlantic speed records in both directions during the month of October, and appeared to be a complete success. The question remaining was: how successful would the Mauretania prove to be?

Opposite top left: This famous view was taken during the ship's formal trials, and looks aft from the Bridge wing along the Boat and Sun Decks. The liner is turning to starboard at high speed, as shown by the flattened smoke emanating from her funnels and the curved wake visible behind her lifeboats. (Beamish Museum)

Opposite top right: A splendid view of the mighty Mauretania during her trial runs. Her First Class Promenade Deck has been enclosed with canvas during the tests. (Beamish Museum)

NOTES

1 (All dates given are DD/MM/YYYY) The Sun, 25/9/1904; Page's Weekly, 11/9/1906.

2 Page's Weekly, 13/10/1905.

3 Annual Report of the Commissioner, United States Department of Commerce, Bureau of Navigation, 1902, p. 399–401.

4 Evening Star, 1/10/1902.

5 Engineering, Vol. LXXXIV, p. 133; Parliamentary Papers: 1850–1908, Vol. 36, p. iv; Shipping and Shipbuilding Subsidies, by Jesse Edwin Saugstad, p. 240.

6 Ships For A Nation, Ian Johnston, p. 109; National Archives (UK) UCS/1/1/13, UCS 1/74/3, University of Liverpool Archives, D42/B8/1. Shipbuilder, Vol. II, Mauretania Special Number, November, 1907, p. 5.

7 University of Liverpool Archives, D42/B8/1; Ships For A Nation, p. 109.

8 Shipbuilder, Nov. 1907, p. 5.

9 Ships For A Nation, p. 111.

10 Ships For A Nation, p. 114.

11 Shipbuilder, Nov. 1907, p. 6; Ships For A Nation, p. 114.

12 The Nautical Magazine, Vol. 74, 1905, p. 1005.

13 University of Glasgow Archives; Ships For A Nation, p. 337; Lusitania: An Illustrated Biography, J. Kent Layton (Amberley, 2015) p. 21. For many years, the keel-laying date of the Lusitania has been mistakenly given as 16 June 1904.

14 Tyne & Wear Archives.

15 Ships For A Nation, p. 111.

16 American Machinist, Vol. 31, Part 1 (5 Mar 1908), p. 351; Ships For A Nation, p. 111.

17 Ships For A Nation, p. 115.

18 Brassey's Annual: The Armed Forces Yearbook, 1906, p. 89.

19 Ships For A Nation, p. 115.

20 'Mauretania and Her Builders', Ian Buxton, Mariner's Mirror, Feb. 1996, p. 62; Scientific American, 24 Mar 1906.

21 Scientific American, 31/3/1906.

22 Some sources reference the date of this meeting as Wednesday 23 May.

23 Marine Review, Vol. 34, 1906, p. 32; Liverpool Daily Post & Mercury, 21/9/1906.

24 *American Marine Engineer*, Oct. 1906, p. 17.

25 *Liverpool Daily Post & Mercury*, 21/9/1906.

26 *Liverpool Daily Post & Mercury*, 21/9/1906.

27 *American Marine Engineer*, Oct. 1906, p. 17.

28 *Engineering*, Vol. LXXXIV, p. 622.

29 *Liverpool Daily Post & Mercury*, 21/91906.

30 *Engineering*, Vol. LXXXIV, p. 622.

31 *American Marine Engineer*, Oct. 1906, p. 17.

32 *Engineering*, Vol. LXXXIV, p. 622; *The Shipbuilder*, Special Number on *Mauretania*, November 1907, p. 57. Henceforth cited as *Shipbuilder*; *The Marine Review*, Vol. 34, 1906, p. 32.

33 *Liverpool Daily Post & Mercury*, 21/9/906.

34 *Mauretania* and Her Builders', Ian Buxton, *Mariner's Mirror*, Feb. 1996.

35 *Shipbuilder*, pp. 138–142; *The Electrical Review*, 1/9/1907.

36 *Electrical Engineer*, 8/11/1907, (Vol. 40 p. 661).

37 *Marine Review*, Vol. 34, 1906, p. 32.

38 *Scientific American*, 23/11/1907.

39 *New York Times*, 23/11/1907.

40 *Shipbuilder*, p. 94.

41 *Page's Engineering Weekly*, 1/11/1907 (Vol. 11, p. 889)

42 *Dundee Courier*, 18/9/1907.

43 *Dundee Courier*, 18/9/1907.

44 *Aberdeen Journal*, 23/9/1907.

45 *Daily Mirror*, 21/9/1907.

46 *Daily Express*, 23/9/1907.

47 *Daily Express*, 23/9/1907.

48 *Mauretania: Landfalls & Departures of Twenty-Five Years*, Humfrey Jordan, (1936, reprinted 1988 by Patrick Stephens Ltd), pp. 69–70. Henceforth cited 'Jordan'.

49 *Yorkshire Post and Leeds Intelligencer*, 12/10/1907.

50 Estimates for the size of the party range from 325 to 450 to about 500, depending on what sources are referred to. The report of about 450 is the most frequently cited. While some reported about 50 press representatives were present, the *Dundee Courier*'s representative reported the precise number of 58; however, the same representative was at the low end of the figuring for the number of guests, citing 325.

51 *Dundee Courier*, 25/10/1907.

52 *Yorkshire Post and Leeds Intelligencer*, 23/10/1907.

53 *Nature*, 31/10/1907.

54 *Page's Weekly*, 1/11/1907, p. 887.

55 *Page's Weekly*, 1/11/1907, p. 887.

56 *Page's Weekly*, 1/11/1907, p. 887.

57 *Daily Express*, 25/10/1907.

58 *Yorkshire Post and Leeds Intelligencer*, 23/10/1907.

59 *Daily Express*, 25/10/1907.

60 *Page's Weekly*, 1/11/1907.

61 *Daily Mirror*, 23/10/1907.

62 *Evening Telegraph*, 24/10/1907.

63 *Page's Weekly*, 1/11/1907, p. 887.

64 *Dundee Courier*, 25/10/1907.

65 *Nature,* 31/10/1907.

66 *Dundee Courier*, 25/10/1907.

67 *Dundee Courier*, 25/10/1907.

68 *Evening Telegraph*, 24/10/1907.

69 *Page's Weekly*, 1/11/1907, p. 891.

70 *Page's Weekly*, 1/11/1907, p. 891

71 *Nature Magazine*, 31/10/1907.

72 *Page's Weekly*, 1/11/1907, p. 891; *Evening Telegraph*, 24/10/1907; *Dundee Courier*, 25/10/1907.

73 *Manchester Courier and Lancashire General Advertiser*, 25/10/1907; *Dundee Courier*, 25/10/1907.

74 *Page's Weekly*, 1/11/1907, pp. 891, 893; *Dundee Courier*, 25/10/1907.

75 *Dundee Courier*, 25/10/1907; *Daily Express*, 25/10/1907; *Evening Telegraph*, 24/10/1907.

76 *Manchester Courier and Lancashire General Advertiser*, 25/10/1907; *Engineering* (PSL reprint, 1987); Introduction by Mark Warren, p. iii.

77 *Engineering*, 8/11/1907 (PSL Reprint, pp. xiii, xiv.)

78 '*Mauretania* and Her Builders', Ian Buxton, *The Mariner's Mirror*, Feb. 1996.

79 *Daily Mirror*, 6/11/1907.

80 University of Liverpool Archives D42/S7/1/9; *Ships For A Nation*, p. 116; '*Mauretania* And Her Builders', Ian Buxton, *The Mariner's Mirror*, Feb. 1996.

2

'MAURETANIA THE MAGNIFICENT'

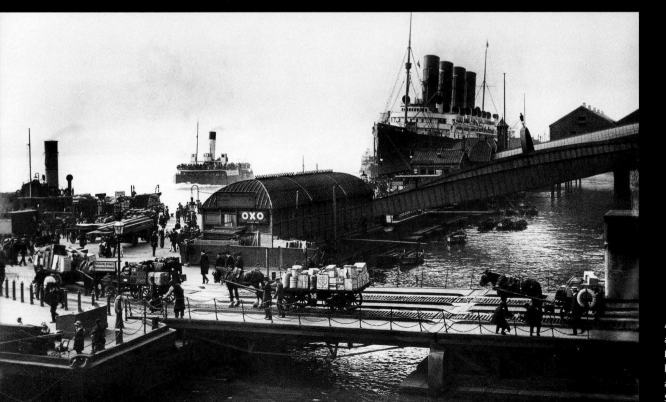

An early view of the *Mauretania* at the Prince's Landing Stage in Liverpool. A cart full of Amstel lager beer is visible on the left, at the waterfront. (Jonathan Smith Collection)

The *Mauretania* was to begin her maiden voyage on Saturday 16 November 1907. The weather was positively beastly. Nevertheless, several hours before the 7.00 p.m. departure time, a crowd, which eventually grew to 50,000, began gathering at the Prince's Landing Stage, all of them wielding umbrellas to ward off the rain. Throughout the evening, passengers, baggage and cargo were all brought aboard the ship; while they waited for the ship to cast off, passengers began to explore the marvels of the liner, which had been dubbed '*Mauretania* the Magnificent'.

The departure was delayed by nearly an hour, however, when the special train carrying about £2.8 million in gold bullion, bound for American banks, turned up late. As longshoremen worked to load the bullion aboard in the growing darkness, it was said that the liner was a 'blaze of

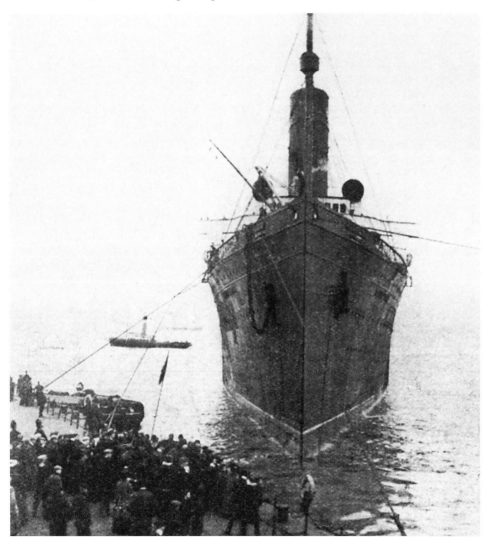

The *Mauretania* pulls up beside the Prince's Landing Stage to embark her first passengers. (Author's Collection)

illumination from stem to stern' and that she 'presented a magnificent spectacle'.[1]

Finally, just before 8.00 p.m., she cast off and was towed away from the stage 'to the accompaniment of intermittent bursts of cheering and the din of hooting sirens'.[2] It wasn't as large a crowd as that which saw the *Lusitania* off on her maiden voyage in September. Neither did they burst into refrains of 'Rule, Britannia' spontaneously as at the older sister's first departure. In all truth, they were probably too drenched to sing. However, their send-off was still 'impressive and strikingly enthusiastic'.[3]

That night, the *Mauretania* steamed toward Queenstown, Ireland through 'the teeth of half a gale,' yet it was said that she 'behaved splendidly' and 'without perceptible motion, she glides along as if on rails'.[4] The next morning, she called at Queenstown, where she took on passengers and exchanged mails. When she passed Daunt's Rock at 11.03 a.m., after a two-hour stay in the port, hopes were high for a splendid, record-breaking trip; indeed, she made a fine start by covering 30 nautical miles up to noon. The North Atlantic, however, had other ideas.

By noon the next day, she had made 571 miles, but the weather had deteriorated to a strong south-west gale with fairly heavy seas.[5] The liner was pitching heavily and taking solid water over her bows. In the afternoon, the spare anchor on the forecastle broke loose, and 'the following seas and the roll of the ship set it to dancing about the deck'.[6] Captain Pritchard was forced to stop in mid-ocean while he and an army of unfortunate crew members went out to secure it again.[7] This process took over two hours, during which time the ship was badly battered by the elements; several windows on the Promenade Deck were smashed, and the rails atop the Bridge were bent out of kilter. Finally, the anchor was secured, and she was able to resume her course. Her run to noon on Tuesday reflected the mid-ocean pause, for she had covered only 464 additional miles. By noon on Wednesday she had managed another 563 miles. That afternoon the weather was improving dramatically, and the ship was able to pour on speed in earnest.

By noon on Thursday, she had covered another 624 miles at an average speed of 25.83 knots. This set the world's record for a single day's steaming by 6 nautical miles, and took one of the *Lusitania*'s records. When news of the run broke during lunch that day, George Hunter – Swan, Hunter's chairman and a passenger for the trip – received an ovation from his fellow passengers in the First Class Dining Saloon.[8] That afternoon the *Mauretania* continued

to steam hard, but by that night she had encountered thick fog, forcing her to decelerate. When she reached Sandy Hook, the official end point of the crossing, at 11.13 a.m. on Friday 22 November, she had covered another 528 miles. There she anchored, having covered 2,780 nautical miles in five days, five hours and ten minutes at an average speed of 22.21 knots – hardly a record-breaking trip, but a solid performance considering the bad weather.

It was several hours before the fog lifted; finally, she was able to enter the new Ambrose Channel at 3.15 p.m. An 'immense crowd' had assembled at Cunard's Pier 54 to see her tie up; she was escorted up the North River by 'a small flotilla of tugs' and 'every whistle in the harbour joined in the greeting', but it was nothing to the grand reception enjoyed by her sister in September. She tied up by 6.35 p.m. and a weary Captain Pritchard spoke a few positive words about the ship's performance for reporters before quickly retiring for some much-needed rest.[9]

Her return to England began on Saturday 30 November. For thirty hours after leaving New York, she was plagued with thick fog. When it lifted, however, she sped up; by the time she passed Daunt's Rock at Queenstown in the evening of Thursday 4 November she had made the crossing at an average speed of 23.69 knots. She thus beat the *Lusitania*'s east-bound record of 23.61 knots, taking the east-bound Blue Riband from her. Over the coming years, the two ships would continuously try to one-up each other as regards speed records in a friendly competition. Cunard personnel no doubt beamed over the fact that both ships proved enormously popular with paying passengers and carried respectable lists over that winter, even though it was the off-season, when travel was typically in a slump.

The *Mauretania*, bearing the title of 'world's largest ship' by a scant 3ft over her sister, was forced to split the title of 'world's fastest ship' with the *Lusitania* into the spring of 1908. Winter storms, high winds and fog all seemed to conspire to prevent her from capturing the Blue Riband in the other direction. Her second west-bound crossing found her in even worse weather than the first, with the barometer slumped to 28.2in. Then a 'big wave struck the ship on the starboard side, washing over the main deck, the water pouring down the hatchways into the steerage' and simultaneously lifting three lifeboats from their chocks, badly damaging one of them.[10] She finished the voyage safely, but during her stay in New York a sudden squall at high tide caused her forward moorings to part. One of her forward hawsers parted; the next two hawsers held,

but twisted the mooring bitts from the dock. The bow of the ship swung out, sinking coal barges and sending men scurrying for safety before tugs were called in to make her fast again.[11]

On 26 January 1908, the *Mauretania* came upon a lifeboat from the sunken coal barge *Fall River*, which had been damaged in bad weather. Those in the boat said that the speedster bore down on them 'like an express train', but when they signalled for assistance, she stopped and picked up all three survivors.[12] After arriving in Liverpool, she was

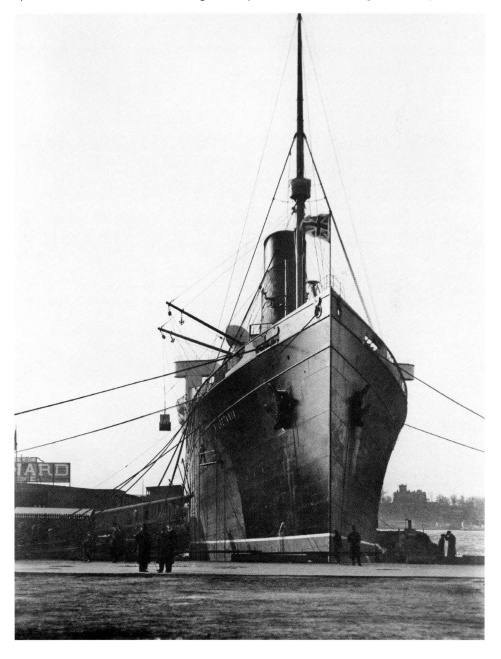

Her harrowing maiden voyage complete, the liner is docked at Cunard's Pier 54 in lower Manhattan. Workmen can be seen repainting her bow, as much of the paint had been torn from the ship's sides during her crossing. (Ioannis Georgiou Collection)

dry-docked for maintenance.[13] On 11 April, as she concluded her sixth west-bound crossing, she managed to average 24.08 knots and shave a single minute from the *Lusitania*. Finally she held the speed record in both directions. Yet at the end of May, the *Lusitania* set up three new records: the shortest time over the long 2,889-mile course from Queenstown to New York; best day's run of 632 nautical miles; and best average crossing of 24.83 knots.[14]

However, the *Mauretania* was not well positioned to reclaim any speed trophies from the *Lusitania* by then, for on 2 May 1908, while west-bound for New York, she suffered a handicapping mishap. At the outset of the voyage, conditions seemed prime for a record-breaking trip; as she steamed west out of Queenstown, she had attained a speed of 26 knots. But only eleven hours out

of port, there came 'a shock that was felt from stem to stern, followed by a momentary pounding at the stern'. The liner had struck a submerged derelict, damaging her outer port propeller. She safely concluded the voyage on the remaining three props, but only averaged 22.89 knots.[15] Arrangements were hastily made to dry dock the *Mauretania* when she returned to Liverpool; on the eastward trip she averaged only 22.32 knots. Her Saturday 23 May sailing was postponed to Sunday, and when the ship arrived she was immediately dry-docked.

While in dry dock her entire undersea surfaces were cleaned and an inspection of the damage to the port prop was carried out. The wounded wing was removed for inspection and it was discovered that the impact had also fractured the stern bracket. The ship's next sailing was

Another view of the ship during her first stay in New York. Here repainting has progressed to under the forward lifeboats. (Author's Collection)

STEAMSHIP "MAURETANIA" IN DOCK, NEW YORK.

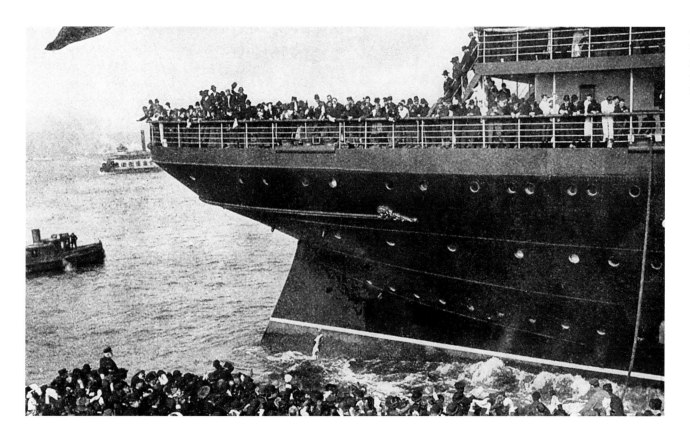

One of the *Mauretania*'s first departures from New York. She is seen off by a tremendous crowd as she backs out of Pier 54. (Author's Collection)

further postponed. Unfortunately, it would take time to prepare a new stern bracket, and Cunard planned to replace it that October. Meanwhile a new three-bladed propeller was fitted to the starboard-outboard shaft. It was one of a pair of available spares that had been specially designed to combat vibration and it was a prime opportunity to test it.

The *Mauretania* left Liverpool on her next trip on 27 May, and no one could have expected much performance from her, since she was running on only three propellers. However, when she arrived in New York late on 1 June, she had managed the incredible feat of averaging 24.86 knots, shaving seven minutes from the *Lusitania*'s best time, and also making a new best day's record of 635 nautical miles. It was a 'phenomenal' performance under the circumstances.[16] The two sisters' abilities did not go unnoticed. On 2 June 1908, the government publicly announced that the speed terms of the loan to fund their construction were satisfied; the annual subsidy of £150,000 was thus won. In New York, *Mauretania*'s Captain Pritchard said he 'had to shake so many hands that he amply qualified for a Presidential nominee'.[17] He told reporters that if all four of his ship's propellers had been working on his last crossing, she would have 'steamed clear out of the water'.[18]

This handicapped, yet record, voyage by the *Mauretania* turned the maritime world on its ear. Marine engineers called it 'most puzzling', and some thought it indicated that the boiler capacity of the two liners was not equal to that of the turbines. To some, the fact that her best performance to date was made 'with one of her high-pressure turbines out of commission afforded further evidence that the most efficient work of the steam turbine is done in the low-pressure turbines'.[19] Others contended that the design of the propellers was entirely to blame for inefficient steaming, and for the vibration both liners had suffered. Even Charles Parsons felt that the original props were 'on the large side'; the problem, he said, was that 'efficiency rises slowly as you diminish the size, until a point is reached which gives maximum efficiency,' but that if the size is reduced too far, then 'the efficiency drops very suddenly, and the results are very disappointing'.[20] Clearly, more research on propeller design was needed. In the meanwhile, the *Mauretania* continued her schedule on three props; happily, the new prop on her starboard outboard shaft noticeably reduced vibration. Cunard planned to add another prop of similar design to her port shaft when she was dry-docked for repairs to the stern bracket.

Meanwhile, by mid June, the *Lusitania* had shown her upstart sister a thing or two by taking back the records for speed at 24.88 knots;[21] in July she averaged 25.01.[22] Still, the memory of being bested by the handicapped *Mauretania* must have stung her crew's pride.

In early August, the *Mauretania* arrived in New York after having made a voyage at only 23.59 knots; it was said 'one of her after propellers' apparently 'picked up some obstruction that hindered its operation'. Her next three crossings showed steadily deteriorating averages. Then, on Thursday 17 September, the *Mauretania* suffered another incident. While west-bound for New York she was in the middle of a tremendous storm equivalent to a Category 3 hurricane. At around noon, her passengers were already uncomfortable and nervous when suddenly the liner 'heaved upward amidships and then began to vibrate, so that

passengers were shaken from their chairs'. One crewman said that the ship's masts quivered 'like bamboo fishing poles'. Firemen working in the bunkers were reportedly buried under piles of shifting coal. Terrified women, 'many of them in scanty attire' – including one woman in first class wearing only 'a chemise and feather boa' – filled the corridors and gangways.

Actress Constance Collier, a first-class passenger, recalled that 'there was an awful crash, and at the same time a wave struck us and a stream of water shot to the bridge. The doors began to open and men and women ran on deck … It was a short-lived excitement, but it was a panic while it lasted.' Another prominent passenger, John W. Gates, later said: 'When that propeller broke, the screw seemed to run away with the great ship. She was racked as though a host of giants with sledges were beating on her sides.' Some passengers began to pray; one passenger, Miss Alice Lloyd, began to sing 'Over the Hills and Far Away', trying to quell the nerves of the frightened ladies around her. She ended up singing for over an hour, and was later commended by Captain Pritchard for her attempts to maintain order.

On the Bridge, Captain Pritchard stopped the engines, and the ship lost headway in the mountainous seas. It quickly became apparent that the starboard-inboard prop had struck something, or that the prop had become 'bent in such a way as to interfere with the turning of the shaft'; some reported that the strain had opened up a web frame and allowed water to enter the ship aft, and that the pumps ran continuously to keep ahead of the seepage. In the engine room, the now useless prop was disconnected from the system, and within an hour the ship proceeded under her starboard high-pressure and port low-pressure props only. She finally made New York safely and landed her shaken passengers. Captain Pritchard, having just lost his wife, was unusually quiet; Cunard's New York agent, Vernon H. Brown, denied any leakage in the stern, and denied any injuries in the incident; divers were sent below to examine the area in question.[23] The liner limped back to Liverpool at 18.72 knots – her slowest passage yet, and a miserable record that would stand until 1920. Upon arrival, she was immediately dry-docked.

A thorough inspection of the hull was made and reportedly found it 'entirely sound'. A new propeller – of a similar design to the prop fitted in May – was installed to replace the newly damaged one, yet the port high-pressure propeller remained inoperable pending repairs to the stern bracket.[24] She made one more round-trip voyage on three props, averaging only 22.04 knots west-bound, and

This early view was taken from the roof of the Second Class Lounge on the Sun Deck level, looking forward. Visible through the rails is the open end of the First Class Verandah Café. (Jonathan Smith Collection)

Opposite: Passengers enjoy fine weather in this early view on the liner's fantail. (Jonathan Smith Collection)

22.33 knots east-bound. Then she once again found her way into the Canada graving dock. She received a full winter overhaul, thorough hull cleaning, new propellers, a new shaft on her port high-pressure propeller and repairs to the damaged stern bracket. About 2,000 men were engaged in the effort. Her outboard, high-pressure shafts now sported new single-cast four-bladed props. Aft, three-bladed props of a design like her original set were employed.

When the liner left on her first voyage after the refit, on 24 January 1909, she showed the merits of these new screws, making over 25 knots on the trip to Queenstown and putting up a 26-knot burst outside Queenstown. When he reached New York, Captain Pritchard said he was expecting to 'clip a few records' on the way back to England. The *Mauretania* did so with abandon, averaging 25.20 knots to Queenstown and beating the best standing time of the *Lusitania* by 0.15 knots. From there she continued to work up her records until her west-bound best stood at 25.84 knots and her east-bound best stood at 25.89. The *Washington Herald* joked that some passengers would 'hardly be surprised if they meet themselves coming back the other way sooner or later'.[25] In July, another newspaper writer jocularly asked if the *Mauretania* had ever made a trip across without breaking her own record.[26]

The *Lusitania* continued to threaten the *Mauretania*'s records, however. When *Lusitania* arrived at the Ambrose Channel Lightship at 4.42 p.m. on 2 September 1909, she took the west-bound prize with an average of 25.85 knots. But when the *Mauretania* arrived in New York at 4.50 p.m. on 9 September, she had crossed at an average of 25.87 knots, and her next west-bound voyage turned in an average of 26.06 knots. West-bound in September 1910, under the temporary command of Captain Daniel Dow,[27] the liner again averaged 26.06 knots, but shaved ten minutes off the trip. It was a record that would stand for nearly nineteen years. While she was always nipping at the *Mauretania*'s heels, from 9 September 1909 the *Lusitania* was unable to take back the *Mauretania*'s records for an average crossing.

While the *Mauretania* ended up holding the records for best average speed from September 1909 on, it has often been said that during their concurrent service, the *Lusitania* was the more popular of the sisters. Although both ships were without a doubt highly successful commercial ventures, a close study of the actual number of passengers carried by the two liners shows the *Mauretania* carried both more passengers during the time of their concurrent service and had a higher average passenger list per crossing.[28]

During the course of her early career, the *Mauretania* had many adventures. At about 10.30 p.m. on the night of 2 September 1910, while east-bound, she stopped to rescue sixteen survivors from the wreck of the steamship *West Point*. The survivors, divided between two boats, had been adrift for six days and had eventually become separated. The steamship *Devonian* rescued the survivors from the second boat. Despite their ordeal, the men had managed to preserve a Persian kitten – one of two given to the *West Point*'s captain by his wife. The kitten was sold at auction to one of the *Mauretania*'s first-class passengers, adding $100 to the subscription of financial assistance taken up for the survivors by the liner's passengers. The purchaser gave the furry sailor to his daughter as a gift. The other kitten was picked up from the second lifeboat by the *Devonian*, but it never gained the notoriety of the kitten rescued by the world's largest and fastest ship.

On 23 September 1908, the *Mauretania* was about to sail from New York when a visitor went over the rail and fell 60ft into the water below; a fireman at a rail below saw the man fall past him and immediately leaped in after him. The fireman kept the man afloat while a sailor lowered himself down a rope into the water and helped pull him to safety.[29]

On 13 December 1907, there was an incident that actually threatened the safety of the ship. While in Liverpool between her first and second round trips, the liner was moved from anchorage at the Cunard buoy in the Sloyne to an anchorage in the Mersey. After anchoring, the weather deteriorated suddenly, with a squall pushing the liner's stern toward the river's east bank while the ebb tide pushed her bow the other way. The result was predictable, and the stern had soon grounded. As the tide continued to fall she listed over to port ominously. Her hull held, though, and when the next tide peaked she was re-floated and moved to a new anchorage.

Right: The port side of the First Class Promenade Deck, looking forward, while the liner is at sea. Passengers are dressed warmly, sporting full winter coats, and many are wrapped snugly in steamer rugs as well. (Steven B. Anderson Collection)

Opposite: A 1908 photograph of a passenger standing beside one of the ship's funnels. (Tad G. Fitch Collection)

Then the storm increased its force; soon the liner was dragging both anchors down the Mersey. Her engines were started and during the morning she was forced to steam continuously in the river, just to maintain a safe position, until she was finally able to tie up at the Prince's Landing Stage. Her next departure was postponed for twenty-four hours while divers inspected the hull; with no damage evident, she sailed without further delay.[30]

A similar incident played out on the night of 6 December 1911. The ship's engines were without steam, her furnaces closed down, when a strong storm came up. She snapped her anchor chain and was carried haplessly upriver by the winds and tide. She nearly collided with the training ships *Conway* and *Indefatigable* before running ashore in the mud near the Herculaneum Dock. The tide was then falling, and without engine power at her disposal, all attempts to re-float her had to be abandoned until the next morning. Then, with the assistance of six tugs, she was finally freed. Although the ship was said to be 'practically undamaged', her next voyage was cancelled and the *Lusitania* made her sailing. The *Mauretania* put into the Canada Graving Dock and over 600 men were put to work replacing about eighty hull plates. She did not leave the dry dock until 13 February 1912, and resumed service on 2 March.[31]

Cunard was always interested in seeing how it could improve service for its passengers. It decided to have the *Lusitania* and *Mauretania* begin using Fishguard, Wales, as a port of call east-bound; this would allow passengers to start overland for England directly while the liner called at Cherbourg and finally docked at Liverpool. The *Mauretania* inaugurated this stop on 30 August 1909; the day was declared a public holiday and the entire town turned out to watch the liner arrive. Speeding in from New York, she dropped anchor at 1.17 p.m., transferred mail and passengers, and was able to depart by precisely 2.00 p.m. The disembarking passengers saved about five hours in reaching London.[32]

At the end of that same year, the *Mauretania*'s first commander, Captain Pritchard, retired from the sea to marry and settle down with his new bride in Wales. While the liner was being overhauled in dry dock that winter, a group of men were bringing in a heavy steel plate for the ship's hull; just then a tidal chain snapped, setting all of the mooring lines 'attaching the ship to the quay in a state of dangerous commotion'. Five men were knocked over and one was killed instantly.[33] When the ship resumed her schedule on 29 January 1910, Captain William Thomas Turner, former commander of the *Lusitania*, took the *Mauretania*'s reins.

In August 1910, the *Mauretania* arrived in New York after 'a vacation in Liverpool'. During a stay in the Huskisson Dock in Liverpool, new cabins had been installed on E Deck to accommodate extra first-class passengers. Similar alterations were carried out on the *Lusitania*, reflecting the fact that the first-class accommodations on the two steamers were incredibly popular, and were full or overbooked on many crossings during the peak months.

Earlier that year, on 20 February 1910, there was a terrific gale which swept over the British Isles and did a great deal of damage; transatlantic traffic reported encountering severe weather at sea. That day, the *Mauretania* nosed out of Queenstown harbour west-bound, and by the next day, rumours were circulating that she had suffered a serious accident. The rumours seemed to originate in Berlin and quickly spread throughout Europe and America. However, in the afternoon of 22 February, the liner made wireless contact with Brow Head, Ireland. She was then 304 miles west of Queenstown, and reported that all was well and that the weather was improving.[34] Afterward she encountered a second storm; Captain Turner said the gales were worse than anything he had ever seen in his entire career as a seaman, and the ship suffered some superficial damage.[35]

More excitement came on the morning of 4 September 1911. As the ship steamed west for New York through rough seas carrying 1,802 passengers, she was hit by a 'good sized wave'

Also taken in 1908, this passenger poses atop the Stern Docking Bridge during a layover in New York. (Tad G. Fitch Collection)

that gave the ship 'a cuff' and 'made her reel'. She had not yet recovered when she was struck by a massive rogue, or 'accumulative' wave – one of the terrors of seamen even today. It was said that water splashed right up to her funnels and 'broke some glass in the wheelhouse'. Yet the liner pounded through, and fortunately no one was injured, a testament to her strength of construction.[36]

Winter months also proved busy at times. On 2 December 1910, the Cunard offices in New York received instructions from headquarters in Liverpool that left them 'perturbed'.[37] The *Mauretania* was to leave New York for Liverpool by 6.00 p.m. on 17 December. However, the ship was only due to arrive there two nights before, and that arrival could easily be delayed by bad December weather. A best-case scenario was that in less than forty-four hours, all arriving passengers, mails and cargo would have to be disembarked and the crew would have to re-coal and re-provision the ship and then embark a fresh batch of 2,000 passengers, Christmas mails, and east-bound cargo. The task typically averaged five days. It was an unprecedented demand.

The ship started her west-bound passage to New York as scheduled on 10 December. The North Atlantic did everything it could to slow her down; Captain Turner reported that she met 'fierce head seas and gales' and that he was 'shipping crests over the bows' as he tried to make time.[38] The liner docked in New York several hours late, managing to average only 23.94 knots on the crossing. She didn't put the first gangway to dock until 4.41 a.m. on 16 December. Her sides 'were incrusted with thick ice and a glistening coat of frost covered her decks and railings'. She also showed scars of her battle with the sea, having lost a section of teak rail on the Promenade Deck, and suffering some bent bulwarks and a smashed window in the wheelhouse.[39]

The coal loaders, crew and longshoremen immediately tore into their work under the supervision of Captain D.J. Roberts, marine superintendent of the Cunard Line. Incredibly, in just twenty working hours, less than thirty-six hours in port and six hours ahead of schedule, the ship was ready to sail. In that time, 5,300 tons of coal had been loaded, 1,000 tons of express freight had been unloaded and a similar amount loaded back aboard, and 50,000–60,000 pieces of laundry had been sent out to local laundering services and returned. Of the crew, Captain Turner alone was able to get any rest during her turnaround – but it was well deserved after his sleep-deprived crossing. Several hours after docking, he was spotted resting on a couch in his cabin, his face looking like 'the proverbial broiled lobster' as he had faced 'the stinging north wind' on the Bridge all the way across until the ship had tied up. When a reporter commented on how uncomfortable it must be, Turner replied tersely: 'Yes, dammit, it was so tough that I can't shave this morning.'[40]

Captain Turner did not generally have much use for reporters, but during that turnaround he did allow one of the few female reporters of the day, Ethel Lloyd Patterson, to interview him in his cabin below the Bridge. He regaled her with his sea stories as he simultaneously plied her with tea and cake. He took the opportunity to do a couple of chin-ups on his 'gymnasium trapeze', which swung from his bathroom ceiling, 'just to prove he could'. Their conversation continued for some minutes, during which time Ms Patterson concluded that Turner was 'canny as a Scotchman'. Quite abruptly, though, it seems that she had asked one too many questions, and suddenly Turner cut her off. 'My dear young lady, I caused five young men representing five different newspapers to make a hasty exit from this same room only a few hours ago. I have been feeding you tea and cake so you could not ask so many questions. I never talk for publication. I do not like it. Now have I not been—?'

'You have, indeed,' Ms. Patterson replied warmly, and the two shook their hands on it before she departed.[41]

Sailing time arrived with startling quickness. At 5.58 p.m. on 17 December, the last visitor, Cunard's local manager Charles Sumner, stepped ashore. He told Superintendent Roberts: 'Let her go.'

'Aye, aye, sir,' Roberts replied. He then signalled Captain Turner, who was on the Bridge wing. Turner told the quartermaster to pull the whistle-cord and the crewman replied by tying down the lanyard; *Mauretania* blew her whistle continuously as she began to back smoothly out of the dock. Some 2,500 spectators had thronged the pier to watch her depart, and they cheered wildly, but the 'prolonged roar of the ship's whistle drowned the din into oblivion'. The scene was one to remember:

The moon and the arc lamps gave just enough subdued light to bring out dimly all the color in the massive red and black funnels, and the white trimmings of the superstructure appeared in plain blue. The escaping steam from the copper whistles behind each of the four funnels shot upward, showing that there was little or no breeze on the river.

This passenger appears to be enjoying his time on deck while the ship is docked in New York. Behind him, progress is seen on the construction of the new Chelsea piers. (Tad G. Fitch Collection)

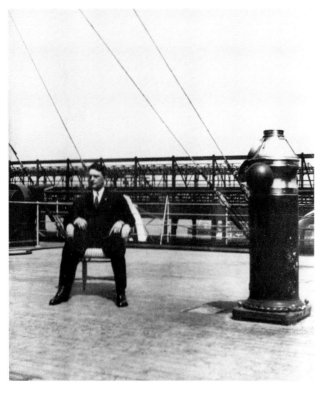

'Great Scott!' one spectator shouted. 'When is the end of that ship going to come out of the dock? There's a mile of it passed out already, and we haven't come to the after funnel yet.' With the aid of three tugs, the liner eventually cleared the dock and turned so her bow was pointed south. Captain Turner started the liner forward, where she was saluted by a noisy whistle and replied with three short blasts. Then 'the *Mauretania* vanished southward into the night.'[42]

She averaged 25.07 knots east-bound and arrived in Fishguard Harbour at 10.22 p.m. on 22 December amid 'the blowing of sirens, firing of rockets, and general activity and excitement'. Her time for the round-trip from Liverpool to New York, and thence to Fishguard, was a record-breaking twelve days, four hours and thirty-nine minutes.[43] When she arrived back at Liverpool the next day, she was greeted by a 'chorus of steam sirens'. Her stokers' band appeared on the aft deck with their makeshift instruments and gave 'a most amusing performance' as the liner tied up at the stage.[44]

From 1907 to 1911, the two 'Cunard flyers', as they were frequently referred to, were wholly unchallenged for supremacy. They criss-crossed the Atlantic filled with the world's most famous people – stars of the theatre, politicians

This early 1909 photo shows the *Mauretania* docked at the nearly complete Pier 56. (Author's Collection)

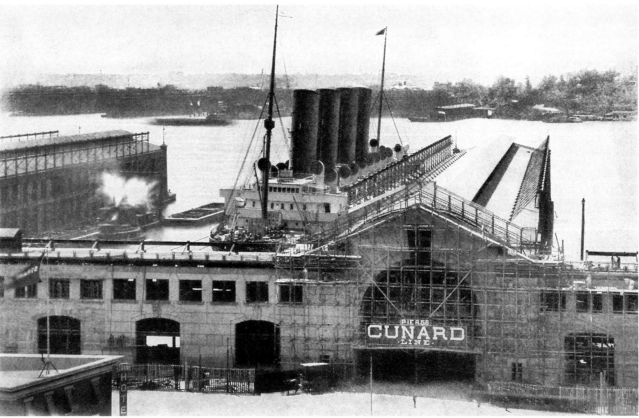

and wealthy socialites from Europe, Canada and America. Anyone who was anyone travelled on the *Mauretania* and her sister. They dined and danced and listened to ship-board concerts, willing the great Cunarders to break a new record, and eagerly betting in the ship's pool on what mileage their ship would post the next day. However, the supremacy of the sisters could not remain unchallenged forever.

In 1911, the White Star Line's new behemoth *Olympic* entered service. Her gross tonnage, or internal volume, was roughly 50 per cent greater than the *Mauretania*'s; she was more spacious, and arguably had more luxurious and comfortable amenities ... but she was not faster. Instead she, and her younger sister *Titanic*, which would enter service in early 1912, would be content to make moderate speeds carrying very comfortable passengers. They would rely on *luxe* to make them stand out from the Cunarders.

Just before the *Olympic* entered service, the *Mauretania* made a west-bound crossing to New York with 1,615 passengers. At about 3.30 in the morning on Wednesday 7 June, she sped past 'an iceberg which was longer than the liner and towered sixty feet above the water'; she kept a distance of about 4 miles. 'Under a clear, bright moon, the berg made a splendid show for the few persons who chanced to be awake,' Captain Turner later said.[45]

In February 1912, the Cunard Line began sailing their fastest liners out of New York at 1.00 a.m. on Wednesdays, again trying to make for a more convenient arrival time for passengers in English ports. This led to a new Tuesday routine for many of *Mauretania*'s first-class passengers. They would enjoy an afternoon and evening in New York City, at the opera or a social event, board the ship late wearing evening attire and partake of a buffet meal before the ship sailed. By morning, when they finally roused themselves from their slumber, they found that they were already well out to sea.[46]

On 24 March 1912, the *Mauretania* called at Queenstown to pick up passengers and mail, but due to heavy weather had to sail for New York without making any actual transfers. Some 132 booked passengers were left behind. When she returned to England, landing her passengers on 8 April, it was said that the weather had been unusually fine, with the ocean like 'a mill pond'.[47] The new White Star liner *Titanic*, sister of the *Olympic*, sailed from Southampton on her maiden voyage on 10 April. She found the weather in Queenstown quite fine when she called there the next morning. She also found that the Atlantic was very much a 'mill pond' through most of her voyage toward New York –

particularly on the evening of Sunday 14 April, when the sea was noted to be as smooth as glass.

On that Sunday, the *Mauretania* sailed from Liverpool, also bound for New York. Among her passengers were Cunard chairman Alfred A. Booth and at least five people who had planned to sail with the *Titanic* but had changed their plans due to various circumstances. By that evening, the voyage was already proving a bleak one, for a second-class passenger had leaped into the sea from the ship's rail. Although the liner stopped and a boat was sent out to search for him, he was not found and eventually the voyage had to be resumed. That same night, the *Titanic* ran afoul of an iceberg. She was seriously damaged and sank two hours and forty minutes later, taking 1,496 passengers and crew to their deaths.

News of the disaster reached the Cunarder on Monday night, but the news was withheld from passengers until two days later. When word was finally released, it was as if a pall had been cast over the whole ship. On 18 April, the *Mauretania*'s wireless sent the following message: 'The saloon passengers of the *Mauretania* desire to express their profound sympathy with the relatives of those who perished in the terrible *Titanic* disaster; also with the White Star Line. The second cabin passengers have passed similar resolutions. The collections for the seamen's charity are £175; no concerts; band silent.'[48] Warned of the iceberg hazards, the *Mauretania* steamed a southerly course; even so, she passed just four miles south of 'an iceberg of medium size'. She arrived in New York with her ensign flying at half-mast.[49] She also brought with her, in among her registered mail, a duplicate of the *Titanic*'s cargo manifest.[50]

The *Titanic* had carried enough lifeboats for only 1,198 of the 2,208 who had been aboard her, and had only been two-thirds booked. Although the speed with which the ship sank meant that her crew was only able to launch eighteen of her twenty boats and were forced to float two off the ship as she went under, the disaster shed light on the outdated lifeboat regulations. At the time, both the *Mauretania* and *Lusitania* were suffering from a similar lack of lifeboats. The public suddenly clamoured for lifeboats for everyone on all ships, and after two formal enquiries into the sinking – one American and one British – the regulations were updated to ensure adequate lifeboat capacity.

Steamship companies did not wait for regulations to be changed, however. Passengers booked on the *Mauretania*'s next east-bound crossing were anxious to ensure that there would be a seat in a lifeboat for them should the need arise.

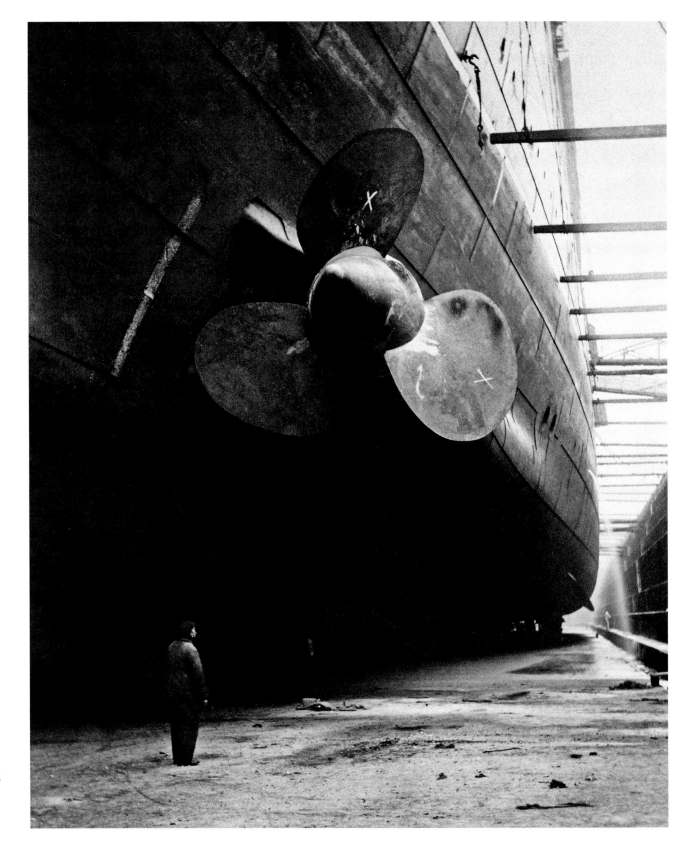

This is the first of a series of six photographs taken during the liner's dry-docking, which ended in February of 1909. This photo shows the forward starboard high-pressure propeller, which was initially installed in May 1908 and is of a markedly different design from her original props. (Beamish Museum)

One woman, booked into an expensive first-class cabin, called Cunard's New York offices and asked for assurances as to the number of lifeboats the steamship had and whether they were 'sufficient in number to keep all the passengers and crew afloat at one time'. The clerk was forced to admit that there were not, whereupon the woman told him that she was considering cancelling passage. He replied politely that he would 'consider it a favor' if she would let him know promptly 'as there were scores of persons anxious to get the room.'[51]

Behind the scenes, Cunard officials were scrambling to find more lifeboats for the *Mauretania* before her next departure, yet they had difficulty finding enough. Charles P. Sumner complained to reporters: 'I can't get enough lifeboats. I am ready to purchase all I can get. After hard work I have managed to get nine lifeboats, eight metallic and one wood. Only seven are ready for the ship. When the *Mauretania* reaches England she will be completely fitted out with lifeboats, as will every other boat in our service.' He added: 'We consider the *Mauretania* one of the safest boats in the world. She has 175 watertight compartments and was built under the supervision of the British Admiralty as a reserve cruiser.' When asked if any passengers had cancelled passage, Sumner admitted that several had; he hastily added that for every cancellation someone else had booked in their place.

In the end, eight new lifeboats were fitted before she departed; this was supplemented with seven life rafts. While the total lifesaving capacity was still far short of the estimated number of souls she was about to carry, it was much better than the 976-person capacity of her original sixteen boats. Yet no provision to launch these boats was made; the new boats were held in temporary chocks installed hastily about the decks wherever room could be found. The rafts were stacked up astern.[52] When the ship actually sailed on 24 April, she carried 2,200 souls, including about 150 passengers who had been booked to sail on the *Titanic*'s first east-bound crossing.[53]

Before leaving, Captain Turner stated to reporters: 'It remains an undisputable fact that large vessels are superior to smaller craft. No vessel is unsinkable but the big ship is stronger than the little one and keeps afloat longer after a collision. This gives them time to get the lifeboats off and to do the utmost possible for the passengers.' He then took time to commend the *Titanic*'s officers, saying that they had 'displayed the highest efficiency in the face of a great emergency. They deserve great commendation for preventing any panic on board. Some persons were drowned who might have been saved, but, on the other hand, a panic among the passengers or a stampede for the boats would have caused terrible consequences.'[54]

As she left dock at 1.05 a.m., *Mauretania* struck the pier, damaging her bridge wing rail and the pier itself but causing no injuries. Despite this inauspicious start, Captain Turner safely navigated the ship along the new southern course in order to avoid the ice entirely, and docked safely in Liverpool after averaging 24.54 knots across the Atlantic – a much higher speed than *Titanic* had been steaming when she struck the iceberg. In Liverpool, further lifeboats were added, until *Mauretania*'s Boat Deck was 'covered with lifeboats and rafts, making deck golf impossible.'[55]

Her next east-bound departure from New York came at 1.00 a.m. on 22 May. When she cast off, the weather was fine and the water 'still as a mirror'. On the second night out, ice warnings were telegraphed to Captain Turner, and he took the extra precaution of taking the liner some 50 miles further to the south to avoid them.[56] However, many potential passengers were still nervous about the risk from icebergs.

On 29 May, Cunard's Board of Directors met and decided to create a new position among the senior officers of the *Lusitania* and *Mauretania*: that of the staff captain. The men appointed to this position were full-fledged masters of other vessels, and would be second only in authority to the captain himself. Their primary responsibilities would include ensuring the safety of passengers by holding regular lifeboat drills, and seeing to the discipline and efficiency of the ship's crew. Captain Samuel 'Sandy' G.S. McNeil (R.D., R.N.R.), master of the *Albania* and former chief officer of the *Lusitania*, received a letter dated 30 May, appointing him to this position aboard the *Mauretania*. The appointment was immediate, and he was aboard when the ship left Liverpool on 1 June. On the *Mauretania*'s first arrival in New York, McNeil got right to work, and held lifeboat-rowing races for the crew in the North River.

Cunard's very public efforts to assure passengers of their liners' safety seemed to be highly rewarded. In the wake of the *Titanic* disaster, some had steered clear of ships like the *Olympic*. But throughout the summer, the *Mauretania*'s passenger lists remained healthy and, at times, overcrowded.

And yet, while steaming toward New York on Tuesday 16 July, there came another iceberg scare. The ship was then not far from where the *Titanic* had sunk, and a warning came in from the White Star liner *Adriatic* of at least one large iceberg – estimated to be some 800ft long and 200ft high –

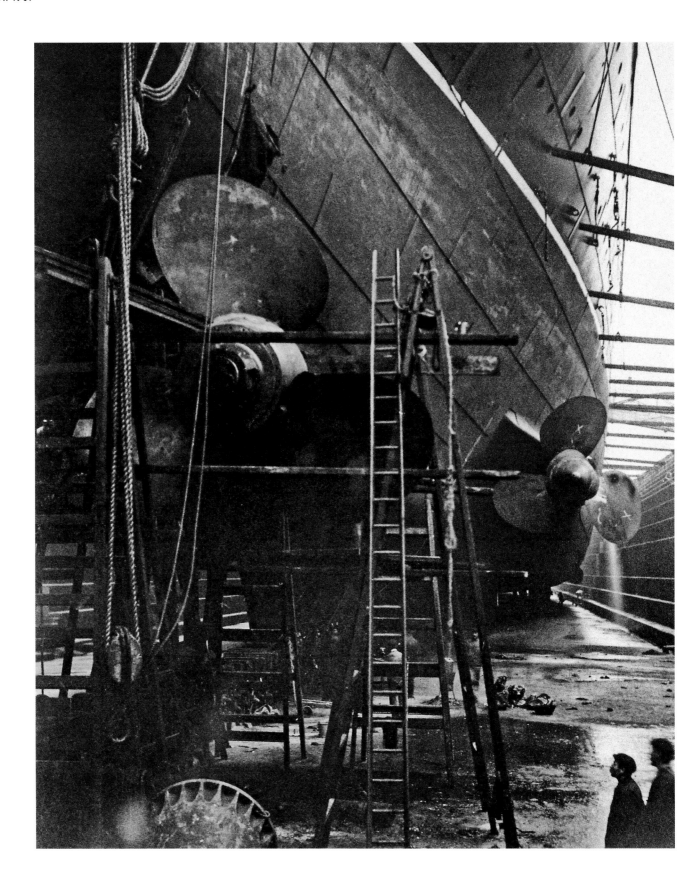

This photograph shows that both starboard props had been replaced during 1908. In this view, the aft propeller is being prepared for removal. (Beamish Museum)

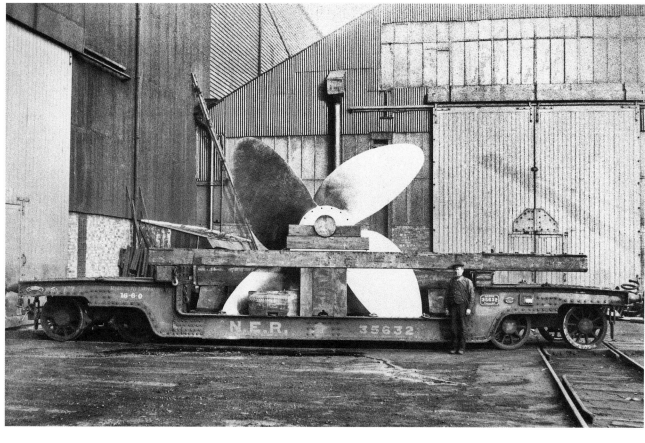

One of the new four-bladed, single-cast propellers destined for installation on the liner's forward shafts. (Beamish Museum)

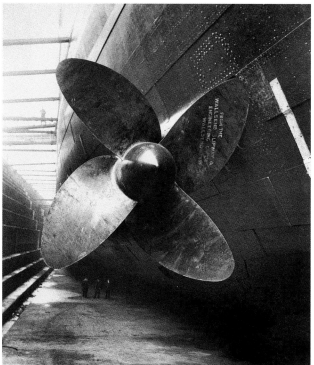

in the vicinity. The weather was 'clear but dark', with much starlight, and at about 11.30 p.m. there was a sharp drop in temperature as the *Mauretania* approached the reported position. Captain Turner took no chances, reducing speed to half, and then again to only 10 knots, while trebling his lookouts. The lookouts kept a close eye, but never spied the berg, even though it was estimated that they had passed within 5 miles of it.[57]

Because of the longer southern course the *Mauretania* was forced to take that summer, in June the Cunard Line pushed back her 1.00 a.m. Wednesday sailing times from New York to 5.00 p.m. on Tuesday evenings. This would ensure that passengers still reached London before late the following Monday night.[58] However, the 24 July departure from New York saw a resumption of the 1.00 a.m. departure time. It was also a very special evening for two wealthy first-class passengers: Colonel E. Alexander Montgomery and Antoinette M. Schwarz. The pair were married in 'one of the larger staterooms', likely a reference to one of the Regal Suites.[59] Captain Turner did not personally officiate; instead a New York minister presided. The reception, which included

The port high-pressure four-bladed propeller in place. (Beamish Museum)

73

nine guests, lasted until midnight and the calls of 'all ashore'.[60] The couple were to honeymoon in Europe for the remainder of the summer, not returning until September.

In the early morning of 9 December 1912, rumour of a serious 'accident' to the *Mauretania* spread like wildfire through London and Liverpool, and was even cabled to America; the report had been published in a German newspaper, starting very much the same way as the February 1910 rumours. With the *Titanic* incident still fresh in the minds of many, Cunard offices were 'inundated with inquiries' from 'all parts of the world' by anxious relatives of passengers. By noon, however, the *Mauretania* wirelessed Queenstown reporting 'all well', and laying the reports to rest.[61]

Very shortly thereafter, the liner's strength was truly put to the test during another west-bound voyage. On Tuesday 4 February 1913, she encountered a gale with 100mph winds and mountainous seas. Nearly all of the passengers were ill with *mal de mer*, and the wind shrieked through the rigging outside. Then, the liner's bow crested one enormous wave, while the wave behind unexpectedly lifted her stern on its crest. 'The trough fell away until her amidships were almost clear of the water.'

This scenario was one that ship designers planned for on the drawing boards but which had rarely, if ever, been borne by a large liner. Yet her hull bore the strain like the pro that she was, and she slid over the crest and into the next trough safely. Before she could right herself, the next wave crashed down on her bows. It pounded into the Bridge, 'smashing every bit of glass in the wheelhouse' – even though each pane was a half-inch thick – and twisted their frames out of kilter before sweeping the decks clear of 'everything that was not bolted in place'. In crashing into the overhang of the Bridge, the wave even managed to disable the telegraphs that controlled the engines as well as some of the electrical controls; for some time, the only means of communication between the Bridge and the rest of the ship was via speaking tube. The bulwarks of the Promenade Deck were bent in, several stateroom ports were smashed, the wireless was disabled, exterior electric lights were torn off and lifeboats were loosened from their mounts. George B. Hunter was aboard for the ordeal. He later told reporters:

I did not believe the ocean, no matter what her mood, could throw a ship the size of this about the way it did Tuesday night. After we had been tossed about for hours as if we were a yacht I began to have a great respect for the ship, for it seemed that nothing that human hands constructed could have withstood the hammering we got. We were afloat while the seas poured over us and tore away everything that was not fastened down.

We slowed down for thirteen hours on Tuesday, while the ship spun around and around like a crazy horse. The navigation of Captain Turner was splendid. I dread to think of what would have happened had there been a less experienced man in command. There has always been a question in my mind as to what a big ship would do when balanced on the crests of two waves. I found out this time. She was not strained in the least. Not a bolt or a rivet was found to be loose.[62]

Her average speed for the entire crossing was a flat 21 knots, her second-worst average speed in either direction since entering service. At the end of March, she hit another gale with 100mph winds. Only one first-class passenger was in attendance in the Dining Saloon on the worst day of the ordeal: it was 17-year-old Marguerite Skirvin, 'a charming little actress and dancer' whose equilibrium seemed wholly impervious to the ship's gyrations.[63]

Perhaps the pinnacle of the *Mauretania*'s career came in July 1913. At the time, the port of Liverpool was trying desperately to keep up with the port of Southampton, which had more favourable tide conditions and docks. The White Star Line had already moved its primary English terminus there in 1907, and there were rumours that Cunard was going to follow suit. To help increase Liverpool's appeal, the new Gladstone Graving Dock was built as part of an ongoing series of dock improvements. In August 1912, it was announced that the *Lusitania* would officially open the dock, but those plans went by the board when the *Lusitania* was laid up for eight months of repair work to her turbines. In her place, the *Mauretania* was to take up a position of honour on the River Mersey for the gala event, which featured a royal visit.

On 11 July, King George V, Queen Mary and their son Prince Albert boarded the tender *Galatea* from the Prince's Landing Stage. They were to spend half an hour that sun-soaked afternoon inspecting a double line of 109 ships – cruisers, liners, training ships and yachts – which stretched for some 10 miles. Among the liners present were Canadian Pacific's *Empress of Ireland* and White Star's *Ceramic*. Yet the *Mauretania* was at the head of the line, and the royal party was scheduled to embark upon her for an hour's tour.

Opposite: Looking forward from the dock floor with the work complete, the ship now sports three-bladed props of a design similar to her original set; they are not new, as damage is visible on each one. The four-bladed props are just visible further forward. (Beamish Museum)

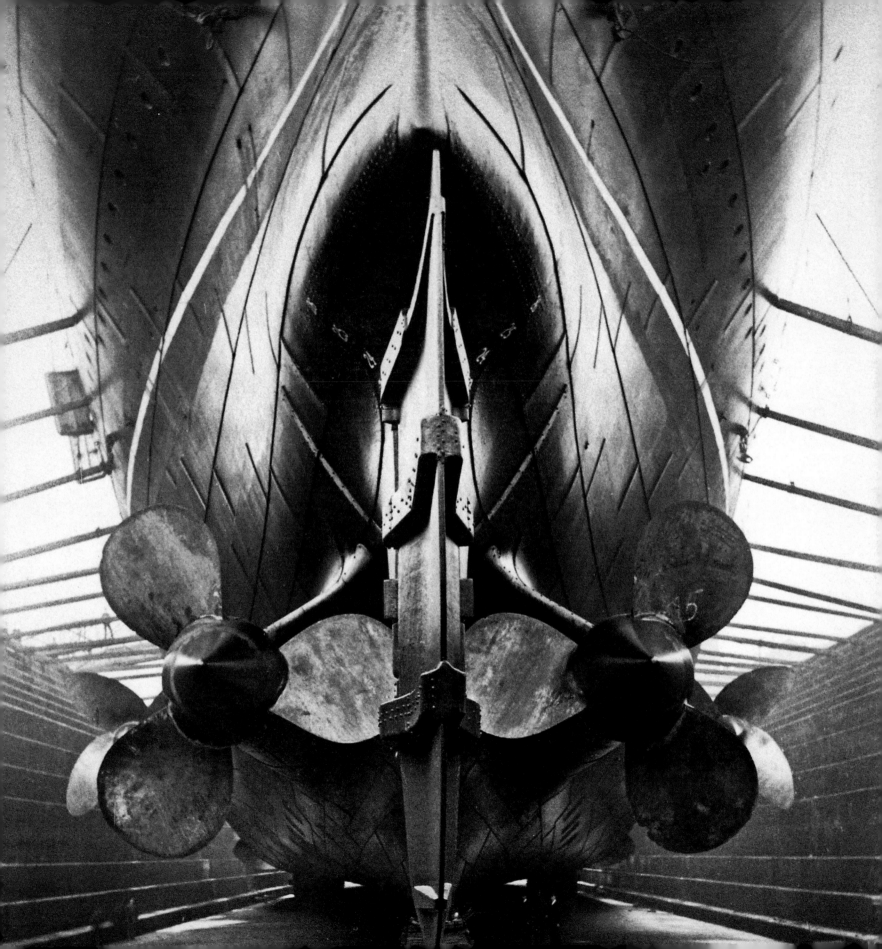

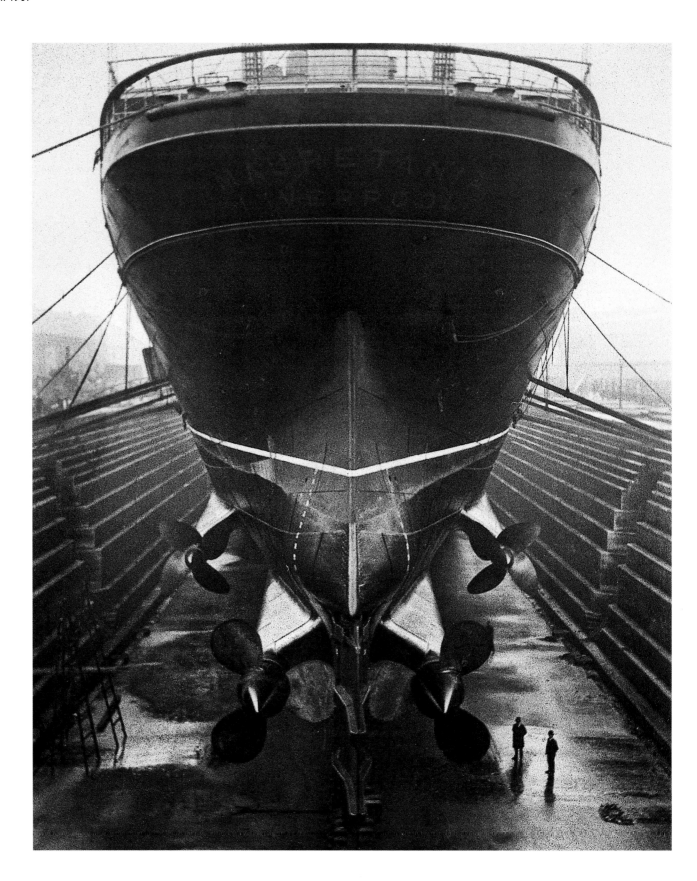

The new prop configuration,
as seen from above
(Beamish Museum)

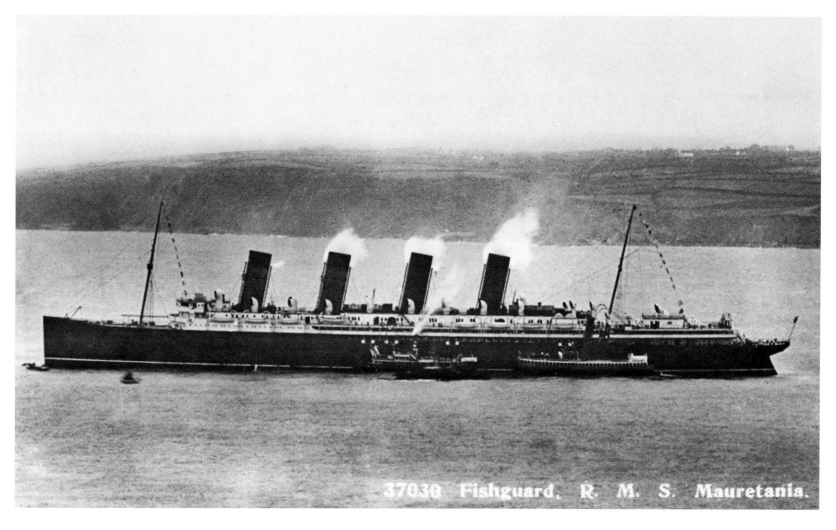

37030 Fishguard. R. M. S. Mauretania.

The ship was filled with pink roses, and the King and Queen toured staterooms, kitchens and steerage quarters, meeting Captain Turner and the senior officers, and even taking tea. Before leaving, they paused to speak with stewardess Annie Robinson, a survivor of the *Titanic* disaster the previous spring, and asked for her recollections of the disaster. Mrs Robinson first said, 'I try to forget all about it,' but managed to give some account of her experiences; it was said that she was 'greatly moved by the sympathy and tenderness of the Queen's interest'.[64]

After their tour, which had to be shortened to only half an hour,[65] the procession moved back to the *Galatea*. The tender entered the new graving dock at 4.30 p.m., breaking the ribbons placed across its entrance, then followed the usual pomp and circumstance of a royal salute, a band and choir which performed Elgar's *Land of Hope and Glory* and other pieces, and a royal inspection

of the Guard of Honour from the cruisers *Lancaster* and *Liverpool*. Then the King brought the proceedings to a crescendo by declaring the graving dock officially open. To commemorate the event, portraits of the King and Queen, bearing their royal signatures, were hung conspicuously in the *Mauretania*'s first-class entrance.

Over that spring and summer, the North Atlantic was growing more crowded. The *Olympic*, which had left service in October 1912 for a thorough refit after the *Titanic*'s loss, had re-entered service. The *Lusitania*, fresh from her turbine refit, resumed sailings in late August. Meanwhile, the new German Hamburg-American liner *Imperator* had made her maiden voyage in June. The three-funnelled floating palace was the largest ship in the world; her 52,117grt outsized the *Mauretania* by an easy 20,000 tons. She was magnificently appointed, with more space and luxe than anyone really knew what to do with; she had a strong pull on potential

The *Mauretania* makes her first stop at Fishguard, Wales, on 30 August 1909. (Jonathan Smith Collection)

This view of the *Mauretania* manoeuvring in Liverpool's docks was printed as a photo postcard. This particular copy was posted on 29 January 1910. At the liner's stern, canvas has been rigged along the rails of the Promenade Deck, an appearance that the ship would retain for many years. (Author's Collection)

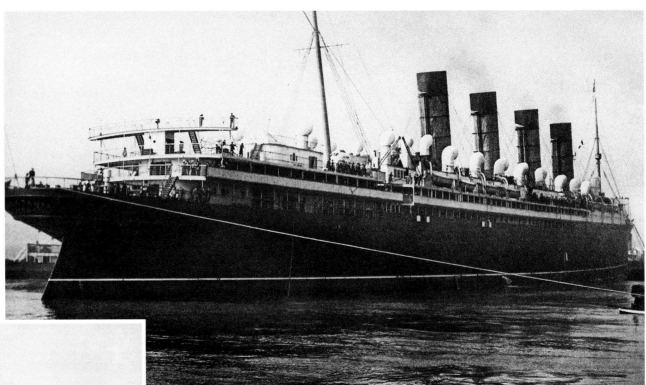

A fine portrait of the liner at the landing stage. It was printed as a postcard and posted on 9 August 1910. (Author's Collection)

passengers craving travel on the biggest and most luxurious ship. However, unlike the *Mauretania*, the grand *Imperator* proved somewhat disappointing as an actual ship. So many luxurious, if heavy, fixtures had been added to her upper decks that she tended to lean drunkenly over to one side or the other on a whim – particularly when arriving at port with her coal bunkers depleted. The *Mauretania* would have deemed such behaviour distinctly unladylike and thoroughly un-British. For her splendid sea-keeping qualities and uniquely British 'feel', she retained a fiercely loyal clientele. She also retained one 'best' that not even the enormous *Imperator* could lay claim to: the title of 'world's fastest ship'.

In late November 1913, more change was in the air. Captain Turner received orders that, after the end of the December round-trip voyage, he was to report to Clydebank. There he would oversee completion of the new Cunard liner *Aquitania*. Captain Charles, then *Lusitania*'s commander, would take Turner's place on the *Mauretania*, and Captain Daniel Dow would take Captain Charles's place on the *Lusitania*. Meanwhile, the *Mauretania* went into the Canada Dock for a much-needed overhaul.

On 26 January 1914, while thirty workmen were brazing turbine blades in the engine room, the cylinder containing the condensed gas exploded. Three men were killed instantly; a fourth was critically injured and seven others were seriously hurt. The critically injured worker later died of his injuries. The engine room was immediately plunged into darkness. The explosion shook the ship from stem to stern and was heard throughout north Liverpool. A cloud of steam began to seep from the ship's hatches, giving the impression that the ship was on fire. Fortunately, the damage to the liner was not severe despite the human carnage, and she was able to re-enter service on 7 March 1914.

On 12 and 13 March, the *Lusitania* – with her turbines freshly tuned up from her overhaul – tried to take the *Mauretania*'s speed records. While east-bound for Liverpool, she set a new record for a single day's steaming in that direction: 618 nautical miles at an average speed of 26.7 knots. This beat the *Mauretania*'s standing record of 614. However, the ship did not regain the Blue Riband by the time her voyage had finished and, although her crew was determined to do so, she did not take that prize during the next five months.

On 14 May, the new German liner *Vaterland*, larger sister of the *Imperator*, began her maiden voyage, and at the end of the month the *Mauretania*'s new running mate *Aquitania* entered service. Things were shaping up for a very busy season of transatlantic competition when, seemingly overnight, the world changed forever.

This photo was taken on 1 December 1910. The liner had just arrived from New York and has not yet left the landing stage. (Jonathan Smith Collection)

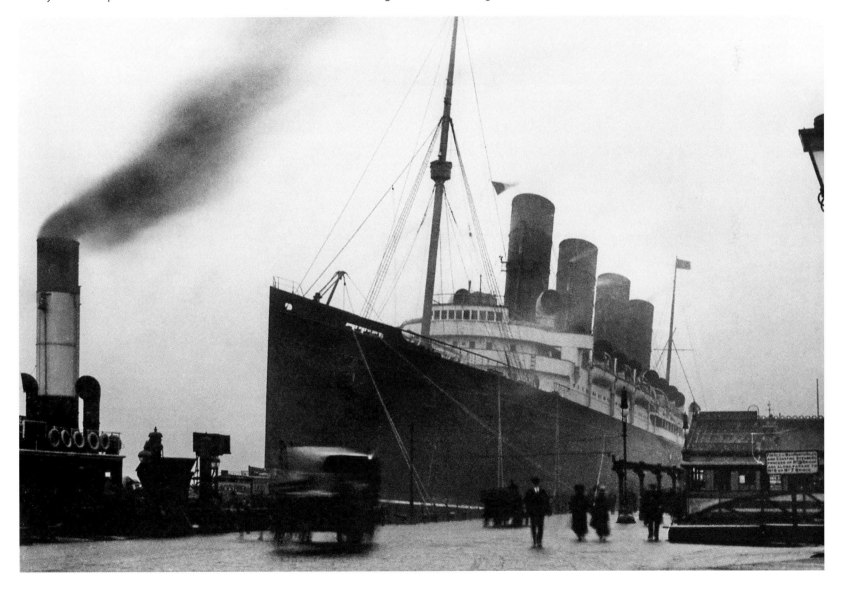

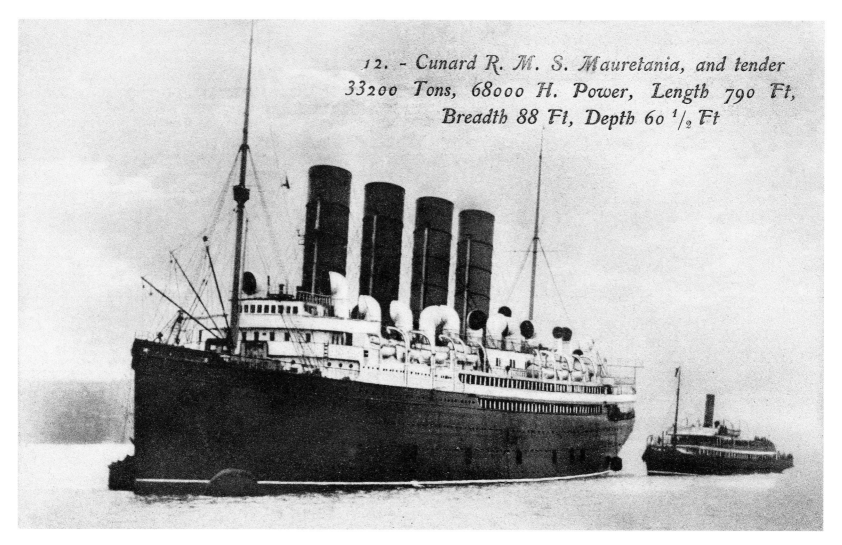

12. - Cunard R. M. S. Mauretania, and tender
33200 Tons, 68000 H. Power, Length 790 Ft,
Breadth 88 Ft, Depth 60 ¹/₂ Ft

This postcard of the liner gives her basic statistics and dimensions. Handwritten in pencil on the card is 'on its record breaking trip', alongside tatistics for her September 1910 record-breaking 26.06-knot voyage. It was a record she would not break for nearly two decades. (Author's Collection)

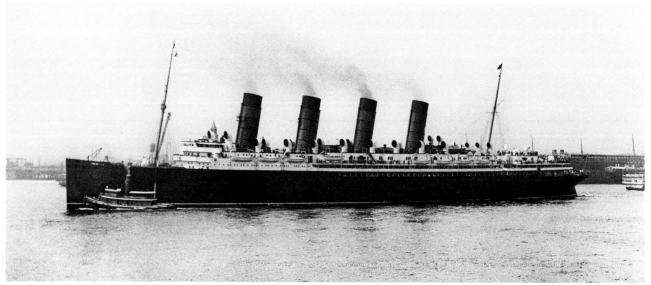

In this fine view, the *Mauretania* is seen leaving New York and turning her nose south into the Hudson River, her rails lined with passengers eager for a fine crossing. (Author's Collection)

Right: A 1912 or 1913 photo of the smokestacks shows the Marconi Shack atop the Sun Deck. (Ioannis Georgiou Collection)

Far right: In the wake of the *Titanic* disaster, it was very important for lifeboat drills and maintenance to be carried out publicly, to ease the nerves of anxious passengers who were suddenly in fear of coming to grief by an iceberg. This photo was taken as the liner departs New York. (Eric Sauder Collection)

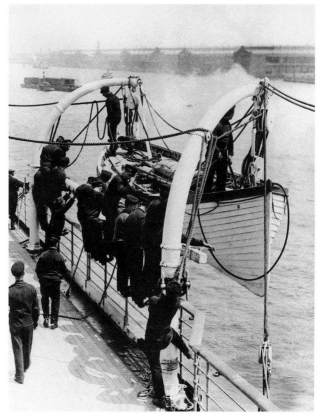

In the immediate aftermath of the *Titanic*'s sinking, extra lifeboats and life rafts were hastily placed aboard the *Mauretania*. In this late 1912 or early 1913 landing-stage photograph, new boats can be seen chocked to the First Class Boat Deck, while extra rafts are visible piled up on the Second Class Boat Deck astern. (Author's Collection)

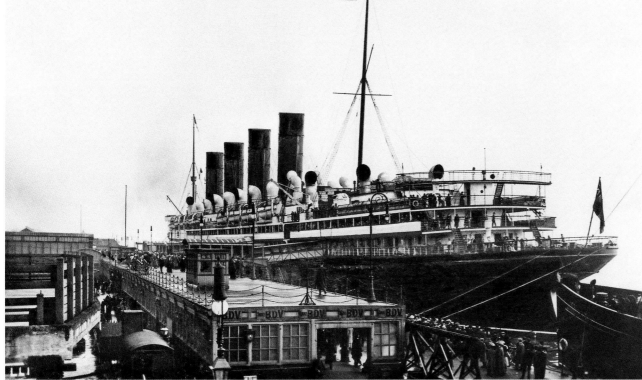

The royal yacht (near left) makes its way down the River Mersey. The *Mauretania* is visible at the right, with the gangway extended to receive the royal party. (Author's Collection)

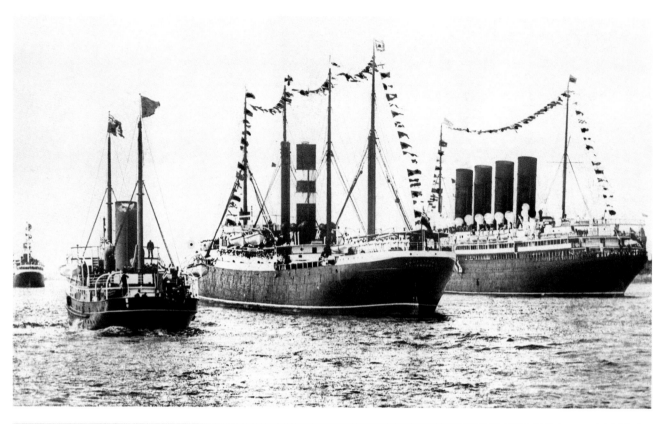

King George V, Queen Mary, Prince Albert and the rest of the royal party board via the port side gangplank. (Eric Sauder Collection)

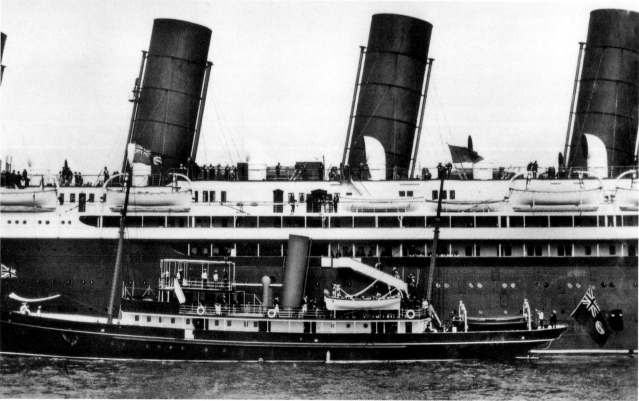

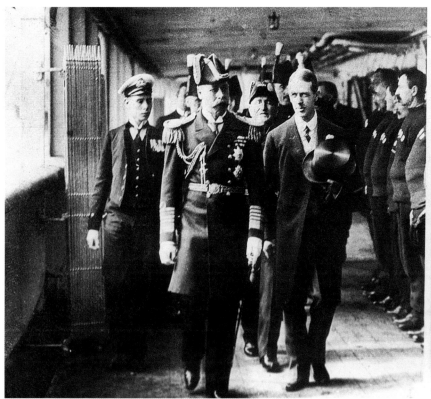

In this fine view, King George V passes a line of the *Mauretania*'s stokers on the Promenade Deck. (Eric Sauder Collection)

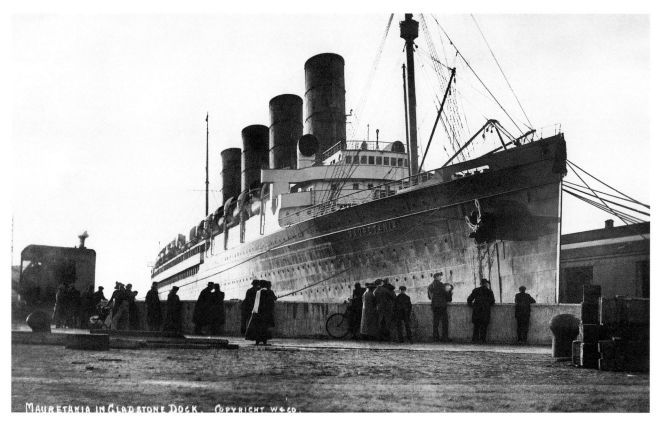

A 1913 photo of the *Mauretania* in the new Gladstone Dry Dock. (Ioannis Georgiou Collection)

A group of passengers poses beside a lifeboat on the First Class Boat Deck during 1913. (Mike Poirier Collection)

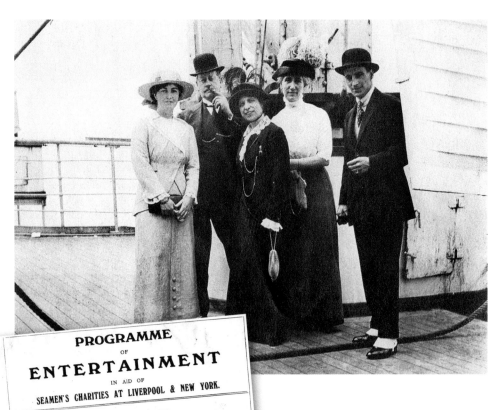

This programme is for the 10 July 1914 shipboard concert. Proceeds from these concerts were donated to various seamen's charities. Within days, all of Europe would be at war. (Mike Poirier Collection)

THE LIVERPOOL
Seamen's Orphan Institution.

WAS founded in 1869 to feed, clothe and educate the destitute or necessitous children of all classes of seamen or seafaring men. From that date to the 1st January, 1914, 8,223 children have received the benefits of the Institution, and many poor widows have been enabled to keep a roof over their heads, and their little ones from the workhouse; there are at present 1,056 children upon the books.

The benefits conferred are not restricted to any Nationality or Religious Creed, though children of seamen who have sailed five years out of the Port of Liverpool, have a preference.

A very large number of these Orphan children have lost their fathers by the perils of the sea in crossing the Atlantic, and conveying passengers and cargo to and from America. A still larger number of seamen die from diseases contracted by exposure to the weather, in all seasons and at all hours; and no more fitting tribute of gratitude can be shown to the Almighty hand, who brings the ship in safety to her journey's end, than by helping to support the children who are left fatherless by the necessities of the seamen's life.

The returns from the Board of Trade are appalling in their evidence of the loss of life at sea, for they show that in forty one years following the establishment of this Orphanage, no less than 160,612 seamen died in English ships abroad, of whom 104,231 were drowned. This number does not include those who die in the United Kingdom.

The Orphanage is open for the inspection of Visitors every day except Saturday and Sunday, from 2 till 4 p.m. Visitors who are in Liverpool on Sundays can have no greater treat than by attending the Children's Service at 11 a.m., or at 3-30 p.m., to which they are cordially invited. A card with visitor's name handed to the Verger will always command attention. The Green Lane and West Derby tramcars from the Pier Head or Lime Street pass within two minutes walk of the Chapel and Orphanage.

During the year 1913, 1,346 Children received the benefits of the Institution, of this number there were:—Children of

CAPTAINS, OFFICERS, ENGINEERS, PURSERS and PILOTS.	SEAMEN, including CARPENTERS and SAILMAKERS.	FIREMEN and COAL TRIMMERS.	STEWARDS, COOKS and BUTCHERS,
155	394	508	289

PROGRAMME
OF
ENTERTAINMENT
IN AID OF
SEAMEN'S CHARITIES AT LIVERPOOL & NEW YORK.

HELD ON BOARD THE
CUNARD R.M.S. "MAURETANIA"
By permission of CAPTAIN J. T. W. CHARLES, C.B., R.D., R.N.R.
ON FRIDAY EVENING, JULY 10th, 1914,
In the First Class Lounge, at 9 o'clock.

Chairman - - - DR. JOHN H. FINLEY

PART 1.

I—"MAURETANIA" ORCHESTRA	OVERTURE
II—MR. JOHN MARTIN	PIPER
III—MR. J. W. BOEHM	PIANOLOGUE
IV—MR. LEO CARRILLO	MONOLOGUE

CHAIRMAN'S ADDRESS. COLLECTION.

PART II.

V—MR. FRANK RICARD	VIOLIN
VI—MISS ELENOR B. DANFORTH	READING
VII—MR. PHILIP SPOONER	SONGS
VIII—MR. GEO. ANDERSON	COMIC SONG

"AMERICA." "GOD SAVE THE KING,"

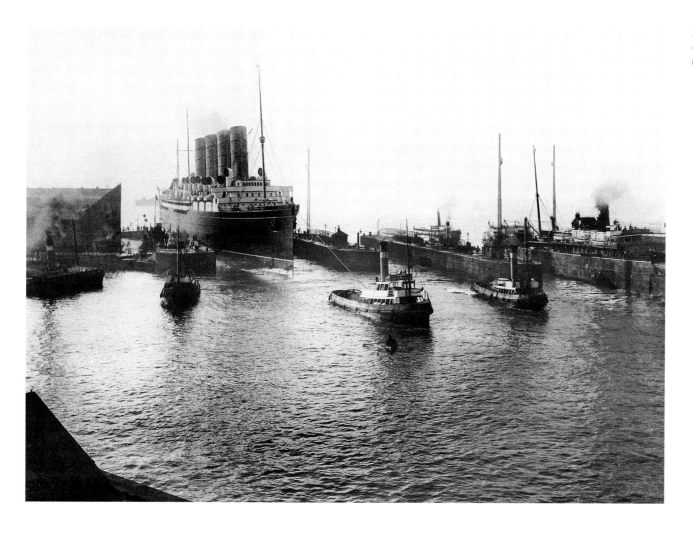

An early view of the *Mauretania* entering the docks at Liverpool. (Author's Collection)

NOTES

1 *New York Times*, 17/11/1907.

2 *New York Times*, 17/11/1907.

3 *Daily Mirror*, 18/11/1907.

4 *Daily Mirror*, 18/11/1907.

5 *Daily Mirror*, 20/11/1907.

6 *New York Times*, 21/11/1907.

7 *New York Times*, 21/11/1907.

8 *New York Times*, 22/11/1907.

9 *New York Times*, *Daily Mirror* and *Daily Express*, 23/11/1907.

10 *Evening World*, 20/12/1907.

11 *Daily Mirror*, *Daily Express*, *New York Tribune*, *The Sun*, *Stark County Democrat*, 24/12/1907.

12 *Marion Daily Mirror*, 31/1/1908; *Daily Express*, 1/2/1908.

13 *The Sun*, 29/2/1908.

14 *NY Times*, 23/5/1908.

15 *Washington Times*, 9/5/1908; *New York Times*, 10/5/1908; *The Sun*, 10/5/1908.

16 *New York Tribune*, 2/6/1908

17 *Evening World*, 2/6/1908

18 *New York Tribune*, 3/6/1908

19 *Journal of the American Society of Naval Engineers*, Vol. 21, p. 241.

20 *Transactions*, 1908 (Vol. 50), Royal Institution of Naval Architects, p. 110. (Meeting 9 April 1908)

21 *Alexandria Gazette*, 12/6/1908

22 *Los Angeles Herald*, 11/7/1908.

23 *Washington Times, Evening World*, 19/9/1908; *New York Times, New York Tribune*, 20/9/1908; *Daily Mail, Daily Express*, 21/9/1908; *Salt Lake Tribune*, 26/9/1908; *Pullman Herald*, 25/6/1909.

24 *New York Times*, 8/10/1908.

25 *Washington Herald*, 23/5/1909.

26 *Daily Arizona Belt*, 21/7/1909.

27 *The Sun*, 16/9/1910.

28 '*Lusitania* and *Mauretania* – Perceptions of Popularity', *Titanic Commutator* (2008, Vol. 32, No. 184), pp. 196–200. Article also available on Mr Chirnside's site, www. markchirnside.co.uk.

29 *New York Times*, 24/9/1908.

30 *Washington Herald, The Sun*, 14/12/1907; *Washington Herald*, 15/12/1907.

31 *New York Tribune*, 7/12/1911; *New York Tribune, Western Gazette, Daily Mirror*, 8/12/1911; *Aberdeen Journal*, 14/12/1911; *New York Times*, 14/2/1912.

32 *The Scientific American Handbook of Travel*, (Munn & Co., Inc., New York, 1911), p. 270; *Washington Times*, 30/8/1909; *Daily Mirror*, 31/8/1909.

33 *Manchester Courier*, 21/1/1910.

34 *Los Angeles Herald*, 21/2/1910; *The Sun, Washington Herald, Washington Times*, 22/2/1910; *Los Angeles Herald*, 23/2/1910

35 *Bemidji Daily Pioneer*, 1/3/1910.

36 *The Sun* and *New York Tribune*, 8/9/1911.

37 *The Sun*, 3/12/1910.

38 *The Sun*, 15/12/1910.

39 *New York Tribune*, 17/12/1910.

40 *Evening World, New York Tribune*, 17/12/1910.

41 *Evening World* 17/12/1910.

42 *New York Tribune*, 18/12/1910.

43 *Washington Herald*, 23/12/1910.

44 *Daily Mirror*, 24/12/1910.

45 *Evening World*, 9/6/1911

46 *Bryan Daily Eagle and Pilot*, 29/2/1912; *The Record* 14/3/1912; *Lusitania: An Illustrated Biography* (J. Kent Layton, 2010, Amberley Books), p. 201.

47 *The Sun*, 9/4/1912.

48 *The Sun*, 18/4/1912; *Evening World*, 19/4/1912.

49 *The Sun*, 20/4/1912; *New York Tribune*, 20/4/1912

50 *New York Tribune*, 21/4/1912.

51 *New York Tribune*, 19/4/1912.

52 *Bismarck Daily Tribune*, 27/4/1912.

53 *Evening World*, 23, 24/4/1912; *Washington Times*, 24/4/1912.

54 *Evening Standard*, 24/4/1912.

55 *Evening World*, 17/5/1912.

56 *Willmar Tribune*, 10/7/1912.

57 *Evening World*, 19/7/1912; *The Sun, New York Tribune*, 20/7/1912. Some newspapers said that the ship had nearly struck a berg on emerging from a fog bank, but Captain Turner denied that they had spotted any bergs, and the weather on that night was also reportedly clear.

58 *New York Tribune*, 12/6/1912.

59 *New York Tribune*, 24/7/1912.

60 *Washington Herald*, 24/7/1912.

61 *Rock Island Argus, Albuquerque Evening Herald*, 9/12/1912; *Daily Mirror, Daily Express*, 10/12/1912.

62 *San Francisco Call, Washington Herald, The Sun, New York Tribune*, 9/2/1913.

63 *Evening World*, 28/3/1913.

64 *Daily Mirror, New York Tribune*, 12/7/1913; *The Sun* 19/7/1913.

65 *Daily Mirror*, 12/7/1913.

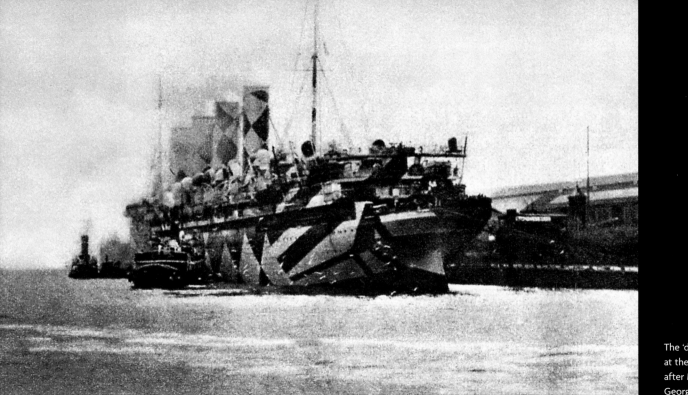

The 'dazzle'-painted *Mauretania*
at the Prince's Landing Stage
after March 1918. (Ioannis
Georgiou Collection)

This view, taken on 17 April 1915, shows the *Mauretania* in Liverpool. It was from an album of photographs taken by passengers during the last west-bound crossing of the *Lusitania*. The photograph was apparently taken from the *Lusitania* as she made her final departure from Liverpool; it is thus the last time that the two sister ships saw each other. Just three weeks later, the *Lusitania* was torpedoed. (Mike Poirier Collection)

Europe had been a powder keg from the latter half of the nineteenth century on. Its major powers were divided into two camps: the Triple Alliance, consisting of Germany, Austria-Hungary and Italy; and the Triple Entente, formed by Britain, France and Russia. A series of treaties guaranteed that, if any one of their allies was attacked by another nation, the remaining members of that party would come to its defence. There had been several scares and near misses over the years when a localised conflict had nearly burst into a full-scale European war. Yet each time a major crisis had been averted, and among the general population confidence in continued peace ran high.

In 1909, Norman Angell argued in his book *Europe's Optical Illusion*, reprinted the following year as *The Great Illusion*, that international finance had become 'so interdependent and so interwoven with trade and industry' that war between political powers had become 'socially and economically futile, and can have no relation to the prosperity of the people exercising it ... that, in short, war, even when victorious, can no longer achieve those aims for which peoples strive', and that, indeed, it would prove 'self-injurious' even to the victors. Although he did not argue that war was impossible, he did argue that it had become useless.[1]

Yet when the flashpoint came on 28 June 1914, it soon became clear that not all shared the opinion that war had become 'useless'. On that dark day, a 19-year-old Bosnian Serb named Gavrilo Princip shot the Archduke Franz Ferdinand, heir to the Austro-Hungarian throne, and his wife. In the moment those two members of royalty breathed their last, the entire world was set on course for an unprecedented war that would take the lives of millions. The path to war was traversed in the span of a mere thirty-seven

days. The first declaration of war came on 28 July, and by 4 August, all of Europe was engulfed in the conflict. The First World War had begun.

What is truly astounding about the period between 28 June and 4 August is how entirely oblivious most of those in Europe were to how quickly their world was crumbling around them, and how normal everything seemed in the routine of ships like the *Mauretania*. Yet by Saturday 1 August, as the *Mauretania* prepared to depart for New York, things were clearly unravelling.

There was great anxiety as to whether the sailing would be cancelled, even as three boat trains brought what was called 'a record load of passengers'. Among these were some who had transferred from later sailings of the *Imperator* and *Aquitania*. It was said that 'little but war talk was heard on all sides' that afternoon.[2] The liner's departure was delayed, although in the end she cast off at 4.55 p.m.[3] Some who were trying to make the passage had to be left behind because there was no room for them.[4]

The *Mauretania* made her customary call at Queenstown early the following morning, but some passengers noticed that as she departed for the open sea, she was under escort by a British cruiser – a rather ominous sign.[5] There were 1,670 passengers – 475 first, 428 second and 767 third – and 843 crew on board, for a total of 2,513 souls. They were setting out on what was later called the 'fastest and most dramatic voyage across the Atlantic in the history of ocean-going liners'.[6]

As the ship moved west across the Atlantic that Sunday, no further news of the crisis came in.[7] At church in the first-class 'sitting room', Captain Charles read the service; the hymn was 'a prayer for peace'.[8] At noon, the first run of the voyage was posted: the ship had made 585 miles since departing Queenstown. By noon on Monday, she had put another 610 nautical miles between her and Europe, and this was furthered by another 592 up to noon Tuesday. War news came in during Monday; more followed on Tuesday 4 August of the war between Germany and Russia.

On Wednesday 5 August, the ship had steamed another 580 nautical miles up to noon, and news broke 'of the crisis involving France, Belgium and England, which produced an undercurrent of excitement' among the passengers.[9] Passengers anxiously speculated over what would happen next but, frustratingly, it was at that point that they stopped receiving news on the subject.

There were ominous signs, though. Beginning at 6.00 p.m., the crew busied themselves turning off all unnecessary lights, while others used blankets or canvas to cover over what porthole and window lights could not be put out completely; other ports and windows were painted out, and canvas was rigged along the Promenade Deck to help prevent any light from showing. To those with a deductive mind, these facts all added up to something terrible – and yet, no official word of war between England and Germany reached passengers.[10]

That night there came another unpleasant surprise. The typical after-dinner concert and dancing in the Dining Saloon had been scheduled; this invariably required stewards to unbolt tables and chairs from the saloon floor in order to make room for passengers' gyrations. One passenger later recalled that during the concert there was singing and speeches, and that the air was 'stifling' as all of the windows had been closed.[11] If things seemed vaguely normal as the passengers danced, that sense was soon dispelled. Concert attendees were surprised when the lights were extinguished right in the middle of a dance. After a moment of darkness, which served as a warning, the lights were turned on again so that the passengers could make their way to their staterooms.[12]

'Shortly before midnight', as passenger John W. Davis, Solicitor General of the United States, recalled,[13] there came another development. George B. Winship, the former publisher of the Grand Forks *Herald* newspaper, said that without any warning, 'the big steamer gave a lurch, and it seemed for a moment or two that the boat would turn over'. Unbeknown to passengers, the British cruiser HMS *Essex* had signalled by wireless, warning *Mauretania*'s captain of potential danger from German warships, and ordering him to put in to Halifax instead of New York. To comply, the *Mauretania* had made a hard turn of about 90° to starboard, to the north. She also sped up considerably, making 27½ – and some reports indicated as high as 28 – knots as she dashed to the Canadian port.[14] To accomplish this Herculean task, an extra watch of stokers had been placed on duty below decks. It was said that 'streams of black smoke poured in dense volume' from the liner's 'huge funnels'.[15]

George Winship said that the 'tremendous activity of the engines caused the ship to vibrate from center to circumference. It fairly leaped through the water.'[16] In a letter, another passenger wrote: 'The *Mauretania* is racing as if possessed. We shake in our berths because of the excessive vibration. Everything trembles. Long, nerve racking oscillations adds itself to the vibrations.'[17]

John Davis said: 'It was asserted by several passengers that a searchlight flashed in our direction from the horizon and a shot fired. These assertions were not substantiated, though, and can easily be ascribed to imagination due to the excitement among the passengers.' Substantiated or not, the rumours spread like wildfire and did little to ease concerns as passengers tried, in many cases without success, to sleep.[18]

Captain Charles was not getting any sleep, either. He remained on the Bridge for seventy-two hours straight, not even allowing himself the luxury of a nap. He did not rest until his ship was safe in Halifax Harbour on Thursday morning. Chief Engineer James Carruthers spent the same amount of time awake and on duty in the sweltering engine room; he later boasted that the ship could have put on even more speed if there had been a real crisis.[19] As it was, she had made a fantastic performance, steaming 515 miles from noon Wednesday until reaching Halifax. The entire trip had encompassed 2,882 nautical miles, made over four days and ten hours at the average speed of 26.06 knots.[20]

In the end, although the *Mauretania* averted trouble on her trip across the Atlantic, the stay in Halifax proved a public-relations nightmare for Cunard. Passengers were held on the ship for two days while arrangements were made to get them to their destinations. In the end, some passengers grew impatient and pooled their funds to book a train down to Boston. Although they were unanimous in praise of Captain Charles for getting them safely across the Atlantic, many loudly criticised Cunard for not making alternative transportation arrangements in a more timely fashion.[21] Other passengers waited more patiently while the Canadian government, the local Cunard representative, Captain Charles, and Philip Franklin – a *Mauretania* passenger who also happened to be the president of J.P. Morgan's International Mercantile Marine – worked together to investigate the facilities at Halifax terminals for processing them.[22] When the passengers finally boarded their trains, they were each given a lunch bag to help tide them over for the trip.[23] Perhaps the most disgruntled among the *Mauretania*'s passengers were those Austrians or Germans who 'couldn't satisfy the Canadian government that they were American citizens' and who were removed from the ship by 'several Canadian soldiers' on Saturday 8 August.[24]

Speculation was rampant that the *Mauretania*, along with the *Lusitania*, would immediately be called up for war service; there were even some reports that *Mauretania* was being converted at Halifax.[25] The British Admiralty had informed Cunard that the sisters would be requisitioned, and indeed on 7 August the *Aquitania* was called up and work began to convert her into an armed auxiliary cruiser. However, on 11 August the Admiralty released the *Lusitania* and *Mauretania* from government duties.[26]

The reasons for this decision are not entirely clear, particularly when one recalls that the loan which funded construction of the two speedsters had been justified by the concept of their quick transformation into high-speed warships in case of war. While often cited, it could not have been based on the disastrous battle between the *Carmania* and the *Cap Trafalgar*, nor the collision between the *Aquitania* and the *Canadian*, for both of those incidents happened afterward.

The real reason may have been that, at that point, there was simply nothing for the two ships to do as armed auxiliaries. The British had very effectively bottled up the German navy in harbour at war's outbreak. Furthermore, very few German liners had escaped the net to be converted into armed merchant cruisers; indeed, a mere ten days after the war had started, the Admiralty declared the transatlantic routes 'safe' for ships like the *Lusitania* and *Mauretania*. Simultaneously, the twin superliners were expensive to operate, requiring vast quantities of expensive fuel. Additionally, under the terms of the 1902 contract agreement, if the government chartered the liners, they would have to pay fees of 25s per gross registered ton per month – and an additional 5s per gross registered ton per month per ship if Cunard provided the officers and crew.[27] Without much apparent need for the ships to serve, the decision to release them from government duties made a lot of sense. The subsequent collision of the *Aquitania* and the *Canadian*, followed by the battle between the *Carmania* and *Cap Trafalgar*, merely added to the Admiralty's growing list of reasons why converting the speedsters into armed auxiliaries was not a wise venture.

In the meantime, Cunard had use for the *Mauretania*'s passenger-carrying capacity. Thousands of American citizens who had been enjoying a summer holiday in Europe as the war began were suddenly seized with one thought: to get home as quickly as possible. There were several things working against them, however. For one thing, many sailings – including those of the *Aquitania*, *La Provence* and the German liners *Imperator* and *Vaterland* – were cancelled outright.[28] This meant that berths on remaining steamers were more precious, and travellers stormed steamship offices in droves to secure passage back home. Complicating

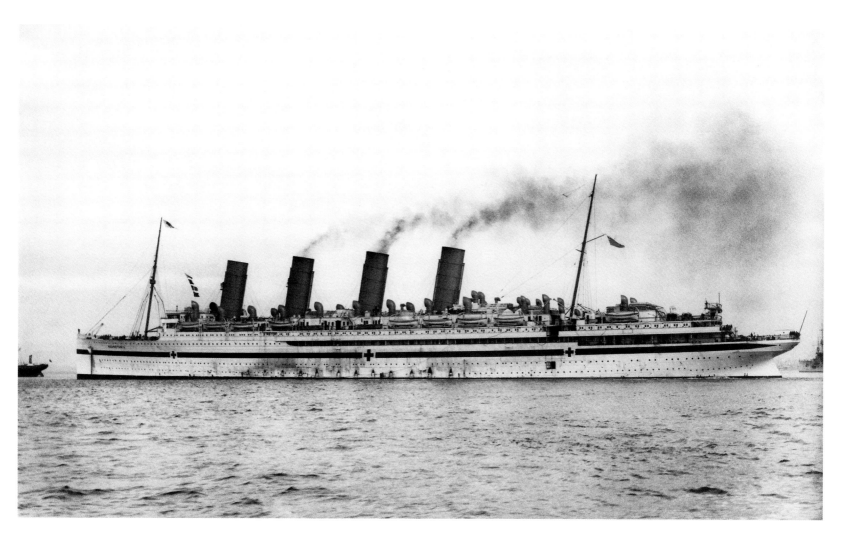

This photograph shows the liner serving as a hospital ship in late 1915 or early 1916. (Author's Collection)

matters, many American citizens wanted to sail under American-flagged ships, fearing that it was not safe to sail under flags of combatant nations.[29]

Yet there were plenty of passengers willing to travel on a prestigious British ship like the *Mauretania*. She arrived in Liverpool on 19 August, having made the east-bound trip back from Halifax without passengers – an 'unprecedented experience' for the fastest ship in the world.[30]

When she sailed again, she carried a respectable 1,574 passengers, including 568 in first class. Captain Charles steered 'just north of the southerly course' and the voyage took five days, five hours and seven minutes, at an average speed of 24.02 knots. For the most part, the weather held, and passengers accustomed to fine cuisine were not disappointed; however, the ship's lights were dimmed and there was no concert or dancing during the trip. When she reached Quarantine Station in New York safely at 6.30 p.m. on 3 September, her appearance proved a great shock to those accustomed to watching her come and go on the North River for the previous six and a half years: 'She was all black—plates, bridge, funnels and ventilators.' Even though she remained unarmed, it was said that she 'looked like a fighter'. Captain Charles said that this was to give her, if viewed head on, 'the appearance of a big cruiser' but that the voyage had been 'an easy and comfortable one'.[31] When she sailed for Liverpool at 1.00 a.m. on 9 September, she carried only 85 first, 90 second, and 150 third-class passengers.[32]

The *Mauretania*'s next sailing from Liverpool was on 19 September, and she carried a near-capacity list in first and second class.[33] But when she next arrived in New York on the evening of 15 October, she had only 365 first-class passengers.[34] It was clear that the westward flow of panicking Americans was reaching its inevitable conclusion.

During the ship's stay in New York, there was rumour of a bomb scare. It was said that on the evening of 20 October, a quartermaster had run across a German spy planting a bomb in a hold, which was set to go off as she departed the next day. It was said that the two men had fought so viciously that both ended up in the ship's hospital. New York police inspectors were sent down to investigate the matter. They found security at the wharf doubled: off-duty crewmen were dressed in their shore clothes and patrolled the decks and companionways; guards at the gangplank questioned all those boarding, and searched through all packages carried aboard by visitors. Despite the tight security, the Cunard officials denied the bomb scare, and the only occupants of the ship's hospital were sick passengers who had been denied entry into the United States.

Even though the incident was almost certainly nothing more than a waterfront rumour, it did go to show that Cunard officials were concerned for the safety of the *Mauretania* while she was in New York. Officially it was a neutral port, but it brimmed with German-Americans who could potentially try to bring harm to her. With the worst of the westward migration over, it was no secret that, when the *Mauretania* returned to England, she would be leaving Cunard service for the foreseeable future. What was unclear was whether she would be laid up or pressed into service as a transport.[35] Her arrival back in Liverpool on the morning of 27 October was made amid rumours that there were twenty-four German spies aboard bearing American passports. Government officials examined each passenger as they disembarked, and fortunately none proved to be German spies intent on wreaking havoc.[36] The ship was then laid up in Liverpool.

The *Lusitania*, on the other hand, remained in service through the remainder of the winter. She was the only big liner to stay on in that capacity; one after another, the other great ships were removed from service and laid up.

It was not until the spring of 1915 that life began to return to the *Mauretania*. Cunard announced on Wednesday 5 May that it would be bringing the *Mauretania* back to the Atlantic passenger trade, with the permission of the British Admiralty. The war hysteria that had kept passenger traffic artificially low over the winter was dispersing. As spring began to blossom, Cunard was banking on passenger bookings increasing, and queries from potential passengers looking for berths confirmed this expectation. It was even said that shipping men could 'begin to see the end of the war' on the horizon. Over the winter months, the *Mauretania* had undergone an overhaul and had her engines

'tuned up'. She would make her first sailing from Liverpool on 29 May, the same date as the *Lusitania*'s next scheduled sailing from New York.

Cunard sailing schedules published in newspapers on the following day showed the two speedsters alternating sailing dates over the course of the summer months through the beginning of August. The *Aquitania*, it was said, would join them at an unspecified later date, 'if business demanded' her use. Even by that point, the *Aquitania*'s luxurious fittings, which had been removed the previous August when she was employed as an auxiliary cruiser, had been 'replaced more luxuriously than they were before'.[37]

At the time the announcement was made, the *Lusitania* was making her way east toward Liverpool on her 202nd crossing of the Atlantic, with 1,261 passengers on board. It was her largest east-bound passenger list since war's outbreak.[38] There were good reasons for hope on the part of Cunard personnel. The German fleet remained bottled up and their plans of commerce raiding by armed liners had all but completely failed. They had begun a submarine campaign around the British Isles, but as of that point they had met with only limited successes. No ship travelling over 15 knots had yet fallen victim to a U-boat attack, and what ships were sunk were mostly small to medium-sized vessels. Most German submarine commanders were still adhering to the honourable 'cruiser rules', giving fair warning to a ship and making provision for the safety of its passengers before actually attacking. It may have been felt that no German U-boat skipper would have the audacity to attack a great passenger liner like the *Lusitania* or *Mauretania* – certainly not after the 'rape of Belgium' the previous year, and the resulting loss of face Germany had suffered in the eyes of the civilised world.

Twenty-four hours later, everything had changed ... Kapitänleutnant Walther Schwieger of the German submarine *U-20* happened across the *Lusitania* just off the Old Head of Kinsale, Ireland. The liner was then steaming at reduced speed; her captain, William Turner, who had commanded the *Mauretania* and *Aquitania* before the war, had apparently been lulled into a false sense of security despite numerous warnings of submarine activity in the area. When Schwieger attacked without warning, the single torpedo shattered not only the mighty ship's steel hull but the notions of civilised warfare throughout the world. Incredibly, although touted as the last word in maritime safety in 1907, the *Lusitania*'s system of longitudinal watertight subdivision caused a severe list to starboard and sealed her fate. She sank in just

eighteen minutes, carrying about 1,200 men, women and children to their deaths. Clearly, the North Atlantic was not a safe zone of operation for passenger liners any more, and many German U-boat skippers would not, after all, hesitate to destroy them with or without warning.

On 11 May, a reeling Cunard Company announced that all of the *Mauretania*'s planned sailings in commercial service were cancelled.[39] That same day, the Admiralty formally requisitioned her; she was to be pressed into service as a troopship in support of the Dardanelles and Gallipoli campaigns in the Mediterranean theatre of the war. The conversion to utilitarian troopship did not take very long. Under the command of Captain Dow, former master of the *Lusitania*, she made three voyages to Lemnos in the Aegean, carrying a total of 10,391 troops.

In the course of these voyages, the 'Hired Military Transport', or HMT, *Mauretania*, was attacked by an enemy submarine without warning. When a torpedo wake was seen streaking toward the liner, Captain Dow ordered a crash turn to starboard. She responded brilliantly to the order, and the torpedo passed astern of the ship by no more than 5ft, according to some eyewitnesses.

By September 1915, wartime needs had changed; fewer troops were needed at the fronts and more wounded needed to be transported back to England. Thus, the Admiralty laid out £68,000 to refit the *Mauretania* as a hospital ship, and similar conversions began on the *Aquitania* and White Star's incomplete giantess *Britannic* – third and final entrant of the *Olympic*-class.

When the *Mauretania* was ready to enter service in her mission of mercy, she was placed under the command of Captain Arthur H. Rostron, the same skipper who had raced Cunard's *Carpathia* to rescue survivors of the *Titanic* disaster in 1912. From September 1915 to February 1916, the *Mauretania* made three round-trip voyages from Southampton to the Mediterranean and back, all without any serious incidents from enemy action. When demand for hospital ship capacity fell off, the Admiralty released the *Mauretania*, *Aquitania* and *Britannic* from service. *Mauretania* was first to make her exit.

On 24 February 1916, it was officially announced by the British government and the Cunard company that the *Mauretania* was to be returned to her owners and placed back in service as a passenger liner.[40] The Admiralty was confident they would not need her services again, and paid some £60,000 so Cunard could restore her to commercial service at Liverpool.[41]

By that autumn, however, plans had changed once more. The Admiralty again requisitioned the *Mauretania* and turned her into a troopship. She was to be employed once more on the Atlantic, under Captain James Charles, but this time she would run between Halifax and Liverpool. Over the course of two such trips, she carried 6,214 Canadian troops to England. On one of these trips, however, the ship was nearly lost.

The trouble began two days out of Liverpool, west-bound across the Atlantic. Staff Chief Engineer Andrew Cockburn – a survivor of the *Lusitania* disaster – noticed, while making his rounds that evening, that water was flooding the ship through one of the coal-bunker hatches. Apparently, when the coaling had finished at Liverpool, some errant worker had not properly sealed the hatch, and no one else had caught the mistake. Cockburn told the on-duty engineers to monitor the problem, and then he turned in.

He was awakened shortly afterward by the chief engineer, who told him to go up to the captain, tell him there was a problem and have him stop the ship. Water was flooding into the boiler rooms; it was deep enough to extinguish some of the fires in the boilers and the ship had developed a severe list. The pumps had failed because they had become clogged with ash and coal debris. The situation was critical and worsening rapidly; engineers worked in water up to their necks to clear the pumps and save the ship. Captain Charles slowed the ship and turned her so that the wind was pushing against her low side. Eventually, after working through the night, the engineers managed to get the pumps running again and to get ahead of the flooding. The ship was saved and managed to make Halifax under her own power.

At the end of 1916 the *Mauretania* was laid up in Greenock, Scotland. She remained there throughout 1917, even after the United States had entered the war on 6 April. By the year's end, however, the United States asked the Admiralty if they could use the *Aquitania* and *Mauretania* to transport American troops to Europe. Initially First Lord of the Admiralty Eric Geddes felt that it would be impractical to run the ships from America to Liverpool, England, or direct to Brest, France; he believed a port such as Southampton would be the best European terminus.[42] However, in the event, the *Mauretania* was able to use Liverpool to disembark troops.

Perhaps there is no better way to form a picture of life aboard the *Mauretania* during this final segment of her wartime service than to relive a single eight-day east-bound crossing from New York, the first of her seven voyages

moving American troops to the fronts of Europe. During the trip in question, she was filled with American soldiers of the 55th Regiment bound for the French fronts.[43]

The regiment's adventure began on Sunday 24 March 1918 at the ghastly hour of 3.30 a.m. By 5.30, they had embarked upon a train that would carry them from Cresskill, New Jersey to Jersey City. At Erie Terminal, the men were herded aboard a ferry boat, which took them across the Hudson River toward Manhattan. As the craft approached Cunard's Pier 54, the men could see that both the largest Cunarder, *Aquitania*, and the fastest, *Mauretania*, were docked. The two grand ships were sporting what Chaplain Frederick Cutler later recalled was a 'weird, striped camouflage … painted on the sides where all used to be glossy black' and the *Mauretania* bristled with 'six big guns on her deck'.

It took only an hour for the entire regiment to board the *Mauretania*. Once they were aboard, the men discovered that they would be sharing the liner with the 65th Artillery, C.A.C., and two medical groups – Base Hospital Unit 116 and Medical Department Unit L – which included more than a hundred nurses. The men were happy to discover this fact. All told, about 4,000 'passengers' would be making the voyage.

The ship's interior spaces were just as altered as her external appearance. Cutler recalled:

Mahogany furnishings had been removed, so that twenty soldiers could be comfortable in a cabin where one fussy globe-trotter formerly lived in state; but it did seem peculiar to see upper berths, made of rough pine boards, nailed to the exquisite fancy woodwork of the first-class cabins, where there had been only lower berths originally. The sick bays were larger and more workmanlike; the palatial dining-saloons were now plain mess-rooms. Everyone among the officers had at least one friend in the regal suite, so that excuse existed for him to make himself at home where only the richest or those of highest station had formerly traveled. In fact, the giant engines down below were all that reminded one of the old *Mauretania*.

Unfortunately, there was 'considerable confusion' in getting the baggage aboard, as the men assigned the task were new to the position and had no idea where it should all be stowed. As Sunday became Monday, divers worked beneath the filthy waters of the river. They were 'dragging the ship's bottom to forestall any possible danger from enemy mines'.

Meanwhile, the soldiers were pleased to find that Captain Arthur H. Rostron was in command, as they clearly recalled the heroic details of his rescue of the *Titanic*'s survivors some six years before. With such a fine skipper overseeing their passage, they believed that they had better odds of escaping destruction at the hands of enemy U-boats. Rostron told the men: 'We always make the trip alone, with an escort only at each end of the journey. We cannot travel in convoy. The others cannot keep up with us. Our average speed is 22 to 23 knots, and our fastest clip is 25¾ knots. Our motto is to get there and not look for trouble.'

Finally, at 5.47 p.m. on Monday 25 March, 'the ship's siren shrieked the signal to start'. The men were all ordered inside the vessel in order to conceal their presence from the prying eyes of spies, who could easily send a warning ahead of the ship to Germany and its prowling U-boats. The *Mauretania* cast off and backed into the Hudson River, then turned and began to proceed toward open water.

A careful watch needed to be maintained during the crossing: a sentinel was stationed at each of the watertight doors, so that in the event of an emergency they could be closed instantly; another great danger lay in the outbreak of fire; a third and highly critical danger lay in ensuring that the ship's blackout was maintained completely through the entirety of the voyage. To maintain this watch, some 300 men were employed for every shift, with an entire battalion going on duty at the same time.

'Guards,' Chaplain Cutler recalled, 'were cautioned to stop at nothing at enforcing' the blackout. One officer directed the sentries 'to shoot an offender or knock him down and in no case to hesitate'. Upon hearing this order, one of the men who would be standing watch realised that although he had a revolver, he had no ammunition for it. Asking the captain how he should proceed with that particular handicap to enforcement, he was quickly advised that he should 'do anything' he could, and, if all else failed, he should 'pick up a rock and throw it' at the offender. Although the sentinel didn't question the order, he must have wondered where he would find a rock aboard the *Mauretania* in the middle of the North Atlantic.

Routine began to set in as the ship steamed east, far south of her regular transatlantic course. The weather was 'pleasant and moderate', and the seas remained calm. There were a few cases of seasickness, but fortunately these poor souls were in the minority, and most had a very hearty appetite at mealtimes. Some of the soldiers felt that although there was sufficient food served, there wasn't an abundance; however,

there were tricks the truly smart ones could employ to make the best of things. They soon learned, for example, that dry rolls were served at breakfast and jam without rolls was served at lunch; by pocketing rolls at breakfast and saving them, they were 'all set' to use the jam at lunch.

There was an 'abandon ship drill' twice a day, prompted by a bugle call. Predictably, there was no small amount of confusion the first couple of times this took place, but eventually chaos turned to order, and:

> nearly four thousand Americans acquired the ability to move from all parts of the vessel, absolutely emptying all the cabins, and to form line, six deep, around the outer edge of the lower decks—and to do it all within five minutes—a remarkable achievement in view of the vast distances some had to travel. If it had not been for a narrow passage amidship which caused congestion, the formation would have been even quicker.

It was clear that there were not enough lifeboats for all, and that in the event of a real emergency, some would have to depend on 'life rafts'. Every officer, including Chaplain Cutler, attended the drills armed in case there was a panic.

Soldiers were aroused daily at 7.00 a.m. and breakfast was finished by 9.00. Rifles were inspected and greased before the first daily lifeboat drill; after that there was a band concert. Officers and nurses would dance on the deck, despite the encumbrance of their ever-present life preservers. Cutler recalled that it was 'some stunt to dance up hill when the boat rolled'. There were also too few nurses to provide a partner for every soldier; those with no dance partner were forced to watch and wait for a partner to become available. Even though some of the men thought that this particular batch of nurses was much older and significantly less attractive than nurses ought to be, all agreed that their presence was a pleasant diversion. The dances were held twice a day until the ship reached the submarine zone.

When the *Mauretania* reached that area, the tension aboard the ship became palpable. The ship's course 'became a series of irregular and sharp zig-zags at high speed, so that one would be thrown off one's feet when the vessel changed direction'. The men watching to ensure no light was shown at night further heightened their vigilance, and 'ship's officers dreaded to see the moon rise'. Just then, there was a mutiny among some of the ship's stokers, and they

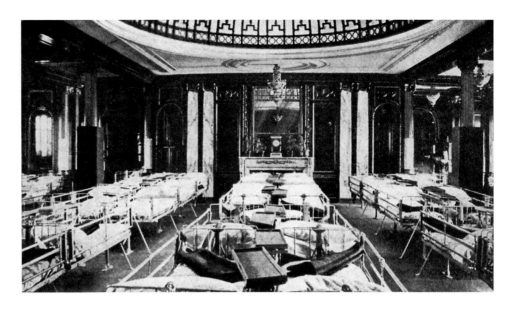

refused to feed the furnaces; this forced Captain Rostron to engage thirty of the troops aboard, at $1.75 per day, to take their place and keep the ship's speed up, for speed was the *Mauretania*'s best defence against enemy U-boats.

At 8.30 p.m. on Saturday 30 March there came a special concert in the First Class Lounge, by permission of Captain Rostron. It featured music and the performances of several talented soloists. On Easter Sunday, there came a fright, for the bugler mistakenly sounded the call for lifeboat stations, and other buglers around the ship echoed his call. Many of the men feared that a genuine disaster was playing out as they jostled to their lifeboat stations, but they were soon relieved to find it was all a mistake.

That evening, about 700 enlisted men were in the sweltering First Class Lounge for religious services; about halfway through the sermon, word came from the bridge to douse all lights immediately. The chaplains continued their service to a nervous audience in pitch darkness, everyone sweating from the heat and anxiety; when the services finished and word had not come that the lights could be turned back on, the chaplains directed the band to play the 'Star-Spangled Banner' in the gloom. No official word was received on the cause for this scare, and Captain Rostron and his officers were very tight-lipped on the subject, but there was talk that a submarine had fired torpedoes at the ship, and that 'the wakes of three' were visible just before the lights had been extinguished.

At 4.30 a.m. on 1 April, the *Mauretania* was intercepted by destroyer escort. An exhausted Captain Rostron, who had slept only one hour during the last two days, was

The grandeur of the First Class Lounge was converted into a hospital ward during the ship's service as a hospital ship. (Ioannis Georgiou Collection)

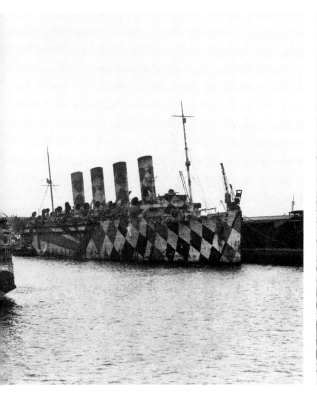

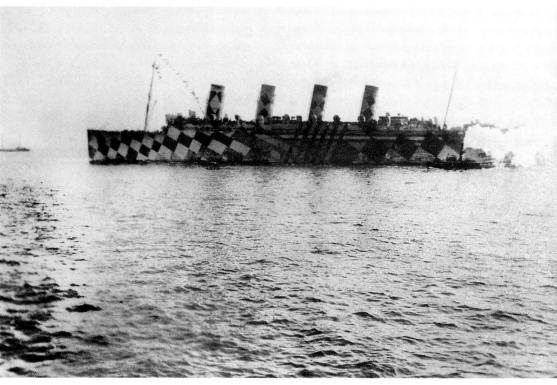

A beautiful original photograph of the *Mauretania* at Southampton in her dazzle paint scheme. (Author's Collection)

An original photo of the *Mauretania* in New York Harbour on 21 December 1918. (Author's Collection)

grateful for its presence, and one of the American soldiers exclaimed a heartfelt 'Thank God'. The convoy showed careful orchestration as it zig-zagged toward port. All hands kept a careful watch for submarines and for the Irish coast, but neither appeared – unlike Captain Turner on the *Lusitania* three years before, Captain Rostron was staying well clear of the shoreline.

The next day, the *Mauretania* entered the Irish Sea. The hills of Wales could be seen gliding past the ship's starboard side; a dirigible could be seen watching for submarines, and seaplanes occasionally passed overhead. The destroyer escort departed as the ship approached the bar at the entrance to the Mersey and Liverpool Harbour. The port gave its beloved liner a rousing welcome, for a rumour had spread ashore that the *Mauretania* had been torpedoed and sunk on 1 April:

> Harbor craft blew their whistles, and dense masses of people lined the shore on both Birkenhead and Liverpool sides; the 55th Band responded by playing the three national anthems, American, French and British.

Captain Rostron later told reporters that they had only sighted one submarine during their crossing, and it had been some 2 miles distant; some of the men wondered if it was that sighting which had prompted the scare during Easter services.

At 3.00 p.m., the *Mauretania* safely entered the dock and tied up. In a great surprise, the soldiers were forced to wait on board overnight, even though no provision had been made to feed them. Another shock came as the new 'Daylight Saving Time' had gone into effect for the first time the day before; the soldiers had not compensated for this while aboard, and now they had to push their watches forward by a full two and a half hours in order to meet adjusted English time.

Early on 3 April, the men were roused for the last time on board the *Mauretania*. They climbed down the gangplanks and stepped ashore, bound for the French fronts, where they would play a pivotal role in upcoming battles. Of the 4,000 who had been packed aboard, no one had died during the trip.

Nor was this safe passage a singular event in this final stage of the *Mauretania*'s wartime career. Six more equally safe crossings followed. Captain Rostron later recalled that this was 'a critical period' of the war, and that the liner proved to be 'a real British bulwark'.

Before the start of one of these east-bound crossings to England, as the ship lay at Pier 54 preparing for departure,

Captain Rostron received an unpleasant report. The chief engineer informed him that there was a problem with the ship's steering gear. Several thousand troops had already embarked, but Rostron knew that this trouble would cause a delay of several days. As a result, the troops were transferred to other ships, which departed for Europe; for a week the *Mauretania* lay at the New York pier while repairs were made. Finally the steering gear was put right, a fresh batch of troops was taken aboard, and the ship sailed for Liverpool at her utmost speed. Despite the delay, Rostron recalled: 'We reached our destination and disembarked our troops two days before the transport which had left a week in advance of us!'[44]

As the *Mauretania* made her seventh east-bound trooping voyage that November, news of the Armistice reached her. She docked in Liverpool with her load of American troops, now unneeded for the war. After two days, she brought the same men back to the United States, reaching the Ambrose Channel Lightship at 7.10 p.m. on 1 December. She had to anchor in Gravesend Bay overnight, as she had been delayed by four severe storms, each worse than its predecessor. As she made her way to the overnight anchorage, she made a dramatic picture, with every light showing and searchlights from nearby forts and warships picking out the 'weird streaks of camouflage paints on her long sides'.[45] She tied up at Pier 54 the next morning and discharged 4,467 officers and men to a hero's welcome – even if they hadn't participated in the conflict, they were the first troops to return from 'over there'.

For the next six months, the *Mauretania* was engaged in repatriating American and Canadian troops. By the time she was released from government service on 27 May 1919, she had carried 78,406 persons – 8,655 medical staff and wounded, and 69,751 troops – in His Majesty's Service. Her contribution to the Allied victory in the First World War had been significant, but as the world tried to piece itself together in the wake of that unprecedented conflict, many must have wondered what peace had in store for the 12-year-old liner.

This very rare photo shows the *Mauretania*'s dazzle paint scheme being obliterated by her civilian colours. Traces of the dazzle paint are just visible below the Bridge and Boat Deck on the forward superstructure. With the war's end, the liner was poised to begin a new chapter of her career. (Ioannis Georgiou Collection)

NOTES

1 *The Great Illusion* (1910, 4th American Edition), Preface and Synopsis. Norman Angell was born Ralph Norman Angell Lane; he won the Nobel Peace Prize in 1933.
2 *New York Times*, 2/8/1914.
3 *New York Times*, 7/8/1914 reported a 3.30 p.m. departure; 4.55 p.m. departure was cited by the same paper in a different article on the same day, however, and this was confirmed by numerous other reports.
4 *New York Tribune*, 1/8/1914.
5 *New York Times*, 7/8/1914; *Anderson Daily Intelligencer*, 7/8/1914.
6 *Daily Mirror*, 8/8/1914.
7 *New York Times*, 7/8/1914.
8 Letter written by unidentified passenger, Mike Poirier Collection.
9 *New York Times*, 7/8/1914; letter written by unidentified passenger, Mike Poirier Collection.
10 *Bismarck Daily Tribune*, 12/8/1914. Again, there is a dissenting report stating that the announcement of war between Germany and Britain was released in the ship's newspaper.
11 Letter written by unidentified passenger, Mike Poirier Collection.
12 *New York Tribune*, 11/8/1914; *Rock Island Argus*, 14/8/1914; *Hartford Courant*, 10/8/1914. Interestingly, one unquoted, paraphrased report mentioned that this concert was cancelled by Captain Charles, but others – including the first-hand letter contained in the Mike Poirier Collection – reported that it was held as scheduled. Of these, the report by two female first-class passengers quoted in the *Tribune* article holds the detail that the concert ended so abruptly in the middle of a dance.
13 There are some discrepancies in the exact reported time of this course correction, but most agree that it was between 11.00 p.m. and Davis's recollection is a direct quote. *Washington Times*, 11/8/1914.
14 *Anderson Daily Intelligencer*, 7/8/1914.
15 *The Sun*, 7/8/1914.
16 *Williston Graphic*, 20/8/1914.
17 Letter written by unidentified passenger, Mike Poirier Collection.
18 *Washington Times*, 11/8/1914; *Rock Island Argus*, 14/8/1914.
19 *Anderson Daily Intelligencer*, 7/8/1914.
20 *New York Times*, 7/8/1914.

21 *New York Tribune*, 10/8/1914.
22 *New York Tribune*, 7/8/1914.
23 *Rock Island Argus*, 14/8/1914.
24 *Washington Herald*, 8/8/1914; *Rock Island Argus*, 14/8/1914.
25 *Washington Herald*, 8/8/1914.
26 *The Edwardian Superliners*, p. 60.
27 *Engineering*, Vol. IXXXIV, p. 622. The 25s per grt per month fee applied to all Cunard ships with a rated speed above 22 knots. For the *Mauretania*'s 31,938 grt, this amounted to 798,450s per month at 25s per grt. With 20s to a pound, this came to roughly £39,923 a month without crew and officers supplied, or roughly £47,907 per month if they were included. As the war drew on, these prices were negotiated down; by May of 1915, for example, they were chartering the *Aquitania* at 15s per gross ton per month, and by August that sum had been reduced again to 10s. At the opening of the war, the government was looking at a very high charter fee on each of the high-speed ships, and without much for them to actually do.
28 *New York Tribune*, 1/8/1914.
29 *The Sun*, 4/9/1914.
30 *Daily Express*, 20/8/1914.
31 *Sun*, 4/9/1914; *New York Tribune*, 4/9/1914.
32 *New York Times*, 9/9/1914.
33 *New York Times, New York Tribune*, 20/9/1914; *New York Tribune*, 25/9/1914.
34 *The Sun*, 16/10/1914.
35 *Evening World*, 21/10/1914.
36 *New York Times*, 28/10/1914.
37 *New York Tribune, Richmond Times-Dispatch*, 6/5/1915; sailing schedule published in *The Sun*, 6–10/5/1915.
38 This was broken down as 290 first, 601 second and 370 third class. See the full passenger list in *Lusitania: An Illustrated Bibliography*.
39 *Daily Express, New York Times*, 12/5/1915.
40 *New York Times, The Sun*, 25/2/1916.
41 *Bennington Evening Banner*, 22/3/1916.
42 The National Archives (UK), CAB/24/37.
43 All quotations from the account of this voyage are excerpted from *The 55th Artillery (C.A.C.) in the American Expeditionary Forces, France, 1918*, by Frederick Morse Cutler, 1920.
44 *Nambour Chronicle and North Coast Advertiser*, 3/12/1926.
45 *New York Times*, 2/12/1918.

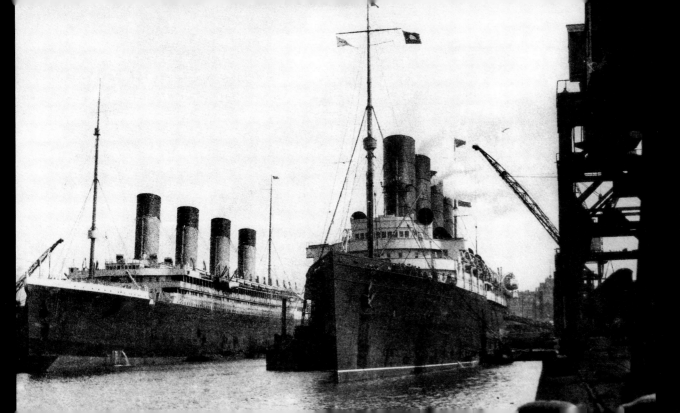

This rare image, taken on 21 July 1919, shows the *Mauretania* re-coaling in Southampton beside the White Star liner *Olympic*. The White Star vessel had finished her repatriation sailings and was about to return to Belfast for a full overhaul. *Mauretania* had been released from government service, and was then engaged in a series of civilian voyages, which have gone largely forgotten in the years since. (Ioannis Georgiou Collection)

When the *Mauretania* was released from government service, Cunard was keen to rebuild its regular transatlantic service. However, a weekly transatlantic service then required three ships of similar capabilities; the *Lusitania* had been sunk, and only two top-calibre liners, *Aquitania* and *Mauretania,* were available to hold down their premier service. Both were in need of overhaul after years of hard wartime service. The *Aquitania* was engaged in so-called 'austerity' sailings throughout the latter half of

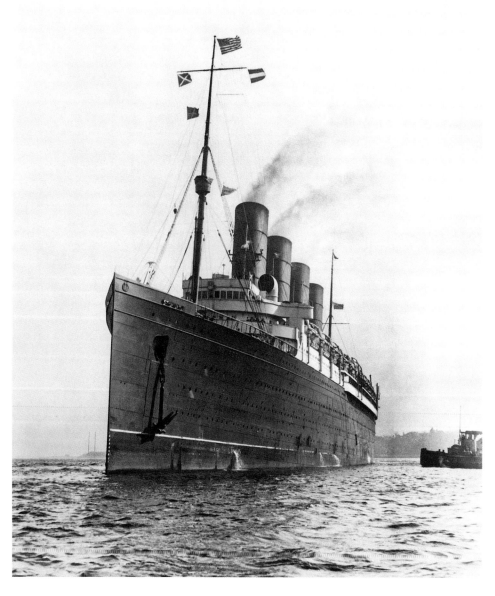

Mauretania at Quarantine Station in New York, *c.* 1920. (Clyde George Collection)

1919, and was then sent for a refit in November. That same month, Cunard managed to acquire the former German liner *Imperator* to run with the *Mauretania* and *Aquitania*; however, she immediately showed symptoms of serious operational issues that would require attention before she could be placed in regular service.

This meant that during the second half of 1919, the *Mauretania* was one of only two express liners representing Cunard interests on the prestigious New York route; during the first half of 1920, she was wholly without peer in that service. This nine-month period saw her make a total of seven round-trip voyages to the United States and back, which have largely been left out of the historical record. She followed these with another six round trips, which ran their course through early November 1920. For these voyages, Captain Arthur Rostron remained in command, a position that he would retain until 1926. Only after these voyages did the great ship take time for a full winter overhaul.

It was during this period that Cunard finally opted to change its primary English terminus from Liverpool to Southampton; *Mauretania* had used that port at times during the war, and its many advantages finally won the company over. The *Aquitania* was the first Cunarder to sail from there on 14 June 1919; *Mauretania* followed suit two weeks later.

During August, the *Mauretania* paused in Southampton for some interior freshening. Unfortunately, labour unrest caused a stoppage of work before it was completed. The ship's next sailing, originally scheduled for 2 September,[1] was delayed until 20 September. Another delay came that October in New York, when a longshoremen's strike meant that she was unable to refuel for the return trip. Her passenger list was so lengthy that the assistant pursers and several officers reportedly had to give up their cabins for the overflow. After a delay, the ship left New York for Halifax, where she was able to fill her bunkers properly before returning to Southampton. Unfortunately, the entire east-bound crossing lasted for thirteen days, and the Cunard Company had to cover the expenses of accommodating and feeding passengers for an extra eight days over and above the average crossing time.[2]

Things were certainly different from before the war. The world seemed eager to celebrate the end of more than four years of unprecedented conflict. Long-held social barriers had been broken down during the war: the millions killed had taught people a carefree, live-for-today mentality; particularly among the young, moral standards were being

disregarded as archaic and boring; everyone seemed to be making money; music was changing and jazz was becoming popular; dancing 'the Charleston' was the rage; and young girls who became known as 'flappers' were wearing daring clothing. Motion pictures, or 'movies', were becoming more popular and more available as movie theatres began springing up in every city and town; with these came the fame of actors and actresses of the silver screen like Clara Bow, Douglas Fairbanks, Mary Pickford and many others. Although Prohibition gripped the United States in January 1920, the nation was 'dry' in name only; cheap, low-quality booze – often provided by unsavoury criminal elements – flowed freely in speakeasies and private homes all over America. It was an era that author F. Scott Fitzgerald would term 'the Jazz Age', and would later be known as 'the Roaring Twenties'.

With Prohibition leaving many Americans thirsty, British ships like the *Mauretania* had special appeal to potential travellers, as her bars could offer liquid fortification once outside American territorial waters. In April of 1920, as she cast off on an east-bound crossing with a lengthy passenger list, many first-class passengers were obviously anxious as they waited for the ship to clear the harbour. A reporter aboard said they 'strolled along the deck; they looked frequently at their watches; they sighed as they passed the Statue of Liberty and shook their heads sadly, and then, as the ship passed through the Narrows and headed toward the Sandy Hook lightship, they one and all turned involuntarily toward' the ship's bar. As *Mauretania* passed abeam of the lightship and entered international waters, a 'great sigh of relief went up from nearly three hundred parched throats'. An older steward pulled out his watch and announced: 'Gentlemen, we have crossed the Sandy Hook bar at 7.18 p.m. We are now beyond the three mile limit. The bar is now declared open for the service of refreshments. The line forms on the left.' The reporter later recalled: 'The first night at sea of the *Mauretania* was productive of more drinking than I have ever seen outside of a New Year's Eve celebration at a Broadway restaurant.' Interestingly, he noticed that during the remainder of the crossing, he did not see a single intoxicated passenger, as the 'novelty of getting all the drinks one wanted wore off after the first night'.[3]

Labour trouble reared its head again in late September 1920. Since the *Mauretania* and her sister had entered service in 1907, first-class passengers had been accustomed to using the Dining Saloon as a dance floor every night after dinner; this task required the removal of all of the fixed chairs and tables – no small task for weary stewards who had been hard at work all day. Because of the scale of the task, after the war Cunard had agreed with the stewards' union that there would only be one dance per crossing. Yet while west-bound for New York, the chief steward ordered the chairs and tables cleared for a second dance; the stewards refused. The chief steward 'imported third class help from the hold of the ship' to do the task, and this led to an impromptu meeting of the 'Union of Ships' Stewards, Cooks, Butchers and Bakers', where it was decided that if the chairs were touched again by anyone but them, 'the stewards would all quit stewarding, the cooks wouldn't cook, the bakers wouldn't bake and the butchers would cease butchering'.

By the time the *Mauretania* had reached New York, the threats of a strike were building. It was said that the stewards did not want to go back 'to pre-war days', and didn't even want dances in the saloon at all. They knew that Cunard planned to 'build glass windows around certain decks, to use them for dancing instead of the saloons. But if the company does not do that, and if it hearkens to demands of dance-loving passengers who want more than one dance on a voyage', they promised there would be 'trouble'.[4]

Other problems were becoming obvious during 1920 and 1921: the 'world's fastest ship', was turning in miserable average

Another *c.* 1920 view of the mighty ship at anchor in New York harbour. She rides high in the water. Water streams from her anchor well as crewmen wash down the Forecastle Deck. A sailing ship is seen in the distance beyond. (Clyde George Collection)

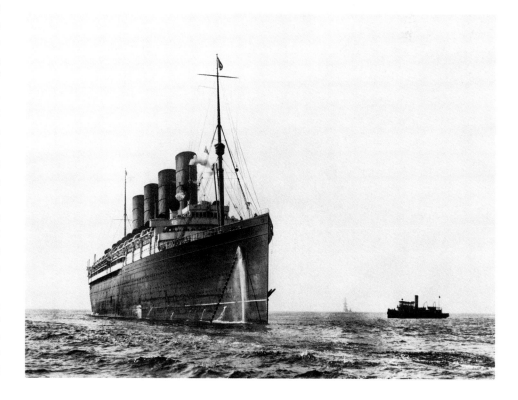

speeds on nearly every voyage. Before the war, her slowest crossing had been made at 18.72 knots, but she had been running on only two propellers. When she completed her mid April 1920 crossing to New York, she showed a new record for sluggishness at 17.81 knots. In fairness, the weather had been unusually rough. When she arrived in New York on 12 June 1921, however, having averaged only 18.23 knots – the second-slowest average of her career, yet without prop or weather handicap – it was said: 'If ships had feelings and could express them the Cunard liner *Mauretania* might have said she was humiliated yesterday on her arrival from Southampton.'[5]

These poor average speeds seem to be partly due to the poor quality of coal that was available to feed her furnaces. At the time of this June crossing, for example, there was a strike on; a lengthy delay in sailing was imposed, and only a partial load of good-quality Welsh coal could be obtained. She was forced to sail to Brest to finish coaling, and was there filled with tons of 'exceedingly poor quality' coal. Another 'black-eye' on this crossing was that, during the westward trip, the *Aquitania*, freshly converted to burn oil, had beat the *Mauretania* into New York by twenty-nine hours. Clearly, the advantages coal boasted over oil had long since begun to crumble.

However, suddenly on Monday 25 July 1921, the importance of the *Mauretania*'s average speeds seemed quite trivial. That afternoon, while tied up at Southampton's White Star Dock[6] preparing for her next voyage to America, a workman was cleaning carpeting in a cabin on the starboard side of E Deck; he was using highly flammable liquid while simultaneously smoking a cigarette. The results were highly predictable and by just after 2.00 p.m., the whole area was ablaze.

A steward rushed up to Staff Captain McNeil, who was then finishing his lunch, and informed him of the fire. Senior First Officer James Bisset was boarding the ship just as the alarm of 'fire' was being raised. He ran into McNeil as the staff captain was running along the Promenade Deck. 'There's a fire down below on E Deck. Tell the Chief there's no pressure in the fire hoses!' McNeil ordered. Bisset found Chief Engineer Andrew Cockburn in his office. As soon as he was told of the situation, the chief 'sprang out of his chair as though something had stung him' and rushed off to try to raise enough steam to operate the fire hoses.[7]

As Bisset headed down the main staircase, he was enveloped in thick, acrid smoke. He arrived at E Deck and found the crew assembled, fire hoses in hand, with only a trickle of water oozing from them – without water pressure, they were helpless to do anything to stop the flames.

Suddenly, the water hoses sprang to life, evidence that Chief Cockburn had done his job quickly.[8] Four of them, two down each corridor on either side of the ship, were turned on the fire. Still, McNeil found that owing:

to the dense smoke and the inadequacy of our smoke-helmets it was impossible to get to the seat of the fire; and, realising that we could not save that section of cabins, we devoted our efforts to preventing the flames from spreading either to the deck above or below. Two passenger tugs were commandeered, and having rigged stages overside and broken in the port glasses, we used their hoses from this vantage point on the flank of the fire. On the other side, also, stages were rigged and the local fire brigade hoses from the shore played water on this flank as well.[9]

McNeil quickly realised that with all of this water pouring aboard, it was likely that the ship would take a list one way or the other. So he quickly ordered two carpenters, the shore bosun's mate and twenty men to close the coal ports along either side of the hull so that if the ship heeled over, she would not flood and sink at the dock.

The 'dockside was enveloped in a dense cloud of smoke, which attracted thousands of people to the scene. To many, it seemed that the whole ship was doomed.'[10] During the six-hour battle with the conflagration, the fire 'endeavoured to run up the airshafts' and spread to other decks.[11] The uptakes ran all the way up to the cowl ventilators sitting atop the Sun Deck between the funnels, passing through the walls of the First Class Dining Saloon and Lounge. Bisset recalled that the 'uptake shafts were encased in exquisite, carved panelled wood, with mirrors and filigree work. These were now smouldering, bulging, and cracking with the heat, as also was the fine parquet flooring round about.' McNeil ordered crewmen to stand by at every deck, A through D, above the fire, and to spray water 'on any woodwork or ironwork that got hot', while the main team tried to kill the fire below.[12] Meanwhile, the crew of the *Olympic*, then berthed nose-to-nose with the *Mauretania*, made preparations to move their ship in case her safety became endangered.

Water collecting on D and E Decks would ordinarily have been able to drain out through scuppers into the bilges below, but they became clogged with debris. Water began to pour out of the open gangway doors on the port side, but the doors on the starboard side were closed, and the water started to collect there. At about 5.30 p.m., two

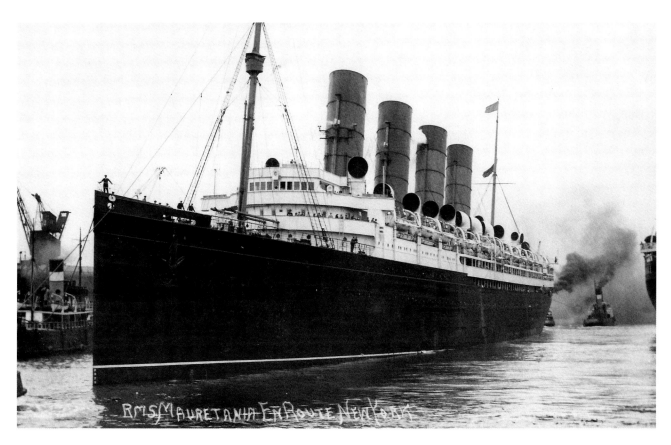

In this fascinating photograph, the *Mauretania* makes a departure from Southampton prior to the end of 1923. She is heavily laden, so deeply freighted into the water in fact, that the white stripe of her waterline disappears beneath the harbour's surface amidships and aft. Tugs strain to carefully manoeuvre the ship out of dock; a large liner, likely one of the ex-German trio, lies opposite. (Author's Collection)

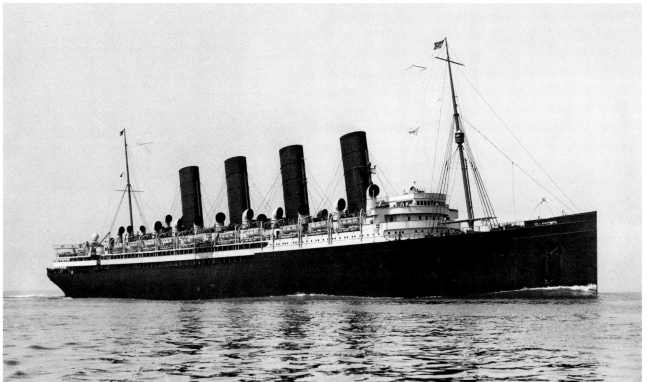

This spectacular spring 1921 photograph shows the liner steaming down Southampton water in the vicinity of Cowes. She is gliding through the water at a respectable speed, while her starboard anchor hangs nearly to the water. This photo shows one of the changes made to the ship's appearance during the war years: the forward bulwarks on either side of her Forecastle had their angled backs removed in 1918 to accommodate armament. They remained vertical at their after extreme for the remainder of the ship's career. (Author's Collection)

A rare photo of the *Mauretania* during the 25 July 1921 fire. Numerous fire hoses run from shore to ship, while smoke billows from every open port or hatch in the vicinity of the fire. The ship is leaning away from the pier, threatening to capsize if nothing is done to evacuate the water building up on her upper decks. (Courtesy Ralph Currell)

mooring wires forward on the port side snapped, and the *Mauretania* took a list of about 15° to starboard. All of the water on E Deck suddenly rushed to starboard, building to a depth of 6ft. Bisset and two carpenters worked furiously to open the gangway door there. Finally, they succeeded.[13] The water pushed the door open, the rush giving 'those in one of the tugs alongside a bit of a shock'.[14] The list eased, and the liner then settled over somewhat on to her port side, leaning toward the dock. Due to the hard work of McNeil and the other men, the fire was put out by about 8.00 p.m. Overnight, the crew damped down embers which tried to flare up again.[15]

The damage was severe. The 'horrible stench of smoke and burnt fabrics and paint permeated everywhere'. There had been 'tremendous damage to the ship's fittings and furnishings by water as well as by fire'. The next afternoon, Captain Rostron arrived by train from Liverpool, where he had been spending time at home between voyages. Several members of the Cunard Board of Directors, 'engineers, marine surveyors, and insurance assessors' also came aboard. The ship's structure and engines were intact, and someone had the bright idea of simply boarding up the charred E Deck first-class cabins and cleaning up the scorched panelling and flooring in the Dining Saloon, for the upcoming round-trip voyage was solidly booked. Fortunately, cooler heads prevailed, and the decision was made to send the liner out for a full overhaul. During the course of this, the opportunity would also be taken to convert the ship to burn oil fuel. Cunard decided to place the contract for the repairs and conversion with Swan, Hunter & Wigham Richardson, the ship's original builder; the order was a welcome one at the shipyard, for unemployment was high because of the widespread post-war downturn in shipbuilding.

A skeleton crew, including Bisset, was kept to sail the ship from Southampton up to Newcastle; *Mauretania* was coaled for the last time at Southampton, and she sailed for her birthplace on the evening of Friday 9 September.[16] It was her first return there, and her original fitting-out berth had been specially re-dredged to accommodate her.[17] Tens of thousands of locals turned out on Sunday morning, 11 September 1921, to see the great liner's homecoming. She made a splendid sight despite her internal scars, although she was curiously devoid of many of her lifeboats. Her trip up river was a scene reminiscent of her first departure nearly fourteen years earlier.[18]

The work on the oil conversion was, perhaps, the most involved. Each of the 192 internal coal-burning furnaces in the ship's twenty-three double-ended and two single-ended boilers was removed and replaced. The decision was made to convert the ship's original coal bunkers, which were located outboard of the boiler rooms so that they were watertight, to carry liquid fuel. The newly adapted spaces made a total of fifteen oil-storage tanks along each side of the ship, for a total capacity of 5,350 tons; unlike the *Aquitania*, which was converted to burn oil the previous year, *Mauretania* would carry no oil in her double-bottom spaces. Coal bunker doors, ash ejectors and ash ejector pipes were all removed. Four filling stations, two on each side of the ship, were installed above the Main Deck; the ship could now be filled to capacity through several pipes in just eight hours – a far cry from the mess, manual labour and lengthy fuelling periods of the ship's coal-burning days.

Aft, the two low-pressure ahead turbines, and one of the low-pressure astern turbines, were opened for examination; all main and auxiliary machinery was overhauled and inspected by the Board of Trade. Above, the burnt-out E Deck cabins were replaced, all other fire damage was repaired and restored, all cabins received new carpeting, and all of the public rooms were modernised. Extra private bathrooms were supplied for some of the first-class staterooms. Many of the en suite rooms were re-panelled with silk. In the First Class Dining Saloon, the tables were rearranged, the old fixed seats were removed for the last time, and they were replaced with 'four-legged chairs of the period of decoration'. The floor

of the saloon was laid with marble tiling. Above, a 'specially designed parquet floor for dancing' was laid in the centre of the Lounge – no more would stewards be asked to unbolt chairs in the Dining Saloon for dancing after dinner. On this new dance floor, passengers would be 'able to dance without interfering with the general comfort of non-dancers, the alcoves of the lounge being utilized as sitting-out rooms.'[19] 'A profusion' of growing plants were also added to the public rooms and companionways, and included '82 palms, 30 bay trees, 100 ferns and 500 potted plants, blooming in a great variety of color.'[20]

The *Mauretania* left Swan, Hunter's yard on Saturday 11 March 1922 a thoroughly new ship. A 'large party of guests' was aboard for the trip down to Southampton; when she arrived, she was placed in the Trafalgar Dry Dock for underwater hull maintenance. When that work was complete, she was returned to White Star Dock – which would be renamed Ocean Dock within a very short period of time – and final preparations were made to prepare her for her next voyage.[21] The ship's gross registered tonnage was remeasured at 30,696 – a reduction of 1,242 tons from her original measurement; her new passenger carrying capacity

was reduced to 589 first, 400 second and 767 third-class passengers, for a total of 1,756. It was said that these alterations would open up a 'new chapter in the career of one of the most famous vessels that has ever flown the Blue Ensign'.[22] Truer words were never spoken.

The *Mauretania*'s next crossing began on 25 March 1922; hopes ran high that she would return to her old self as regards speed. She arrived in New York on 31 March, having averaged 23.93 knots despite bad weather. Captain Rostron told American reporters that the *Mauretania* was then 'a better ship … than she ever was' and expressed his confidence in her upcoming record-breaking.[23] At the end of April, she even ran for several hours between Cherbourg, France and Southampton at a reported speed of 27½ knots.[24] Throughout 1922 and 1923, the liner's averages were much improved, although they were still not record-breaking ones.

On 30 July 1922, two men died aboard the *Mauretania* while she lay in Southampton between trips; the ship was being fumigated, and the hapless fellows entered the liner wearing gas masks to examine the ship's interior spaces. Despite their precautions, they were overcome by the fumes and died on the way to the hospital.[25] In September, the

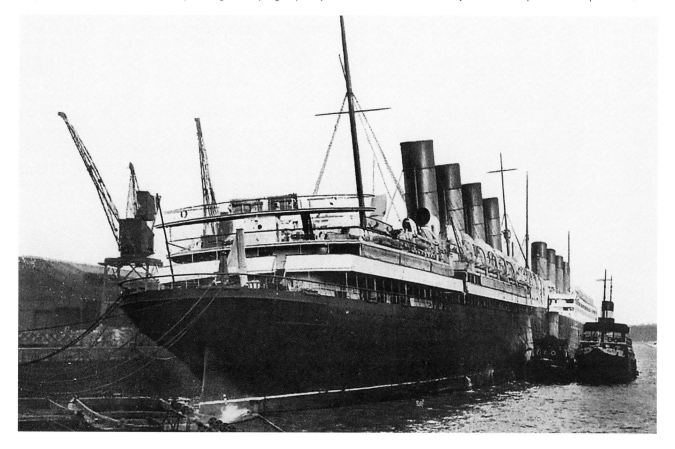

In this photo, also taken on 25 July, the ship's list has reversed, and she now leans to port and toward the pier. Ahead of the *Mauretania* lies the *Olympic*, her anxious crew ready to move the ship if the need arose. (Courtesy Ralph Currell)

Mauretania began calling at Plymouth, England east-bound, before calling at Cherbourg, France, and finally docking at Southampton.[26] This marked the first time in Cunard history that any of its ships would make scheduled stops at that port. That summer and autumn, the *Mauretania* suffered some serious issues with her turbine engines that left her sailing at reduced speed and even forced the cancellation of her 7 October sailing.

In May 1922, the new White Star behemoth *Majestic* had entered service. Not only was she nearly double the tonnage of the *Mauretania*, but she was quite fast as well, giving rise to fears that she could even take the Blue Riband. Late that year, she managed a crossing to New York at an average of 24.59 knots.[27] During the *Mauretania*'s winter lay-up that year, maintenance work was carried out on her turbines, but again they were not thoroughly overhauled.

In February 1923, the liner resumed service. After crossing to New York, she picked up some 531 millionaires for a

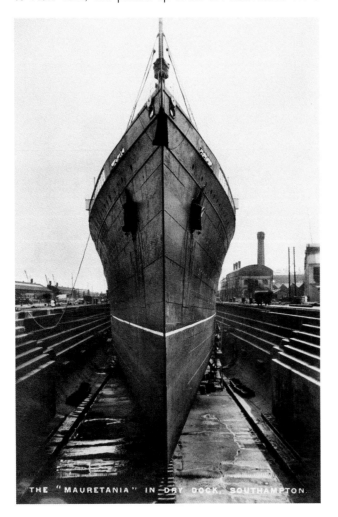

A fine bow-on view, taken in the early 1920s, of the *Mauretania* in Southampton's Trafalgar Dry Dock. (Eric Sauder Collection)

sixty-six-day cruise across the Atlantic and to various Mediterranean ports. She had been chartered for this, her first cruise, by the American Express Company. The average fare for each of the passengers was about £5,500, with the Regal Suite being booked by steel magnate Judge Elbert Gary; well over £10,000 of liquor was reportedly consumed on the trip.[28] Passengers were able to see the sights in the Valley of the Kings and the tomb of Pharaoh Tutankhamen and buy freshly woven baskets from Luxor, pet canaries from Madeira or sweet peas from Lisbon. Eventually she returned to Southampton, where she gave her American tourists five days of sightseeing in England before bringing them back to New York. In the course of this voyage, she steamed some 10,132 miles, which did not include the final west-bound crossing from Southampton to New York. The cruise was such a success that it was repeated every February and March from 1925 to 1930.

When the United States Line's *Leviathan*, formerly the German liner *Vaterland*, entered service in July 1923, she showed signs that she could threaten the *Mauretania*'s speed records. On her trials, running up the eastern seaboard of the United States for twenty-five hours – roughly equal to the twenty-five-hour days of an eastward crossing to England – she averaged an incredible speed of 27.48 knots.

Although these results were aided by prevailing currents, Cunard was clearly worried by the performances of both *Majestic* and *Leviathan*, and by the fact that *Mauretania* still was not able to match or exceed her pre-war records. It was right to be concerned; in early 1924, the Atlantic Conference of Transatlantic Passenger Lines announced that the *Leviathan* had the best average speed for the entire year of 1923, at 23.57 knots, while the *Mauretania* came in second place at 23.51 knots and the *Majestic* nipped at her heels with 23.20 knots.[29] While neither ex-German liner made a single crossing that took the Cunarder's pre-war records, something clearly needed to be done to ensure *Mauretania* retained the Blue Riband. Thus, when she docked in Southampton on 5 November, she was scheduled for a complete overhaul of her turbine engines during her annual refit.

The contract for the project went to John I. Thornycroft & Co. of Southampton. Some 600 men were engaged to work on the turbines, while another 500 busied themselves on other tasks around the ship. The work was done while the ship lay along the quay at Southampton, and without disturbing a single deck plate or boiler flue.[30] But before the task was completed, a two-month labour strike began.

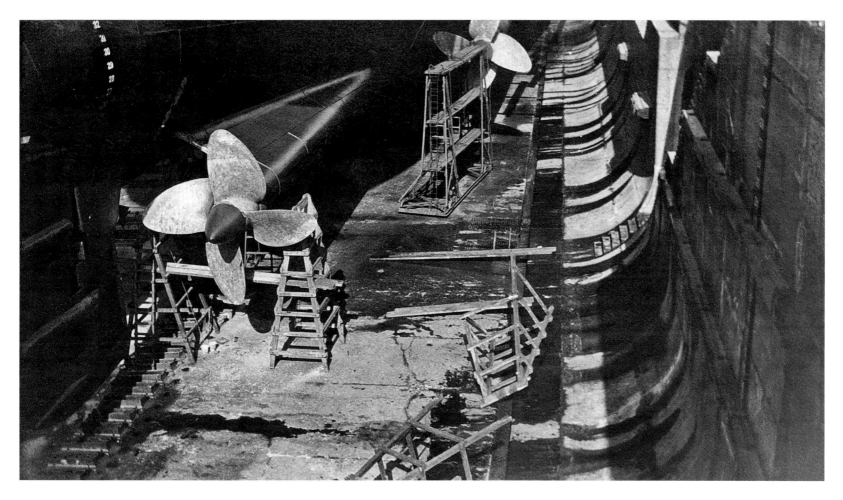

With the liner's turbines disassembled, she was incapable of moving under her own power. It may have seemed as if the strikers held all the cards. By 4 March 1924, Cunard was forced to cancel the *Mauretania*'s 29 March sailing.[31] Then, on Friday 11 April, Cunard played a wild card: that afternoon, Captain Rostron and a number of crewmen secretly boarded the ship, and, with the carefully choreographed arrival of five Dutch tugboats, the powerless *Mauretania* set out on what may have been her most unique trip.

Cunard had made arrangements, kept secret from the strikers, to finish the turbine repairs at Cherbourg, France. The journey across the Channel needed to be made carefully, for hundreds of thousands of individual blades for the turbines were sitting all over her engine rooms; a rough passage could turn an engineering puzzle into something that could never be pieced back together again. During the passage to Cherbourg, the odd flotilla with the helpless liner at its core encountered a north-westerly gale. Soon the tugs were unable to keep up against the combined effects of

wind and tide. Captain Rostron stood helpless on the Bridge, watching 'the five tugs, their engines at full speed, being driven backwards with us' towards the rocky coast at Cape Barfleur. Finally, the tide turned just in time to prevent the liner from coming to grief on the French coast, and she was tied up safely in Cherbourg. Captain Rostron later said that it was both a 'close shave' and 'the most anxious fifty-six hours I have ever experienced in my long career at sea'.[32]

The turbine work was completed successfully by French workers, its price totalling a third of the ship's original cost. Of the 385,700 blades in the turbines, 132,960 were said to have been 'renewed'.[33] The ship was also dry-docked and her hull cleaned. The forward half of the First Class Promenade along either side of the ship was enclosed with windows in the hope that passengers wishing to engage in a stroll or dancing on the decks would find better shelter from the elements. The opportunity was also taken to renovate or renew every piece of furniture on the ship, lay hundreds of yards of new carpet, and clean or repair

This rare original snapshot, taken in March 1922, was also taken in the Trafalgar Dry Dock. Here we see the liner's underwater surfaces have been cleaned. The two starboard propellers are clearly visible. (Author's Collection)

wooden panelling and flooring, lead mouldings, marble and glass throughout the ship.[34] On her return from Cherbourg to Southampton, *Mauretania* made steaming trials. Over a distance of 28 nautical miles, 14 with and 14 against the tide, she averaged 26.4 knots, a thoroughly respectable speed.[35]

By this point, the liner had steamed approximately a million miles and carried about 400,000 passengers, yet some of her best performances were ahead of her. At a luncheon on board the ship, the manager of Cunard's Southampton offices, Mr Cotterell, welcomed his guests aboard after the liner's 'return from the beauty specialists'.[36] The *Mauretania* began her first post-refit crossing on 31 May, and only a day out from port snapped one of her propeller shafts, making a record trip impossible. Despite this disappointment, the liner still averaged an impressive 22.67 knots on three props. In August, following repairs, she averaged a healthy 25.58 knots west-bound for New York from Cherbourg, her highest west-bound average speed since August 1911, and lowering the record time for a west-bound crossing from Cherbourg to New York, then held by the *Leviathan*.[37]

Better still, when she arrived at Cherbourg on Monday 25 August, she had made the 3,198-mile east-bound trip in

On 15 August 1922, 25-year-old actress Lilyan Tashman sailed from New York aboard the *Mauretania* for a European holiday. At the time, she was making a transition from Broadway to Hollywood films. Her next work had been announced as a play called *I Will if You Will*, which was critically deemed a 'bed-room farce'. The *New York Clipper* of 6 September said that the play did open on 29 August, with Tashman playing a 'sophisticated vamp'. (Author's Collection)

five days, one hour and forty-nine minutes at an average of 26.16 knots. Not only did this break her best average for a crossing, set in September 1909, but she also lowered the previous east-bound record to Cherbourg, then held by the *Majestic*, of five days, five hours and twenty-one minutes. Captain Rostron was elated, reportedly exclaiming, 'The dear old ship!' to a reporter. The reporter thought that the skipper 'wanted to pat her steel side as one pats the flank of a favorite horse'. Every man in the crew was said to be 'tingling with excitement' over the ship's record.[38] Interestingly, many press reports of the time cited a 26.25 knot average for the crossing, and Cunard even went to the trouble of taking out an advertisement in *The New York Times* on 27 August giving that figure as the average.[39] Whichever was correct, the record was further proof that she still had great life left in her. As she steamed up to Southampton from Cherbourg, she managed 28.25 knots for five-and-three-quarter hours' time.[40]

With her records now safe from the *Leviathan* and *Majestic*, the *Mauretania* settled down to maintaining a fast and extremely punctual career; no matter what delays she encountered during the voyage, she had enough reserve speed to maintain her schedule. Captain Rostron was almost invariably able to catch the same 3.18 p.m. train home when arriving in Southampton.[41] At the end of her second lengthy Mediterranean cruise, consisting of 9,549 nautical miles, she pulled into Southampton a mere two minutes late, moving Captain Rostron to comment that 'the dear old *Mauretania* will do anything you ask her'.[42]

In November 1924, while steaming down Southampton waters, the harbour pilot took the ship through a bit too quickly; the result was a heavy wash which caused flooding in Cowes. Streets were flooded, as were business premises, and 'considerable damage' was done to shipbuilding yards there. The Cowes Harbour Commissioners decided to appeal to the Board of Trade to have the ship's speed limited in confined waters to prevent a recurrence of the incident.[43] However, their complaints had little effect, for even as late as July 1930 the *Mauretania* passed Cowes at 16 knots, sending a tidal wave crashing over the esplanade, swamping boats, and 'imperilling bathers and children'.[44]

Meanwhile, the shipping industry was changing. In 1921, the United States restricted the annual number of immigrants from any given foreign country to 3 per cent of the foreign-born population of that country living in the United States in 1910; these numbers were further curtailed to a mere 2 per cent in 1924. As the mass

immigration from Europe to the United States waned, steamship companies were forced to reconsider how to maintain healthy profit margins.

Ships like the *Mauretania* had been designed to carry large numbers of emigrants. To keep passenger numbers up, a new class named 'Tourist Third Cabin' was introduced in 1925. It was formed by taking the better third class, and the less desirable second-class accommodations and combining them; these accommodations were then marketed to tourists, college people or teachers. The concept found traction quickly. So many college people booked into Tourist Third Cabin that it was nicknamed 'College Third Cabin'. It was said that for 'anyone who wishes to save money and cross comfortably with a congenial group it is an ideal solution of the way to Europe' – there was plenty of deck space, time to read while enjoying afternoon tea, 'a wonderful group of girls and boys from colleges all over the country', and a college jazz orchestra which put the old ship's orchestras to shame and brought interlopers down from first class to enjoy the music and dancing.[45]

Times continued to change quickly. On Saturday 10 July 1926, the *Mauretania* left Southampton without Arthur Rostron on her Bridge. Rostron, recently knighted, had left to take command of the *Berengaria*, and in his place Captain E.G. Diggle took command of the *Mauretania*. In June 1927, change struck again with the maiden voyage of the French Line's *Île de France*. Previously, the great Atlantic liners – including *Mauretania* – almost exclusively boasted interiors based on historical styles of decoration; but the *Île de France*'s interior decor instead broke new ground. Patterned after the Paris *L'Exposition Internationale des Arts Décoratifs et Industriels Modernes* of 1925, which eventually gave birth to the term 'Art Deco', the French liner's style immediately made all other ships on the Atlantic look like floating museums.

At the end of 1926, for her annual overhaul, the *Mauretania* went to Liverpool for the first time in seven years. Confusingly, the designations of her decks were reshuffled at this point. Previously they had been labelled, starting with the Boat Deck A, and descending through B, C, D and E decks; after that, and profoundly confusing to the modern enthusiast, the decks were changed to A, B, Upper C, C and D decks, so that the original E Deck was now known as D Deck, the former D Deck was now C Deck, and the former C Deck was now Upper C Deck, with the Boat Deck A and B Deck retaining their original letter designations.

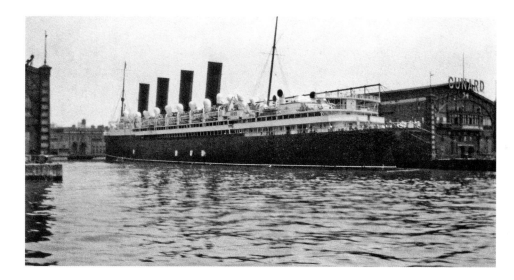

Likely in response to the forthcoming *Île de France*, Cunard also invested in significant upgrades of the *Mauretania*'s interiors during this stay. All first-class staterooms on the new D, formerly E, Deck were reimagined. Cabins were enlarged, and large cot beds, dressing tabes and wardrobes were brought in. Also, four private bathrooms and eight public baths – in ever-increasing demand during the 1920s and '30s – were installed. On the former D Deck, now C Deck, the groups of small staterooms were 'converted to fewer and larger' ones. Many former groups of eight became four in the process, giving the *Mauretania* some of the largest staterooms afloat. Every stateroom on A Deck, also known as the Boat Deck, was redecorated with new colour schemes. Hot and cold running water was brought to each stateroom for the first time, and additional fans, electric radiators and lights were installed. All bunks were finally removed, leaving only beds and the occasional Pullman berth.

All first-class public rooms were also renovated. This included a thorough cleaning of the oak panelling in the Dining Saloon from the build-up of cigarette and cigar smoke residue. On the Boat Deck above, the Verandah Café was completely redecorated. Always a troublesome space, it had been improved before the war, but remained unsatisfactory. This refit finally saw it completely enclosed with large double doors and sliding windows, which could be opened in warm, fine weather; it could also be heated in cold weather through steam pipes. The scheme of decoration adopted was patterned after that of the Orangery at Hampton Court. The new wooden floor was 'treated specially for dancing,

This photograph, showing the *Mauretania* alongside Pier 54 in New York, was taken during 1922 or 1923. A number of the gangway doors on the port side of E Deck are open. Pier 54 caught fire on 6 May 1932, about ten years after this photo was taken, and had to be rebuilt. (Author's Collection)

This private photograph catches the *Mauretania*'s brilliant profile before the end of her 1923 season. (Mike Poirier Collection)

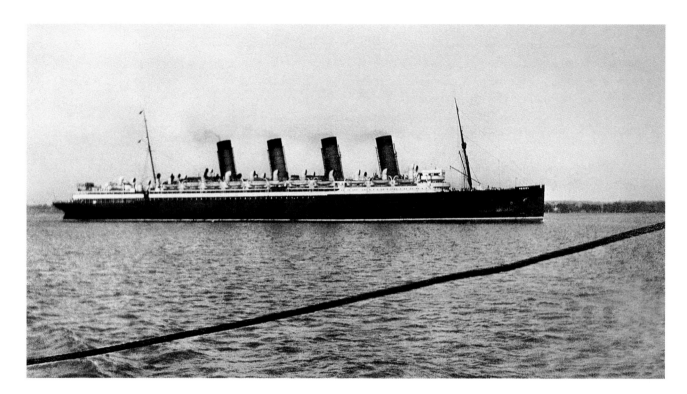

This set of diagrams shows the arrangement of the *Mauretania*'s engineering spaces after she was converted to burn oil fuel. The original wing bunkers, which ran alongside the outer edges of the boiler rooms, had been altered to hold oil fuel. (Courtesy of Ralph Currell)

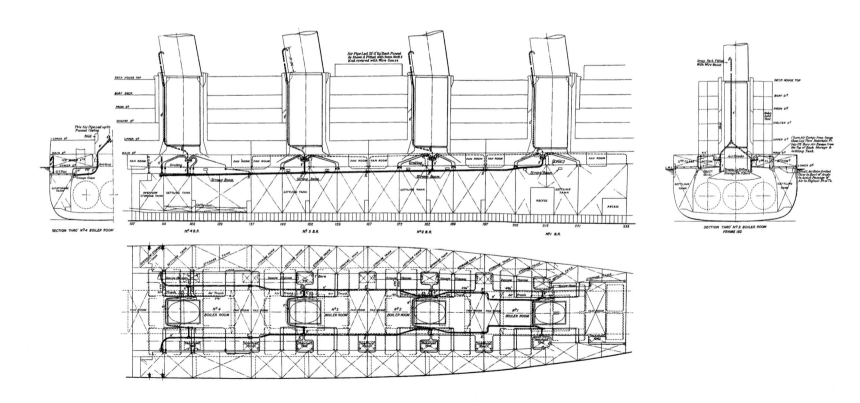

a form of amusement which continues very popular on transatlantic vessels'. It was said that the location of this new dance floor had the additional advantage in that there were no staterooms directly below, so that dancers would 'not feel the necessity of undue restriction'.

In second class, the Drawing Room furniture was replaced with modern pieces, and a new floor was installed in the Smoking Room. All staterooms were redecorated and repainted. Work was also carried out on the ship's machinery; two new propellers, supplied by J. Stone & Co., were fitted, as well as a new propeller shaft. A new oil bunker was adapted, providing some 670 additional tons of fuel capacity; there was also some work done on the turbines. All

of her furnaces were cleaned. To handle increased demand from the new bathrooms and running water in staterooms, a new calorifier was installed.

The ship left Liverpool on Saturday 5 February, and sailed down to Southampton. During this trip, the machinery was tested, and she reached speeds of over 26 knots.[46] She sailed on 9 February for New York and then began her annual Mediterranean cruise from that port on 21 February. The remainder of 1927 and most of 1928 passed rather uneventfully. She remained a popular ship on the North Atlantic despite the introduction of much larger, more luxurious, or more modern ships; to many, she had become an old friend, a symbol of stability.

This photograph was taken immediately after the conversion to oil fuel. It shows the centre section of the No. 4 stokehold, looking to starboard. The noise, grime and discomfort of coal-burning days have been replaced with remarkable cleanliness and quiet. A workman can be seen making an adjustment at the face of one of the boiler's furnaces. (Courtesy of Ralph Currell)

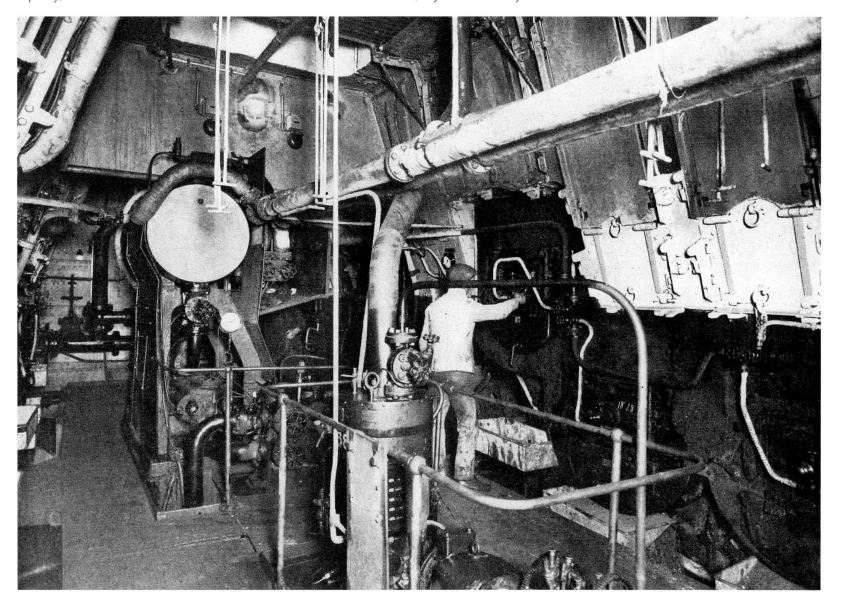

A rare view inside the aft fuelling station on the *Mauretania*'s port side as the ship takes on her liquid fuel. A previously back-breaking, noisy, messy task, which left the ship covered in a grimy dust, was now a relatively clean and simple process. (Courtesy of Ralph Currell)

The port side aft fuelling station, as seen from the deck of the fuelling barge. The simple piping arrangements were a vast improvement over pre-war coaling processes. (Courtesy of Ralph Currell)

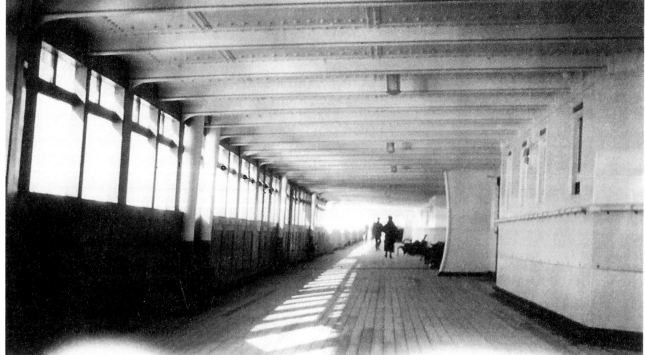

Views showing this portion of the Promenade Deck after it was enclosed during the 1923–24 overhaul are quite rare. In this original photograph, the photographer is looking aft along the starboard side of A Deck. (Mike Poirier Collection)

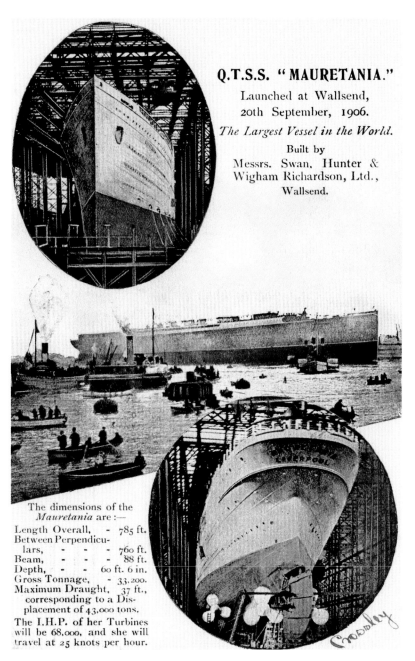

Q.T.S.S. "MAURETANIA."

Launched at Wallsend,
20th September, 1906.

The Largest Vessel in the World.

Built by

Messrs. Swan, Hunter &
Wigham Richardson, Ltd.,
Wallsend.

The dimensions of the
Mauretania are :—

Length Overall, - 785 ft.
Between Perpendicu-
lars, - - - 760 ft.
Beam, - - - 88 ft.
Depth, - - 60 ft. 6 in.
Gross Tonnage, - 33,200.
Maximum Draught, 37 ft.,
corresponding to a Dis-
placement of 43,000 tons.
The I.H.P. of her Turbines
will be 68,000, and she will
travel at 25 knots per hour.

This colour-tinted card commemorates the launch of the *Mauretania* and gives some of her statistics. (Jonathan Smith Collection)

A colour cigarette card of the Starting Platform in the *Mauretania*'s engine room. (Author's Collection)

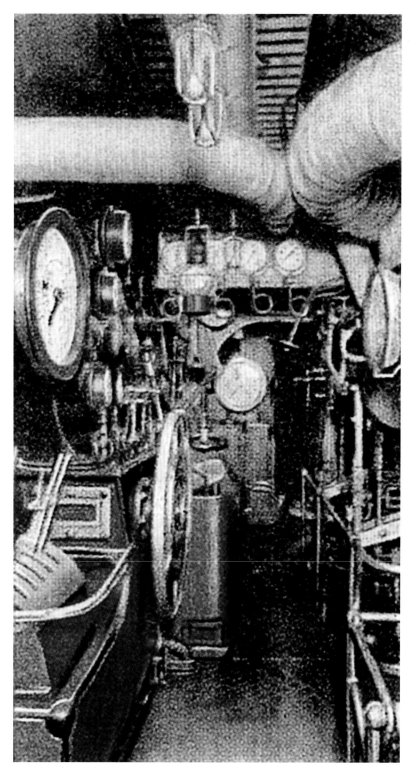

An artistically colourised view of the *Mauretania* on her trials shows her graceful lines. Unfortunately, most period colourisations show the 'Cunard red' of the *Mauretania*'s funnels far too red and is a closer match to the modern shade used by the line. In reality, the *Mauretania* and other Cunard liners had a more orange tint to their funnels than a deep brick red. (Jonathan Smith Collection)

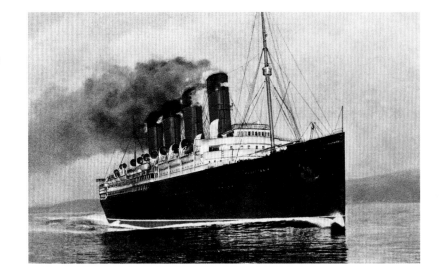

This photograph, later tinted for release as a postcard, was likely taken at Liverpool before the liner's maiden voyage. Within the life ring is a profile of Captain Pritchard, the liner's first Captain. (Jonathan Smith Collection)

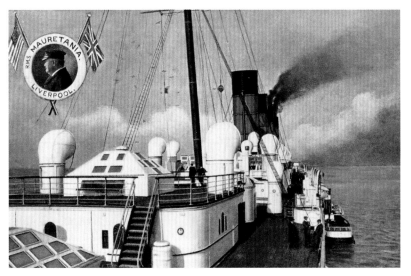

An early view of the *Mauretania* at the Prince's Landing Stage, with a crowd on the quay. (Author's Collection)

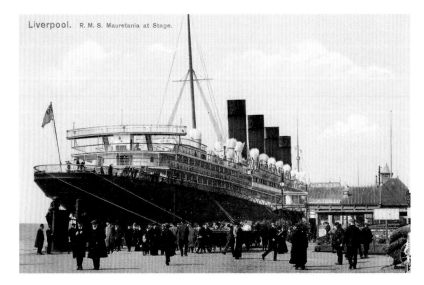

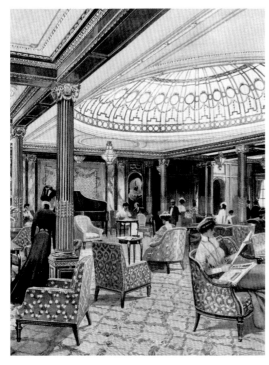

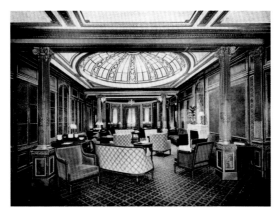

This colourised view of the First Class Library shows the grey stain of the wooden panelling, an interesting and very unique choice on the part of designer Harold Peto. (Jonathan Smith Collection)

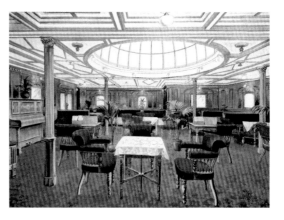

A colourised photograph of the Second Class Drawing Room. (Jonathan Smith Collection)

Left: Passengers in their Edwardian finery enjoying the First Class Lounge and Music Room. (Ioannis Georgiou Collection)

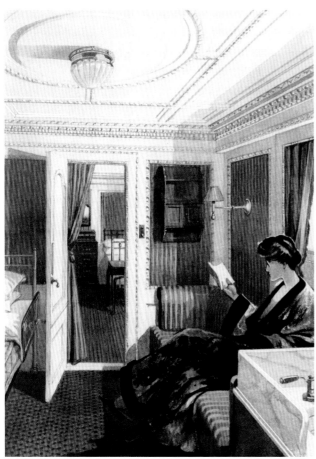

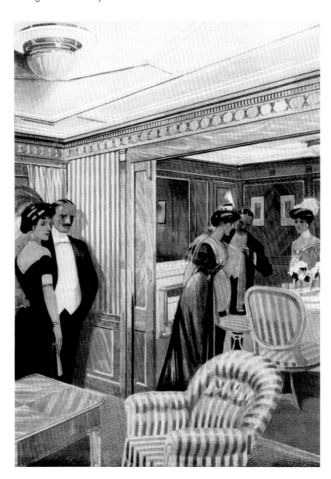

Far left: This early artist's view shows a passenger enjoying the comfort of one of the *Mauretania*'s fine en suite staterooms. (Ioannis Georgiou Collection)

Left: This early piece of artwork depicts passengers enjoying the comforts of the Regal Suites – at the time the finest accommodation available on the North Atlantic. It would appear that a party of finely dressed men and women are preparing to sit down for a meal in the dining room. (Ioannis Georgiou Collection)

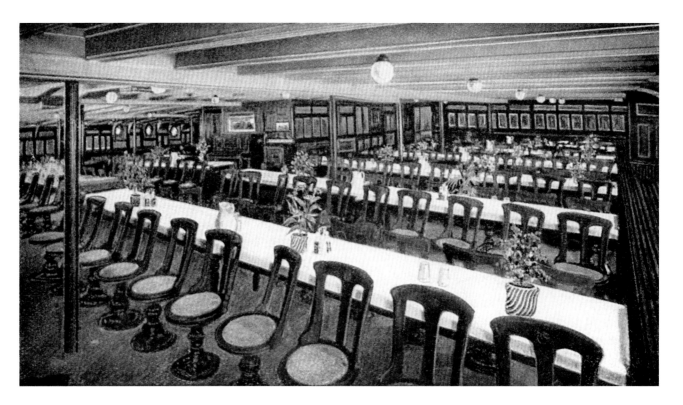

A colour piece showing the Third Class Dining Room. (Steven B. Anderson Collection)

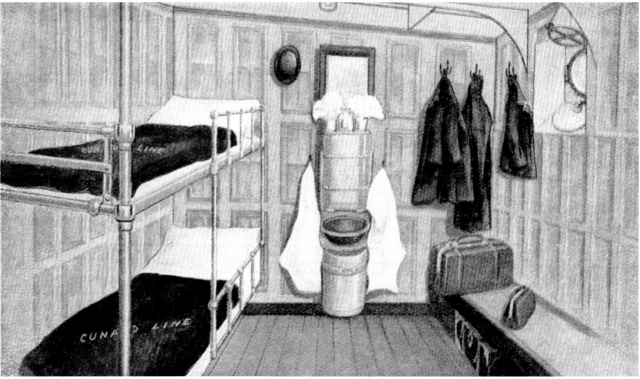

An artist's view of a Third Class cabin as it would appear when occupied. (Steven B. Anderson Collection)

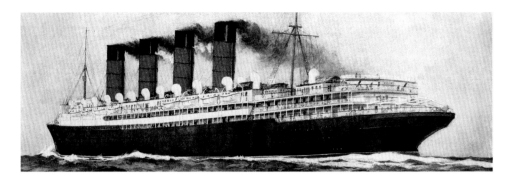

A fantastic early stern portrait of the *Mauretania* at speed on the open sea. (Steven B. Anderson Collection)

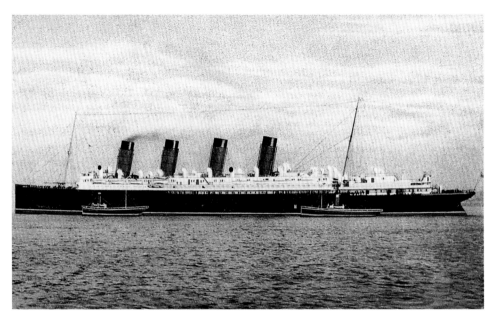

A colourised photograph of the *Mauretania* in Liverpool early on in her career. (Author's Collection)

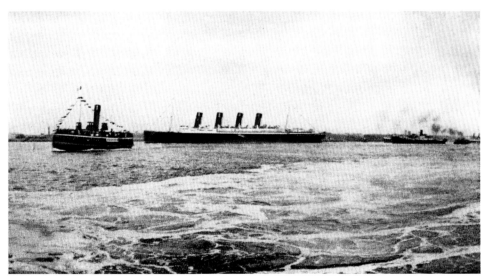

Taken from the cover of an Italian brochure for Second Class passengers, this piece shows the *Mauretania* in Liverpool surrounded by harbour traffic. It was likely based on an original photograph. (Steven B. Anderson Collection)

A fantastic view of the *Mauretania* at the Prince's Landing Stage in Liverpool before the war. The colourisation shows a more accurate, if still not perfect, tint on the ship's funnels. (Author's Collection)

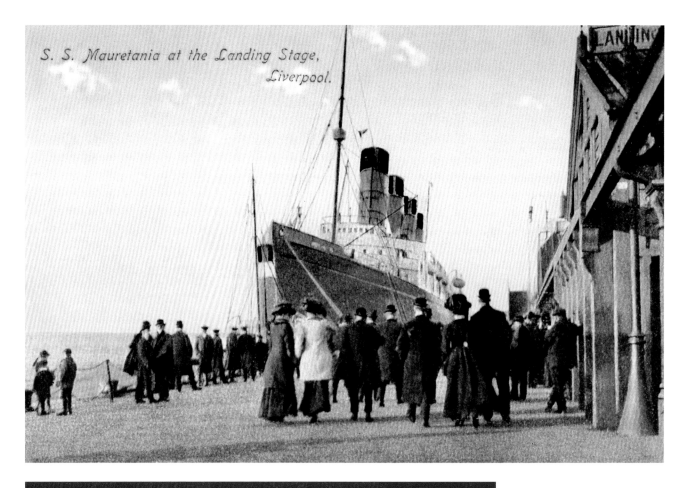

S. S. Mauretania at the Landing Stage, Liverpool.

The cover of a Cunard brochure advertising their transatlantic services via Fishguard, which the *Mauretania* inaugurated in August 1909. (Steven B. Anderson Collection)

THE CUNARD LINE
FROM NEW YORK TO
LONDON AND PARIS

VIA
FISHGUARD

This colourful cover of a Cunard passenger list features artwork by C.E. Turner. (Mike Poirier Collection)

The cover of a Mauretania menu showing the Cunard and British flags entwined, appropriately enough, with a blue ribbon. (Mike Poirier Collection)

This colourised photo postcard shows a rare and historic moment: the *Mauretania* (left) and *Lusitania* (right) together in Liverpool. The two ships were together between 5 and 14 October 1909, unusual since they were normally at opposite ends of the same Liverpool–New York route. The photo was likely taken around 14 October, when the *Lusitania* was departing dock preparatory to leaving on her next crossing, which began on 16 October. The *Mauretania*'s next crossing began on 23 October. (Author's Collection)

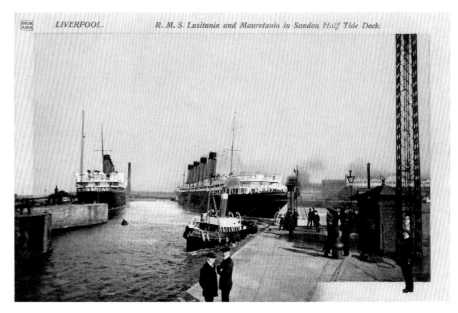

A postcard release of W. Fred Mitchell's fine painting of the *Mauretania* at speed on the open sea. (Author's Collection)

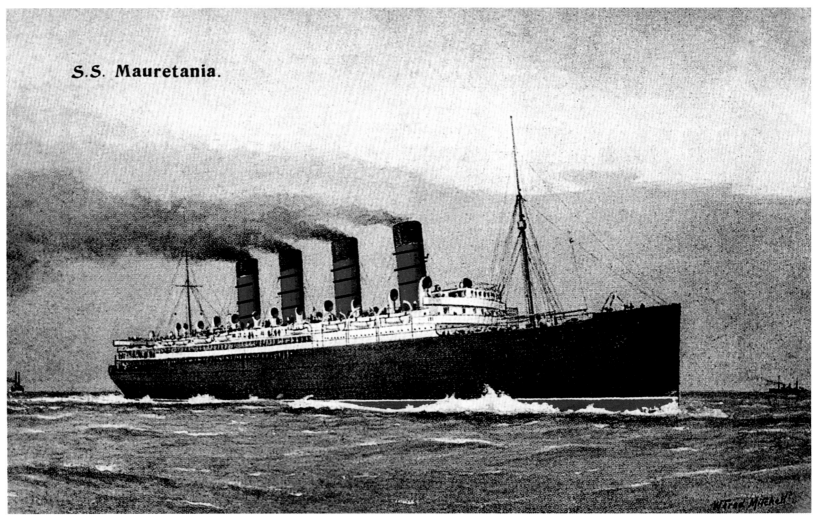

S.S. Mauretania.

A unique piece of artwork graces the cover of this 1910 Cunard booklet. (Mike Poirier Collection)

The cover to a 1910 supplement to the *Cunard Daily Bulletin* printed every day on board Cunard ships. In this view, a finely dressed Edwardian woman stands on the deck of a tender approaching the *Mauretania*. (Ioannis Georgiou Collection)

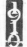

Right: This 16 May 1913 Third Class menu shows the selections Steerage passengers had to choose from during a typical crossing. Today, the hearty and simple fare presented for Third Class passengers has broader appeal than some of the delicacies offered to First Class passengers of that period. (Eric Sauder Collection)

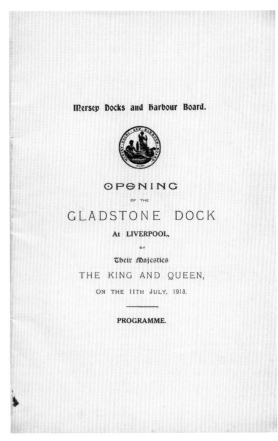

Far right: The cover for a programme of the 11 July 1913 royal visit to open the Gladstone Dock in Liverpool. (Author's Collection)

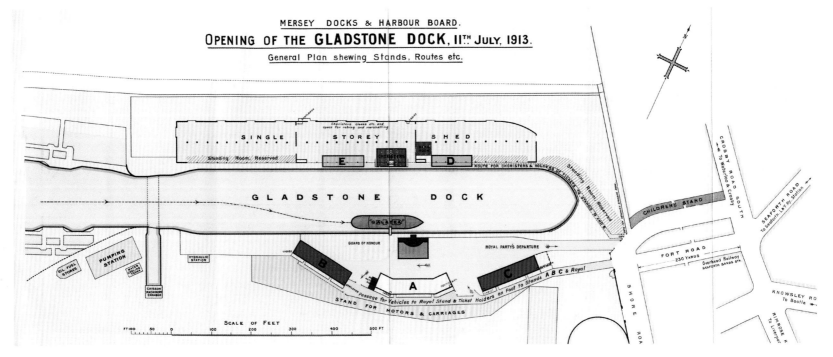

This foldout map was contained within the programme. It shows the Gladstone Dock, as well as the intended path of the Galatea and the royal party, as well as the location of the various grandstands. (Author's Collection)

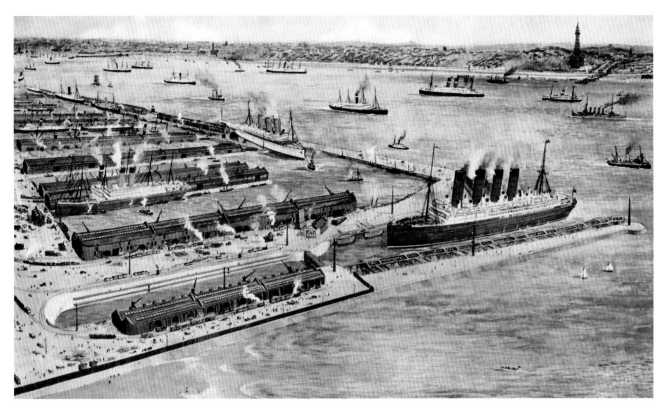

This artist's conception included in the programme shows the Gladstone docks as they were intended to appear when completed. The *Mauretania* can be seen in the foreground, while on the opposite bank of the Mersey the New Brighton Tower is visible. (Author's Collection)

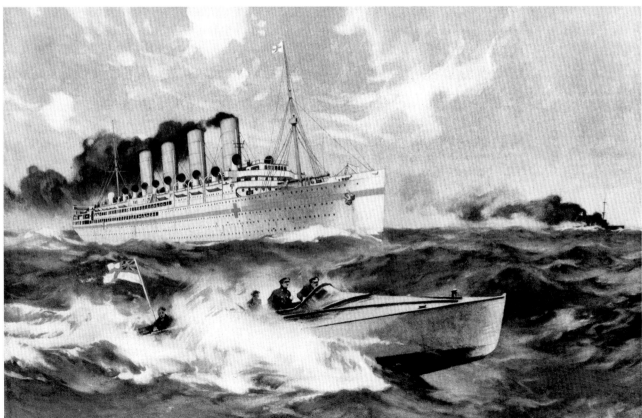

A C.M. Padday painting showing the *Mauretania* in her guise as a hospital ship in late 1915 or early 1916. (Ioannis Georgiou Collection)

A painting by Burnett Poole showing the *Mauretania* sporting the so-called 'dazzle' camouflage created by marine artist Norman Wilkenson in 1917. The liner sported two distinct patterns of dazzle paint during the war, neither of which was identical on both sides of the ship. This painting shows her second scheme, adopted in the summer of 1918. Some period colourisations show dazzle-painted ships sporting bright colours, which would have defeated the idea of camouflaging the ship's direction and speed; in reality, the schemes were rendered in less overt shades of duller blues, greys and olives. (Jonathan Smith Collection)

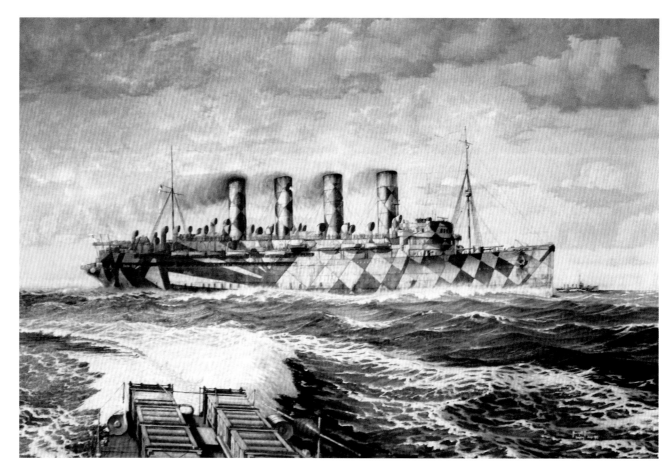

The *Mauretania* in the Trafalgar Dry Dock at Southampton during the early 1920s. A vent added during the 1922–23 refit is not visible in this photo, and the railway car in the foreground is labelled LNWR, a company that went out of business in 1923. Note that many of the ship's lifeboats have been removed in the course of this work. (Jonathan Smith Collection)

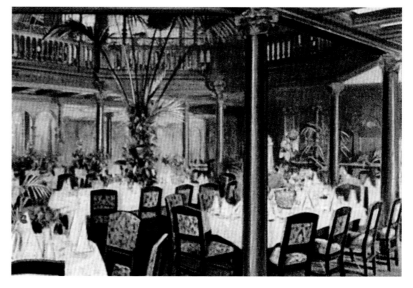

This Churchman Cigarette view shows the First Class Dining Saloon in colour after the 1922 refit and its introduction of movable chairs. The photograph this view is based on was also released as a photo postcard. Note the restraining chains under each seat, which prevented them from travelling too far from their intended locations during storms. (Author's Collection)


Form No. W/I 55.

MESSAGE FOR DELIVERY (Westbound).

THE CUNARD STEAM SHIP COMPANY LIMITED.

WIRELESS DEPARTMENT.

S.S. MAURETANIA Date 2 8 MAY 1925

PREFIX.	NUMBER.	NUMBER OF WORDS.	RECEIVED.		
			From	Time	By
			NSH	2119 F	

OFFICE OF ORIGIN Cleveland Ohio

SERVICE INSTRUCTIONS

CHARGES.

TOTAL

Everett Hill S. MAURETANIA NSH

Welcome home to the whole hill family from entire rotary club of Cleveland but particularly from members of houseclub exclusive committee who realise

THIS VESSEL IS IN TELEGRAPHIC COMMUNICATION WITH ALL PARTS OF THE WORLD THROUGHOUT THE VOYAGE.


WIRELESS DEPARTMENT.

S.S. MAURETANIA Date

PREFIX.	NUMBER.	NUMBER OF WORDS.	RECEIVED.		
			From	Time	By

OFFICE OF ORIGIN

SERVICE INSTRUCTIONS 2

CHARGES.

TOTAL

More & more everyday in every way that a great international president is the biggest aid in making the sixteenth international convention the greatest ever held by Rotary

George Miller

THIS VESSEL IS IN TELEGRAPHIC COMMUNICATION WITH ALL PARTS OF THE WORLD THROUGHOUT THE VOYAGE.

153RD ANNIVERSARY INDEPENDENCE DAY. **89TH ANNIVERSARY CUNARD LINE.**

CUNARD LINE

IN CELEBRATION OF THE

4th JULY

ON THE ATLANTIC OCEAN

The cover of the 4 July 1929 dinner menu, the contents of which are found on page 128. (Author's Collection)

A 28 May 1925 telegram sent to the *Mauretania* from George Miller and other members of the Rotary Club of Cleveland, Ohio. It was addressed to Everett Hill, then president of the club, and his family as a welcome home. Preparations were then underway for the 16th International Convention of the Rotary Club, which was held in Cleveland 15–19 June 1925. (Author's Collection)

This colour-tinted stereoview dates to around late 1929 or early 1930. It shows the *Mauretania* at Southampton, with the *Majestic* on the other side of Ocean Dock. (Jonathan Smith Collection)

CUNARD
EXPRESS SERVICE

This cover of a Cunard Express Service brochure shows the *Berengaria* (left), *Aquitania* (centre) and *Mauretania* (right). These three ships maintained the pride of Cunard's transatlantic service throughout the 1920s and 1930s. (Steven B. Anderson Collection)

The cover of the 3 August 1932 passenger list for her sailing from New York to Southampton. She had only fifteen more transatlantic crossings before her career came to an end. (Author's Collection)

A colourised photograph of workmen painting the hull of the *Mauretania* white in May 1933. The image was used as the cover for *Shipping Wonders of the World*. The colours used are not an accurate depiction of the actual colours of the funnels and a green paint was added below the waterline during the process, not the red seen here. Clearly the project is incomplete, as is evidenced by the jagged edge of the line between the white upper hull and the hull below the waterline. During this project, the foremast was painted brilliant white, while the overhead of the open Promenade Deck was painted pale green. (Ioannis Georgiou Collection)

The cover of an advertisement for Cunard cruises from New York to the West Indies and South America. The 9 March, 23 March and 6 April 1934 twelve-day cruises are being advertised and, after those, the ship would only make an additional five cruises before returning to England for the last time. (Russ Willoughby Collection)

This photo was taken on the starboard wing of the *Mauretania*'s Bridge in August 1924. Cunard's Southampton manager, Charles Cotterell, shakes hands with Captain Rostron. (Ioannis Georgiou Collection)

This mid-1920s view shows the *Mauretania* in Cherbourg Harbour, passing the breakwater. (Ioannis Georgiou Collection)

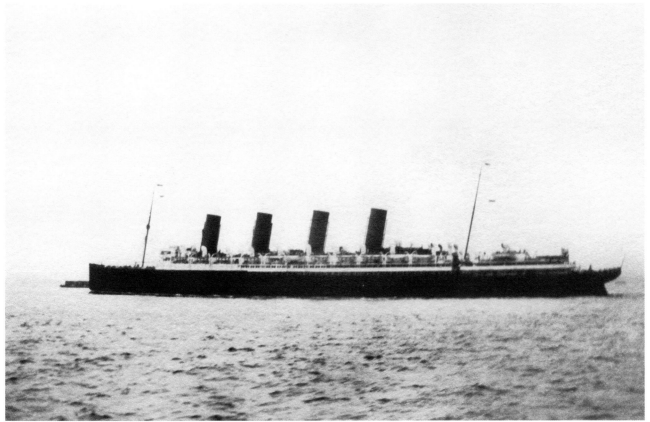

This early 1925 view shows Alexander P. Moore, American Ambassador to Spain, his niece Miss Mildred M. Martin and Miss Elizabeth Kendall of New York on the *Mauretania*. (Ioannis Georgiou Collection)

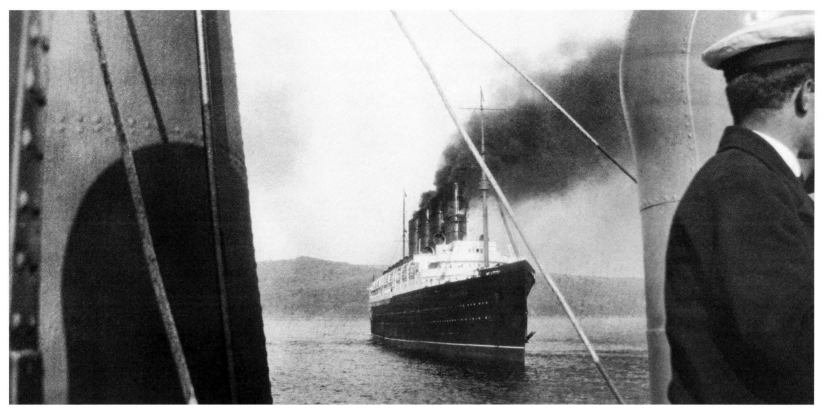

This image, taken between 1924 and 1926, shows the *Mauretania* in Plymouth Harbour, likely as seen from the deck of a tender. The liner is anchored using her starboard anchor, while her port anchor is partially extended. (Ioannis Georgiou Collection)

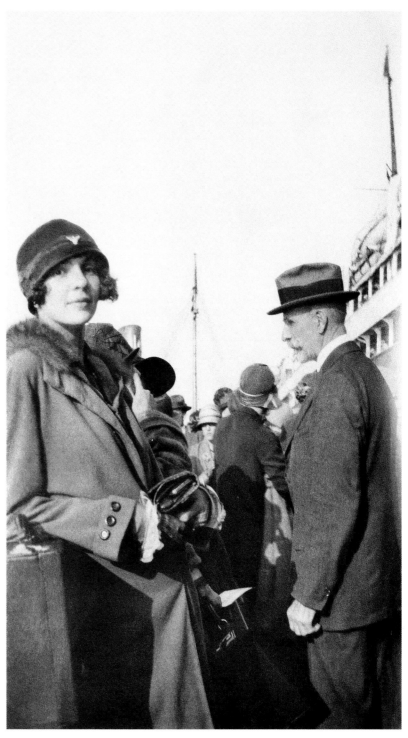

The first of a pair of original photographs, taken at Southampton in the mid to late 1920s, showing people staring up at the mighty *Mauretania*. (Ioannis Georgiou Collection)

The second photo of the group shows well-dressed passengers on the quay with the foremast and forward funnel of a second liner visible just behind. (Ioannis Georgiou Collection)

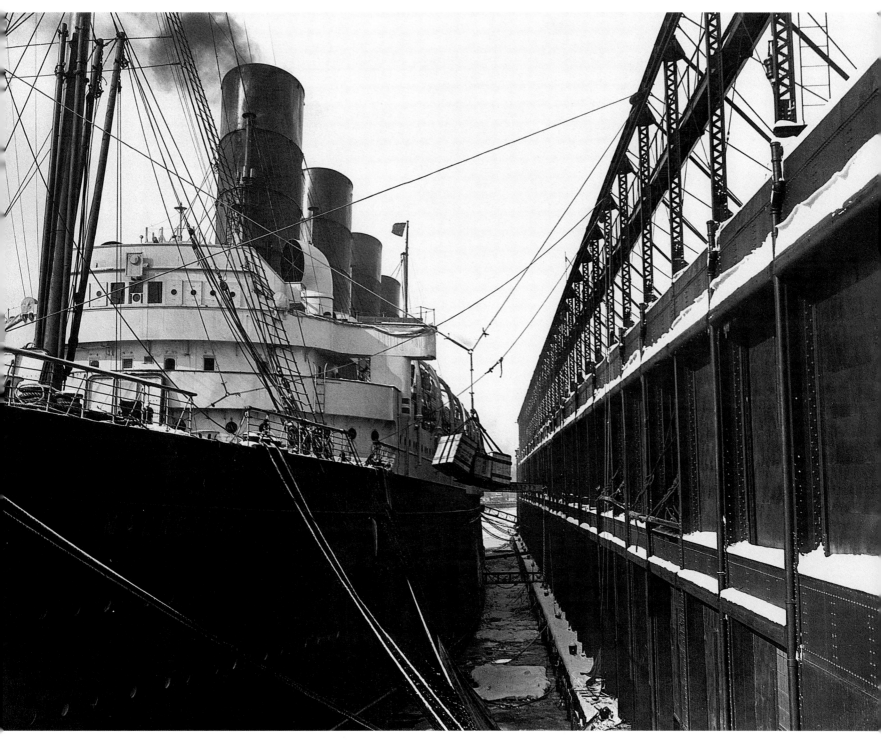

This winter-time photograph shows the *Mauretania* tied up to the Cunard pier in New York, with a bundle of cargo in mid-air between ship and shore. Fresh snow is visible on both the pier and the decks of the ship. The protective covers are firmly in place on most of the Bridge windows, a sure indication of the strength of winter storms on the Atlantic. (Clyde George Collection)

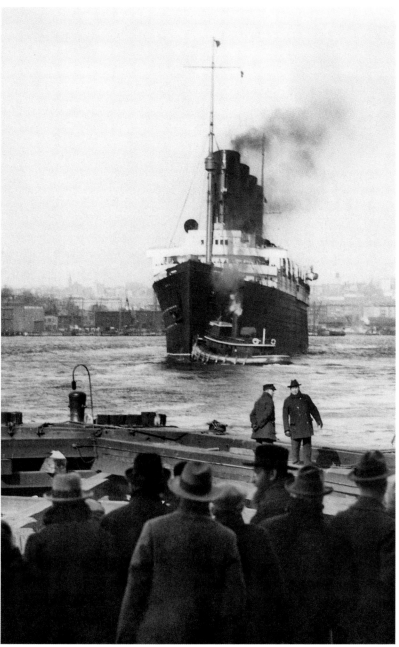

An atmospheric and well-composed original photograph of the *Mauretania* at dock in New York. The shape of the brim on the lady's hat indicates that the photo was likely taken in the mid to late 1920s. The ship's name is visible at the bow, and the cargo hatch on the forecastle is open. (Author's Collection)

A mid-1920s view of the *Mauretania* departing from her New York pier. The tug at her bow is beginning to push her nose to starboard so she can steam down the North River toward the open ocean. (Steven B. Anderson Collection)

This spectacular aerial view, taken by the Airmap Corporation of America, shows the *Mauretania* departing New York between 1924 and early 1929. She is still in the Upper Bay, with Governor's Island visible in the near background and lower Manhattan visible on the upper left. Ahead of her lies the Narrows, the Lower Bay and then Sandy Hook, the starting point of her eastward voyage. The photograph was shown at the French International Photographic Salon in 1929 and won top honours against other specimens of aerial photography. It was later featured in Cunard publicity material. (Library of Congress, Prints & Photographs Division; Author's Collection)

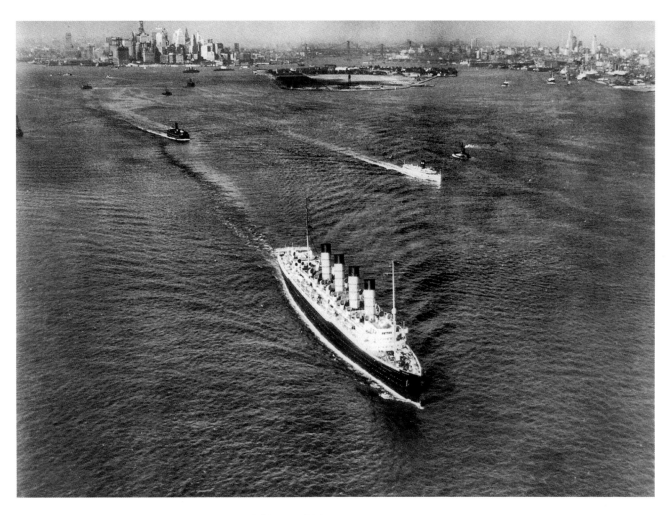

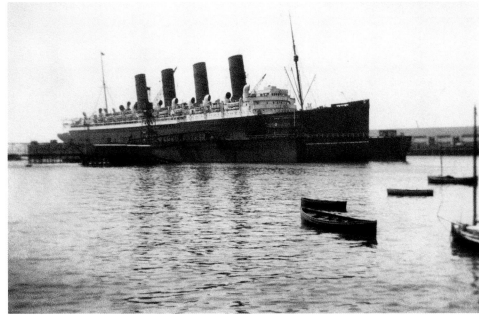

The *Mauretania* in Southampton's floating dry dock during the mid 1920s. The ship is seen here halfway between being fully out of the water and being afloat. (Ioannis Georgiou Collection)

This splendid aerial photograph taken at Southampton dates from 8 January 1926. On the left side of Ocean Dock are Cunard's *Mauretania* and *Berengaria*; on the right side are White Star's *Olympic* and *Majestic*. Sandwiched between the *Berengaria* and *Majestic* is the White Star liner *Homeric*. (Ioannis Georgiou Collection)

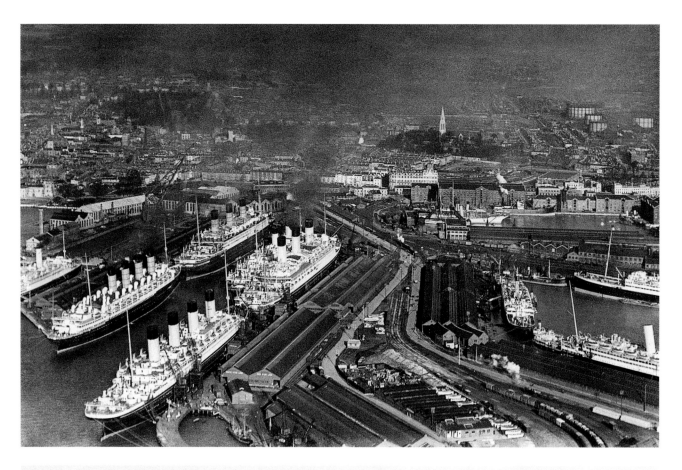

This late 1926 or early 1927 view shows the *Mauretania* in Liverpool for the first time since the war. She was there for an extensive overhaul, during which much of her passenger accommodation was upgraded to compete with newer liners. (Author's Collection)

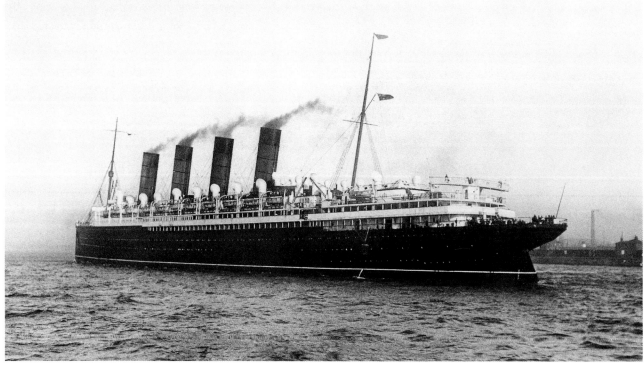

CUNARD LINE

See Your Local Agent

"He waited an extra week to cross on the Mauretania"

(An eavesdrop from The Ritz)

"He" is of the travel-wise from The Avenue who prefer the MAURETANIA for:—

Her speed . . . she holds the world's records;

Her Passenger List . . . including many of one's friends and acquaintances;

Her menu . . . an irresistible story of expert chefs and fine food.

And . . . the genial cosmopolitan atmosphere of her exquisite salons . . . her new luxurious staterooms with beds and private baths . . . and of course the perfect service from her British stewards . . . are three other and three excellent reasons why smart and seasoned travellers are willing to wait to travel on the MAURETANIA.

THE MAURETANIA SAILS
May 25 · June 15 · July 6

TO PLYMOUTH, CHERBOURG SOUTHAMPTON

1840 · EIGHTY · SEVEN · YEARS · OF · SERVICE · 1927

This 1927 advertisement was aimed at American travellers, and specifically mentions the *Mauretania*'s 25 May, 15 June and 6 July sailings from New York. Her speed, her clientele and her fine cuisine are prominently listed as reasons why the wisest passengers were willing to wait an extra week just to cross on the *Mauretania*. (Author's Collection)

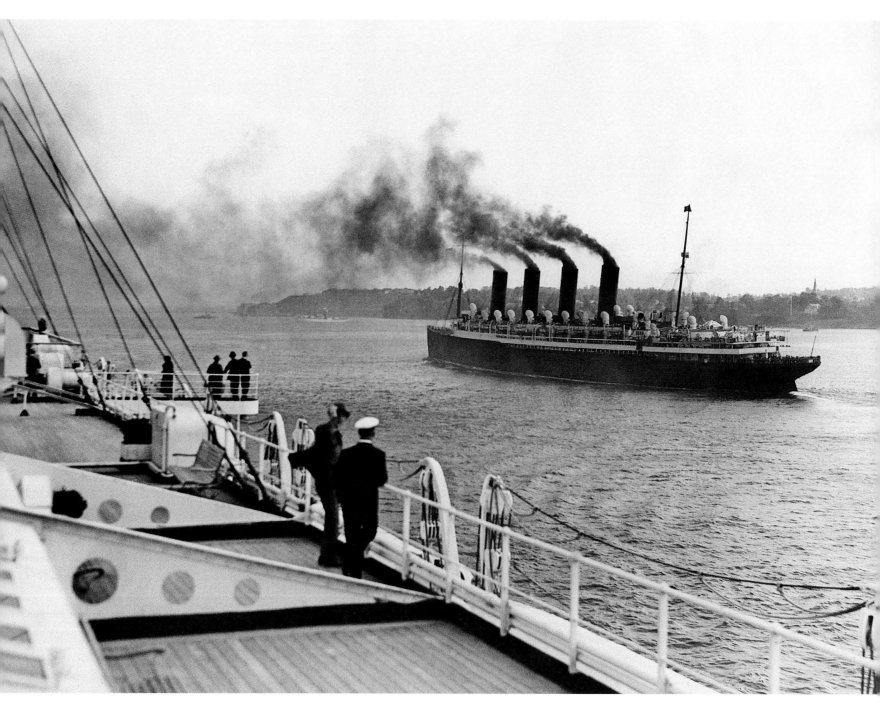

This photograph was taken on 3 February 1928 and shows the *Mauretania* departing Southampton on her first sailing of that year. It was taken from the deck of an inbound liner, showing that, even after two decades of service, the mighty liner could still turn heads as she passed. (Author's Collection)

CHANGING TIMES, CHANGING ACCOMMODATIONS

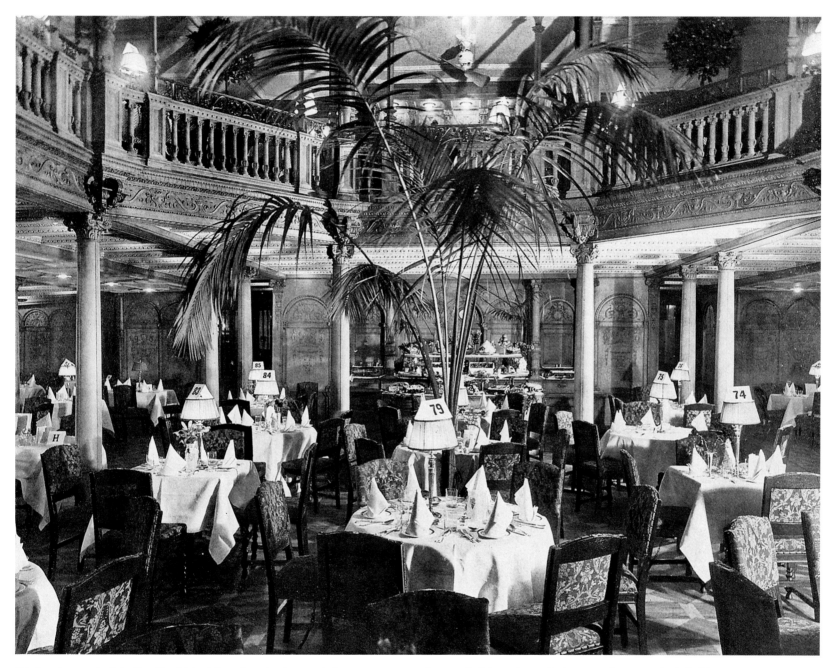

This fine photograph of the First Class Dining Saloon shows just how much the room's seating configuration had changed since she first entered service. Individual tables are much smaller, for fewer people at each, and the chairs are no longer bolted to the decks. Lamps are sitting atop each table, and a large palm fills the central well between upper and lower levels. (Ioannis Georgiou Collection)

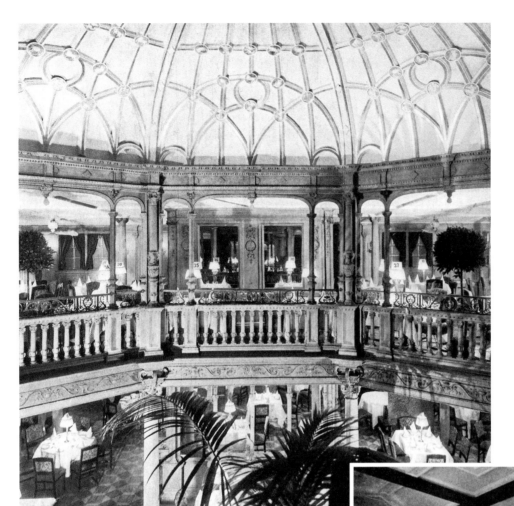

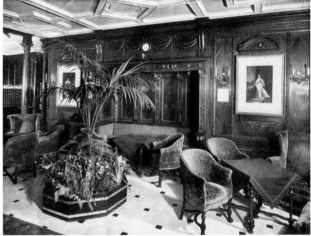

This 1920s view shows the first-class entrance on A Deck. There is more floral interest than in 1907, as well as tables and chairs. The portraits of the King and Queen hanging on the wall are a memento of the 1913 royal visit in Liverpool. On the extreme left of the photo, on the starboard side, a sign announces the presence of a branch office of the London, City & Midland Bank, which was installed in 1920. According to the *The Bankers Magazine* of October 1920, branches were also opened on the Cunarders *Aquitania* and *Imperator* at about the same time. (Ioannis Georgiou Collection)

Looking down from the upper level of the First Class Dining Saloon, both the changed table locations and the large palm are clearly visible. Note the extra level of railing mounted atop the original wooden balustrade surrounding the central well. Another interesting change since 1907 is the numerous ceiling fans visible on the upper level. (Ioannis Georgiou Collection)

This later view of the entrance, looking forward and to starboard, shows wicker chairs instead of the more solid furniture visible in the previous photograph. There is also a profusion of potted flowers and trees. (Ioannis Georgiou Collection)

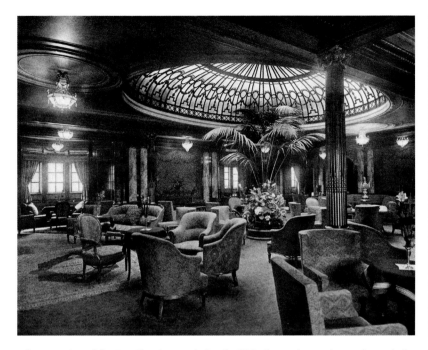

A fantastic view of the First Class Lounge during the 1920s shows a large palm tree beneath the dome. (Steven B. Anderson Collection)

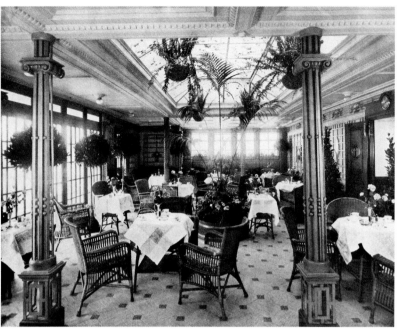

This 1927 or later view shows the First Class Verandah Café after its major redecoration. The room is a tremendous improvement over its 1907 self. The new wooden floor, specially designed for dancing, differentiates the room from its appearance during the first half of the 1920s, where the original wooden decking from the Boat Deck ran inside. The need for a dance floor in this location, where dancing would not disturb passengers below, seems to indicate late night dancers in the Lounge or on the enclosed Promenade Deck may have been an irritant to passengers trying to sleep in cabins below. (Ioannis Georgiou Collection)

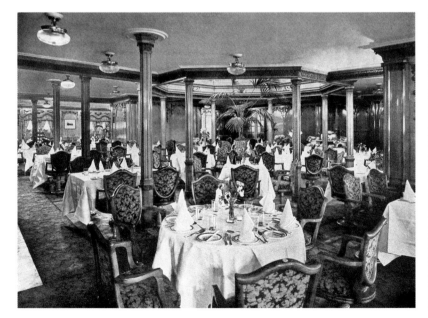

A fine mid-1920s view of the Second Class Dining Saloon. (Steven B. Anderson Collection)

A Cunard publicity photo of the third-class foyer during the 1920s. The space had undergone dramatic improvements since 1907, and now had flowers, wicker chairs and what was termed a 'well-stocked shop'. (Steven B. Anderson Collection)

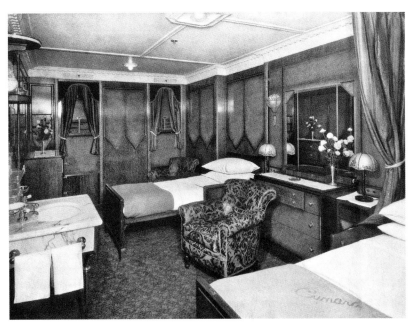

One of the B Deck cabins available later in the ship's career, No. 107, shows tremendous improvement in space and amenities over the ship's 1907 offerings, including hot and cold running water, an adjoining bath, built-in closet, and generous shelf space. (Ioannis Georgiou Collection)

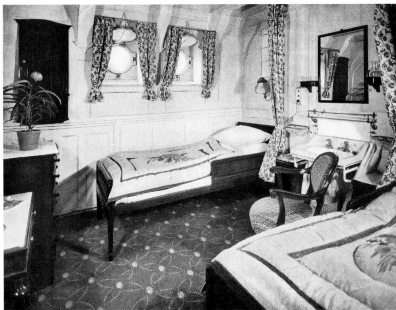

On D Deck, formerly E Deck, came the most dramatic changes in passenger accommodation during the 1926–27 overhaul. Although not as lavishly decorated as the cabins on decks above, they were pleasant rooms and among the largest offered on any ship at the time. (Ioannis Georgiou Collection)

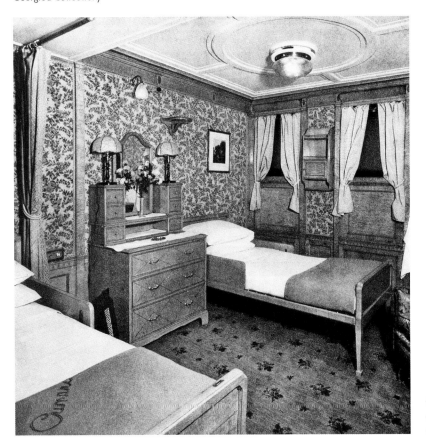

Cabin B-105 was also heavily remodelled during the 1926–27 overhaul. Its decoration was quite different to B-107, featuring silk tapestries on the wall, but offered similar amenities. (Ioannis Georgiou Collection)

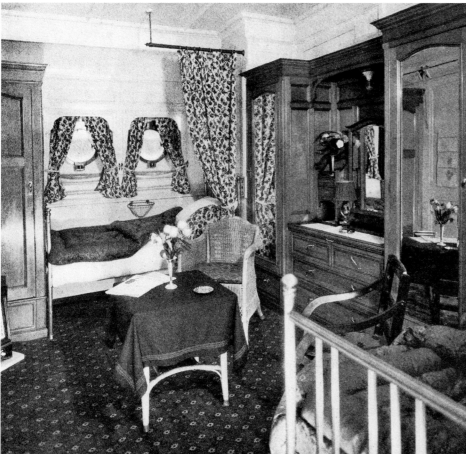

Cabins on C Deck, such as this one, were also heavily remodelled and offered a pleasant sitting area. (Ioannis Georgiou Collection)

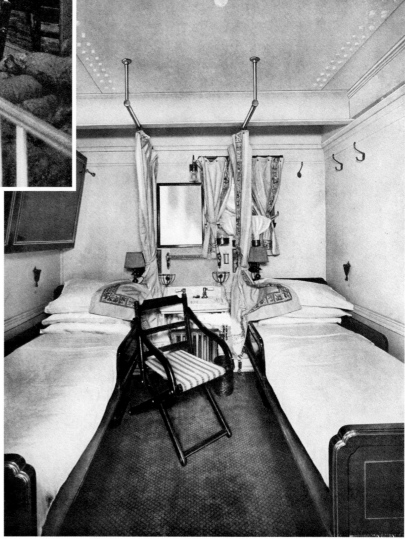

A second-class cabin also shows some improvements over 1907 offerings, including running water. (Steven B. Anderson Collection)

A programme for the 3 July 1929 concert held in the Third Class Dining Saloon. The programme belonged to Miss Clara Ledecky, who was scheduled to sing the eighth song that evening. (Author's Collection)

CONCERT

Held on Board

R.M.S "MAURETANIA"

Captain—S. G. S. McNEIL, R.D., R.N.R.

IN THE THIRD CLASS DINING SALOON, On Wednesday, July 3, 1929, at 9.00 p.m.

Chairman - MR. RUSSELL O'HARA

PROGRAMME

1. Overture
 THE "MAURETANIA" ORCHESTRA

2. Viola Soli
 MR. F. RITTENER

3. Song
 MISS MILDRED SCHUMACKER

4. Impersonations
 MR. PRATT

5. Song
 MRS. R. TUDGOR

Chairman's Remarks ♪ ♪ Collection

6. Dance
 JOSEPHINE and BARBARA HOUGHTON

7. Piano Solo
 MISS MILDRED WORELL

8. Song
 MISS CLARA LEDECKY

9. Recitation
 MISS VLASTA VESELY

10. Song
 MISS EMILY HLEDIKOVA

A third-class menu from 4 July 1929, celebrating not only the American anniversary of independence, but also the 89th anniversary of the Cunard Line's operation. The menu's left page is signed by Miss Ledecky's table companions. The *Mauretania* had begun her last month as the speed queen of the North Atlantic. (Author's Collection)

INDEPENDENCE DAY.

R.M.S. "MAURETANIA."

THURSDAY, JULY 4, 1929

MENU

Turtle Soup Georgia	Cream California

Boiled Salmon—Hudson Bay

Ribs of Beef Western Style
Roast Vermont Turkey - Cranberry Sauce
Beans Saute—Louisiana
Boiled and Roast Idaho Potatoes

Martha Washington Pie	Iced Pears Manhattan
Fresh Fruit	Ice Cream
Rolls and Butter	Coffee

Third Cabin

A fine view of a tender at Plymouth, just off the starboard side of the *Mauretania*, during the 1920s. (Steven B. Anderson Collection)

A rare perspective likely taken from the Crow's Nest atop the Foremast, looking down on the Bridge and starboard Bridge wing. The officers standing on the wing are wearing their summer whites, and passengers are enjoying fine, sunny weather from the forward edge of the Boat Deck. (Steven B. Anderson Collection)

Looking aft from the starboard wing of the Bridge over the Boat Deck c. 1929. The ship is making excellent speed, but a fresh breeze is still curling the smoke emanating from her funnels to starboard. (Author's Collection)

Yet nothing could last forever. During 1926, Cunard began to explore the idea of replacing its current 'Big Three' superliners – *Berengaria*, *Aquitania* and *Mauretania* – with two new ships. The concept took some time to develop, and in the meantime the German Norddeutscher Lloyd Line had set its sights squarely on the *Mauretania*'s long-standing speed records. It began building two 50,000-ton superliners, eventually named *Bremen* and *Europa*, each of which would boast roughly 100,000 horsepower and was very likely to be a record breaker. Cunard delayed placing an order for its new ships until it was sure of how stiff the competition from the *Bremen* and *Europa* would be. In October 1928, it was said that the '*Mauretania* cannot be expected to retain the Atlantic speed much longer, and the [Cunard Company] directors wish to have their new ship take her place as the fastest liner in the world.'[47]

About three weeks later, the *Mauretania* endured a severe punishment at the hands of the North Atlantic. While east-bound to Plymouth from New York on her last voyage of the season, she encountered a gale that tossed the ship about like a child's toy; a number of passengers 'were cut and bruised by being thrown against the furniture'. At the peak of the storm, the ship 'was confronted by a towering wall of water which bore down on her like a tidal wave'. One passenger later recalled: 'The mass of water rushing towards us looked even higher than the *Mauretania*'s funnels. I had visions of the water pouring down her four smoke-stacks. I just held on for dear life as the tidal wave approached.' When it struck, some of the lower cabins were flooded out, but no serious damage was done and the ship managed to arrive in port only half an hour late, having made an average speed across of 25.04 knots.[48]

Over that winter, Cunard laid up the *Mauretania* in the floating dry dock at Southampton. With the certainty of a challenge to her supremacy as the 'world's fastest ship' coming in 1929, it implemented a plan that would, it was hoped, give her a fighting chance at retaining the title. Over the course of seven weeks, 1,000 men were employed aboard. There was the usual battery of cleaning and renewing her interior spaces, and the installation of a new bar between the First Class Lounge and Smoking Room. More importantly, down below, some 'secret' improvements to the ship's power plant and auxiliary machinery were being carried out. Captain Sandy McNeil, in command of the ship since 1928, later said that during the course of this work, 'our condensers had been thoroughly overhauled, pumps reconditioned, and a small job carried out in two of the turbines'.[49] Rotary feed pumps were installed in place of the older reciprocating ones, which would allow for faster steam condensation and quicker feeding of water back to the boilers, thus enabling the ship to 'retain for days a head of steam which she has hitherto only possessed for short bursts of a few hours'.[50]

The advantages of the improved condensers and feed pumps in producing greater speed are obvious; the exact details of the 'small job' done on the turbines are not. But the cumulative effect of these changes was profound. As originally built, the *Mauretania* was designed to produce a nominal 68,000 horsepower. On her trials in 1907, she had made 78,000 at 188rpm, propelling her at 26 knots. After these improvements, her engines were capable of producing 90,000 horsepower. The ship's engineers felt confident that, with favourable conditions, the liner could attain 28 knots and possibly more.

When the ship resumed service on 2 January 1929, her new capabilities were kept under wraps. On her sixth round-trip transatlantic voyage that year, starting on 13 July, her crew must have been anxious; the *Bremen* was to begin her maiden west-bound crossing three days later. As Captain McNeil guided his ship west, the voyage was 'marvellous'. He had 'never experienced more perfect weather for getting the utmost possible speed out of a ship'. Yet Cunard had not yet given permission to bare the *Mauretania*'s teeth. Meanwhile, the *Bremen* steamed hard on the Cunarder's heels. When the *Mauretania* docked, she had averaged 25.35 knots – 'only steaming at easy full-speed'.[51] It was a wasted opportunity. The *Bremen*, enjoying the same favourable conditions, reached the Ambrose Channel Light at 3.02 p.m. on 22 July, boasting an average speed of 27.83 knots and handily taking the Blue Riband from the ageing liner.[52]

It was a moment reminiscent of 1897, when the *Kaiser Wilhelm der Grosse* had captured the Blue Riband from the British; it was especially difficult for all of those who had grown to love the *Mauretania* for her nearly twenty-two years of magnificent service. Showing grace in the face of defeat, Captain McNeil immediately sent a congratulatory telegram to Captain Ziegenbein of the *Bremen*, and to his crew: 'Captain McNeil, officers and ship's company of the steamship *Mauretania* heartily congratulate you on your record passage and wish you every success.'[53] He even visited the *Bremen* to congratulate Herr Ziegenbein in person. But when the *Mauretania* departed New York on 24 July, her captain and crew 'had something to think about on our passage back to Southampton'.[54] The *Mauretania* made a

respectable 25.58 knots to Cherbourg, but the *Bremen*, again chasing in the *Mauretania*'s wake, took the east-bound Blue Riband with a 27.9-knot average crossing to Plymouth.

When news of the *Bremen*'s west-bound victory had broken in England, the Cunard line told the press: 'There will be a great surprise soon.'[55] During the *Mauretania*'s turnaround in Southampton, Cunard gave Captain McNeil and his crew permission to do 'what was reasonable' to see what they could get out of her revamped power plant. As the liner set out across the Atlantic, Chief Engineer Andrew Cockburn must certainly have been eager to comply. However, this west-bound crossing was plagued with weather that was not conducive to setting records.

Mauretania averaged 26.4 knots down to Cherbourg on Saturday 3 August; departing the French port, she quickly worked up to 205rpm despite the weather. This was about 10rpm more than the ship had ever turned before, yet Cockburn informed McNeil that all was well. By noon Sunday she had steamed 498 miles at 26.11 knots since leaving Cherbourg. On Monday she logged another 680 miles at 27.2 knots; McNeil remembered that this news was 'greeted with loud cheers' from the passengers. Noon Tuesday logged another 687 miles at 27.48 knots, but during that day the wind freshened again, and the liner entered the Gulf Stream, which retarded her forward progress. By noon Wednesday, she had covered 676 miles at a flat 27 knots. The final run to the Ambrose Lightship was made against a head sea, at 26.9 knots. She had covered the 3,162 miles at an average speed of 26.90 knots – 0.93 knots slower than the *Bremen*'s record crossing, but a personal record.

The return trip began when she passed the Ambrose Lightship at 1.57 a.m. on Friday 16 August; up to noon, she averaged 26.85 knots. She made 611 miles at an average of 26.56 knots to noon Saturday, despite very rough conditions. By Sunday, she had logged 630 miles at 27.4 knots. On Monday, it was raining and the noon position was calculated by dead reckoning, coming out to 634 miles at 27.56 knots. Captain McNeil told Chief Cockburn that he hoped to achieve 28 knots the next day. The chief's response was that everything was 'cool as butter' down below, despite the fact that she was making 22rpm more than her previous best. On Tuesday, she had travelled 636 miles since noon the previous day, at 27.65 knots. Everyone was delighted; even the *Bremen* sent a 'most cordial' message on her performance. She made the final run to the Eddystone lighthouse, of 344 miles, at 26.92 knots, forced to slow because of squalls while sailing through waters which were busy with fishermen. Her average

speed for the 3,098-mile trip was 27.22 knots. Again, it was a personal best, but again it was shy of the *Bremen*'s record. Her average for the full round trip was 27.06 knots – an especially impressive performance considering the poor weather she had encountered. She then put on a burst of speed headed to Cherbourg, occasionally touching 32 knots,[56] and turning in an outstanding average of 29..76 knots. When she reached Cherbourg, she had set a record average time from New York to Cherbourg via Plymouth.

During the trip from Plymouth to Cherbourg, a press correspondent stood beside Captain McNeil on the Bridge. As the two men talked:

the *Mauretania*'s graceful bow struck through the sea like a clean, keen blade, while on either side scudding waves rushed by.

Without the slightest tremor the *Mauretania* was travelling at 30½ knots – as fast as any big vessel except a battleship could travel. Faintly came the hum of the great engines and the sound of the wind in the rigging. But for the churned foam in her wake there was no indication that the great liner was travelling at anything but a normal speed. A coin which I placed on the bridge rail did not move an inch, so smoothly was the *Mauretania* traveling.

Captain McNeil smiled, his blue eyes sparkling despite the fact that he had only slept seven hours during the east-bound trip. He said: 'And she is 22 years old. Can you wonder that I, her skipper, am proud of her? Is there another ship in the world that could rush along like this without the slightest vibration? She is the most beautiful ship afloat, and I and every member of my crew cannot help being filled with pride when we realise what she has done, what she is doing, and what she is likely to do.' He also promised that 'with good luck and with good weather' *Mauretania* would soon cross the Atlantic faster than ever before. He admitted that the *Bremen* was a 'fine, well built ship' but said she wasn't 'half as beautiful as the *Mauretania*', which he called 'the most exquisite thing on the sea – fast, and nearly as graceful as any yacht'. Her passengers praised her performance, saying that the 'old lady is still a wonderful ship'.[57]

Steaming up toward her Southampton berth, the *Mauretania* showed no desire to slow up, nearly swamping two seaplanes that would shortly take part in the Schneider Trophy contest.[58] At Southampton, the *Mauretania* received a warm welcome: numerous vessels blew their sirens and

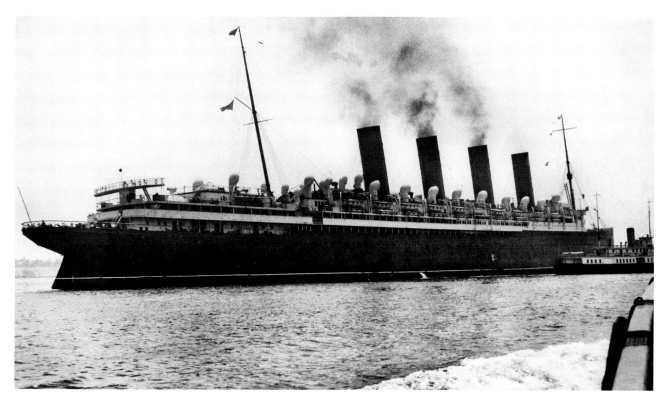

This 8 August 1929 photo shows the *Mauretania* at Quarantine Station in New York harbour, having just failed to recapture the Blue Riband from the *Bremen*. (Author's Collection)

Captain Sandy McNeil keeps a steady eye on the horizon from the Bridge of the *Mauretania*. (Author's Collection)

Captain McNeil on the starboard Bridge wing, being filmed by newsreel reporters after the *Mauretania* finished the best round-trip voyage average of her career. (Author's Collection)

hundreds of people cheered from the quayside.[59] The *Mauretania* could no longer lay claim to any records of being the world's largest, most luxurious or fastest ship, but during her career she had become perhaps the most beloved ship in the world. Her failure to regain the Blue Riband was certainly through no fault of her own and, in fact, it almost seemed to endear her to the public.

The following night, at 10.00 p.m., Captain McNeil did a radio interview with the BBC from the South Western Hotel, only a quarter of a mile from where the *Mauretania* was docked. McNeil had a radio receiver placed on the Bridge, with one of the officers listening in to the interview. As he signed off, McNeil told listeners that he would call out to the liner and tell her to say good night 'like a good girl' by sounding her whistle three times. The officer heard this and sounded the whistle. The sound was picked up in the hotel and broadcast throughout England; people living on the outskirts of Southampton 'heard the whistle through the wireless first, and, then, through their open windows, coming direct from the docks'. It was an 'effective climax to the interview and much enjoyed by listeners'.[60]

Behind the scenes, Cunard's plans for replacement tonnage that would best the new German liners' threat evolved; by the end of May 1930, they announced that John Brown & Co., which had built the *Lusitania*, would construct the first of the new ships. When her first keel plate was laid on 1 December 1930, her hull number was 534: she would eventually be named *Queen Mary*.

Meanwhile, *Mauretania* continued her career; after the record-setting August voyage, she seemed content to turn in solid performances as opposed to record-breaking ones. But 29 October 1929 became the day that would forever be known as 'Black Tuesday'. It was the day that the roaring twenties came to a bitter end; it was the day the music stopped. The stock market crash on Wall Street started the Great Depression, and greatly altered the future of ships like the *Mauretania*.

On Thursday 28 November, the *Mauretania* departed New York just before midnight with 870 passengers on board. As she began to move toward open water, she happened across a tug pulling a double railway car float owned by the Pennsylvania Railroad. Captain McNeil signalled that they were keeping to their side of the river; there was no response from the tug. Again the *Mauretania* signalled, at which point the tug replied that she was continuing her course across the river – that she was going to cross the *Mauretania*'s bow. The harbour pilot stopped engines, but Captain McNeil countermanded by ordering 'full astern port' and putting the helm over hard to starboard. The liner's prow began to swing to port, but they were too close by that point. The *Mauretania* rammed the second float at a speed of about 4 knots, damaging her stem and some of her bow plates. Some of the passengers who had not yet retired felt the trembling motion of the impact, and came out on deck to see what was happening, but there was no alarm. The liner then anchored off Quarantine.

At daybreak, she returned to her pier, where fifty workmen from the Todds Shipyard Corporation were already waiting for her. A new hull plate, 12ft by 6ft, was bolted on and made tight, with 'cement boxes being fitted on the inside'. These temporary repairs allowed the ship to leave with only a twenty-four-hour delay, and they held through to the end of the season, at which time full repairs were made during her annual overhaul.[61]

Yet a turning point had been reached in the *Mauretania*'s career. The proud ship remained in service but, with the world economy faltering badly, passenger numbers on the North Atlantic quickly began to dwindle. She would, therefore, make more cruises to tropical ports of call. Henceforth, she would no longer be chasing Blue Riband records on the Atlantic among younger and more powerful competitors. She would instead be set the task of chasing the sun.

NOTES

1 *Washington Herald*, 27/8/1919.

2 *New York Times*, 30/10/1919.

3 *The Sun* and *New York Herald*, 9/5/1920.

4 *New York Times*, 3/10/1920.

5 *New York Tribune*, 13/6/1921.

6 White Star Dock, opened in 1911, was built to accommodate

large White Star liners such as the *Olympic* and *Titanic*. It was renamed 'Ocean Dock' in 1922 to reflect the fact that Cunard had switched its English terminus to that port.

7 *Commodore*, James Bisset, p. 137.

8 *Commodore*, James Bisset, p. 137.

9 *In Great Waters*, Captain S.G.S. McNeil, Chapter 15.

10 *Daily Express*, 26/7/1921.

11 *In Great Waters*, Captain S.G.S. McNeil, Chapter 15.

12 *Commodore*, James Bisset, pp. 137–142.

13 *Commodore*, James Bisset, p. 140.

14 *In Great Waters*, Captain S.G.S. McNeil, Chapter 15.

15 *In Great Waters*, Captain S.G.S. McNeil, Chapter 15.

16 *Evening Telegraph*, 8/9/1921; *Lancashire Evening Post*, 8/9/1921; *Aberdeen Journal*, 9/9/1921.

17 *Shipbuilding and Shipping Record*, 1/9/1921 (courtesy of Ralph Currell).

18 *Commodore*, Bisset.

19 *American Shipping Magazine*, 22/4/1922; *Marine Engineer and Naval Architect*, April 1922 (courtesy of Ralph Currell).

20 *New York Tribune*, 1/4/1922.

21 *Marine Engineer and Naval Architect*, April 1922 (courtesy of Ralph Currell).

22 *American Shipping Magazine*, 22/4/1922.

23 *New York Tribune*, 1/4/1922.

24 *New York Times*, 2/5/1922.

25 *New York Times*, 1/8/1922.

26 *Daily Express*, 11/8/1922; *New York Times* and *New York Tribune* 19/8/1922; *New York Tribune*, 27/8/1922.

27 *New York Times*, 30/11/1922; *Columbia Evening Missoluian*, 1/12/1922.

28 *The Register*, 16/5/1923.

29 *Daily Express*, 3/4/1924.

30 *Daily Express*, 24/12/1923.

31 *Daily Express*, 4/3/1924.

32 *Nambour Chronicle and North Coast Advertiser*, 3/12/1926.

33 *Cairs Post*, 15/8/1924.

34 *Cairs Post*, 15/8/1924.

35 *The Register*, 7/7/1924.

36 *Cairs Post*, 15/8/1924.

37 It is important to note that at no time did the *Leviathan* hold the Blue Riband because her time from Cherbourg to New York was the best. The trophy for the Blue Riband is based on average speed; additionally, *Mauretania*'s records before the war west-bound were made from Queenstown, not Cherbourg, over a somewhat different course. So while the *Leviathan* held the west-bound time record between Cherbourg and New York for a time, she did not hold the Blue Riband.

38 *Daily Express*, 27/8/1924.

39 Humfrey Jordan and some sources put this trip at four days, nineteen hours flat at an average speed of 26.16 knots. Most figures released in the press at the time of the crossing and for years afterward were of an average speed of 26.25 knots, not the 26.16 recorded by Jordan. Further research on this obvious discrepancy is worthwhile. *Binghamton Press*, 17/8/1929; *Mauretania: The Ship & Her Record*, Aylmer; *New York Sun*, 26/8/1924; *New York Times*, 27/8/1924; *Daily Express*, 27/8/1924; *Daily Mirror*, 26/8/1924; *Nambour Chronicle and North Coast Advertiser*, 3/12/1926.

40 *The News*, 22/11/1924.

41 *Daily Mirror*, 25/11/1933

42 *Daily Express*, 19/3/1925.

43 *Daily Express*, 15/11/1924.

44 *Daily Express*, 3/7/1930.

45 *Princeton Alumni Weekly*, 14/4/1926.

46 *Shipbuilding and Shipping Record*, 10/2/1927 (Contributed by Ralph Currell); *Morning Bulletin*, 2/4/1927; *Townsville Daily Bulletin*, 6/4/1927.

47 *West Australian*, 29/10/1928.

48 *Daily Express*, 14/11/1928.

49 *In Great Waters*, McNeil, p. 229.

50 *Sydney Morning Herald*, 23/3/1929; *The Mercury*, 20/3/1929.

51 *In Great Waters*, McNeil, pp. 228–9.

52 *Evening Tribune*, 22/7/1929.

53 *Montreal Gazette*, 23/7/1929.

54 *In Great Waters*, McNeil, p. 229.

55 *Toledo News-Bee*, United Press, 23/7/1929.

56 *Daily Express*, 22/8/1929.

57 *Glasgow Herald*, 22/8/1929.

58 *Daily Express*, 22/8/1929.

59 *Glasgow Herald*, 22/8/1929.

60 *In Great Waters*, pp. 235–6.

61 *Shipbuilding and Shipping Record*, 9/1/1930 (Courtesy Ralph Currell); *In Great Waters*, McNeil, pp. 243–4; *Daily Mirror*, *Daily Express*, *Montreal Gazette*, 29/11/1929.

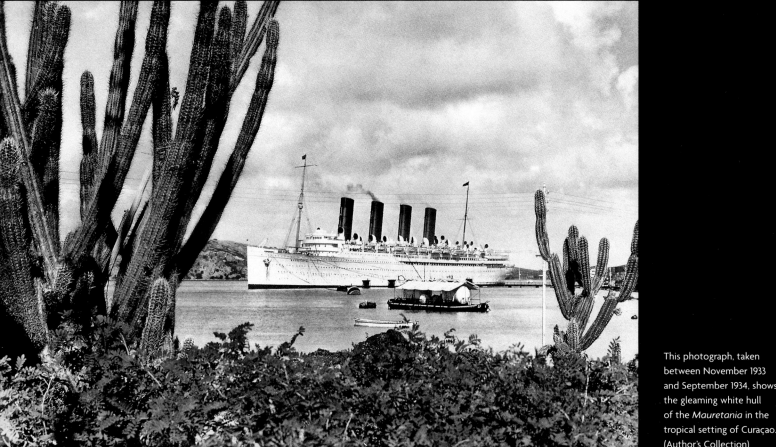

This photograph, taken between November 1933 and September 1934, shows the gleaming white hull of the *Mauretania* in the tropical setting of Curaçao. (Author's Collection)

On 12 February 1930, after a tempestuous crossing to New York, the *Mauretania* started out on her first cruise to Havana, Cuba. Captain McNeil said that he had 'seen many ovations to ships on their arrival in port, and New York, as a general rule, easily takes first place in enthusiasm and generosity. But when the *Mauretania* reached Havana on Saturday February 14th, 1930, a general holiday was declared, and no celebrity ever landed in New York to the accompaniment of half the enthusiasm that greeted the *Mauretania* on her arrival in that old-world harbour.' A million people lined the entrance to the port to watch her pull in, and the Cubans, 'whose eye for feminine beauty is well known, appreciated the fact that the liner is a lady, and they were unstinting in their praises of the graceful lines of the *Mauretania*'.[1] The president of Cuba held a special banquet in honour of Captain McNeil and the ship's officers. The liner returned to New York on 17 February, and three days later began her last 9,549-mile Mediterranean cruise.

Fuelling in Southampton around 1930. (Jonathan Smith Collection)

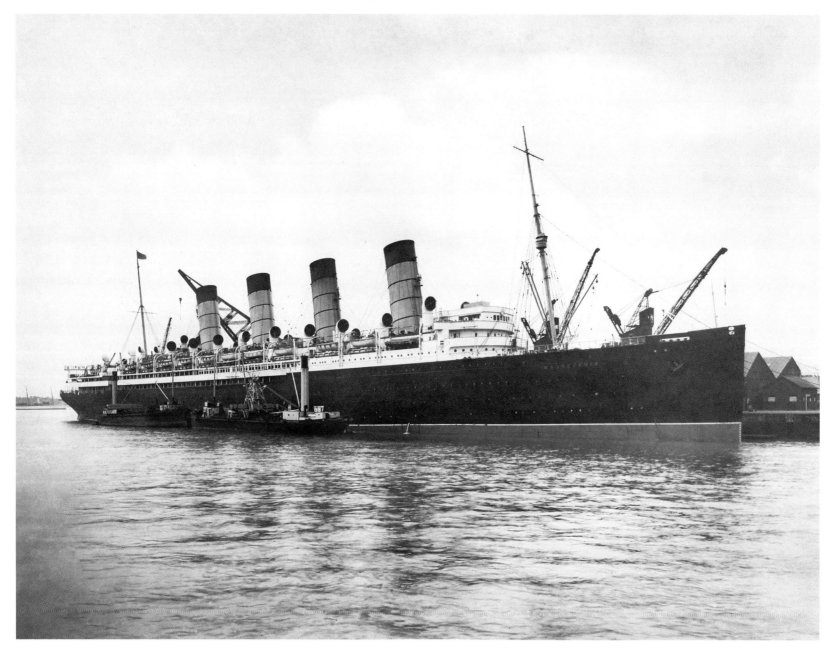

In late August, the *Mauretania* and the new *Europa*, then holder of the Blue Riband, left Southampton together. The *Mauretania* beat her into Cherbourg by a full mile – if she couldn't beat the Germans all the way across the Atlantic then at the very least in short bursts she could still give them quite a run for their money.[2]

In the early morning of 19 November 1930, while west-bound for New York, a distress call was received from the Swedish freighter *Ovidia*. The *Mauretania* was then 230 miles away, and proceeded to steam at full speed for her; four other ships, which were much closer, also answered the distress call, but the *Mauretania* beat them to the scene. The freighter had a heavy list and was clearly not long for the surface. When the *Ovidia*'s captain decided to abandon ship, Captain McNeil manoeuvred in close and managed to rescue all twenty-seven crew members, the captain's wife and the ship's cat. Then he resumed course for New York.[3]

In December 1930 and January 1931, the *Mauretania* pulled off another impressive feat: two round-trip voyages to New York and back in the space of one month instead of the usual five-and-a-half weeks. This was not accomplished through record steaming, but instead through quick stays in port – including turnarounds in New York of only twenty-three hours each. It was said that in this, the 'Old Lady of the Atlantic' had 'beaten all her much younger competitors'.[4]

When the *Mauretania* sailed from New York on Saturday 14 February 1931, she carried three very famous passengers: Captain Malcolm Campbell, who then held the land speed record; jockey Steve Donoghue; and silent film comedian Charlie Chaplin. Chaplin had just finished his film *City Lights*, a project he had worked on since 1927; he had composed the score for and edited the film himself, and it had debuted in January as a commercial success. It was later remembered as one of his finest films. While on board, he wirelessed ahead to confirm that he had decided to push up the British release by a week, so that it would debut in London on 27 February.[5] Chaplin and Campbell became shipboard friends during the crossing, and the comedian joked about his severe seasickness, which kept him from most of the gala dinners, from the cinema showing of Captain Campbell's Campbell-Napier-Railton Blue Bird, and from almost all other events outside his stateroom. 'I have the idea that the way sailors overcome illness is to tighten their belts. I am now wearing mine under my armpits,' he said.

When the *Mauretania* arrived in Southampton in the evening of 20 February, she 'gave a sigh and came to rest' on

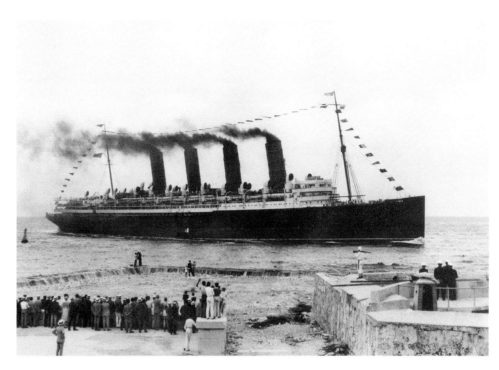

The *Mauretania* entering Havana Harbour, Cuba, for the first time on 12 December 1931. Spectators came out in force to greet the legendary ship. The liner is dressed in salute. (Steven B. Anderson Collection)

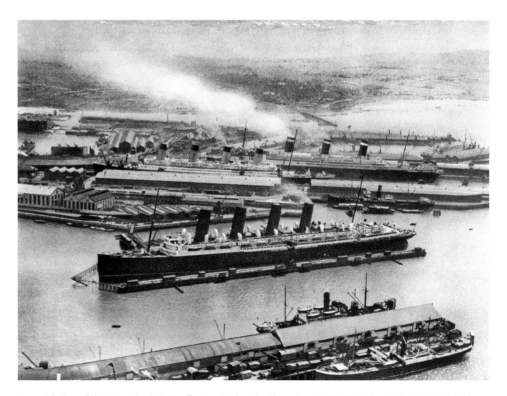

An aerial view of the *Mauretania* in the floating dock at Southampton in 1931. The *Olympic* is visible behind her, at left, while the *Leviathan* is on the right behind the *Olympic*. (Jonathan Smith Collection)

This photograph shows
passengers boarding the
Mauretania from a tender
during one of her cruises. The
aft swimming pool is in place just
forward of the Stern Docking
Bridge. (Clyde George Collection)

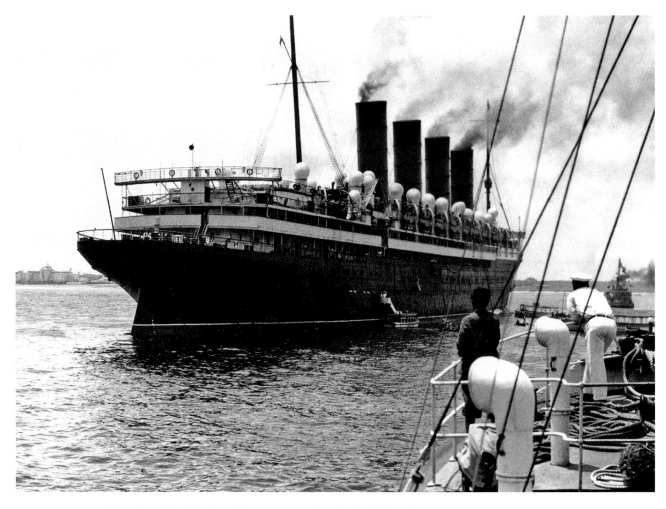

The *Mauretania* on one of her
tropical cruises, likely during 1931
or 1932. The ship is dressed in
salute to the port she is visiting,
and a passenger tender lies
alongside. The swimming pool
just forward of the Stern Docking
Bridge is clearly visible. (Ioannis
Georgiou Collection)

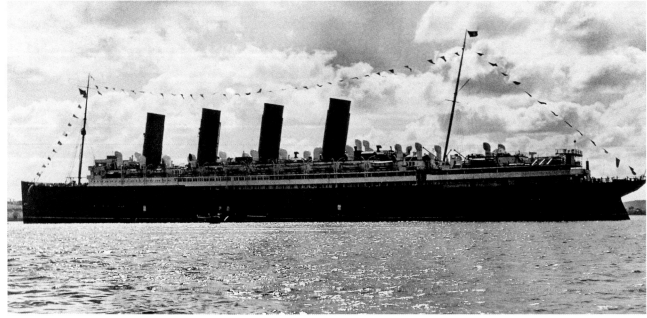

a mudbank of the West Bramble, between Cowes and Hurst Castle on a full ebb tide. The pilot and Captain McNeil tried to free the ship under her own power. 'First her engines were driven forward, and then in reverse. The mud was churned up all around her, stirring up the chocolate-coloured sea. But all without avail. The giant did not budge.' An hour later, two tugs came up and took the ship by the stern; together with the ship's engines, they tried to pull her off the bank, and the liner 'shivered and shook', but could not free herself. The Mayor of Southampton and a large party of dignitaries had formed to greet Captain Campbell and inform him that he had been knighted, so a tug was put out to bring him ashore. Only some time later did the *Mauretania* manage to free herself from the bank and pull in to her berth.[6]

In March 1931, Cunard announced that the *Mauretania*'s second-class accommodations would take on the designation 'tourist class' and would carry former tourist third-class passengers. Transatlantic crossings in tourist class cost less than £25 in either direction, even for outside staterooms.[7]

In the meantime, as the Great Depression dragged on, *Mauretania*'s transatlantic crossings were becoming fewer, and her cruises more frequent. In 1929, she had made twenty-nine crossings and a single cruise – on a par with her peak of thirty crossings during some of the pre-war years. Then, in 1930, she made twenty-eight crossings and two cruises; in 1931, her crossings declined to twenty-four, while her cruises increased to nine; in 1932, she made only twenty crossings and eight cruises.

Cunard was really at the forefront of using a great liner as a cruise ship, offering inexpensive, sun-drenched, exciting and alcohol-available cruises. Ordinary people who could never have afforded passage aboard the legendary liner in times past now had the opportunity of doing so. Captain McNeil, who retired in the summer of 1931, always enjoyed the cruises from

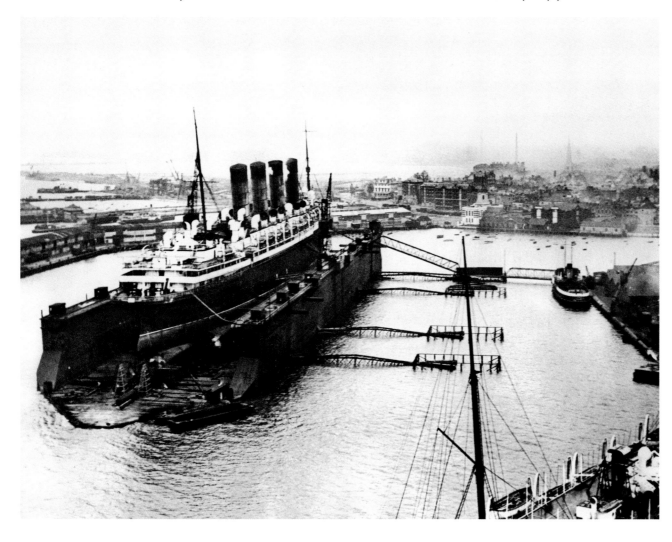

This February 1932 photo shows the *Mauretania* in the floating dry dock at Southampton from a unique perspective. (Author's Collection)

This view of the *Mauretania* in the floating dry dock shows the fine lines of her bow below the waterline. (Ioannis Georgiou Collection)

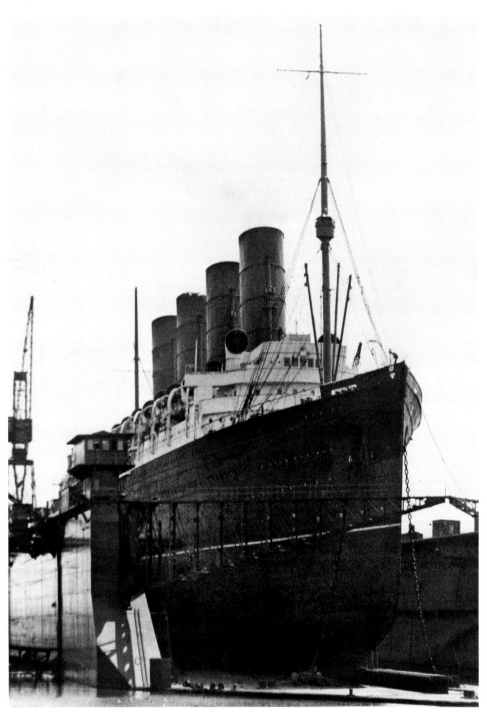

New York, finding them a change of pace from the 'steady grind' of transatlantic service. He recalled that although many newspapers disparaged these short tropical hops as 'booze-cruises' filled with revelry, there was 'little more drinking on these cruises than on ordinary voyages'.[8] Captain McNeil's successor, Reginald V. Peel, once told reporters that he was glad when the *Mauretania*'s cruising season finished, because he did not like running a thoroughbred at half speed. In order to avoid embarrassment, he reportedly took the ship outside the usual shipping lanes and 'skulked' along somewhat off the beaten path.[9]

In December 1931, Cunard announced a Whitsuntide cruise from Southampton to Gibraltar and back, from 14–19 May 1932. Accommodations would be made for first-class passengers only, and ticket prices for the six-day voyage would be a mere 8 guineas.[10] Within a month of the announcement, nearly every available berth had been booked for the trip.[11] In the event, the cruise was a wise choice; the weather in London was so poor on Monday 16 May that it was called a 'Whitsun-less' day; while thousands of people on the bank holiday crowded the British Museum, the Natural History Museum and any other indoor venue, *Mauretania*'s 836 passengers enjoyed warm weather as they cruised along the Spanish coast. The weather was so fine that 'pyjama dances were a feature of the evening entertainments'.[12] On the 1,166-mile outbound trip, the speedy liner loafed along at an average speed of 19.41 knots; on her return, she made the trip at an impressive average of 25.33 knots. It was a record passage from Gibraltar to Southampton by a merchant ship.[13]

On 19 October 1932, at the end of her operating season, the *Mauretania* became the first big liner to use the new Western Docks at Southampton. She was tied up there for the beginning of her annual overhaul, and by the end of November was in the floating dry dock for hull cleaning and maintenance.[14] The *Mauretania* departed Southampton on her next crossing to New York on 28 December and began a remarkable year of activity. However, her engines were now in the care of a new chief engineer, Edward Barton. Just before the liner returned to service, Chief Engineer Andrew Cockburn – a fixture aboard the *Mauretania* since he was first appointed to the post in September 1919 – had retired.

The 'cruise habit', as it was called, had 'taken England by storm' largely as a result of the Great Depression. Cruises worked for the steamship companies 'only by mass production', as individual ticket prices were much less expensive than before.[15] Cruise advertisements and articles promoting cruising read like a modern-day cruise brochure: 'The very essence of a holiday,' one article from May 1933 read, 'is, after all, freedom from care.' For that, the article continued, a cruise was the:

> ideal form of holiday ... For your fortnight's holiday the variety of choice in cruising delights is, figuratively

The first of six photographs from the *Mauretania*'s Whitsuntide cruise to Gibraltar, taken by passengers William Parker and his family, and shared for inclusion in this volume by William's great-grandson Roger Marks. This view was taken on 17 May while the ship was in Gibraltar, and shows the famous promontory behind her quartet of smokestacks. (Roger Marks Collection)

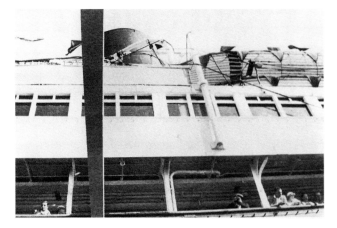

This view shows the *Mauretania*'s upper decks from a passenger tender. A fellow passenger at the ship's rail snaps a photograph, likely capturing the photographer of this image. (Roger Marks Collection)

Another shot from from the tender, this photo shows not just the starboard side of the ship, but also a number of local craft in the water nearby. (Roger Marks Collection)

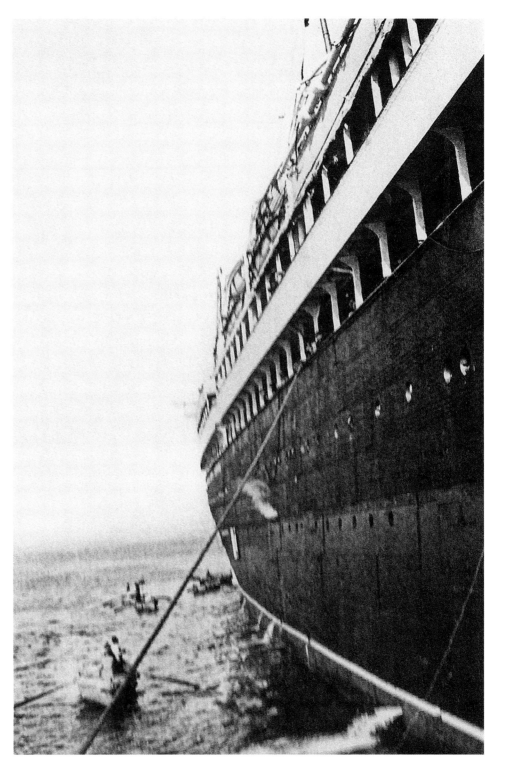

This photo, also taken from a passenger tender, shows the port side of the *Mauretania* and her aft three funnels. Well-dressed sightseers were enjoying a fine, warm holiday – unlike those who, due to poor weather, were scouring England for indoor venues of entertainment that same holiday. (Roger Marks Collection)

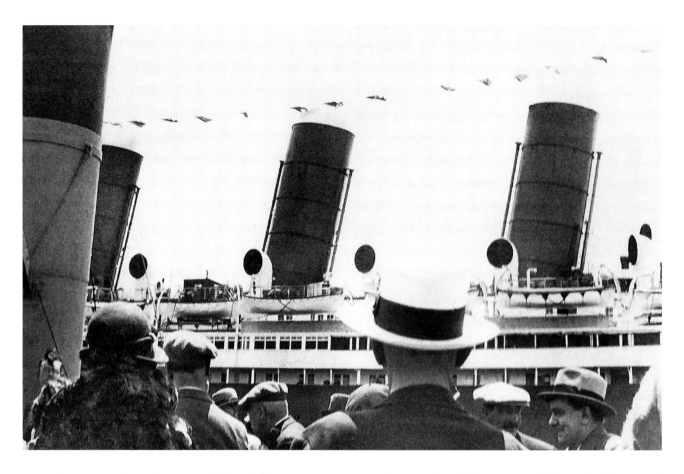

speaking, as wide as the sea itself. And if you can afford a holiday at all, you can afford a cruise. Think for a moment of the wonderful ease of a holiday of this kind. ... You take your hotel with you. Once on board and in possession of your state-room, your mind is free. The ship, and the efficient ship's company, do the rest.

That year, 1933, would prove to be the peak of the *Mauretania*'s cruising itinerary. Though she would make only four transatlantic crossings during the year, she made seventeen cruises, fifteen of them out of New York, and two from Southampton.

Cunard scheduled a pair of Whitsun cruises from Southampton – the first to Casablanca and the second to Madeira – that year. These required her to make an east-bound crossing from New York to Southampton in late April. She departed on 21 April, and upon arrival in Southampton, was dry-docked for maintenance. Then she tied up at the new Western Docks. During the refit, her appearance was indelibly altered in preparation for the season's remaining

tropical cruises: her hull was painted white, the bottom of her hull up to the waterline was painted green, the openings of her cowl ventilators were painted red, and 'the overhead on the promenade deck' painted pale green. The foremast was painted brilliant white, while her mainmast was painted white for its lower third, and black from there up to its peak. Her funnels continued to sport Cunard's house orange-red with black peaks, interspersed by black bands.[16]

The reason for this dramatic change in colours – a first for a Cunard liner in peacetime – was simple. Ships of the period were not air conditioned like modern cruise liners; cruising through tropical waters in brilliant sunshine, their black hulls became veritable ovens. It was said that engineers working for Cunard 'proved that the white ship is twelve degrees cooler than the one painted black'.[17] As the *Mauretania*'s schedule was for more cruising than crossing that year, the alteration was most timely. A pair of temporary canvas swimming pools had already been erected aft on her Tourist Class Boat Deck as early as 1932, and many passengers happily splashed away in those; but for those not in the pools, this measure would certainly

help them keep cooler. The paint scheme was deemed so successful on the *Mauretania* that it was soon repeated on the *Franconia* and the *Carinthia*.

When the *Mauretania* returned to service in her new paint scheme, Chief Engineer Barton had moved on to another assignment; in his place there was a new chief, William Sutcliffe. After the two Whitsun cruises from Southampton, the *Mauretania* made a west-bound crossing to New York. When she arrived in New York, Americans got their first glimpse of the liner's new paint scheme. As she lay off Quarantine in the gathering twilight that evening, one spectator said she was still beautiful, her 'narrow, yachtlike hull coated in fresh white paint from stem to stern, her four red and black funnels standing out against the sky'.[18]

Later that month, the liner showed that she still had a remarkable penchant for speed. When she left Havana on 19 July, her engines were unleashed, and by noon the following day, she had averaged 27.78 knots. Her best speed was made as she steamed north off the east coast of Florida: between Carysfort Reef Lighthouse, located in the vicinity of Key Largo, and Jupiter Inlet Light in Jupiter, Florida – a distance of 112 miles – she managed an average of 32 knots. Although her performance was certainly aided by the 3–4-knot northward flow of the Florida Current, this was truly impressive for a 26-year-old liner initially designed for a 25-knot service speed, and with roughly 3 million miles' steaming in her wake. The record east- and west-bound crossings then held by the *Bremen* were both less than 29 knots. One British newspaper even speculated that the *Mauretania* was 'being "trained" in secret' to win back the Blue Riband.[19]

The liner departed New York on 22 August on another West Indies cruise, under the command of Captain George Gibbons, but the trip was to prove unusual.[20] Shortly after clearing New York water, she steamed into the teeth of a gale with winds of 50mph. Captain Gibbons slowed to a mere 6 knots the following day, trying to ease the discomfort suffered by his 742 passengers.[21] After getting out of that storm, things seemed to be returning to normal; however, a tropical disturbance was forming north-east of the Windward Islands. As it moved west-north-west through the Turks and Bahamas, it began to gain strength and attained hurricane status by the afternoon of 28 August.[22] Its strength continued to grow, and with frightening speed; the lowest recorded pressure was 930mb, indicating that it topped out as a modern-day Category 5 storm, with estimated peak winds of about 140 knots. As the storm

A pillow fight in the forward of the two canvas swimming pools on the former Second Class Boat Deck. In the background, an officer can be seen chatting with a passenger on the Sun Deck over the First Class Verandah Café. (Roger Marks Collection)

Above: A group of passengers on the so-called 'Sports Deck', by the skylight to the Second Class Smoking Room, and just forward of the Stern Docking Bridge. William Parker is visible at left, with his sons John Parker (hands in his pockets) and Norman Parker (the young man in the middle). The photo was taken by John and Norman's brother from the roof of the Second Class Lounge. (Roger Marks Collection)

Right: This August 1932 photograph shows Chief Engineer Andrew Cockburn standing on the Sun Deck, just forward of the No. 2 funnel, with an unnamed passenger. Original photos like this, of the Chief Engineer on deck and posing for photos with passengers, are very rare. (Author's Collection)

very successful in reducing the ship's interior temperature by 7–9°C.[25] Her foremast was repainted in a darker colour. She returned to New York carrying fewer than 300 passengers through very rough seas.[26] When she docked, customs inspectors swarmed over the ship searching for smuggled liquor. No stone was left unturned; Captain Peel, Chief Surgeon G. Jameson Carr and Staff Captain Battle all watched as the inspectors went so far as to search the officers' and captain's personal quarters. All of this was in spite of the fact that repeal of Prohibition was less than two weeks away.[27]

As 1933 drew to a close, a paradigm shift was in the offing. For two years, Cunard had been interested in acquiring the White Star Line, which had fallen on hard times because of poor management and the ongoing effects of the depression; Cunard was in better shape than White Star, but had been

moved toward Cuba, it weakened slightly, but still wreaked havoc and caused considerable loss of life as it ran along the northern coast of the island and moved toward Havana.

The *Mauretania* was due to dock in the Cuban capital in the evening of Friday 1 September; she was approaching from the west even as the hurricane was striking the city that afternoon. Yet she could already feel the effects of the storm as early as Thursday. Captain Gibbons was able to 'keep dodging' the hurricane, keeping ahead of it with an easy speed of 17 knots until it had passed safely by. Once the storm had passed Havana, it continued west-north-west, regained strength, and made a run across the Gulf of Mexico for Brownsville, Texas, where it killed still more people.[23]

As the *Mauretania* steamed up to Havana on Friday night, the seas were so rough that it was deemed unsafe to dock there. A second attempt was made the next day, but sea conditions were still too dangerous. Meanwhile, the weather at Nassau in the Bahamas was also reportedly 'unfavourable'. Another hurricane was forming there, which would eventually cross the Straits of Florida and strike Jupiter, Florida. Because of the weather conditions, Captain Gibbons wisely decided to proceed directly back to New York.[24] The *Mauretania* was wholly unaccustomed to sailing through such punishing weather in the normally placid Caribbean.

On 27 September, the *Mauretania* crossed to Southampton, where she underwent an overhaul during October and early November. When she emerged from this, her white paintwork had been freshened; it had been found

This splendid 1932 photo was taken by the ship's on-board photographer. It shows a cluster of passengers along the forward rail of the Boat Deck during one of the ship's cruises. The photographer is standing on the Forecastle looking aft, while on the roof of the Bridge, a solitary crewman stands watch. (Author's Collection)

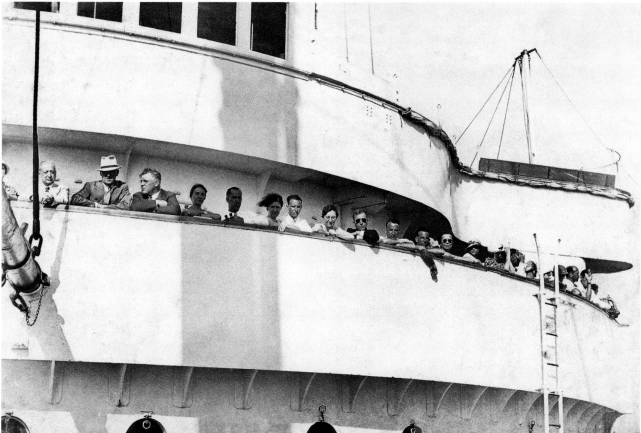

This photo was taken at roughly the same time as the preceding one but from a closer vantage point, and shows only passengers on the port side of the rail to the Boat Deck. (Author's Collection)

A striking photo, likely taken in 1932 by the *Mauretania*'s photographer. The *Mauretania* is framed by a pair of trees on the beach at La Guayra, Venezuela. The harbour lighthouse is visible to the right of the *Mauretania*'s stern. (Author's Collection)

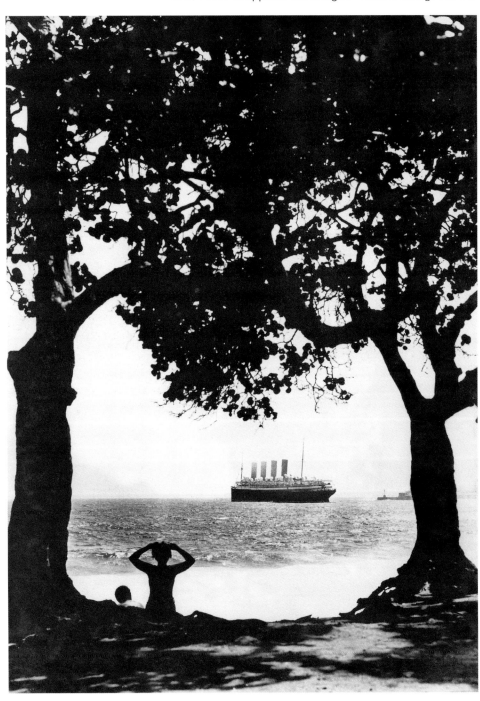

forced to suspend all work on its new superliner, John Brown Hull No. 534. The British government had become involved in negotiations to merge the two companies. By December, the merger talks were said to be nearing a successful conclusion.[28] On 20 March 1934, the directors of the Oceanic Steam Navigation Company, which owned the White Star Line, voted to approve the merger.[29] Cunard emerged as the dominant portion of the new company, holding 62 per cent of the controlling interest. Cunard-White Star Line, Ltd was registered on 10 May 1934, and it was quickly apparent that the newly amalgamated company needed to divest itself of some old tonnage in its ranks. This brought immediate speculation that the *Mauretania* – some years older than her fleet-mates *Aquitania*, *Berengaria*, *Majestic* and *Olympic* – would be the first to go. The ship was then scheduled for a 30 June departure from Southampton to New York for four months of cruising.

Before departure, newspapers reported that, after her upcoming series of West Indies cruises, the *Mauretania* would be scrapped.[30] However, Cunard-White Star officials in New York said that the *Mauretania*'s destiny was 'undecided and that so far as they knew the famous liner might continue in the service for some time'.[31] When the liner arrived in New York on 7 July, she looked 'spick and span' carrying some 650 passengers. Company officials again took the opportunity to deny the rumours. Captain Peel agreed that there was no foundation to the reports:

I have heard nothing to that effect. The ship has been in dry dock at Southampton and put into splendid shape for the cruises. Her hull and boilers are as sound as they ever were and there is lots of life in the *Mauretania* still. We discovered on the voyage over that all the windows of the public rooms had brass casements. During the war they were painted. Now we have removed the paint and any one can see for himself what a splendid brass job it was – stuff that is calculated to last a century.

No matter where you scrape the *Mauretania*, it is to find class and quality. She has better materials in her than any ocean liner ever built, and she's good for many years more if the company decides she shall be kept in the North Atlantic trade.[32]

Despite the denials, this was to be the last time that the *Mauretania* would arrive in New York at the end of a transatlantic crossing. She carried out five West Indies cruises from there, with the last one ending on 21 September. On 26 September, she sailed from New York for the final time; that same day, the new Cunarder *Queen Mary* was launched. The *Mauretania* arrived in Southampton on 2 October and tied up at the Western Docks. A company official admitted that 'for the time being, there is no employment for her and she is not scheduled to make any further voyages'.[33]

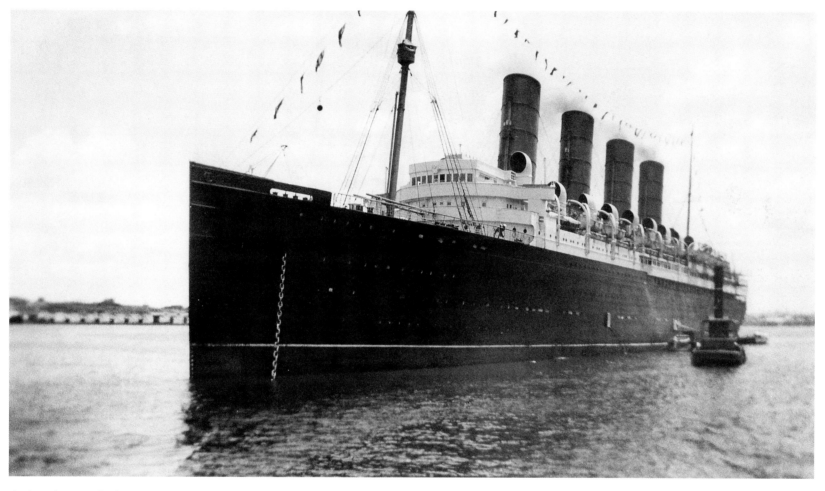

The first of a series of eight original photos from an album taken during the *Mauretania*'s 16–29 July 1932 cruise to the West Indies. This photo was taken on 21 July and shows the *Mauretania* at anchor in La Guayra Harbour, Venezuela. (Author's Collection)

A wonderfully unique view of the *Mauretania*'s stern, as seen from the tender at La Guayra, Venezuela on 21 July. (Author's Collection)

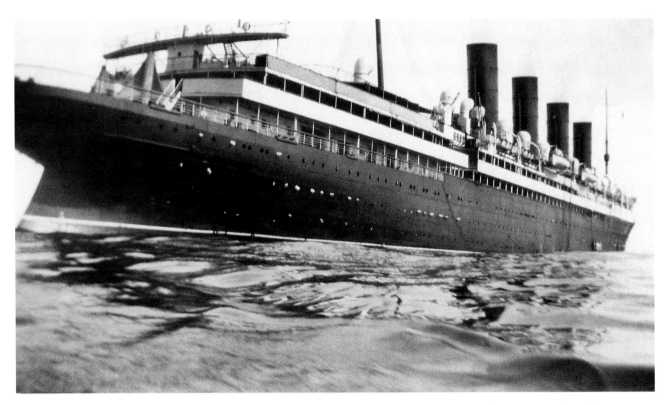

This rare photo overlooks the fantail. The photographer did not date the image but wrote a caption on the back which gives a tantalising glimpse of a noteworthy incident. The shot was taken 'the morning after we barely missed hitting a sail boat' and shows all of the crew's bedding and personal effects drying out from the resulting 'flood'. Even at 25 years of age, the *Mauretania* could cut a crash turn that left her crew's quarters drenched. (Author's Collection)

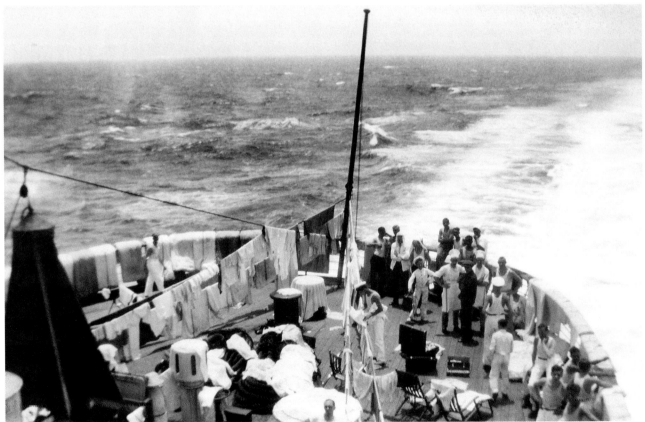

Passengers play shuffleboard beneath canvas screens erected over the deck to protect them from the sun. Contrary to some previous reports, even at this late stage in the ship's career the covers over her stern deck rails were stretched canvas, rather than steel plates. (Author's Collection)

This 27 July 1932 photo shows one of the girls from the group lounging on the Promenade Deck. (Author's Collection)

Taken from the roof of the Second Class Lounge, this 22 July photo shows a trio of crewmen who have just finished mending the smaller, forward swimming pool for passengers' use. The two portable wood-and-canvas pools on the aft Boat Deck proved very popular with passengers during the *Mauretania*'s cruising days; however, the reality was that they needed frequent maintenance and leaked almost as fast as they could be filled. The doors to the Verandah Café are wide open for ventilation, while in the background the fourth funnel towers above the decks. (Author's Collection)

Swimmers splash playfully in the aft pool on 22 July. (Author's Collection)

Left: Not quite in and not quite out of the swimming pool, this bather has perched on the corner of the pool's frame on 22 July. Behind her, passengers line the rails on the roof of the Second Class Lounge. The designers of the *Mauretania* could hardly have believed of such frivolities on board under a tropical sun when she entered service in 1907. (Author's Collection)

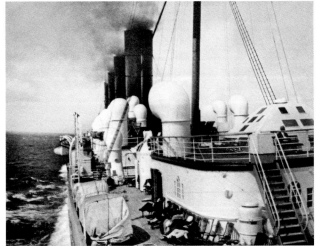

The first of eight photos excerpted from another private album in the author's collection. This set was taken during the *Mauretania*'s 3–9 September 1932 west-bound transatlantic crossing. This shot looks forward from the Stern Docking Bridge on the port side along the length of the Boat Deck. The *Mauretania* is making fine speed in clear weather, and is showing a bit of a lean to port at the moment the photo was taken. (Author's Collection)

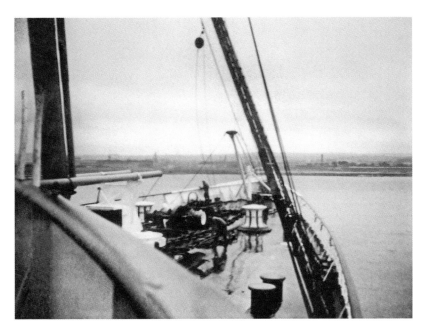

This photo was taken from the starboard side of the forward Boat Deck, and shows the port of Cherbourg, France, beyond the liner's Forecastle. It is 3 September; the ship had left Southampton just hours before. The decks are wet, either from rain or because the crew was washing them down. One crewman stands against the port side bulwark at the prow, while another is at work much closer to the photographer. (Author's Collection)

One of the most unique photographs ever taken aboard the *Mauretania*. The photographer daringly held his camera out through the porthole cabin on the starboard side and took this photo of the ship's hull as she cuts through the seas. (Author's Collection)

Overlooking the fantail and the wake of the *Mauretania* in the open sea. The weather looks fresh and cool; passengers are dressed warmly as they enjoy the sea air. (Author's Collection)

On 8 September, the last full day of the voyage, the *Mauretania* had encountered a strong storm. This photo was taken in the middle of the tempest, the photographer looking aft on the starboard side of the Second Class Boat Deck toward the Stern Docking Bridge. The decks appear deserted. It was a brave soul that would risk venturing out onto the decks in heavy weather. (Author's Collection)

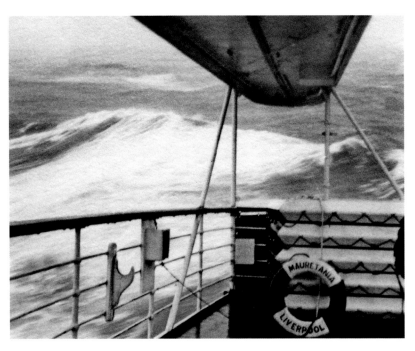

Just minutes after the preceding snap, this photo was taken astern on the Boat Deck, looking to port from beneath the Stern Docking Bridge. The *Mauretania* is rolling sharply to port. Getting there was not always, as Cunard publicity agents later claimed, half the fun. (Author's Collection)

Looking over the fantail from the aft Boat Deck during the 8 September storm, this photo shows an angry sea. (Author's Collection)

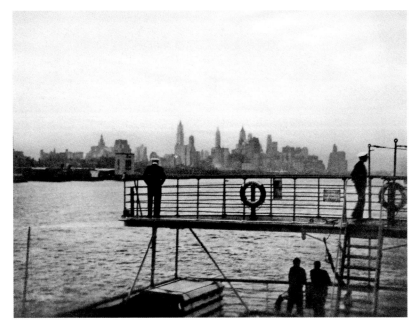

Steaming up New York's North River on 9 September, having safely concluded her crossing of the Atlantic. (Author's Collection)

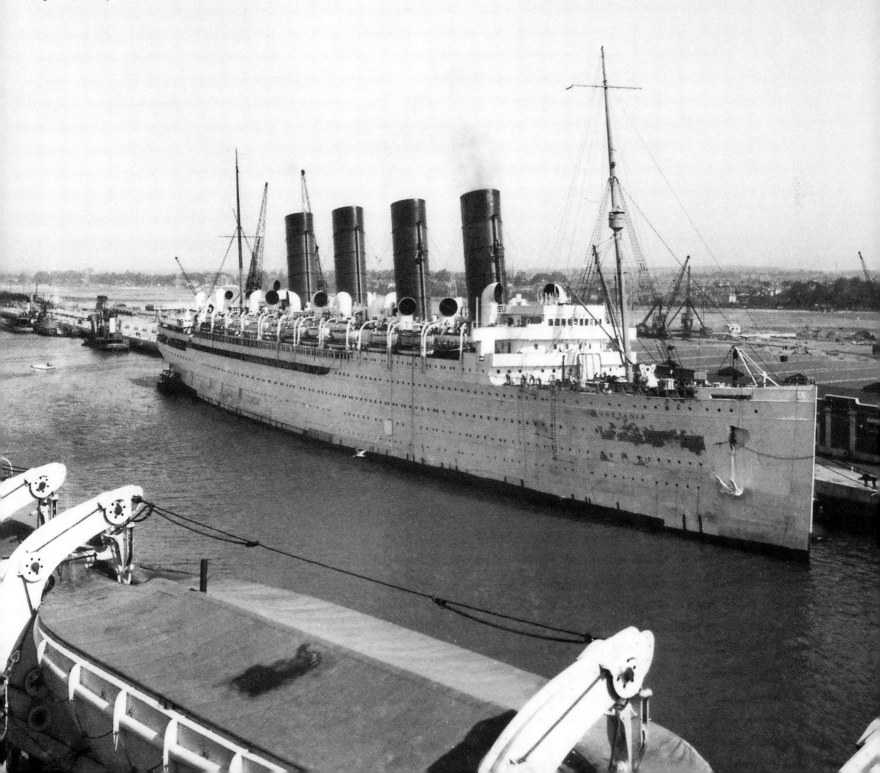

This very rare photograph was taken in May 1933 from a passing German liner, while the *Mauretania* lay at the new Western Docks in Southampton. Workers have painted most of the hull white, but a trace of dark paint remains just above the waterline for much of the ship's length. An area of hull beneath the Forecastle remains unfinished, and the foremast has not yet been painted white. (Ioannis Georgiou Collection)

Taken between May and October of 1933, this photo shows the *Mauretania* in her fresh coat of 'cruising whites'. Notice that her foremast and cargo derricks are all painted bright white at this time. (Jonathan Smith Collection)

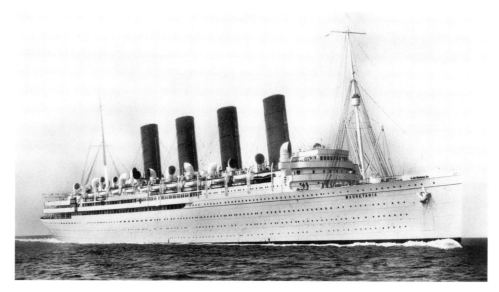

The *Mauretania*'s first arrival in New York in her cruising colours, in the evening of 6 July 1933. She is at anchor off Quarantine with a pair of tenders alongside, and is dressed in salute to the city. (Author's Collection)

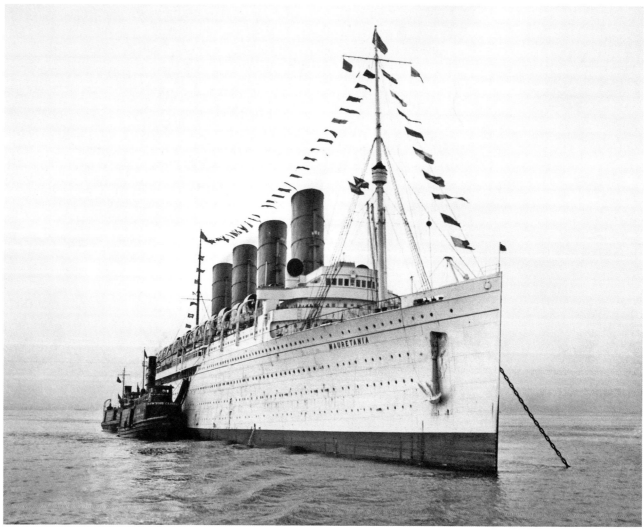

Seven photos from a large album of original pictures taken on the *Mauretania*'s 5–18 August 1933 cruise. Stops included Trinidad on 9 August; La Guayra, Venezuela on 10 August; Curaçao on 11 August; and Colon, Panama Canal Zone on 12–13 August. This view is looking forward along the starboard side of the Promenade Deck. Notice the string of lights running overhead to illuminate the deck at night. (Author's Collection)

Dancer Francine Edwards (also occasionally spelled Francene in the album) poses on the tender as her group returns to the ship. The photo gives a unique perspective along the ship's white hull and up toward her lifeboats. (Author's Collection)

Passengers returning to the *Mauretania* at one of her ports of call. The periodical *Cunard Cruise News*, published on board during her cruises, advised: 'Passengers are requested to report to their Bedroom Steward immediately upon returning from shore. Failure to do so will delay the sailing of the ship.' Other tidbits included advice to be careful of what they ate and drank ashore, and that cots could be made available on deck for anyone who found their cabins too stuffy at night. (Author's Collection)

A pair of female passengers on Boat Deck aft. The woman on the left, in the lighter-coloured swimming ensemble, is Francine Edwards. (Author's Collection)

This photo, also likely taken by the ship's photographer, was added to the album and showed 'Francine & Franco' of the 'Club Mauretania'. The photo was taken in the First Class Dining Saloon during a well-attended performance. (Author's Collection)

Only two of the three women in this photo are named in the album: seated and at right are the Poetz sisters. (Author's Collection)

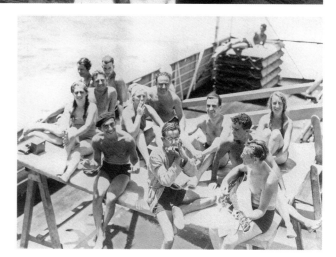

A group portrait aft on the starboard side of the Boat Deck, taken by the ship's photographer. The woman who compiled the album tagged the photo as 'Club Mauretania'. (Author's Collection)

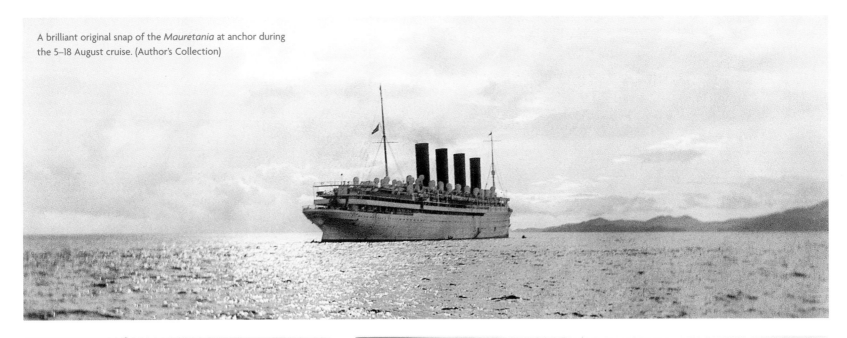

A brilliant original snap of the *Mauretania* at anchor during the 5–18 August cruise. (Author's Collection)

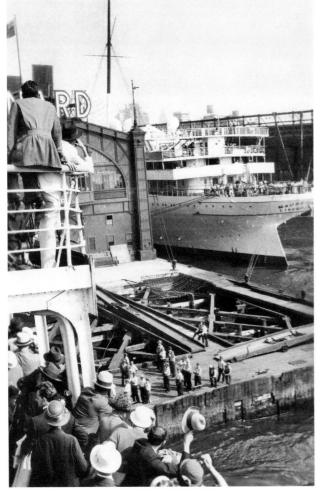

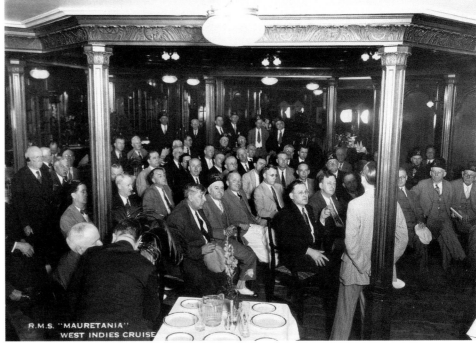

A rare 1934 photo, taken by the shipboard photographer, of the Tourist (ex-Second) Class Dining Saloon during a gathering of male passengers. (Author's Collection)

This original photograph was taken on 8 September 1933 in New York, from an unnamed ship. The *Mauretania* is tied up at the other side of the same pier, and a large party of her crew has formed on the fantail to bid farewell to the passengers of the departing ship. (Author's Collection)

TO-DAY'S PROGRAMME

Sunday, March 25, 1934

7.00 a.m.	Outdoor Swimming Pool, 'A' Deck aft. Open all day
8.00 and 9.00 a.m.	Holy Mass, Main Lounge
10.00 to 10.45 a.m.	Deck Sports, Sun Deck
11.00 a.m.	Divine Service, Main Lounge
11.30 a.m.	Deck Sports Tournaments, Sun Deck
1.00 p.m.	Luncheon. Buffet Luncheon, Swimming Pool
2.00 to 4.00 p.m.	Cruise Office open, Upper 'C' Deck
2.30 p.m.	Deck Sports Tournaments, Sun Deck
3.45 p.m.	Social Hour: Spelling Bee Contest, Main Lounge
4.30 p.m.	Thé Dansant, Swimming Pool
4.45 p.m.	Horse Racing, 'A' Deck
6.00 p.m.	Cocktail Hour Music, Verandah Café
7.00 p.m.	Dinner
8.45 p.m.	Illustrated Talk on Trinidad by Mr. H. W. Wack, Main Lounge
9.30 p.m.	Concert, Main Lounge

Note—*The Social Directress, Mrs. George E. Hawley, will be glad to meet passengers in the Main Lounge from 10.30 to 11.00 a.m. daily except Sunday, while at sea.*

R.M.S. **MAURETANIA**

WEST INDIES CRUISE

10.30 p.m.	Dancing, 'B' Deck
11.30 p.m.	Dancing, Main Lounge

TO-MORROW'S PROGRAMME

Monday, March 26, 1934

Cruise Office open 10.00 a.m. to 12 noon, and 2.00 p.m. to 4.00 p.m., Upper 'C' Deck

7.00 a.m.	Outdoor Swimming Pool, 'A' Deck aft. Open all day
8.00 a.m.	Holy Mass, Main Lounge
10.00 a.m.	Deck Sports, Sun Deck
10.00 a.m.	Deck Sports Tournaments, Sun Deck
10.30 a.m.	"Shopping Hints" by Social Directress, Main Lounge
11.00 a.m.	Concert Music, Main Lounge
11.00 a.m.	Golf Instruction by Mr. M. Walsh, Sun Deck
11.00 a.m.	Bridge Instruction by Mrs. Ruth Williams, Verandah Café
11.30 a.m.	Dancing Instruction, Smokeroom, 'B' Deck aft
11.30 a.m.	Music, Swimming Pool
12 noon	Turtle Racing, (live turtles) Sun Deck
From 12 noon	Informal Talks on Leeward & Windward Isles by Mr. H. W. Wack, 'B' Deck, Port Side
1.00 p.m.	Luncheon. Buffet Luncheon, Swimming Pool

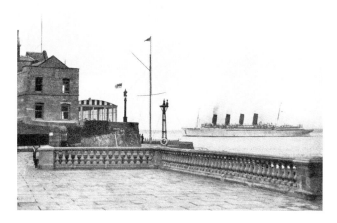

It's likely that this photo was taken in 1934. It shows the *Mauretania* steaming within a half-mile of Cowes, in Southampton water. The glass-enclosed pavilion of the Royal Yacht Squadron served as the grandstand for royalty and other VIPs during Regatta Week. (Author's Collection)

A programme for activities on board the *Mauretania* for 25 and 26 March 1934. Highlights included swimming in the pool, which opened at 7.00 a.m. each day, a *Thé Dansant* (tea dance), a live turtle race on the Sun Deck, and illustrated or informal talks on the various islands that would be visited. (Russ Willoughby Collection)

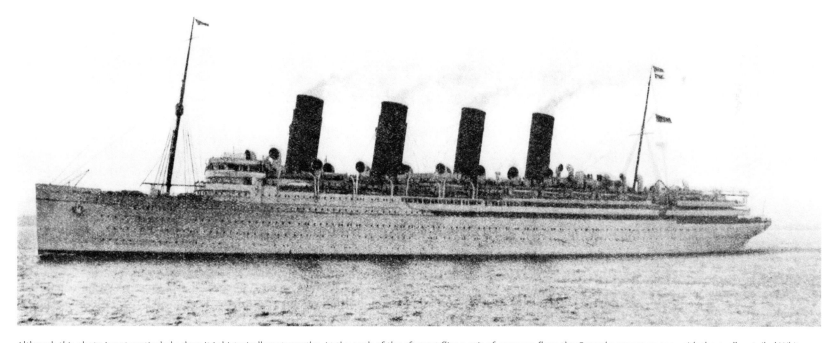

Although this photo is not particularly clear, it is historically noteworthy. At the peak of the aft mast flies a pair of company flags: the Cunard pennant on top, with the swallow-tailed White Star flag below. This means that the photograph was taken after the merger of the two companies, which was registered on 10 May 1934. After the merger, Cunard ships flew the Cunard flag above the White Star flag, while former White Star ships flew the pair in the opposite configuration. (Jonathan Smith Collection)

NOTES

1 *In Great Waters*, McNeil, p. 242.

2 *Daily Express*, 24/8/1930.

3 *Telegraph Herald*, 20/11/1930; *In Great Waters*, p. 237–8.

4 *Daily Express*, 10/1/1931.

5 *Daily Mirror*, 16/2/1931; *The Daily Express*, 18/2/1931.

6 *Daily Express*, 20/2/1931.

7 *Daily News*, 31/3/1931; *The Daily Mirror*, 20/4/1931.

8 *In Great Waters*, p. 241-2.

9 *New Yorker*, 26/9/1931.

10 *Daily Express*, 22/12/1931.

11 *Daily Mirror*, 19/1/1932.

12 *Daily Mirror*, 20/5/1932.

13 Details from abstract of log card, courtesy of Roger Marks.

14 *Daily Express*, *Daily Mirror*, 20/10/1932; *Daily Express*, 25/11/1932.

15 *Daily News*, 23/1/1933.

16 *New York Times*, 17, 21/5/1933.

17 *Buffalo Courier-Express*, 17/12/1933.

18 *New York Sun*, 10/7/1933.

19 *Daily Express*, 29/8/1933.

20 Although Captain Peel is usually listed as having commanded the *Mauretania* from 1931 to 1934, Captain Gibbons is clearly named in period press accounts of this trip, and gave direct interviews to reporters. It is unclear how long he was in command or if, indeed, it was beyond the length of a single cruise. Captain Walter Battle was listed as his staff captain on the *Mauretania* at this time. (*New York Times*, 6/9/1933.)

21 Period press accounts list 775; Humfrey Jordan listed 742, which seems better documented.

22 *Monthly Weather Review*, August 1933; NOAA Hurricane Research Division, 2012 re-analysis of storm data: www.aoml. noaa.gov/hrd/hurdat/metadata_1933.html#1933_8

23 NOAA http://www.aoml.noaa.gov/hrd/hurdat/metadata_1933. html#1933_8.

24 *New York Times*, 3, 5/9/1933.

25 *New York Times*, 10/9/1933.

26 *New York Evening Post*, 21/11/1933.

27 *New York Times*, 22/11/1933.

28 *Daily Express*, 7/12/1933.

29 *New York Times*, 21/3/1934.

30 *New York Times*, *Miami News*, *Montreal Gazette*, *News-Sentinel*, 22–23/6/1934.

31 *New York Times*, 22/6/1934.

32 *New York Times*, 7/7/1934.

33 *Daily Express*, 3/10/1934.

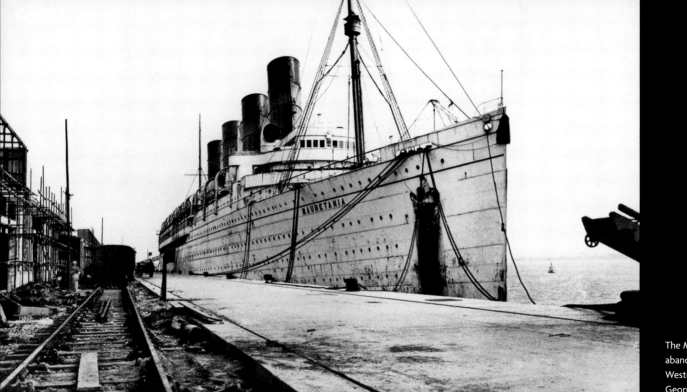

The *Mauretania*, tied up and abandoned at Southampton's Western Docks. (Clyde George Collection)

During the winter of 1934–35, the *Mauretania*, the 'Grand Old Lady of the Atlantic' sat lonely and derelict at Southampton's Western Docks. Her white hull, kept so pristine during 1933 and 1934 through regular maintenance, quickly began to show signs of neglect. On 12 April 1935, she was joined by the *Olympic*. The two former rivals, only recently united under the same pair of company flags, now both faced an ignominious end.

In mid March there had been a brief ray of hope. Negotiations for *Mauretania*'s sale to a Rosyth scrapyard were said to have broken down, and some thought that she could return to service on the North Atlantic in order to help deal with the increased demand for berths due to the King's Jubilee.[1] However, on 18 March Cunard officials made it public that, during the previous day, representatives of various ship-breaking firms had inspected the *Mauretania* 'with a view to the purchase of the liner for disposal'.[2] Some were hopeful that the British government, which had initially loaned Cunard funds to build the *Mauretania*, might move to block the sale, yet Sir Neville Chamberlain, Chancellor of the Exchequer, spoke from the floor of the House of Commons on 26 March and said that the government would not interfere.[3] In the evening of 2 April, Cunard announced that the *Mauretania* had been purchased by Metal Industries Ltd of Rosyth and would be scrapped.[4]

The report sparked a wave of public sentiment over losing a fixture on the North Atlantic. Since 1907, the *Mauretania* had become a part of the British Empire, soldiering on in both war and peace, a constant symbol of reliability and steadfastness during rapidly changing times. Even after she had been eclipsed by much larger and more luxurious liners, even after she had lost the Blue Riband, her last claim to fame, she continued to hold a special place in the hearts of Britons and Americans alike.

On Thursday 9 May, a number of visitors were allowed aboard to see what they might be interested in buying at the upcoming auctions of the ship's equipment, furnishings and fittings. Among these potential buyers, there were more than a few who were primarily interested in a walk down memory lane. Many middle-aged people could be seen wandering through staterooms, corridors and public rooms of the ship, all quiet and obviously reminiscing about past voyages. One of these was Mrs Elizabeth Hynes, a woman from Detroit,

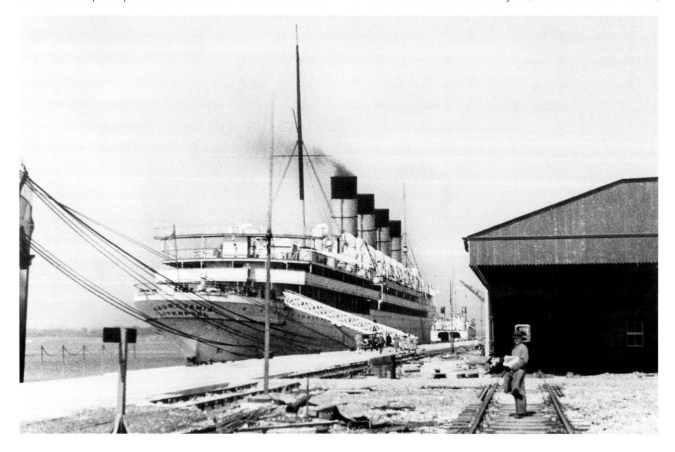

A brilliant stern view of the *Mauretania* during her lay-up In Southampton. At the extreme left is the bow of the *Olympic*, which was by then also laid up. A group of people is walking along the edge of the dock toward the gangplank, possibly indicating that the photo was taken during the auctions of her fittings, or during the public viewing held shortly before. (Ioannis Georgiou Collection)

Michigan. As she toured a vacant stateroom, she reminisced about her personal connection with the *Mauretania*. Some twenty-five years before, she had met her future husband Teddy in Paris while she and her family were travelling abroad. Teddy had not intended to travel but booked a berth on the *Mauretania* so he could journey to America with Elizabeth.

'Well, you know what it is like on ships,' Elizabeth said, 'especially a match-maker like this one. We were in love before and we became engaged' – before the liner reached New York. The couple was married for twenty-three years and every year, except during the war, they made a trip on the *Mauretania*; her husband had died two years before. While in London travelling, she heard that the old ship was going to be scrapped, and made a special trip down to Southampton to see the *Mauretania* one last time.

Between 14 and 17 May, the first auction was held; it was followed by a second between 20 and 23 May. Although bidding was expected to be brisk because of the ship's long career and popularity, as the auction started, bidders seemed lethargic, underwhelmed, or both. However, on the second day, when the First Class Smoking Room and Dining Saloon went up, bidding picked up steam. From there, interest seemed to escalate; bidders with connections to the ship came in to try to snatch a memento of her. One attendee had worked at the Wallsend shipyard as an apprentice and had helped to build her; another, Harry Allport, had sailed nearly a million miles with the *Mauretania*. He had been on her maiden voyage, had been a survivor of the *Lusitania* disaster, and had found his way back to the *Mauretania* during her service as a hospital ship.[5] By the time the auction had concluded, some £14,877 had been realised for the various items.

Over the subsequent five weeks, all of the sold items were removed from the *Mauretania*. Her masts, too tall to allow the ship to pass under the Firth of Forth Bridge on her way to Rosyth, were cut down, their dismembered extremities abandoned and left laying on the deck, and all of the beautiful panelling was removed from the steel bulkheads, leaving little trace of the ship's beautiful decor. About eighty-five mournful passengers were invited by Cunard-White Star for the upcoming final voyage, and only what was needed to care for them during that trip was left aboard.

At 6.00 p.m. on Sunday 30 June, the first watch held aboard the ship in nine months began; steam was raised below and the electric generators were started up. The ship's chief electrician, who had been with the *Mauretania* since she entered service, would resume his post for the final voyage. Her chief engineer would be H. Botling, who

had cared for the engines during the liner's layup. For this last, sad voyage she would be commanded by Captain A.T. Brown, who had served as staff captain under Captain Rostron; Rostron had been invited, but declined, saying: 'I prefer to remember her as she was in her best days. I do not wish to see her staterooms stripped, and all her fittings gone.'[6] He instead stood on the quay, a little distant from other sightseers who were gathering that night.

The ship was a dilapidated mess, looking more like a derelict than one of the finest ships in the history of the Atlantic – but very few had anything negative to say about her shabby appearance. A band was brought in to play, and thousands of people gathered to bid farewell to one of the greatest and most successful ocean liners in history. As the ship slipped her moorings, looking 'grey, like a ghost', the band began to play 'Auld Lang Syne'. The crowd took up the refrain in a growing chorus; the ship's passengers stood at the rails and locked hands as they joined the tribute. Aeroplanes circled overhead, while small craft jammed with spectators dotted the waters. Just astern, the *Olympic* – soon to head off to the scrapyard herself – began a salute with her sirens that was followed by every other vessel. *Mauretania* still flew the proud red Cunard pennant; she also flew a ribbon with the numbers '1907–1929', signifying her twenty-two-year reign as the world's fastest ship.

Looking aft from the roof of the *Mauretania*'s Tourist Class Lounge, the *Olympic* is visible astern. In the distance are the four funnels of the *Aquitania* at Ocean Dock. (Ioannis Georgiou Collection)

SOUTHERN RAILWAY

SALE BY AUCTION ON
THE "MAURETANIA"
of FURNISHINGS, PANELLING and APPOINTMENTS
at SOUTHAMPTON DOCKS.

PRIVATE VIEW —May 9th.
GENERAL VIEW—May 10th, 11th and 13th.
SALE DAYS —May 14th to 17th inclusive, and 20th to 23rd inclusive.
Commencing 11.30 a.m. each day.

CHEAP RETURN TICKETS
from
LONDON
(Waterloo Station)

	1st Class. s. d. 20/-		3rd Class. s. d. 13/3		
Forward :	a.m.	a.m.	*Return :*	p.m.	p.m.
Waterloo dep.	8.30	9.30	Southampton West dep.	4.41	6.22
Southampton West arr.	10.29	11.31	Waterloo ... arr.	6.50	8.20

A special service of buses will run between Southampton West Station and the berth in Southampton Docks at which the "Mauretania" is accommodated, at a fare of 6d. each way.
Admission to Private View by Catalogue only, price 5/- each, and to General View and Sale Days, price 2/6d. each. One Catalogue will admit one person only.

Catalogues obtainable from Hampton & Sons, Auctioneers, 20, St. James's Square, London, S.W.1, at the Offices of Cunard White-Star, Ltd., Southampton, or at the Enquiry Office, Waterloo Station.

REFRESHMENTS will be obtainable on the "MAURETANIA."

TICKETS OBTAINABLE IN ADVANCE AT STATIONS AND AGENCIES.

Waterloo Station, S.E.1.

H. A. WALKER,
General Manager.

C.X. 1068/ 10/30435 April 23433

Printed by McCorquodale & Co. Ltd., London.

Vertical text left margin: SECURE A SOUVENIR OF YOUR VOYAGE.

Vertical text right margin: CHILDREN UNDER 14 YEARS OF AGE, HALF-FARE.

An advertisement for the private and public viewings held aboard the *Mauretania*, as well as the auction of her fittings and furnishings. (Jonathan Smith Collection)

She moved down Southampton water for the last time, escorted by small craft and saluted by their passengers. It was a moment of great tragedy, like the passing of an old friend, and everyone wanted to make sure they paid their respects.

The trip was not to be a record-breaking one; as she was under the control of the ship-breaking firm, rather than the Cunard Line, excess expenditure in fuel would have been a needless expense. Once in open water, Captain Brown stood vigil on the Bridge; in the English Channel she was engulfed in a summer thunderstorm, which added drama to the trip. Every vessel she passed cut loose with their sirens and horns, and the *Mauretania* – stripped of her own siren – made her best croaking response. A final lifeboat drill was held, during which the passengers all donned their lifejackets.

The last habitable public room was the First Class Dining Saloon; one half was used for eating and the other half as a lounge. The ship was strangely muted, 'silent and deserted as the grave'.[7] Passengers with notions of romanticism might have believed that, along her deserted corridors, her dozens of empty staterooms and cabins, and in her bare public spaces, they could see a ghostly glimpse of her past: passengers in their Edwardian finery celebrating her first Blue Riband-winning voyage; nervous men and women fretting as the ship sped her way to Halifax in the opening hours of the Great War; anxious troops or weary wounded being transported to and from the fronts; revellers dancing the Charleston during the roaring twenties, living to the full a life which – they had learned all too harshly during the war – could be shattered or taken from them in a heartbeat; even the average New Yorkers seeking a brief reprieve from a brisk winter as they steamed through tropical waters. Emigrants, stars of the stage and screen, eminent politicians, people from all walks of life ... all living, laughing, honeymooning, making love, telling jokes or enjoying one last cigar and brandy in the Smoking Room before bed, splashing in the makeshift pools and enjoying their voyages. Or maybe they were praying, during the violent weather, that she really had been built as well as she needed to be, and would be relieved to set foot on solid ground again when the crossing was over. The ship was a veritable microcosm of the world over a span of twenty-seven years, and it was as if those memories had seeped into the ship's steel itself.

On 2 July, the *Mauretania* approached Bridlington and Scarborough, where thousands gathered to catch sight of her as she passed by. The next day, at 10.00 a.m., *Mauretania* stopped for half an hour off the mouth of the River Tyne, where she had been built. From those waters she had

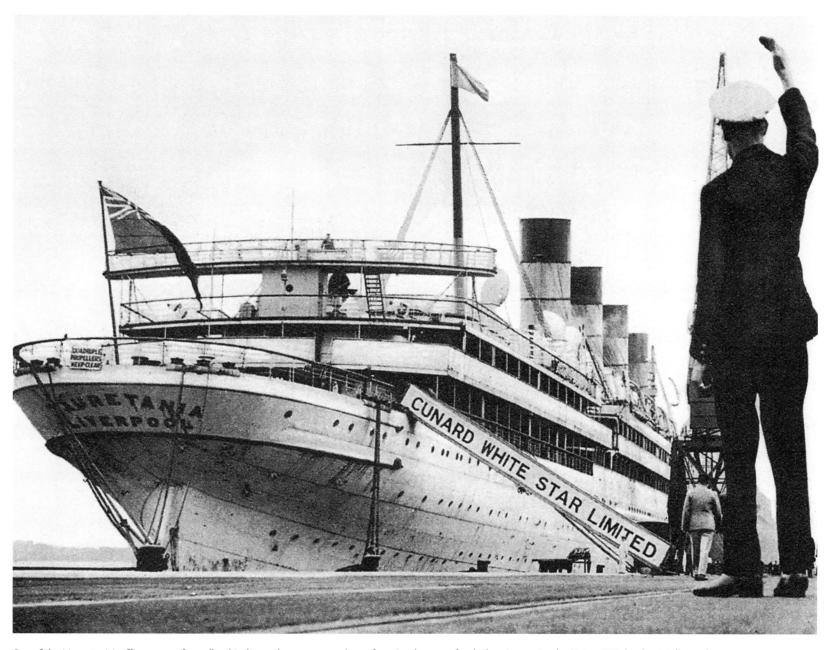

One of the *Mauretania*'s officers waves farewell to his ship as she prepares to depart from Southampton for the last time on Sunday 30 June 1935. (Author's Collection)

ventured into the open sea for the first time. More crowds had gathered on shore to see her; aeroplanes buzzed overhead and small vessels came out to greet the ship, all of them saluting and carrying passengers intent on saying farewell to their beloved ship. As she paused, she sent this message to the Lord Mayor of Newcastle: 'Thank you for your greeting. For 28 years have I striven to be a credit to you and now my day is done. Though I pass on, may Tyneside ever reach out to further and greater triumphs. With pride and affection I greet you. Farewell – Mauretania.'[8] The mayor boarded shortly thereafter and was received by Captain Brown. As the Mauretania restarted her engines to resume the final leg of her trip, passengers in the small craft nearby sang refrains of 'Auld Lang Syne'.

By the end of the day, the liner had made the Firth of Forth, where most of her passengers disembarked. She proceeded up the Forth after midnight, and by early the next morning had successfully passed under the Forth Bridge, escorted by two tugs; finally, she entered the dry dock at Rosyth Dockyard. As she was warped in, a solitary kilted figure with a set of bagpipes stood at the side of the dock and played a lament. Her engines were rung off, and the ship's mighty power plant fell silent for the last time. In short order, the workmen threw themselves into their sad task, cutting the ship up piece by piece and sending her steel off to be recycled.

As they worked, the Iron & Steel Institute's Corrosion Committee set up three inspections of the Mauretania – carried out on 29 August and 26 September 1935 and 28 August 1936. Their purpose was to ascertain how well she had withstood the elements during her career. The general conclusion 'was that in all readily accessible parts little appreciable corrosion had occurred, as a result of very thorough maintenance'. Paint flaking off the inside of the Promenade Deck was 1/16in thick, 'representing perhaps a dozen or more coats of paint'. The ship's outer paint had also been well maintained:

A group of crewmen poses with the famous 1907–1929 blue pennant which the Mauretania would fly from her shortened foremast as she left on her final trip to the breakers. (Author's Collection)

Above the water line the vessel was painted white, and below that green. The paint coats in each case were very thick (about 1/16 in.) and generally difficult to remove. Beneath the composite coats of white paint there was a coat of red paint, apparently red lead. The paint below the water line consisted of several layers of brown paint below several coats of green paint.

The positions of the rivets could be seen only with difficulty; there had been no preferential attack on them. The paint was blistered in a band about 6 ft. wide in the neighbourhood of the water line, the blistering being more marked below the line. In this region the paint had been removed from small areas by bumping and scratching, more particularly on the port side. These areas had rusted and stained the adjacent paint … On scraping off the rust from these areas or, with considerable difficulty, from other areas, the underlying metal surface was found to be fairly smooth and in good condition.

Although they found 'several instances of corrosion' in the superstructure or inside the ship, structurally these were found to be 'unimportant'. The deck plating at the stern 'was badly corroded and perforated in places', but this was not extremely serious since the plating had been covered with teak decking. 'Some wastage had occurred inside the funnels, perhaps to the extent of about 1/32 in.', but the 'underlying metal surface was fairly smooth and the plates were still serviceable'. The plating of some ventilator shafts in the vicinity of the First Class Smoking Room had 'completely perforated in places', which was likely caused by condensation; a similar problem had occurred 'at the foot of a stiffening side-plate adjacent to the first-class entrance, which was panelled.'

Deep within the hull, the 'side framing and plating of the shaft tunnels, the shaft stools, and the tank tops were in good condition.' Although the 'cement washing inside the double-bottom and on the floors and frames had perished generally', the steelwork was 'well preserved'. The ship's oil fuel bunkers were also 'found to be in good condition' where examination was possible. Although some localised instances of corrosion were noted, particularly in 'spaces enclosed with wood lining' and in 'the refrigerated space in the lower between deck, forward of No. 1 boiler room', there could be no question about the structural strength of the liner's steel work even during her demolition.[9]

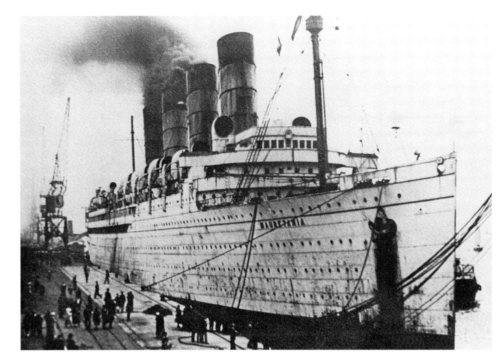

A crowd begins to gather on the quay as smoke belches from the liner's aft funnels. Tugs approach her port bow, waiting to take her in their care once she casts off. (Author's Collection)

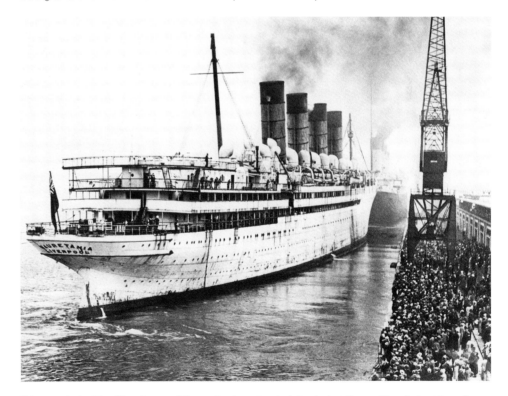

'*Mauretania* the Magnificent' casts off from a Southampton dock for the last time and is pulled out in to the channel. A large crowd of people has gathered to wish a fond farewell to the legendary ship. The stumps of the liner's masts strike an undignified note in an otherwise memorable scene. (Author's Collection)

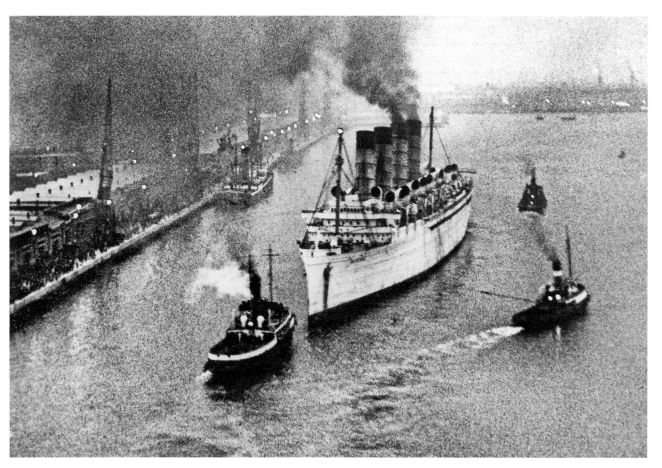

An aerial view of the liner being pulled away from the quay and into the channel. Many of the forward lifeboats have already been removed from the ship. (Author's Collection)

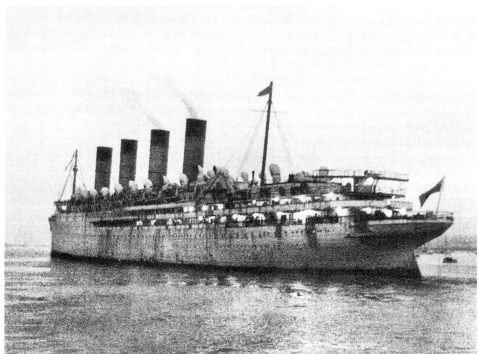

The *Mauretania* steams down Southampton Water, a ghost of her former self. Her open promenades are brightly illuminated as she heads into a summer thunderstorm on one last sad journey. (Author's Collection)

George Hunter was determined to make a name for his company when it embarked upon the construction of the *Mauretania*; as a result, no expense had been spared in building the ship. Cunard had lavished great effort and expense over the years to maintain and protect her from the elements. There is no question that she could have seen many more years of service before her hull's integrity even approached the point of suspicion.

Once the *Mauretania* had gone, an era had ended. New ships like the *Normandie* and *Queen Mary* were out breaking records on the Atlantic in her place, but times were different. In just a few short years, a growing malevolence would necessitate a second world conflict. With the end of that war, and the advent of jet-engine technology, the stage was set for the liners to almost pass entirely from the North Atlantic.

Very few people watching the *Mauretania* – with her rust-stained white hull, and her stern deck lights ablaze – sail into a summer's evening thunderstorm on 1 July 1935 could have imagined the enormous vessels that would follow in her wake, culminating in the city-like cruise ships of the early twenty-first century. But *Mauretania* and her sister had been the first of a whole new breed of 'superliner'; successors were evolutions of their technological marvels.

At the end of her life, Franklin Delano Roosevelt, President of the United States, wrote a touching eulogy memorialising the *Mauretania*. He said, in part: 'Neither size nor speed alone could have given the *Mauretania* her fame. That rested on something more secure and intangible – on her *personality*. For the *Mauretania* was a ship with a fighting heart. First and foremost, she was not just a great & successful liner. She was *the Mauretania*.'

Her former commander, Arthur Rostron, poignantly reflected: 'I suppose all good things have to come to an end sooner or later. But with the *Mauretania* one feels that something intimate has gone. It does make you feel there is a loss somewhere. I don't think anyone who was associated with her will ever forget the *Mauretania*. She was a credit not only to her builders and her owners, but to Britain and the Empire.'[10]

As she sailed through the stormy North Atlantic, pitching heavily and shooting curtains of water over her Bridge, very few of her passengers – snugly ensconced in her resolutely British interiors – would have dared disagree with such sentiment.

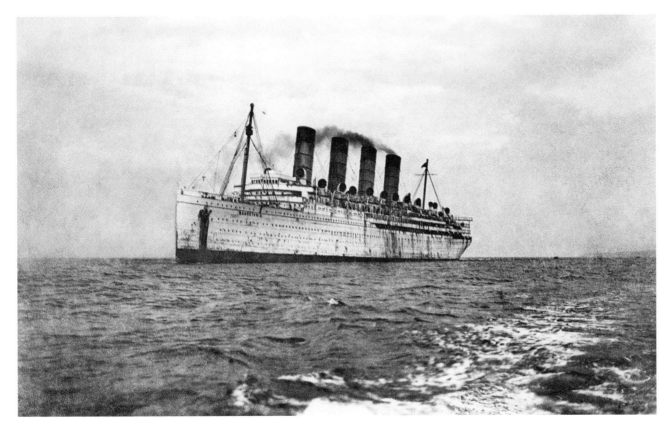

The *Mauretania* passing Scarborough at 10.00 p.m. on Monday 2 July. (Jonathan Smith Collection)

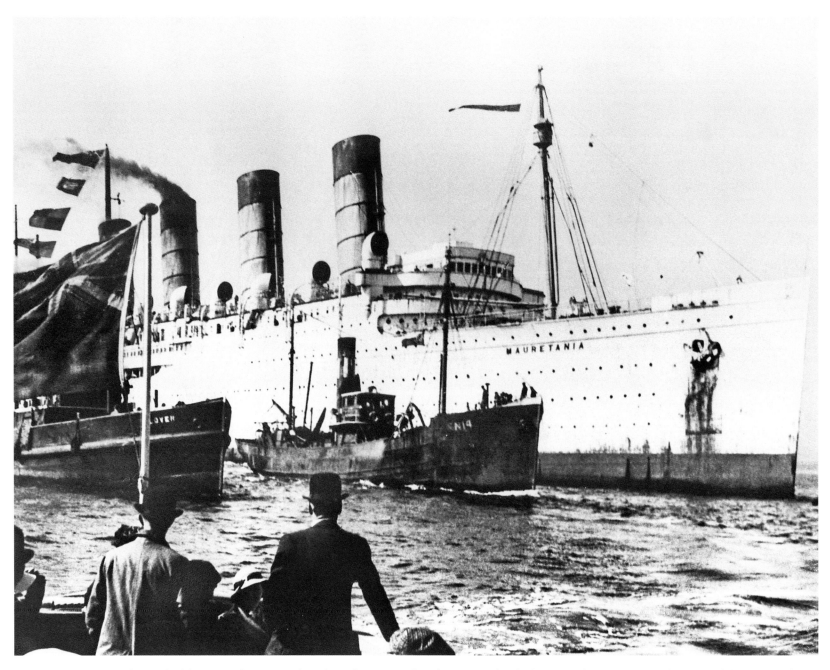

The *Mauretania* pauses at the mouth of the Tyne on the morning of Tuesday 3 July 1935. It was from this very spot that she first ventured into open water in late 1907, and the visit was a fitting tribute to those who had constructed what was then the world's largest and fastest ship. (Beamish Museum)

'West Indian Sunset', a 1934 photo taken by the *Mauretania*'s official photographer during one of the sun-drenched cruises she had become so famous for during her final years. (Author's Collection)

NOTES

1 *Daily Express*, 14/3/1935.

2 *Yorkshire Post*, 19/3/1935.

3 *Daily Express, Yorkshire Post*, 27/3/1935.

4 *Daily Mirror, Yorkshire Post, Daily Express*, 3/4/1935.

5 *Gloucestershire Echo*, 17/5/1935 (Courtesy of Mike Poirier); *Daily Express*, 18/5/1935.

6 *Yorkshire Post*, 2/7/1935.

7 *Daily Mirror*, 3/7/1935.

8 *Yorkshire Post*, 4/7/1935.

9 Fourth Report of the Corrosion Committee, Iron and Steel Institute, 1936, pp. 145–7. By courtesy of the staff of the Cornell University, Ithaca, NY.

10 *Yorkshire Post*, 3 April 1935.

BIBLIOGRAPHY

BOOKS

In Great Waters, Memoirs of a Master Mariner, Sandy G.S. McNeil (Harcourt, Brace & Co., 1932).

Lusitania: An Illustrated Biography, J. Kent Layton (Amberley Books, Centennial Edition, 2015).

Mauretania: Landfalls & Departures of Twenty-Five Years, Humfrey Jordan (Hodder & Stoughton, 1936; reprinted by Patrick Stephens Ltd, 1988).

On A Sea of Glass: The Life & Loss of the RMS Titanic, Tad Fitch, J. Kent Layton & Bill Wormstedt (Amberley Books, 2013).

RMS Mauretania: The Ship and Her Record, Gerald Aylmer (Percival Marshall, 1934).

Ships for A Nation: John Brown & Company, Clydebank, Ian Johnston (West Dunbartonshire Libraries & Museums, 2000).

The Edwardian Superliners: A Trio of Trios, J. Kent Layton (Amberley Books, 2013).

JOURNALS AND ARTICLES

Engineering, The Illustrated Weekly Journal, W.H. Maw and B. Alfred Raworth (ed.), vol. LXXXIV (July–December 1907). Portions of the original magazines were issued in this bound volume and were later reprinted by Patrick Stephens Ltd as *The Cunard Turbine-Driven Quadruple-Screw Atlantic Liner Lusitania* and *The Cunard Turbine-Driven Quadruple-Screw Atlantic Liner Mauretania*, edited and expanded by Mark D. Warren. Page numbers given in this book's endnotes refer to the original volume, not the later reprints.

The Shipbuilder: A Quarterly Magazine devoted to The Shipbuilding, Marine Engineering and Allied Industries, November 1907, vol. II, SPECIAL NUMBER. The Cunard Express Liner 'Mauretania'. Later reprinted by Patrick Stephens Ltd, as *Ocean Liners of the Past*, No. 2 in a series of reprints from *The Shipbuilder*. Page numbers given in this book's endnotes refer to the original volume, not the later reprints.

'Lusitania and *Mauretania*: Perceptions of Popularity', Mark Chirnside (*The Titanic Commutator*, 2008, vol. 32, no. 184).

'*Mauretania* and Her Builders', Ian Buxton (published in Mariners' Mirror, February 1996).

This splendid photo was taken in the mid-Atlantic in September 1932. The passenger who took it has ventured far out onto the Forecastle to capture a view of the liner's instantly recognisable bridge and forward superstructure. (Author's Collection)

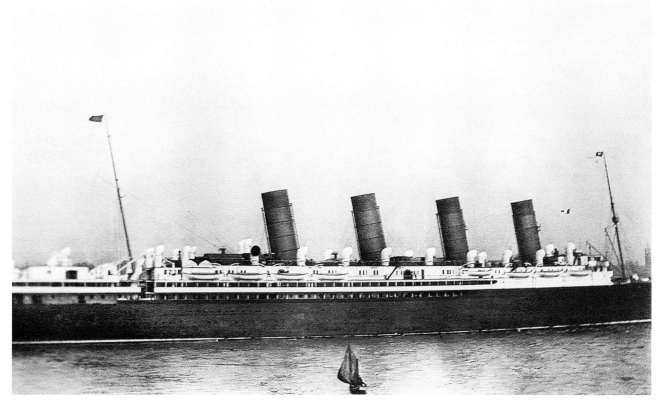

A unique, private image of the *Mauretania* passing a small sailing boat in Liverpool early in her career. (Mike Poirier Collection)

ALSO AVAILABLE

9780750994323

9780750993777

9780752497051

9780750967358

The History Press

The destination for history
www.thehistorypress.co.uk